E. McKNIGHT KAUFFER *the* ARTIST *in* ADVERTISING

E. McKNIGHT KAUFFER *the* ARTIST *in* ADVERTISING

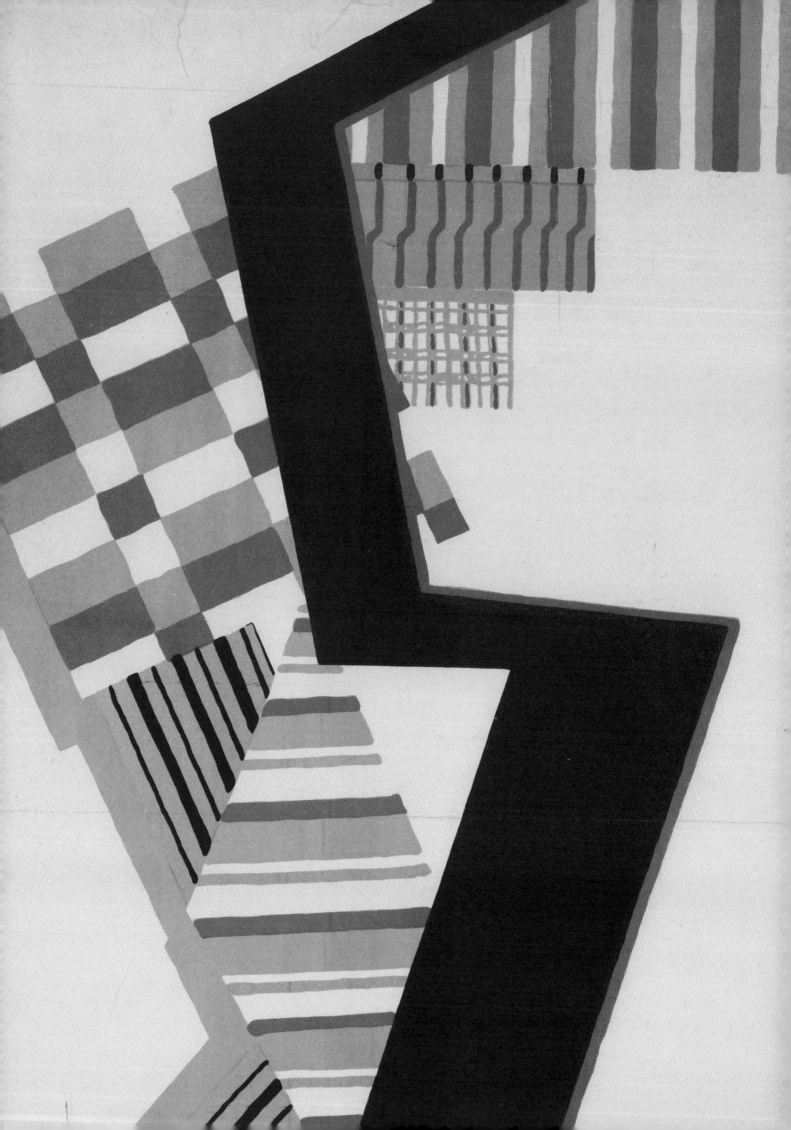

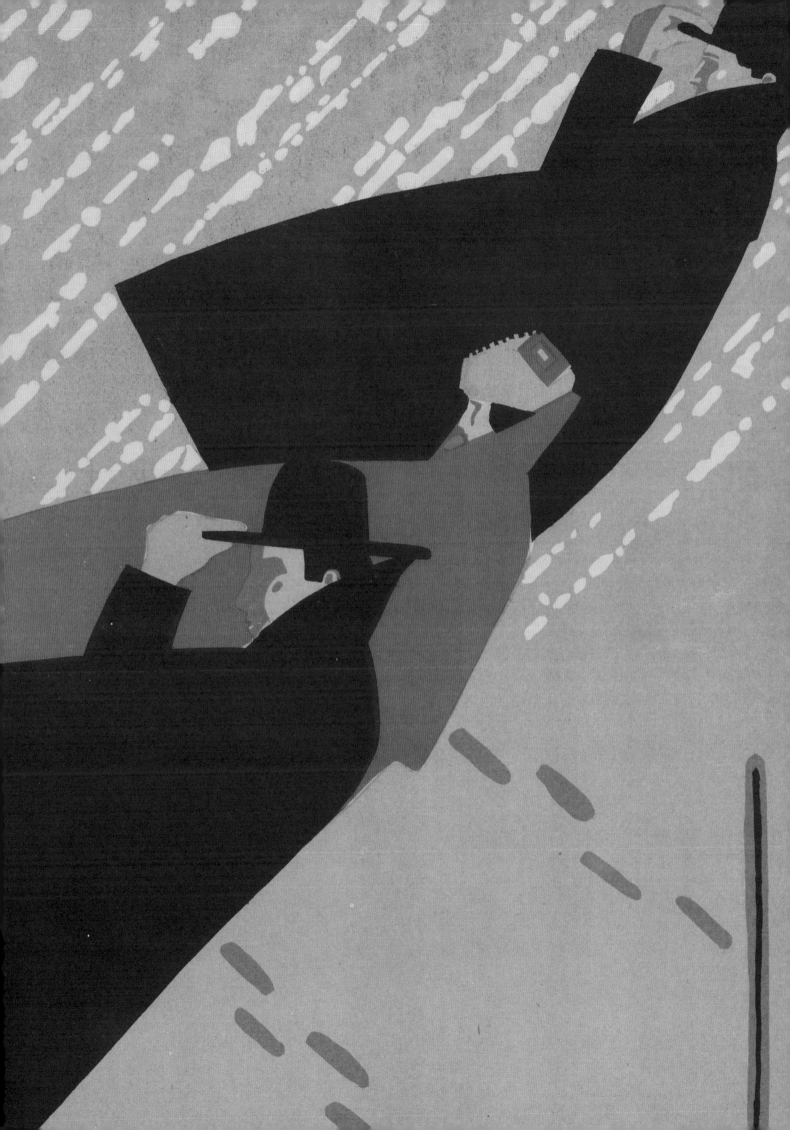

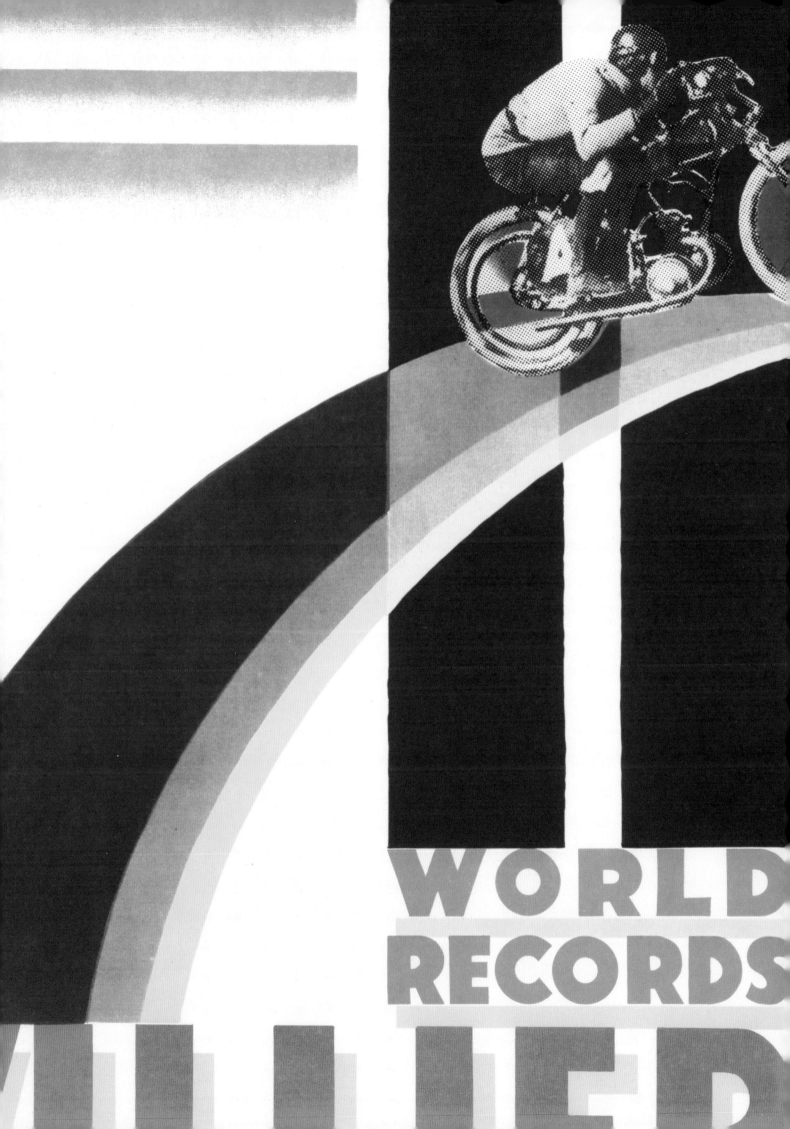

WORLD
RECORDS
MÜLLER

E. McKNIGHT KAUF– FER

RIZZOLI Electa COOPER HEWITT

the ARTIST *in* ADVERTIS—ING

edited by **CAITLIN CONDELL** *and* **EMILY M. ORR**

CONTENTS

Foreword John Davis 14

Preface Caitlin Condell and Emily M. Orr 16

Introduction: A Commercial Artist with Ideals
Caitlin Condell and Emily M. Orr 18

Rebel Artist 28
Caitlin Condell

The Underground's Alchemist of the Modern 42
Teri J. Edelstein

**Illustration as Commentary:
Modernizing the Classics** 50
Julie Pastor

**Fear, Sex, Maternity, Snobbism:
Kauffer and the Modern Woman** 58
Aidan O'Connor

Setting the Modern Stage 68
Kristina Parsons

Equipping and Exhibiting the Modern Interior 78
Emily M. Orr

**Educative Publicity:
Posters for the Government** 90
Caroline O'Connell

**Illustrating Race:
Kauffer and the African American Connection in Literature** 98
James Smalls

Kauffer and The Museum of Modern Art, New York 108
Juliet Kinchin

**Design Here Is Living:
Marion Dorn in New York** 116
Kimberly Randall

**A Parable of Uncompromise:
Kauffer in New York** 126
Steven Heller

Chronology 138
Taryn Clary

PLATES 142–259

Works Illustrated 260
Selected Bibliography 267
Index 270
Contributors 273
Acknowledgments 274

FOREWORD

Cooper Hewitt, Smithsonian Design Museum is uniquely positioned to share the story of E. McKnight Kauffer (American, 1890–1954), a pioneering designer famous in England between the world wars, who is represented in the museum's permanent collection with over 1,500 works. We are thrilled to bring new attention to Kauffer's career with this publication, *E. McKnight Kauffer: The Artist in Advertising*, which reveals a rich understanding of Kauffer's wide-reaching impact, and to produce the exhibition *Underground Modernist: E. McKnight Kauffer*—the designer's largest retrospective to date.

At the height of his career in the 1920s and 1930s, Kauffer was among the most influential artists in England, designing stage sets, carpets, book illustrations, and London Underground posters. In New York from 1940 until his death in 1954, Kauffer produced arresting book covers for Random House's Modern Library series and bold posters for American Airlines. Kauffer's collaborations with his avant-garde peers in the fields of art, literature, film, theater, industrial design, and interior design will resonate with enterprising designers today who apply their talents across media.

There is a fortunate tradition of designers giving their own work, and that of their friends, associates, and partners, to Cooper Hewitt as learning tools for the current and future generations of designers. In 1963, the textile designer Marion Dorn, Kauffer's widow, gave a diverse range of work by her late husband to Cooper Union Museum for the Arts of Decoration (later Cooper Hewitt). The scale of Kauffer's ambition is evident in the scope of the gift, which at the time amounted to one of the largest bodies of work by a twentieth-century designer in the museum's holdings.

This project is greatly indebted to the generosity of Simon Rendall, Kauffer's grandson, whose tremendous support and knowledge provided an unfailing foundation for this rediscovery of his grandfather's legacy. Grace Schulman, a poet whose literary ambitions were nurtured by Kauffer during his years in New York, added greatly to Cooper Hewitt's holdings with a significant addition to the archive in 1997. It is our hope that this publication will increase familiarity with a designer in the US who remains better known on the other side of the Atlantic.

Sincere congratulations to Cooper Hewitt curators Caitlin Condell and Emily M. Orr and curatorial assistants Caroline O'Connell and Kristina Parsons, who dove into the Kauffer research and revived the reputation of an underrepresented designer. We are also grateful to our Board of Trustees, dedicated supporters of our collection-based initiatives. *E. McKnight Kauffer: The Artist in Advertising* is made possible in part with the support of Furthermore, a program of the J. M. Kaplan Fund. The trans-Atlantic reach of Kauffer's career has been researched in great depth thanks to the Arts and Humanities Research Council of the United Kingdom, which awarded Caitlin and Emily with AHRC-Smithsonian Rutherford Fellowships in Digital Scholarship. These fellowships enabled extended research at the Victoria and Albert Museum in England. Our appreciation goes to all the museums, galleries, collectors, and scholars who have generously contributed their time, support, knowledge, and exceptional objects to bring Kauffer to light for new audiences.

(opposite) Poster (detail), *Great Western to Cornwall*, 1932 John Davis, Interim Director, Cooper Hewitt, Smithsonian Design Museum

The designs of E. McKnight Kauffer are often hiding in plain sight. Although his work has permeated the lives of millions of people on both sides of the Atlantic and he often made headlines in his lifetime, his name is now commonly known only among graphic-design enthusiasts. Indeed, neither of us knew who Kauffer was until we began work at Cooper Hewitt, Smithsonian Design Museum, in 2012 and 2015 respectively. Yet his book-jacket designs for the Modern Library editions of James Joyce's *Ulysses* and Ralph Ellison's *Invisible Man* had lurked on the bookshelves of our homes since our childhoods.

In the years since Kauffer's work first captivated us, the world has changed. The United States and Britain, the two countries that Kauffer called home, have each turned inward, enacting polarizing policies and legislation that persecute those seeking refuge and opportunity. As we crisscrossed the ocean to uncover Kauffer's legacy, we saw first-hand some of the uncertainty and heart-wrenching upheaval wrought by these political shifts. But we also witnessed remarkable activism, generosity, and hope. More than one hundred years ago, Kauffer arrived in England as an impoverished refugee fleeing war, and soon became one of the country's most innovative and celebrated designers. His life is a testament to the importance of a more open and inclusive society that transcends borders and national identities.

E. McKnight Kauffer: The Artist in Advertising would not be possible without the exceptional scholarship of those who have previously published on Kauffer, and you will find them cited often throughout this book. The writings of Mark Haworth-Booth, Grace Schulman, Peyton Skipwith, Graham Twemlow, and Brian Webb are essential reading for anyone interested in Kauffer, and the pioneering work of Christine Boydell has illuminated the career of his second wife, the textile designer Marion Dorn. *E. McKnight Kauffer: The Artist in Advertising* seeks to build on and supplement their scholarship, looking closely at specific elements of Kauffer's art and moments in his career. In the pages that follow, you will find essays that explore his work as an artist and poster designer, a stage and costume designer, an interior designer, and an illustrator of literature. Several essays examine Kauffer's commissions for major clients: the London Underground, the British government, and New York's Museum of Modern Art. Two essays bring new critical perspectives to Kauffer's visual treatment of women and African Americans in his designs. Kauffer and Dorn returned to New York at the outset of World War II, and two final essays offer analyses of their careers in the United States.

Kauffer dedicated his life to visual communication in the service of the public good. The hundreds of images found in these pages offer a rich range of Kauffer's dynamic work. We hope that this book will spark curiosity and further scholarship on Kauffer and his contemporaries, and will serve as inspiration for generations of artists and designers to come.

Note to the Reader *all figure illustrations accompanying the following essays are by E. McKnight Kauffer, unless otherwise noted.*

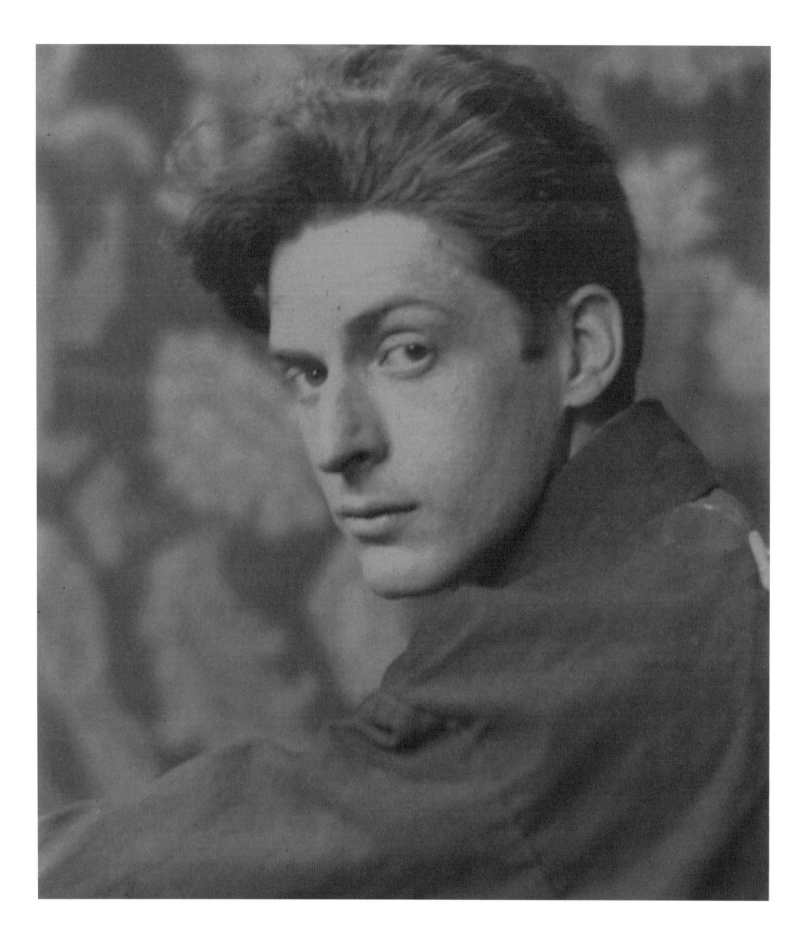

1.1 Photograph, E. McKnight Kauffer, ca. 1920, Photograph by Maud B. Davis

INTRODUCTION: A COMMERCIAL ARTIST *with* IDEALS

Caitlin Condell
Emily M. Orr

"THE ARTIST IN ADVERTISING IS A NEW KIND OF BEING. HIS RESPONSIBILITIES ARE TO MY MIND VERY CONSIDERABLE. IT IS HIS BUSINESS CONSTANTLY TO CORRECT VALUES, TO ESTABLISH NEW ONES, TO STIMULATE ADVERTISING AND HELP TO MAKE IT SOMETHING WORTHY OF THE CIVILISATION THAT NEEDS IT."

E. McKnight Kauffer
"Advertising Art: The Designer and the Public," 1938

FOR NEARLY TWENTY YEARS BETWEEN the two world wars, E. McKnight Kauffer, an American, was the most celebrated graphic designer in England. He was best known for his eye-catching posters, but his book covers and illustrations, graphic identities, carpets, stage sets, costumes, and ephemera were also among the most arresting of his era. Kauffer's distinctive artistic perspective quickly gave rise to an outstanding reputation that by the early 1920s, one of his clients could placate a waiting public between designs by papering billboards with a label: "A New McKnight Kauffer Poster Will Appear Here Shortly."[1]

A man of populist conviction, Kauffer believed fervently that modern art should move beyond the walls of museums and galleries to infiltrate all elements of daily life. His belief that innovative expression should be matched by social and cultural engagement marked him as a modernist. From the outset of his career until his death, Kauffer championed the principle that a designer held a responsibility not only to his client but also to his public. A poster, he believed, was a work of art that served the dual purpose of informing people and aiding industry.[2] It was an opportunity both to share important information and to introduce people to a new way of seeing. Kauffer's genius lay in his ability to synthesize conventions of the avant-garde and to adapt them to the needs of a client and to respond to the public's desire to be challenged. Although "E. McKnight Kauffer" was for a time a household name, it was not synonymous with one style but evocative of many. Kauffer constantly sought to metabolize what he

1 See Eastman and Son label, ca. 1924. Oversize box 5, scrapbook 1, item 1, E. McKnight Kauffer Archive, Cooper Hewitt, Smithsonian Design Museum, New York.
2 E. McKnight Kauffer, "Advertising Art: The Designer and the Public," *Journal of the Royal Society of the Arts* 87, no. 4488 [November 25, 1938]: 53.

3 Arnold Bennett, quoted in Frank Zachary, "E. McKnight Kauffer: Poster Designer," *Portfolio* 1, no. 1 [1950]: n.p.
4 Sir Colin Anderson, "E. McKnight Kauffer," in *Advertising Review* 1, no. 3 [Winter 1954-55]: 36. Anderson was the director of the Orient Line shipping company.
5 "I am just reading 'Soldier's Pay.' Faulkner seems to come through with a fine swing," wrote Kauffer to Blanche Knopf in 1930. "Who is Faulkner?" replied Blanche a few weeks later. Kauffer, letter to Blanche Knopf, July 26, 1930, and Knopf, letter to Kauffer, August 13, 1930. Alfred A. Knopf, Inc., Records, series IV, box 719, folder 4, Harry Ransom Center, University of Texas at Austin.
6 Marion Dorn, letter to Mary Hutchinson, n.d. [ca. 1932]. Mary Hutchinson Papers, series II, box 17, folder 5, Harry Ransom Center, University of Texas at Austin. Dorn and Kauffer had not yet married, but had by that time become socially accepted as a couple, having lived together since 1923.

saw in contemporary visual culture and make it relevant and new to an awaiting audience.

In art and life, Kauffer was "as a bird, forever in flight, forever searching for a place to come to rest."[3] Born in Great Falls, Montana, in 1890, Kauffer was restless from an early age. He spent his childhood in Evansville, Indiana, leaving school before the age of fourteen to paint scenery for the town's Grand Opera House. While still a teenager, he left home for good. He joined a traveling theater company as a scene painter, then found work in California, first on a fruit ranch and later at Paul Elder & Company, an influential bookshop in San Francisco. Over a period of just two years, Kauffer passed through Chicago and Baltimore in the United States, Algiers in North Africa, Naples, Venice, Munich, and Paris on the Continent, and Durham in the northeast of England before establishing himself in London by early 1915. As he experimented stylistically during this period, Kauffer also tried out a variety of monikers: Edward Kauffer, Edward Leland Kauffer, Edward McKnight, Edward Kauffer McKnight, Edward McKnight Kauffer, and finally E. McKnight Kauffer. But to his friends, he went by Ted.

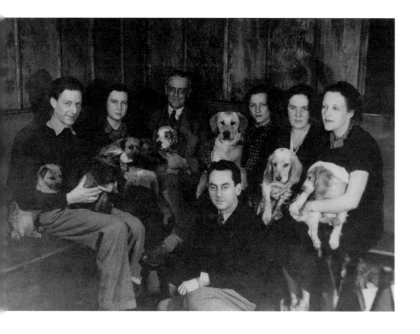

Personal relationships were the crux of Kauffer's creative life. He was handsome and charming (fig. 1.1), described by Sir Colin Anderson as "like a slim, russet eagle in appearance.…Cultured, intelligent and hypersensitive."[4] A voracious reader and consumer of culture, Kauffer formed close friendships with writers, critics, and artists. Arnold Bennett, Sir Kenneth Clark, T. S. Eliot, Mary Hutchinson, Aldous Huxley, Marianne Moore, S. J. Perelman, and Virginia and Leonard Woolf were just some of the members of his circle (fig. 1.2). As his star rose, Kauffer always worked to elevate others, helping artists including Man Ray and Zero (Hans Schleger) to establish themselves in London, and drawing William Faulkner to the attention of Alfred and Blanche Knopf.[5]

Kauffer grew professionally alongside his romantic partner and later wife, the American textile designer Marion Dorn. They collaborated on rugs and interior design projects and shared clients, including the Fortnum & Mason department store (plate 087) and Orient Line cruises. Dorn achieved many independent design successes during her years in London, but Kauffer's fame at times overshadowed her own. She once wrote to Hutchinson, with whom she was very close, "I had a terrible week…with those parties at Claridges and since I have had a little publicity, I am called in brackets—wife of E. Mack. Kauffer—in today's *Observer*. Because obviously no woman must ever be said to do anything on her own. I expected it but it made Ted wild."[6]

The end of the Great War brought a new emphasis on the value of art as a support for industry. A new and distinct role emerged, that of the modern designer, a development to which Kauffer contributed substantially in the London of the 1920s and '30s. In its inaugural issue of October 1922, the journal *Commercial Art* promoted art's use in commerce as "constant, immense and indispensable" and called upon both artists and progressive businessmen "to show the way and make the sacrifice of giving a good example."[7] Kauffer championed the belief that the promotion of anything from dry cleaning to an antacid (fig. 1.3) was an occasion for graphic innovation, but he also insisted that a designer "must remain an artist. He must be more interested in [commercial] art as an art than as a business."[8] And he was indeed more artist than businessman—his artistic integrity and perfectionism often came at the expense of his financial stability, somewhat ironically given his commitment to a sec-

7 "Our Philosophy, Policy and Programme," *Commercial Art* 1, no. 1 [October 1922]: 1.
8 Kauffer, paraphrased in Robert Allerton Parker, "Edward McKnight Kauffer: A Commercial Artist with Ideals," *Arts & Decoration* 14, no. 1 [November 1920]: 51.
9 Ibid.
10 Kauffer, ed., *The Art of the Poster: Its Origin, Evolution & Purpose* [London: Cecil Palmer, 1924].
11 "Too Good for the Films," *Liverpool Post*, December 16, 1926. Oversize box 4, scrapbook 2, item 1, Scrapbooks, Editorial Coverage and Published Materials, E. McKnight Kauffer Archive, Cooper Hewitt.

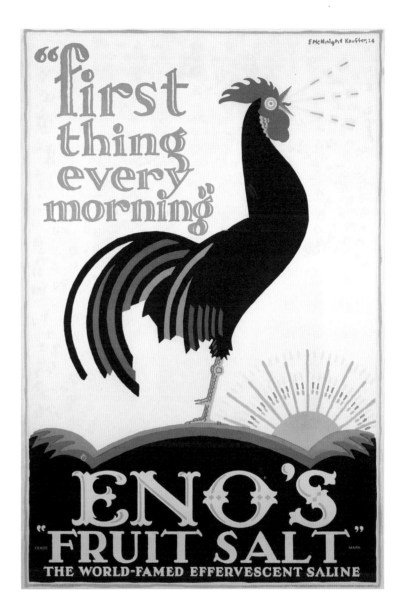

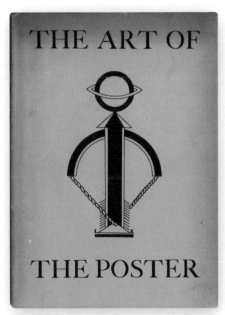

tor that aimed at a productive combination of the two. While maintaining his distinctive point of view, however, Kauffer believed firmly that direct engagement with clients was essential to his profession, "an absolute necessity in obtaining good results."[9]

Kauffer's work for risk-taking clients was often illustrated in the pages of *Commercial Art*, *Posters & Publicity*, and the many other trade journals founded in the period to celebrate art in advertising (fig. 1.4). Cultivating his own reputation as a modern designer with a keen sense of aesthetics, he often published and lectured, and in 1924 he edited a book on the field that had become his specialty, *The Art of the Poster: Its Origin, Evolution & Purpose* (fig. 1.5). In the book's text, he traces the history of advertising back through two centuries and reflects on the essential input of the artist in modern poster design, positioning his own work as integral to the medium's development.[10]

Not everyone was convinced, however, of the value that Kauffer's sophisticated style could bring: in 1926, the film company Gainsborough Pictures rejected several of his poster designs. Kauffer was at the height of his celebrity at the time, and the slight made headlines: "Posters Too Good for the Films," the papers reported.[11] Both works had been designed to promote Alfred Hitchcock's thriller *The Lodger: A Story of the London Fog* (plate 042). "They are sort of Futurist and

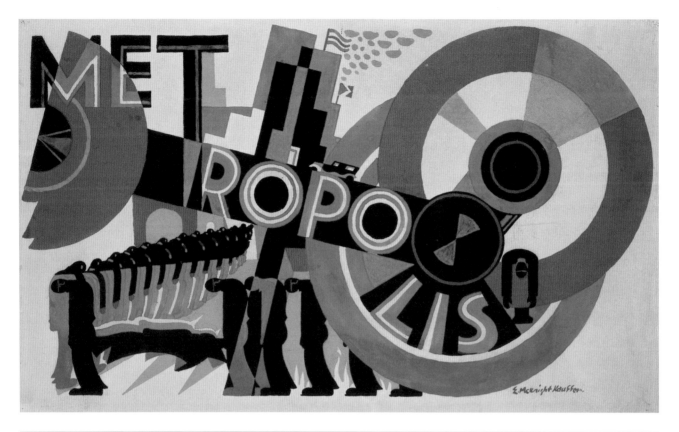

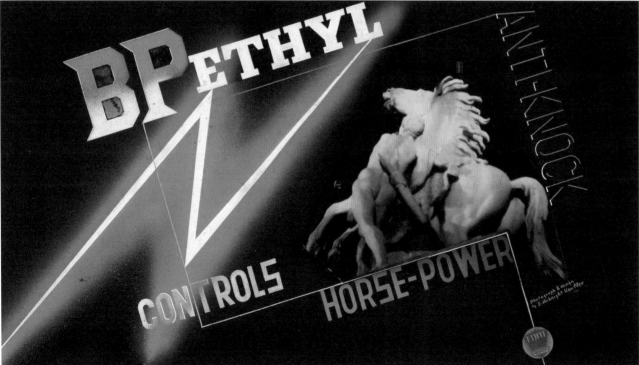

1.6 (this page, top) Drawing, Design for *Metropolis* by Fritz Lang, 1926
1.7 (opposite, left) Print, Design for *Eminent Victorians* by Lytton Strachey, 1921
1.8 (opposite, right) Frontispiece, for *Cornelian* by Harold Acton, 1928
1.9 (this page, bottom) Poster, *BP Ethyl*, 1933

quite attractive," a Gainsborough executive is quoted as saying, "but for one thing we did not want the public to think the film was one of these expressionist pictures like 'Dr. Caligari.'"[12] Despite the rejection of his posters, Kauffer remained involved in the project, ultimately designing the film's titles.[13] Another film poster Kauffer designed, *Metropolis* (fig. 1.6), was also never produced.

Meanwhile Kauffer was finding an increasingly large market for his book jackets and illustrations. Many publishers sought out his aesthetic to captivate new audiences, and by the mid-1920s literary design made up a significant part of his practice. This steady work continued for the rest of his career. Kauffer regularly collaborated with the Hogarth Press, founded in 1917 by the Woolfs, Nonesuch Press (plate 024), founded in 1922 by his friend Sir Francis Meynell, and the reinvigorated Curwen Press (plates 052–055). Each published affordable and finely produced editions of fiction and poetry, by authors including Bennett and Eliot. Kauffer also worked regularly for larger publishers, including Chatto & Windus (figs. 1.7, 1.8), Victor Gollancz (plate 037), Doubleday, Doran (plate 066), Random House, and Alfred A. Knopf.

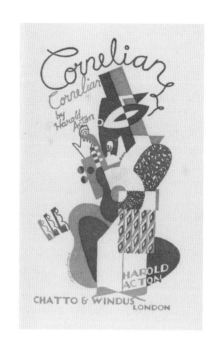

Driven both by the reputation of his talents and the nature of his personality, Kauffer forged client relationships with those who shared his ideals. A few outstanding and formative examples deserve recognition here. In Frank Pick, publicity manager for the Underground Electric Railways Company of London (UERL) and founding member of the Design and Industries Association (1915), Kauffer discovered a like-minded individual dedicated to raising the creative potential and public appreciation of design through the company's station architecture and posters. It was in large part through these UERL posters (plates 039–041) that Kauffer was able to develop his own stature, whether he was promoting an open-air destination with a pastoral landscape or encouraging museum attendance with a cubist composition.

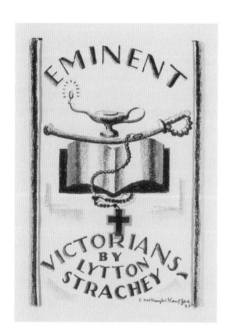

Kauffer also cultivated fruitful collaborations with printers. The Westminster Press (plate 030), founded in 1923 by Gerald Meynell, Francis Meynell's cousin, produced many of his advertising designs in the 1920s. In 1930, Kauffer took on the role of art director for the printing company Percy Lund, Humphries & Co (fig. 1.13). The company's chairman, E. C. (Peter) Gregory, encouraged the engagement of modern artists, and for a time Kauffer shared a studio with both Man Ray and the photographer Francis Bruguière.

In the early years of his career, Kauffer produced some designs for the oil company Shell-Mex and B.P. With the arrival of Jack Beddington, the company's forward-thinking publicity manager, in 1928, that relationship flourished into one of his most significant collaborations (plates 081–082). In exhibitions in London in the 1930s, Beddington presented the company's advertisements (fig. 1.9), guidebooks, lorry bills, and posters in the context of fine art. Sir Kenneth Clark, director of the National Gallery and a close friend of Kauffer's, wrote the introduction to the catalog for *Exhibition of Pictures in Advertising by Shell-Mex & B.P. Ltd.*, at Shell-Mex House, calling the company "among the best patrons of modern art" for the last seven or eight years.[14] In New York in the 1940s, advertising executive Bernard Waldman tenaciously championed Kauffer's talent, helping him to secure numerous commissions. Among the most significant was the American Airlines campaign (fig. 1.10), for which Kauffer produced more than thirty posters. Waldman, his wife, Marcella, and his daughter, Grace, became Kauffer's adoptive family.

12 Ibid.
13 Kauffer was an early member of London's Film Society [founded 1925], and designed the society's logo and some of its ephemera.
14 Sir Kenneth Clark, "Note," in *Exhibition of Pictures in Advertising by Shell-Mex & B.P. Ltd.*, exh. cat. [London: Shell-Mex & B.P. Ltd., 1938], 3. Kauffer was very close with Clark and was godfather to one of Clark's children.

The volume of Kauffer's poster output, as well as the frequent changeover of posters in London's transport system, meant that the city's hurrying commuters and pedestrians experienced his images repeatedly in their daily lives. As a contemporary critic observed, Kauffer eagerly responded to the quickening pace of contemporary life, designing posters for the "fast-moving" public and aiming to "express the message in the simplest and most direct form."[15] He evoked a different form of swift communication, among the fastest known at the time, in describing the poster as "not unlike a terse telegram that gets to the point quickly."[16] The emergence of new and efficient ways of communicating and traveling in the first half of the twentieth century provided Kauffer both with abundant new clients and with subjects for posters—from air mail and telephones (fig. 1.11) to ocean liners and trains.

In fact, fleeting opportunities for experiencing Kauffer's dynamic designs could be found in myriad aspects of contemporary leisure: his set and costume designs for ballets and the theater appeared on stages around the world, his display designs attracted attention in exhibition halls and shop windows, his clever greeting cards filled mailboxes (plate 150), and his striking packaging sold laundry detergent and textiles. For those clients ready to depart from tradition at home, Kauffer's

15 Adolphe Armand Braun, "E. McKnight Kauffer," Artists Who Help the Advertiser [No. 7], *Commercial Art* 2, no. 14 [December 1923]: 324.
16 Kauffer, "The Poster," *Arts & Decoration* 16, no. 1 [November 1921]: 42.
17 Francis Meynell, *My Lives* [London: The Bodley Head, 1971], 168.

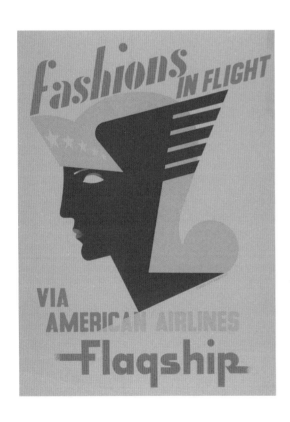

designs modernized domestic spaces; his book jackets lined the shelves of private libraries, his murals and tapestries (fig. 1.12) brought pattern and color to interior walls, and his and Dorn's carpets lined the floors of some of London's first modern apartment buildings. The multiplicity of Kauffer's output, breaking down creative boundaries, contributed to his status as a modern designer. As Francis Meynell reflected, "Kauffer was an example of the abandoned truth that art is indivisible: that a man with the root of the matter in him can paint or design rugs (as he did for Arnold Bennett) or make posters or illustrate books or decorate a room or parti-colour a motor-car (as he did for me) or scheme an advertisement."[17] Intersecting with the fields of architecture, interior design, literature, publishing, the performing arts, and retail, Kauffer and Dorn's projects brought them into a network with some of the most prominent proponents of English modernism—figures including composer Arthur Bliss, architects/designers Serge Chermayeff and Wells Coates, architect and artist Frederick Etchells, fashion journalist Madge Garland, artist and interior designer Curtis Moffat, playwright George Bernard Shaw, and choreographer Ninette de Valois.

Kauffer was in many respects an activist, advocating for the importance of design in the service of the public good. In 1919, in the wake of World War I, he was a founding member of the Arts League of Service (ALS), an organization aimed at increasing access to art and culture through exhibitions on modern art, literature, dance, and music, as well as a traveling theater troupe that ventured throughout Britain. He continued to design for the ALS during the 1920s. Kauffer was known as progressive and socially liberal but was not especially engaged in politics in the 1920s and early '30s. Despite this reputation, Kauffer participated in several problematic and insensitive commissions during this period. His ultimately unpublished illustrations for a special edition of Carl Van Vechten's 1926 novel *Nigger Heaven* (figs. 9.4–9.7) demonstrate that Kauffer was at best naive about matters of race. His illustrations for the Earl of Birkenhead's book *The World in 2030 A.D.* (1930, fig. 5.11) anchor a text that is imbued with misogyny and supportive of eugenics. His symbolic cover design for the fascist treatise *The Greater Britain* (1932; fig. 1.14) by Oswald Mosley seems to stand in contradiction to Kauffer's stated beliefs, yet his active participation cannot be overlooked. But as political upheaval

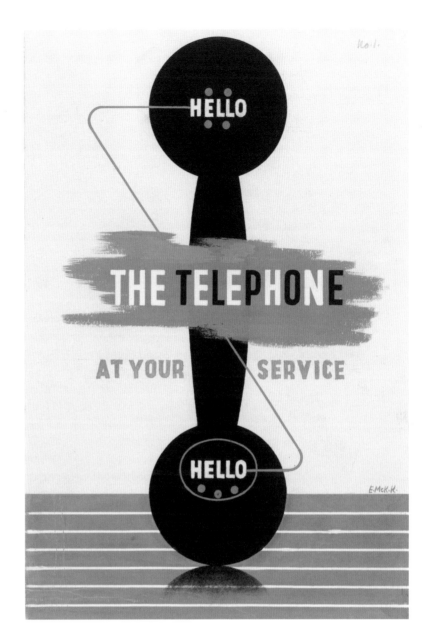

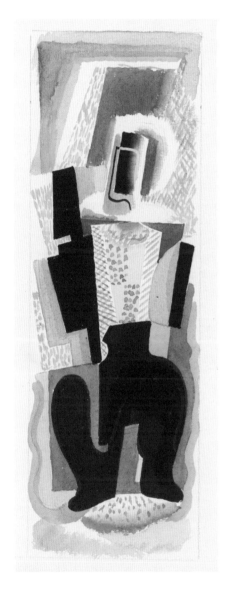

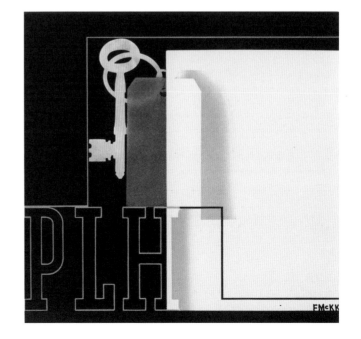

1.10 (opposite) Poster, *Fashions in Flight*, 1946
1.11 (top right) Drawing, Design for *The Telephone at Your Service*, 1937
1.12 (left) Drawing, Design for a tapestry, ca. 1935
1.13 (bottom right) Card, Percy Lund, Humphries & Co., 1932

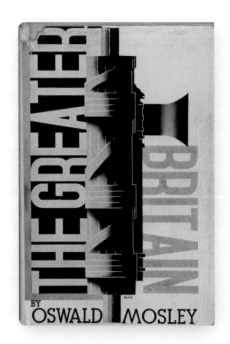

escalated in the 1930s, he became earnestly engaged with a range of worthy causes, lending his talents to organizations including the Peace Poster Service, the Peace Pledge Union, the Cambridge Anti-War Council (plate 109), the Association of Writers for Intellectual Liberty (fig. 1.15), the Union of Democratic Control, and the Festival of Music for the People. Kauffer's disdain for fascism is potently revealed in his powerful cover for Leonard Woolf's *Quack Quack* (1935; plate 107).

After the outbreak of World War II, Kauffer and Dorn moved to New York. Once there, Kauffer continued to support a sophisticated cultural response to wartime needs, working on commissions from the American Red Cross, the Greek War Relief Association, the National War Fund, and more.[18] In 1947, to honor his war-relief efforts, he was named an honorary advisor to the United Nations' Department of Public Information, and he designed a poster for the newly formed organization.

"I had never felt quite at home in my own country," Kauffer once recalled, yet throughout his time abroad he had remained an American citizen.[19] The restlessness that carried him across the United States and then to Europe in 1913 never truly abated. He had arrived in England as a refugee, fleeing Paris with his first wife, Grace McKnight Kauffer (née Ehrlich), at the outbreak of World War I, but would recall, "I think even then, I had the idea in the back of my mind that someday I would go back and find my place."[20] He did indeed return briefly to the United States in 1921, hoping to establish himself there, but found limited opportunities and soon returned to England. A 1925 notice in the newspaper suggested that Kauffer intended to become a British citizen, but he never did.[21] Instead, Kauffer remained an expatriate for twenty-five years. When World War II made his status as an American untenable in England, he left abruptly for New York and never returned.

Although Kauffer prized individual relationships above all, he struggled with the people he loved most. Grace McKnight Kauffer was a gifted concert pianist who sacrificed her own career in service of Kauffer's. In 1923, he abandoned Grace and their young daughter, Ann, having fallen in love with Dorn. The decision to leave his daughter haunted him for the rest of his life. He and Dorn had a happy relationship for many years, championing each other's work (fig. 1.16). In London and later in New York, they kept company with a tight-knit circle of peers who fed each other socially, creatively, and, at times, romantically. Despite their fame and professional success, Kauffer and Dorn weathered years of financial precariousness and bouts of emotional turmoil that led to several periods of separation. The challenges of their return to the United States ultimately proved too much for their relationship, and although they married in 1950, they were largely estranged in the final years of Kauffer's life.

In many respects, Kauffer remained an expatriate on both sides of the Atlantic: an American designer in Britain, a British designer in America. Although this lack of belonging took its toll on those he loved and on those who loved him, it was his stubborn resistance to settling that was the wellspring of his talent. He was always seeking something new, and he thrived when given the opportunity to use his creative abilities for the betterment of all. His firm belief that design was a responsibility distinguished him, for he held equal respect for the advertiser and the public. He took to heart the privilege of communication with all people in the fleeting moments of their lives. Kauffer was a modern designer for modern life.

18 Another important wartime client was Abbott Laboratories, a Chicago-based pharmaceutical company that supplied medicines to the US military. Abbott published an illustrated monthly journal, *What's New*, for which Kauffer designed a series of covers.
19 Kauffer, quoted in Zachary, "E. McKnight Kauffer: Poster Designer," n.p. Kauffer's daughter, Ann Rendall, recalled that Winston Churchill had summoned Kauffer to create an emblem for the Royal Flying Corps, but upon learning that Kauffer would not adopt British citizenship, Churchill rescinded the commission. See Mark Haworth-Booth, *E. McKnight Kauffer: A Designer and His Public*, 1979 [rev. ed. London: V&A Publications, 2005], 20.
20 Kauffer, quoted in Zachary, "E. McKnight Kauffer: Poster Designer," n.p.
21 See Graham Twemlow, "E. McKnight Kauffer: Poster Artist. An Investigation into Poster Design and Production during the Inter-war Period Using E. McKnight Kauffer's Oeuvre as an Example" [PhD diss., University of Reading, 2007], 43. Twemlow has identified an article including the caption "A Briton-to-Be-E. McKnight Kauffer, the clever American artist who is shortly changing his nationality," *Daily Chronicle*, September 10, 1925.

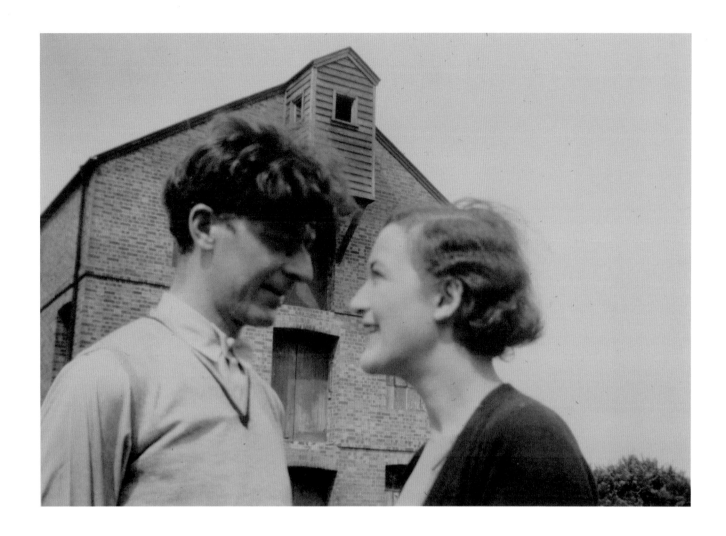

1.14 (opposite, left) Book cover, *The Greater Britain* by Oswald Mosley, 1932
1.15 (opposite, right) Brochure, *In Defense of Freedom: Writers Declare against Fascism*, 1938
1.16 Photograph, E. McKnight Kauffer and Marion Dorn, mid-1920s

2.1 Print, *Self-Portrait*, 1920

REBEL ARTIST

Caitlin Condell

ON APRIL 23, 1921, BURIED AMIDST THE NEWS OF THE DAY IN THE *YORKSHIRE POST* WAS A SHORT CRITICAL NOTICE OF A LONDON EXHIBITION OF MODERN ENGLISH ART. "THE DESPISED CUBIST HAS COME INTO HIS OWN AT LAST," THE ARTICLE DECLARED. "HE IS TO BE THE POSTER ARTIST PAR EXCELLENCE OF THE FUTURE."[1] The statement would prove prophetic, for the "despised Cubist" was none other than E. McKnight Kauffer (fig. 2.1), the man we now know as "the poster king."[2]

Kauffer was thirty years old when the *Yorkshire Post* article was published. Since 1915, he had embedded himself within several competing factions of the "rebel artists" of the British avant-garde,[3] regularly exhibiting his paintings alongside Vanessa Bell, David Bomberg, Frederick Etchells, Mark Gertler, Duncan Grant, Paul Nash, C. R. W. Nevinson, Edward Wadsworth, and others.[4] During that time, though, he had also adapted cubism and futurism for commercial purposes, designing some of the most provocative posters that the English public had ever seen. The critical success of his poster work had come to exceed that of his art, and by the fall of 1921, he had largely abandoned his work as a painter and was pursuing a career in design.

Years later, Kauffer would look back on this moment and recall, "I saw the futility of trying to paint and do advertising at the same time. I wished also to keep my integrity as a painter free from depending on social hypocrisy and the necessity to paint pictures that would sell. I decided to turn my whole attention to advertising and to give up painting entirely."[5] Kauffer's career shift was undoubtedly motivated in part by financial need. Yet it was precisely his integrity as an artist, and his established position in the British art world, that enabled him to challenge the status quo of British advertising by integrating modernism into the graphics that permeate urban life.[6]

1 "Cubist Posters," *Yorkshire Post,* April 23, 1921. Oversize box 5, scrapbook 1, item 1, Scrapbooks, Editorial Coverage and Published Materials, E. McKnight Kauffer Archive, Cooper Hewitt, Smithsonian Design Museum.
2 Wyndham Lewis was the first to apply the term "poster king" to Kauffer, writing in his autobiography in 1937, "One of 'X Group's' most prominent members was MacKnight Kauffeur [*sic*], who became the Underground poster-king: he disappeared as it were belowground, and the tunnels of the 'Tube' became thenceforth his subterranean picture galleries." Lewis, *Blasting & Bombardiering,* 1937 [reprint ed. Berkeley and Los Angeles: University of California Press, 1967], 212.

Although Kauffer strove to establish himself as a rebel artist in London from 1915 to 1921, his painting remained derivative, flirting with post-impressionism, fauvism, cubism, vorticism, and futurism. In his early commercial work, too, he often hewed closely to the graphic language of others. But in the wake of World War I, there was a new enthusiasm for the union of industry and modern art, and Kauffer's enterprising clients gave him free reign. Paradoxically, it was in commercial art rather than painting that Kauffer fulfilled his potential as a rebel artist. Through the promotion of travel, textiles, newspapers, and literature, he experimented more freely, absorbing and assimilating avant-garde styles, tropes, and tendencies and synthesizing them into striking and effective graphics. In his design work, Kauffer sought successfully to bring modern art out from behind the walls of "recognised establishments" and into the "people's art gallery" of the street.[7] And it was through this democratic effort that he ultimately made his most significant works as an artist: posters.

————

Kauffer arrived in England in August 1914, a broke young newlywed seeking to eke out a living as an artist. He did not plan to stay; since leaving San Francisco, where he had studied art in 1912, he had lived a peripatetic life, passing through Chicago, Baltimore, Algiers, Naples, Venice, Munich, and ultimately Paris[8] in pursuit of an art education based as much on observational study as on technical training.[9] London had not been on his planned itinerary, but the outbreak of World War I forced his abrupt departure from France with his first wife, Grace McKnight Kauffer, just weeks after

their marriage. Both were Americans, and they had intended to make their way home as soon as they had the money.[10] But the move from France had to be quick and cheap, and London was where they ended up.

Kauffer's travels had offered him his first direct exposure to European modernism. His brief studies at the Art Institute of Chicago coincided with the installation of the Armory Show of 1913, which traveled there after opening in New York, and which introduced many Americans to cubism, futurism, and fauvism. "I couldn't have spoken about it then," Kauffer recalled. "I didn't understand it. But I certainly couldn't dismiss it. I felt a kind of quickening."[11] Still, the academic training he was receiving did not suit him, and he described "rebelling against the system" in favor of post-impressionism.[12] In Munich he witnessed the blossoming of expressionism and was immediately taken with the German poster style.[13] The writer Colin Hurry, a friend and compatriot of Kauffer's in Paris, described him during this period as "theoretically, a Fauvist" who spoke of the influence of Marc Chagall, André Derain, Maurice de Vlaminck, and Henri Matisse. Yet Kauffer's work remained stubbornly indebted in style and spirit less to his radical contemporaries than to a beloved post-impressionist of the nineteenth century, Vincent van Gogh.[14] Although Hurry claimed that Kauffer "had not consciously seen any of the Dutchman's work," surviving paintings including *Trees, Normandy* (fig. 2.2) and *Hoeing* (fig. 2.3) suggest that Kauffer had spent time looking closely at Van Gogh's use of color and impasto.[15]

On first arriving in England the Kauffers sought refuge for several months in the home of a former roommate of Grace McKnight Kauffer's, the sculptor Maria Zimmern Petrie, who lived in Durham. Kauffer continued to paint when he could, and tried to find work as a poster and textile designer, but he had no success and the couple moved to London.[16] In the years before World War I, the British art world had gone through an upheaval. The London Group had formed in 1913, with the aim of regularly exhibiting a broad spectrum of British

3 The term "rebel artist" was used widely in England around 1913-14 by artists looking to distinguish themselves from their more conservative counterparts, and by the critics who wrote about them. Lewis's founding of the Rebel Art Centre, in March 1914, solidified the use of the term, but it was also associated more broadly with the artists of the London Group. For additional context see Charles Harrison, *English Art and Modernism, 1900-1939*, 1981 [reprint ed. with a new introduction, published for the Paul Mellon Centre for Studies in British Art, New Haven: Yale University Press, 1994], 89-101.
4 The most comprehensive list of Kauffer's exhibitions in 1916-20 is Graham Twemlow's, in "E. McKnight Kauffer: Poster Artist. An Investigation into Poster Design and Production during the Inter-war Period Using E. McKnight Kauffer's Oeuvre as an Example" [PhD diss., University of Reading, 2007], 74-76.
5 Kauffer, "Brief Biography," in *Posters by E. McKnight Kauffer*, exh. cat. [New York: The Museum of Modern Art, 1937], n.p.
6 The birth of Kauffer's daughter, Ann, in 1920 certainly influenced his financial decisions. Colin Hurry, a friend of Kauffer's since his time in Paris before World War I, would recall, "I am sure he had never wanted to become a poster designer but that, as in so many instances, the opportunity had to be taken because of the need for cash." Hurry, letter to Mark Haworth-Booth, October 25, 1970. Simon Rendall Collection.

7 "Hoardings as Picture Galleries," *The Organiser*, 1921, 167. Oversize box 5, scrapbook 1, item 1, Scrapbooks, Editorial Coverage and Published Materials, E. McKnight Kauffer Archive, Cooper Hewitt. The article is a profile of Kauffer. Variations of the phrase "people's art gallery" abound in contemporary publications; Kauffer's own use of the term first appears in his lecture "Modern Posters," given at the Croydon Camera Club in late February 1917. See "Meetings of Societies: Croydon Camera Club," *British Journal of Photography* 64, no. 2965 [March 2, 1917].
8 See, e.g., Colin Hurry, "An American Painter: E. McKnight Kauffer," *Pearson's Magazine* 45, no. 8 [June 1920]: 938, and Haworth-Booth, *E. McKnight Kauffer: A Designer and His Public*, 1979 [rev. ed. London: V&A Publications, 2005], 11.
9 Kauffer took art classes at Mark Hopkins Institute of Art in San Francisco [1910], the Art Institute of Chicago [1912-13], and the Académie Moderne in Paris [1914]. He also likely took classes in Munich in 1913. See Haworth-Booth, *A Designer and His Public*, 11-12.

10 See Kauffer, "Brief Biography," n.p., and "Norwich Girl Is in England; Folks Worry," *Binghamton Press*, August 5, 1914, 8. The newspaper article notes that the couple had been in Germany for their honeymoon when World War I broke out.
11 Kauffer, quoted in Frank Zachary, "E. McKnight Kauffer: Poster Designer," *Portfolio* 1, no. 1 [1950]: n.p.
12 Kauffer would write of this time, "Rebelled against the system of Art education, sided with the Post-Impressionists." Kauffer, "Brief Biography," n.p.
13 See Maria Zimmern Petrie, letter to Haworth-Booth, August 24, 1971. Simon Rendall Collection.
14 "Van Gogh was Kauffer's hero-figure at this time but he talked also of Matisse, of Derain, Vlaminck and of Chagall." Hurry, letter to Haworth-Booth, October 25, 1970.

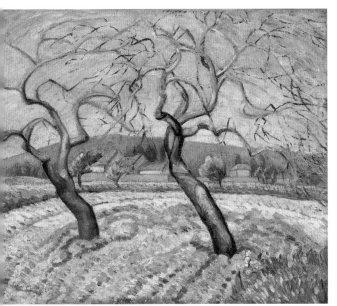
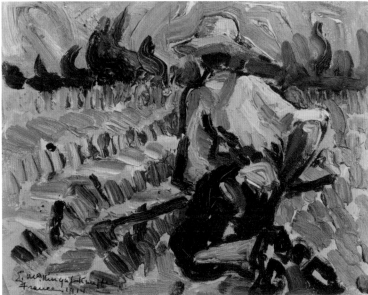

modern art. Its creation had served to draw a firm distinction between the modernist approach of the group's members and the more conservative work regularly exhibited by the Royal Academy and the New English Art Club. The London Group included artists from the Bloomsbury and Camden Town groups, as well as artists experimenting with cubism and futurism. Two of the most outspoken members of London's modern art establishment were the influential Bloomsbury artist and critic Roger Fry, who had introduced the British public to post-impressionism, and the artist and writer Wyndham Lewis. By 1913, Fry and Lewis had had a philosophical falling out, which resulted in a fissure in British modernism. Etchells and Wadsworth were among those who left Fry's Omega Workshop for Lewis's short-lived Rebel Art Centre (founded in March 1914), where they pursued a militant expression of futurism that came to be called vorticism.[17]

Into this fray stepped Kauffer, free of allegiances and eager to paint. He immediately formed close friendships with artists including Maxwell Ashby Armfield, Robert Bevan, Alvin Langdon Coburn, Charles Ginner, Stanislawa de Karlowska, and Raymond McIntyre.[18] In 1916, he was invited to join the Cumberland Market Group and the London Group. Remarkably, although Fry and Lewis were at odds with each other, both artists came to champion Kauffer's work and held him in high esteem.

Desperately in need of money, Kauffer sought clients for design work, but the only one with whom he initially had success was Frank Pick, the publicity manager for the London Underground. Pick had begun to look for artists whose modernist experiments would stand out against the general conservatism of British poster advertising.[19] To encourage wartime excursions to the suburbs made newly accessible by the Tube, Pick commissioned two posters from Kauffer in 1915, *In Watford* (plate 003) and *Oxhey Woods* (plate 004).[20] In his renderings of these settings Kauffer drew inspiration from both Van Gogh and Japanese ukiyo-e prints. Although his painterly landscapes have little in common with the German poster school, he styled his signature as an overt homage to Ludwig Hohlwein.

In June 1915, a few months after these posters went on display on the buses and trams of London,[21] the vorticist group's first exhibition opened at the Doré Galleries. In the exhibition's catalog Lewis imagined a world in which the urban environment was dominated by abstraction:

15 Kauffer spent some of the spring of 1914 in Normandy and brought with him a copy of Van Gogh's letters, which had just been published. Hurry, "An American Painter," 939.
16 Petrie, letter to Haworth-Booth, August 24, 1971. Simon Rendall Collection.
17 See Harrison, *English Art and Modernism*, 76–100.
18 In 1915, both Maxwell Ashby Armfield and Raymond McIntyre painted portraits of Kauffer. Armfield's is now in the National Portrait Gallery, London [NPG 4947], and McIntyre's is in the Museum of New Zealand/Te Papa Tongarewa, Wellington [1968-0002-22]. Kauffer exhibited with both artists that year at the Chelsea Art Stores on King's Road, London. See "Palette & Chisel," *Colour*, December 1915, xii.

19 See Michael Saler, *The Avant-Garde in Interwar England: Medieval Modernism and the London Underground* [Oxford: Oxford University Press, 1999], 102.
20 See Oliver Green, *Frank Pick's London: Art, Design and the Modern City* [London: V&A Publishing, 2013], 43.
21 See Twemlow, "E. McKnight Kauffer: Poster Artist," 95. *In Watford* and *Oxhey Woods* were issued on April 6, 1915.

2.2 (left) Painting, *Trees, Normandy*, 1914
2.3 (right) Painting, *Hoeing*, 1914

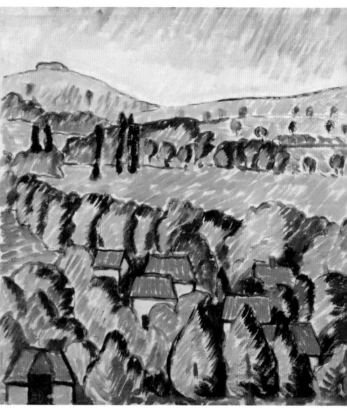

2.4 (bottom right) Poster, *The North Downs*, 1915, printed 1916
2.5 (top left) Painting, *Wood Interior*, 1915
2.6 (top right) Painting, *Berkshire Landscape*, 1916
2.7 (opposite) Painting, Untitled, 1916

Let us give a direct example of how this revolution will work in popular ways. In poster advertisement by far the most important point is a telling design. Were the walls of London carpeted with abstractions rather than the present mass of work that falls between two stools, the design usually weakened to explain some point, the effect architecturally would be much better, and the Public taste could thus be educated in a popular way to appreciate the essentials of design better than the picture-galleries have done.[22]

Neither *In Watford* nor *Oxhey Woods* employed the sort of abstraction that Lewis was calling for, a complex geometric interpretation of mechanical forms. Rather, both posters resorted to an elegant derivation of turn-of-the-century post-impressionism. Even so, the posters were broadly modernist and their success resulted in further commissions from Pick, for *Route 160 Reigate* (fig. 3.2), *The North Downs* (fig. 2.4), *Godstone* (1916; plate 002), and *Surrey Heaths* (1916). Kauffer was noted in the press as "one of the band of artists who have made the posters of the underground railway...so attractive that travelers lose their trains through dallying to look at the posters."[23]

Since arriving in London, Kauffer had begun turning to new influences in his painting, experimenting but in each case still remaining close to his references. Some surviving work reveals that he continued to be enthralled by Van Gogh, but other works from that year suggest that he was also drawing on various French artists for inspiration. *The Thames, Cheyne Walk, Chelsea* (1915) shows him imitating the style of Édouard Vuillard—so much so that he playfully signed his name "Edouard."[24] The impact of Paul Cézanne is apparent in *Wood Interior* (fig. 2.5) and even more so in *Berkshire Landscape* (fig. 2.6) and an untitled still life (fig. 2.7).[25] Several watercolors from this period show Kauffer working out landscapes in flat, vibrant planes of color similar to those that had begun to appear in his poster work.[26]

Kauffer's first monographic exhibition was held at Hampshire House, London, in May 1916. Although the war was raging, Kauffer showed pictures of landscapes, flowers, still lifes, and buildings that seemed to exist in a more peaceful world. The exhibition was quickly followed by Kauffer's inclusion, for the first time, in an exhibition of the London Group, its fourth, at the Goupil Gallery. Reviewing the show for the *Christian Science Monitor*, C. Lewis Hind praised the still life Kauffer exhibited as an admirably successful adaptation of the principles of Cézanne, but spent the largest portion of his review discussing the works that he wished had been included: Kauffer's posters for the Underground. Those posters, he wrote, "may be described as rebel art adapted for commercial purposes....The poster artist has not yet been officially recognized. He belongs to the new school, even to rebel art, and he has the satisfaction of knowing that his work appeals to thousands and thousands, and elates them with the sight of happy and unruffled nature."[27] The review was accompanied by a single illustration, showing one of the works Hind wished had been exhibited: *In Watford*.

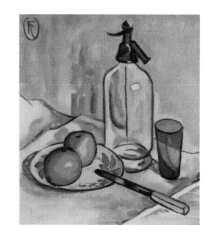

Despite the success of his Underground posters, Kauffer did not receive another poster commission from the company until 1920. Nor was he luckier elsewhere: although Pick believed that modern art offered a new way of seeing and interpreting a rapidly changing world, few other commercial clients were interested in risking a similar approach.[28] Kauffer created a number of poster designs in 1917–18, but only five are known

22 Wyndham Lewis, *Vorticist Exhibition*, exh. cat. [London: Doré Galleries, 1915], n.p.
23 Unidentified newspaper clipping, n.d. [1916]. Oversize box 5, scrapbook 1, item 1, Scrapbooks, Editorial Coverage and Published Materials, E. McKnight Kauffer Archive, Cooper Hewitt.
24 Repr., including the inscription "Edouard" on the verso, online at www.liveauctioneers.com/item /19849716_edward-mcknight-kauffer -oil-on-board [accessed January 9, 2020].
25 According to notes made by Ann Rendall, Grace McKnight Kauffer translated Paul Cézanne's letters in small bound notebooks for Kauffer. These notebooks, and Ann Rendall's notes, are in the Simon Rendall Collection.
26 See, for example, the reproduction of one of Kauffer's watercolors in *Colour*, December 1915, 175.
27 [C. Lewis Hind], "Rebel Artists of London and Their Debt to Cézanne," *Christian Science Monitor*, June 30, 1916, 6.
28 See Saler, *The Avant-Garde in Interwar England*, 99.

to have been published. Nevertheless, he actively sought to further his reputation as an authority on the modern poster.

Meanwhile, elements of cubism and futurism were appearing for the first time in Kauffer's painting, and beginning in the summer of 1916, he also began to draw inspiration from the work of some of his contemporaries in London. The Kauffers spent the summer of 1916 in Blewbury, a village to the west of London, known as a haven for artists.[29] Their neighbors there included Coburn, who after years as a respected portrait and landscape photographer was conducting his first experiments with abstraction, which would culminate in a series of photos he called "vortographs." Produced using a triangular arrangement of mirrors, these images were kaleidoscopic in effect. Coburn's turn to vorticism may well have inspired Kauffer to do the same. Kauffer had also become personally acquainted with Wadsworth, who, since 1913, had been making precisely carved woodcuts translating urban and mechanical forms into complex geometric abstractions. In 1916, Kauffer too began making prints, two of which, *Housetops* (fig. 2.8) and *Flight* (fig. 2.9), are his first vorticist works. In both prints he turned his subjects into geometric forms, using the balance between black and white to flatten the picture plane and convey a sense of motion.

The graphic impact of the bird motif in *Flight* must have been obvious to Kauffer; in January 1917, he published the print in the Poster Gallery section of the art magazine *Colour*, which had previously illustrated several of his paintings.[30] The Poster Gallery section, which *Colour* had introduced the year before, was a single-page spot reproducing "a new design for a poster by a well-known artist" in the hope that a client would purchase it for use.[31] For his first entry in this section, Kauffer set his birds in flight against a vibrant yellow background and refined some features of the woodcut, removing the birds' serrated wings and employing yellow and gray to delineate their forms and movement.[32] The design would prove central in his career, but it would be two more years before a client used it.

In the meantime, Kauffer began to infuse his watercolor landscapes (fig. 2.10), urban scenes, and still lifes (fig. 2.11) with the fractured planes of cubism. The pictures lack the dynamism of the woodcuts, but Kauffer was able to playfully suggest speed in one of his first lithographs, *The Thames* (fig. 2.12). Even as he and his wife struggled to make ends meet, his enthusiasm for artmaking was palpable: "I am so anxious to paint that I can hardly sleep at night thinking of it," he wrote to Armfield in the early spring of 1917.[33] The letter was full of news—Kauffer had been elected to the Artists' Committee of the Allied Artists Association and had moved to a new home—and included a lengthy discussion of the merits of tempera painting. And although he did not discuss his poster work in any detail, he enclosed recently published copies of the *British Journal of Photography* and *Colour* that showcased critical turning points in his design career.[34]

The copy of the *British Journal of Photography* that Kauffer is likely to have sent to Armfield is the issue of March 2, 1917, which featured extended minutes on two matters that had dominated a recent meeting of the Croydon Camera Club. The first was the attendees' general disgruntlement with an exhibition of Coburn's vortographs; the other was a response to a paper read to the group by Kauffer, "Modern Posters." Although Kauffer had at that point published only six posters, all for the Underground, the Croydon minutes described him as an authority "as to what constitutes a good poster."[35] That such a novice designer could be touted as an authority is indicative of how successful his first attempts in

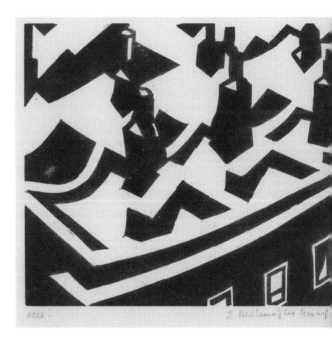

29 The couple rented a local policeman's cottage, which became the subject of one of Kauffer's watercolors. For a black-and-white reproduction see Charles Marriot, "The New Movement in Art," *Land & Water*, October 18, 1917, 19.
30 *Colour*, January 1917, iv.
31 *Colour*, April 1916, iv.
32 On the evolution of *Flight* see Haworth-Booth, *A Designer and His Public*, 17–19, and Twemlow, "E. McKnight Kauffer: Poster Artist," 112–20.
33 Kauffer, undated letter to Armfield. TGA 976/1/84–111, Tate Gallery Archive.
34 "I am going to send a March Colour and a copy of the Brit. Journal of Photography in which portions of my lecture appear." Kauffer, undated letter to Armfield.
35 "Meetings of Societies: Croydon Camera Club," 112.

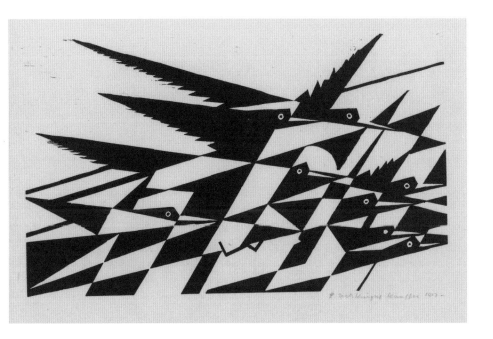

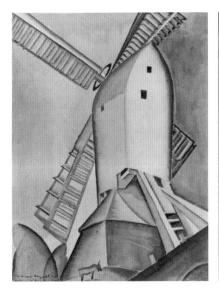

2.8 (opposite) Print, *Housetops*, 1916
2.9 (top left) Print, *Flight*, 1916
2.10 (bottom left) Drawing, Oldland Mill, Ditchling, Sussex, 1917
2.11 (bottom right) Drawing, Still Life, 1918
2.12 (bottom center) Print, *The Thames*, 1917

the medium were, and of how wide open the field must have been. But Kauffer spoke with conviction. "A good poster," he told the group, "must be so arranged that it inflicts an impression, so to speak, like that of an electric shock on the mind of the passer-by.... The potentiality of a poster lies in its force of attraction. The future of the poster is assured. It has its place and work to do in the industrial world, and as long as industry lives so long will the poster live."[36]

The March 1917 issue of *Colour* that Kauffer sent to Armfield featured his third entry in The Poster Gallery, a design derivative of a poster by Hohlwein.[37] Kauffer had already turned to Hohlwein as a source in work for his only ongoing corporate client, Steinthal & Co., a Manchester cotton-export company that employed Kauffer's friend W. H. Zimmern (Maria Zimmern Petrie's cousin). For a long series of cotton-bale labels that he would design for Steinthal, Kauffer initially worked from photographs of locales provided by Zimmern; the donkey in *Colour*'s Poster Gallery design is undoubtedly drawn from one of these, but Kauffer copied the exoticized depiction of a boy directly from Hohlwein's poster *Mittelmeer-Fahrten: Norddeutscher Lloyd Bremen* (fig. 2.13).[38] Kauffer's decision to mimic in subject and style his German contemporary proved successful. Following the precedent set by the Underground in looking for "a more modern and artistic series of Posters,"[39] the department store Derry & Toms purchased the design reproduced in *Colour* for a poster titled *Economy and Smartness in Men's Wear* (fig. 2.14). The store also commissioned a second poster from Kauffer, *Autumn Offerings*, which featured a large cornucopia of fruit. Kauffer designed the tip of the cone to all but obscure the first *r* in "Derry," a somewhat awkward derivation of Lucian Bernhard's *Sachplakat* style, in which a striking image of a product would encroach on the brand name while still leaving it legible to the viewer.

While Kauffer deployed variations of the German poster style for Steinthal and Derry & Toms, he found an opportunity to integrate vorticism into his design work with the card announcing the sixth exhibition of the London Group, in April 1917 (fig. 2.15). Three identical figures, wearing caps and toting flags, march across the space of the card. Though not particularly dynamic, the graphic signals forward movement and merited a dramatic notice in the press before the exhibition had even opened, comparing the figures to "flying buttresses taking a walk" or "painters running off with their employers' ladders."[40] That the image could be read as anything other than three marching figures is a reminder of how radical it must have seemed at the time. The work Kauffer showed in the exhibition, *Low Tide* (presumed lost), received a similarly baffled reaction from another critic, who called it "a prismatic mess which might have been hung upside down (and probably is) without damage to its title."[41]

Although his work was at this point poorly received in the popular press, Kauffer had become sufficiently respected to receive top billing in a two-person exhibition at the Birmingham Repertory Theatre in the summer of 1917, with a catalog essay written by Fry. Kauffer exhibited a range of work, from Normandy landscapes to the more graphic *Tug Boat* (1917).[42] Fry gave him a further boost by re-presenting the exhibition in London as part of a larger show called *The New Movement in Art*, at the Mansard Gallery that October. By November, Kauffer had completed his most significant painting, *Sunflowers* (fig. 2.16), which he debuted in the London Group's seventh exhibition.

Having been elected secretary of the London Group earlier that year, Kauffer continued designing the group's posters and announcements. The poster for the seventh exhibition (fig. 2.17) was the first of a

36 Ibid., 112-13.
37 *Colour*, March 1917, vi. Twemlow has pointed out that Kauffer's design directly references Hohlwein's *Mittelmeer-Fahrten: Norddeutscher Lloyd Bremen* [1913], and that the rendering of the donkey is derived from a photograph provided to him by W. H. Zimmern. See Twemlow, "E. McKnight Kauffer: Poster Artist," 125-27.
38 See ibid., 127, for a more extensive discussion. See also Mike Daines, "The 'Lost' Labels of E. McKnight Kauffer," *Baseline* no. 20 [1995]: 29-36.
39 Stanley J. Toms [a partner in Derry & Toms who was in charge of the store's publicity], quoted in Twemlow, "E. McKnight Kauffer: Poster Artist," 125.

40 "A Jolly Little Picture," *Evening News* [UK], April 24, 1917. Oversize box 5, scrapbook 1, item 1, Scrapbooks, Editorial Coverage and Published Materials, E. McKnight Kauffer Archive, Cooper Hewitt.
41 "Colour Gone Mad," *Star*, April 1917, quoted in Denys J. Wilcox, *The London Group 1913-1939: The Artists and Their Works* [Quantoxhead, UK: The Court Gallery, 1995], 215.
42 *Tug Boat* is in the collection of the Cooper Hewitt [1963-39-782].

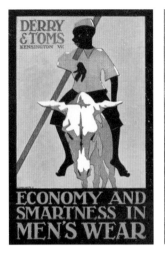

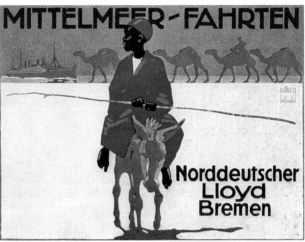

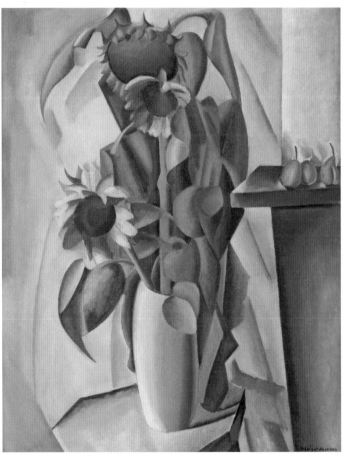

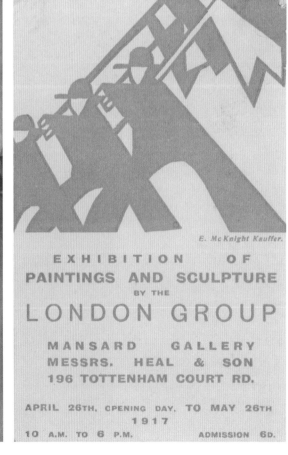

2.13 (top right) Poster, *Mittelmeer-Fahrten: Norddeutscher Lloyd Bremen*, 1913, Ludwig Hohlwein
2.14 (top left) Poster, *Derry & Toms — Economy and Smartness in Men's Wear*, 1917
2.15 (bottom right) Invitation card, London Group, 1917
2.16 (bottom left) Painting, *Sunflowers*, 1917

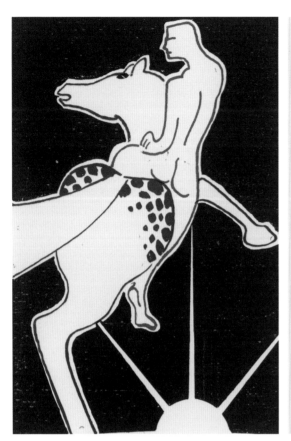

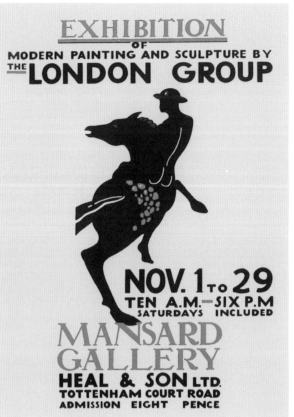

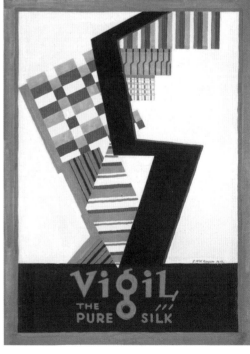

2.17 (top right) Poster, *The London Group*, 1917
2.18 (top left) Drawing, Untitled, 1917-18
2.19 (bottom right) Drawing, Vigil, The Pure Silk, 1919
2.20 (bottom left) Drawing, *Enclosure*, 1915, Edward Alexander Wadsworth

series that he designed. Not bound to the typographic identity of a corporate client, he had free reign to deploy his quirky hand lettering, mixing serif and sans serif fonts. The poster features an image of a rider on a horse, nude save for a steel Brodie helmet used by British soldiers in combat. The horse's hoof infiltrates the *N* in "Mansard Gallery"—a slippage between levels of illusion and reality. Kauffer must have been pleased with the poster's composition, for he submitted a variation of its design, sans lettering, to *Colour*'s Poster Gallery and it was published in the January 1918 issue (fig. 2.18).

The poster for the London Group's eighth exhibition (plate 015) would prove to be Kauffer's most significant graphic work of 1918, introducing a motif that would reoccur in his work well into the mid-1920s. The poster features an image of a striding man, abstracted and seemingly in shadow, whose legs morph into the *O*'s in the word "London." More fluid than any of Kauffer's previous works, the abstraction of the figure's form recalls his work in woodcut and lithography. The figure's stance resonated with Kauffer's peers, and art he exhibited continued to be well received. But he and his wife were so short of cash that early in 1918 they made the difficult decision to leave London to live once again with Maria Zimmern Petrie, this time in Edinburgh. That fall, they received word that Kauffer had been accepted as a volunteer in the American army. Then, as they were on their way back to London by train, they learned that the war was over.[43]

———

Early in 1919, nearly two years after its appearance in *Colour*, Kauffer's poster version of *Flight* finally appeared on the streets of London, adapted to advertise the relaunch of a Labour-leaning newspaper and featuring lettering designed by Francis Meynell (later the founder of the Nonesuch Press). *Soaring to Success! Daily Herald—the Early Bird* (plate 008) signaled a new era not only for the newspaper but also for modern art and advertising: for the first time, the abstraction that Kauffer had been exploring in his art was used to meaningful effect in the poster medium, and a few progressive clients stepped forward. Among the results was *Winter Sale at Derry & Toms* (1919; plate 005), one of the most lyrical of all Kauffer's works. It depicts three figures, heads down, making their way peacefully through the snow. The flat abstracted planes of their coats are again indebted to Hohlwein, but the painterly rendering of the snow, and the clever diagonal pull of the footsteps toward the bottom of the picture plane, are entirely Kauffer.

It was in his first design for Vigil Silk (fig. 2.19) that Kauffer finally achieved the abstraction in poster design that Lewis had called for five years earlier. Vigil Silk was a Yorkshire-based textile firm whose owner, Alec G. Walker, was interested in vorticism, an enthusiasm that probably encouraged Kauffer to try something unprecedented in his practice. His design of diagonally juxtaposed planes of stripes and grids was based on patterned textile swatches from the company,[44] but it is also closely aligned with contemporary art—not so much Kauffer's own art of this period as Wadsworth's from several years earlier. In Wadsworth's *Enclosure* (fig. 2.20), for example, as in Kauffer's design, the eye is drawn by angular lines that zigzag across the composition and pull the eye down—in the poster design, directly to the brand name being advertised. Walker evidently saw the poster as a success, since Kauffer was asked to design another for Vigil Silk in 1921 (plate 020). The 1919 poster would also remain a topic of controversy and conversation in the emerging trade literature for several years, a

43 Haworth-Booth, *A Designer and His Public*, 24.
44 Stephen Arnot, "Art Experiments in Advertising: What the Modern Movement Means," *The Organiser*, June 1921, 224. Oversize box 5, scrapbook 1, item 1, Scrapbooks, Editorial Coverage and Published Materials, E. McKnight Kauffer Archive, Cooper Hewitt.

45 Arnot described "one of the biggest advertisers in the country" arguing passionately in front of Kauffer's 1919 Vigil Silk poster "that an abstract design could not possibly sell silk." Arnot commented, "I was inclined to think that a poster which could so excite and impress a man of his standing could not fail to do the same with the many women who saw it." Ibid., 225.
46 [Hind], "The London Group and Its Aims," *Christian Science Monitor*, May 19, 1919, 14.
47 Hurry, "An American Painter," 939.
48 In a letter to New York collector John Quinn, Lewis described the aspirations of the group to do more than exhibit together. They were to establish "a shop or office, where it is proposed to sell objects...and especially to have a business address from which the poster, cinematograph and other industries can be approached." Quoted here from Haworth-Booth, *A Designer and His Public*, 26; see also *Wyndham Lewis's Letters*, ed. W. K. Rose [London: New Directions, 1963], 112.
49 See Harrison, *English Art and Modernism*, 156.

mark of the impact it made.[45] Yet Kauffer would never again return to pure abstraction in his poster work.

Kauffer's poster for the November 1919 exhibition of the London Group was by far his most successful integration of lettering and image to date for the group (plate 016). The striding silhouetted figure from the 1918 poster, which Kauffer had also adapted in designs for a logo for the Arts League of Service (plate 014) and for the header of *Colour*'s Thoughts and Opinions column, has doubled and taken on a confrontational stance. The two figures are each in themselves doubled: they face each other, head to head (or mask to mask), teeth bared, fists up, yet they also seem to face away from each other, elbows out. Their legs join at the base, making a shape suggestive of ancient amphoras. They are set against a rhythmic amalgamation of flat pink quadrilaterals. In the lettering of the poster, Kauffer deploys triangles as crossbars in the *A*'s and *E*'s, and playfully stresses the *O*'s by twisting them askew, sometimes in opposing directions. For no apparent reason, a lone lowercase *i* appears in the otherwise all uppercase "exhibition."

——

Kauffer's paintings from this period do not appear in public collections and are hard to trace. They are reproduced occasionally in periodicals of the time, but the positive critical reception that his earlier work had enjoyed was beginning to elude him. When he showed in the May 1919 London Group exhibition, for which he also designed the poster, Hind's review in the *Christian Science Monitor* was lackluster: "It was the brightness of his color that was the chief attraction in Mr. McKnight Kauffer's work...when he came to London from Paris a few years ago. Since then he has allowed it to become degraded."[46] But while Kauffer's art was receiving only middling reviews, his posters were having a significant impact. "Kauffer has done an amazing thing," Hurry wrote in *Pearson's Magazine* in June 1920. "He has raised the tone of commercial art in the most conservative country in the world, in a manner that is nothing short of marvellous."[47] By 1920 Kauffer had recaptured the attention of Pick, producing more than a dozen posters for the Underground that year (plate 012), all featuring flowers or landscapes.

The synthesis of vorticism and advertising that had finally come to fruition in Kauffer's work in 1919 had inspired him. As a member of the London Group he retained the support of Fry, now the group's president, but he sought a collective that could support its members in producing work for industry.[48] He accordingly suggested to Lewis a break from the London Group and the formation of something new.[49] In the spring of 1920, Kauffer, Lewis, and eight other artists resigned from the London Group, and in April they opened an exhibition together under the name Group X. Kauffer and Lewis had hoped that Group X would recapture the energy and enthusiasm of earlier avant-gardes, but the exhibition failed to make a compelling and coherent declaration of a new way forward and after that single exhibition the group disbanded. The Kauffer print reproduced in the exhibition's catalog, *Village* (fig. 2.21), indicates that he was continuing to explore landscapes through fractured planes, but does not suggest any pursuit of the purely geometric abstraction suggested by his Vigil Silk campaign. Kauffer's opportunity to make a bold graphic statement with the Group X exhibition poster (fig. 2.22) was also squandered, perhaps out of an effort to ascribe no singular graphic allegiance. Entirely typographic in design, it features an elegantly hand-lettered mix of serif and sans serif forms, but makes no allusions to the visual experiments the group had sought to champion.

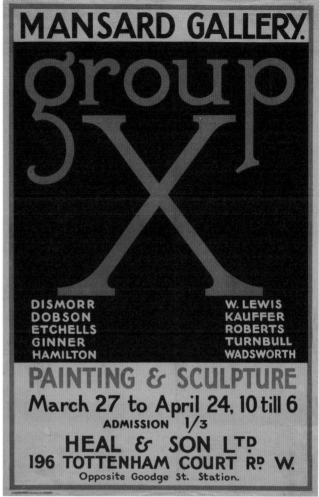

Group X failed to reignite enthusiasm for a distinctly British avant-garde art movement. But Kauffer's modernist approach to design had sparked a debate among advertisers and, at last, won over a critical client. The success of the Derry & Toms sales posters and the *Daily Herald* and Vigil Silk work spurred Pick to commission a new design from Kauffer: *Winter Sales Are Best Reached by Underground* (1921; plate 022). In it, abstracted figures in raincoats strain against the rain, a synthesis of vorticist forms and tropes from Japanese prints. The rebellion that Kauffer had sought to achieve in painting had failed, but through a few provocative works of design, Kauffer had laid the groundwork for a new form of advertising that exploited the geometries of the avant-garde. He was the rebel artist of commercial art.

2.21 (left) Print, *Village*, 1920
2.22 (right) Poster, *Group X*, 1920

3.1 Poster (detail), *London History at the London Museum*, 1922

The UNDERGROUND'S ALCHEMIST of the MODERN

Teri J. Edelstein

IN 1915, THE YOUNG AMERI-
CAN ARTIST E. McKNIGHT
KAUFFER, NEWLY ARRIVED
IN LONDON, CREATED
FOUR POSTERS FOR THE
UNDERGROUND ELECTRIC
RAILWAYS COMPANY OF
LONDON. HIS DESIGNS WERE
DISTINGUISHED BY THE
POWER AND SIMPLICITY
OF HIS COMPOSITIONS
AND USE OF COLOR. KAUFFER WENT ON TO DESIGN MORE, and more-acclaimed, posters for the Underground than any other artist—over 125 in all.[1]

Kauffer's prominence rested heavily on the enthusiasm of Frank Pick, the creator of the Underground's poster campaign. Trained as a solicitor, Pick joined the young company in 1906 and was in charge of its publicity by 1908, when system growth required the creation of a map. Charged with spreading awareness of the map and with increasing ridership, Pick conceived a poster campaign for which he tapped the popular comic-poster designer John Hassall, who created a work titled *No need to ask a P'liceman!* (the need to ask for directions being negated by the new map). Thus began the greatest sustained poster campaign in history.

Pick often remarked that the purpose of the campaign was to create good will for the Underground by compensating riders for any inconvenience while using the transportation system. While this goal played some role, the primary purpose of the posters was to increase travel. Their messages encouraged journeys during off-peak hours—weekdays between 10 and 4, as well as weekends and holidays—and promoted leisure travel to and residence in locales on the edges of London, served by the company's new train lines and by its buses and trams. Pick supervised the campaign until his departure from the company more than thirty years later, and he was also responsible for commissioning the Johnston Sans typeface, Harry Beck's revolutionary map of 1933, the modernist station designs, indeed an entire look and identity that are still in place today. On Pick's death, in 1941, the art historian Sir Nikolaus

1 Between 1915 and 1938, Kauffer designed almost 100 large-format pictorial posters for the Underground, as well as dozens of small panel posters and a great many typographic notices.

Pevsner described him as "the greatest patron of the arts whom this century has so far produced in England."[2]

 The new journal *Commercial Art* took note of Kauffer's advanced designs in its inaugural issue, of October 1922.[3] In later years *Commercial Art* featured rapturous discussions of several of his Underground posters with full-page color illustrations in the plate section at the end of each issue.[4] The magazine honored Kauffer with the seventh in a series of monographic articles, Artists Who Help the Advertiser, stating, "At the suggestion of Mr. Hassall he called upon Mr. Pick of the Underground, and received a commission for two posters."[5] While probably fictional, this creation myth distills an essential truth: after Hassall's dramatic launch of Pick's poster campaign in 1908, it was Kauffer who became central to the Underground's identity. And despite the artist's later relationships with important patrons such as Jack Beddington of Shell-Mex and B.P., Pick was the primary shaper of his career.

 The Underground Electric Railways Company of London (UERL) came to encompass bus, tram, and trolley lines as well as train lines that ran both above ground and below, but the company was generally known simply as the Underground. Kauffer's posters of 1915 and 1916, in the Double Crown size (thirty by twenty inches) for display on the outsides of buses and trams, were all landscapes, the favored genre for the company's posters at the time. These first efforts stood out through their powerfully simplified compositions. Specific motifs—a bridge, assertively colored trees or buildings—replaced more commonplace generalized views (fig. 3.2).

 Few pictorial posters were published in 1917–19, owing to Britain's straitened social conditions during World War I, but in 1920 they returned in full force and Kauffer immediately dominated. Pick commissioned fourteen landscape posters from him that year, more than from any other artist. Unusually for artists working for the Underground, Kauffer's work showed great stylistic variation. By the early 1920s he had become a protean artist, his approach changing dramatically with each poster to best capture an essential theme: the spatial confusion of *Winter Sales* (1921–24; plates 021–023) suggesting the difficulty of negotiating wind and rain; the faux-naïf style of *The "Rocket" of Mr. Stephenson of Newcastle, 1829, at the Museum of Science, South Kensington* (1923; plate 035) evoking the creation of an early locomotive; the primeval, childlike form of the prehistoric woolly mammoth in *Museum of Natural History* (1923; plate 041); the invocation of traditions of scientific illustration in the giant flea depicted in a poster for the same museum (fig. 3.3); the pageantry of the Regatta expressed in the aerial view of the flaglike forms created by parasol, punt, and waves (fig. 3.4).

 The public could not fail to notice these designs and critics were quick to praise them. Laudatory articles on Kauffer's work appeared often in the 1920s and some posters were singled out repeatedly: *Winter Sales*, "a symbol-impression of bad wintry weather";[6] *Twickenham by Tram* (fig. 3.5), "a remarkably successful example...the design in a measure sums up what art is bringing to many things for the enrichment of the daily life of the community";[7] and the three *Pleasures by Underground* posters, *Summertime* (plate 032), *Whitsuntide* (fig. 3.6), and *Whitsuntide in the Country*, where "a similar type of symbolism is exploited in each, and the same use is made of flat and shaded patterns of sharp contrasts in tone.... These rivet the eye, and through the eye the intellect, which is stimulated to a further enquiry...a feature that accounts for the undeniable 'drawing power' of this artist's work."[8] G. S. Sandilands concluded a monographic article on Kauffer in 1927, "It is not too much to say that

2 Nikolaus Pevsner, "Patient Progress: The Life Work of Frank Pick," *Architectural Review* 92, no. 548 [August 1942]: 34.
3 Our Plates, *Commercial Art* 1, no.1 [October 1922]: n.p. [21].
4 "A Masterly Poster by McKnight Kauffer," Our Plates, *Commercial Art* 1, no. 5 [February–March 1923]: 104, and Our Plates, *Commercial Art* 1, no. 6 [April 1923]: 121.
5 Adolphe Armand Braun, "E. McKnight Kauffer," Artists Who Help the Advertiser [No. 7], *Commercial Art* 2, no. 14 [December 1923]: 324.
6 Walter Shaw Sparrow, *Advertising and British Art* [London: John Lane The Bodley Head, 1924], 131.
7 Sydney R. Jones, *Posters & Publicity: Special Autumn Number* [London: The Studio, 1926], 6.
8 L. Gordon-Stables, "London," *The Studio* 90, no. 388 [July 15, 1925]:42.

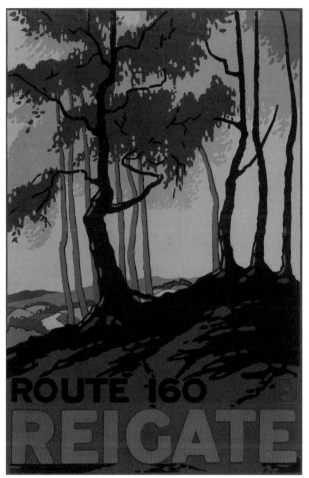

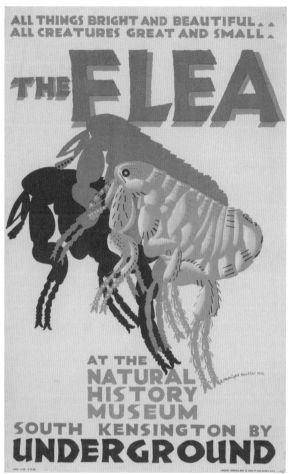

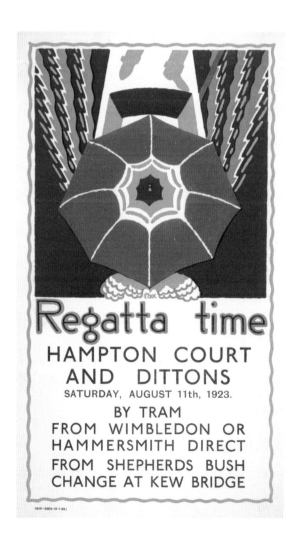

3.2 (top left) Poster, *Route 160 Reigate*, 1915
3.3 (top right) Poster, *The Flea at the Natural History Museum*, 1926
3.4 (bottom right) Poster, *Regatta Time*, 1923

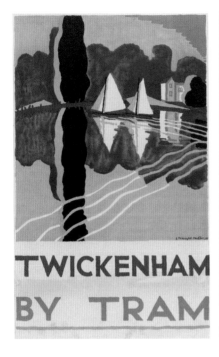

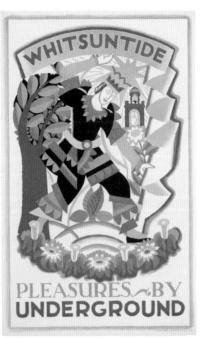

E. McKnight Kauffer is something of a modern alchemist who changes ideas into pure gold,—for those who use his work."[9] Back in the United States, the *New York Times* crowed in 1921, "Edward McKnight Kauffer, whose posters for the London underground and London buses have attracted much attention and praise there, is an American," crediting Kauffer with the success of the Underground poster campaign.[10]

Positive opinions about Kauffer's posters were not universal. In 1923, for example, in the forum "The Present-Day Poster" at London's Art Workers' Guild, Bernard Smith remarked that Kauffer's posters were unattractive and insincere, and that "the public mind is simple and does not want to be intrigued by freakish designs."[11] It should be noted that Smith, as the advertising manager of Pears Soap, represented a company whose campaigns often presented cherubic children, most famously in an ad of 1890 featuring the Pre-Raphaelite artist John Everett Millais's painting *Bubbles* (1886).

Kauffer's museum posters of the 1920s, now in the larger Double Royal size (forty by twenty-five inches) for display outside Underground stations, garnered special praise. Pick himself invited Kauffer to lecture to the Design and Industries Association (DIA) on November 29, 1923, and made extensive and enthusiastic notes on the lecture that caught the essence of the designer's achievements:

> *Mr. McKnight Kauffer, for instance, brings to the designing of a poster a great deal of thought. He asks himself what is the idea to be conveyed rather than what is the object to be illustrated. He asks himself with how little, boldly and bravely executed, will the public be satisfied and convinced. The fire of London becomes a surge of leaping flames, and old St. Paul's a tiny silhouette at the flames' heart. It is the fire of London without any romance or incident or illustration. To achieve this abstract idea of the fire of London is much harder than to draw some incident or illustrate some phase of the fire itself as reported to us. It may seem simple, but there is much labour behind its very simplicity* [plate 029].[12]

In the early 1920s, Kauffer burnished his reputation by publishing articles and a book that placed him in a continuum of distinguished poster designers while promoting his own recent works, particularly those for the Underground.[13] Others obligingly followed

9 G. S. Sandilands, "E. McKnight Kauffer," *Commercial Art* 3, no.13 [July 1927]: 6.
10 "Art: Forthcoming Exhibitions. An American Poster Artist," *New York Times*, October 16, 1921.
11 Bernard Smith, quoted in "The Present-Day Poster," *Commercial Art* 2, no. 14 [December 1923]: 327.
12 Frank Pick, typescript notes on a lecture by Kauffer, 1923, 3–4. Transport for London Corporate Archives, LT000535/006.
13 Kauffer's writings included "The Poster-Tang Tattoo," *Illustration: A Magazine Devoted to the Craft of Mechanical Reproduction, thereby Dealing with Art and Workmanship in Printing, and Science in Advertising and Commerce* 5, no. 8 [1921]: 7–17; "The Poster and Symbolism," *Penrose Annual* 26 [1924]: 41–45; and *The Art of the Poster: Its Origin, Evolution & Purpose* [London: Cecil Palmer, 1924]. The book is dedicated to Pick, and illustrates Kauffer's poster *London History at the London Museum* [1922] in color.

14 See, e.g., Our Special Corre-
spondent, "Art in Advertisements:
Exhibition of Brilliant Example,"
Observer, July 5, 1925, which admir-
ingly mentions *London History at the
London Museum*; and R. R. Tatlock,
"The Art Poster and the Art Book,"
The Burlington Magazine 46, no. 267
[June 1925]: 306, which notes, "He
expresses his personality, one feels,
most fully and freely, by means of
such whimsical inventions as the half
decorative, half symbolical notion of
the Great Fire of London in the poster
advertising London History at the
London Museum."
15 Percy V. Bradshaw, *Art in Advertis-
ing* [London: Press Art School, n.d.
[1925]], 264.
16 Kauffer, letter to Pick, November
30, 1923. Transport for London
Corporate Archives, LT000535/006.
This letter and many others that
Kauffer wrote to Pick in this period
are written in green ink, perhaps in
imitation of Pick, who used green ink
habitually.
17 Minute 927, Poster Committee meet-
ing, December 24, 1938. Transport
for London Corporate Archives,
LT000606/026.
18 Minute 321, Poster Committee
meeting, November 22, 1935. Transport
for London Corporate Archives,
LT000606/009.
19 Minute 258[b], Poster Committee
meeting, August 8, 1935. Transport
for London Corporate Archives,
LT000606/009.

suit;[14] in 1925, for example, Percy Venner Bradshaw, the director of the Press Art School, observed, "The public writes to the [Underground] Company enthusiastically about the posters it likes, buys them for the decoration of its homes, tries to puzzle out the meaning of the adventurous Kauffers." That enthusiasm spurred the Underground to open a "special department for their sale."[15]

Kauffer's greatest patron remained Pick, who commended the designer to friends such as Harold Curwen, of the Curwen Press, and to curators at the Victoria and Albert Museum. After Kauffer's 1923 lecture to the DIA, Pick proposed that Kauffer's ideas be printed in the *Manchester Guardian*. The extent to which his admiration for the artist was mutual is demonstrated by a letter Kauffer wrote to him the day after the lecture:

> *My dear Mr. Pick,*
> *I count last night one of the happiest evenings I have ever known, thanks to you. And I wish you to know that your appreciation of my work now means just as much to me as it did the first day I entered into your office. With best wishes, Sincerely yours, E. McKnight Kauffer* [16]

Change, however, was coming. By the mid-1930s, Pick's opinion of Kauffer had undergone a marked reversal. In 1933, the UERL was reconstituted as the London Passenger Transport Board (LPTB), a quasi-governmental agency, and Pick was named vice-chairman. In that role, despite his vast responsibilities, he chaired regular Publicity Committee meetings on the poster program. Few of the many posters commissioned by the LPTB were brought to his attention, but those that were were often by novice or women artists. At one meeting in 1938, for example, proposals by Irene Hawkins and Nina Nidermieller came up (neither was approved), along with works by students at London's Reimann School.[17] Yet by 1935, designs by Kauffer, the most admired and prolific artist to work for the Underground, were regularly placed on the agenda. Furthermore, Pick often transmitted specific instructions to Kauffer, as he did to inexperienced artists. The minutes for a meeting of December 5, 1935, for example, record him directing Kauffer to use his older posters for the Underground as models: "The Vice-Chairman reviewed all the posters designed by Mr. Kauffer and directed [Publicity Officer] Mr. Barman to discuss with Mr. McKnight Kauffer a proposal that he prepare a series of four posters somewhat in the style of his former posters 'The Flea' [1926] 'Stibnites' [1922; plate 025] and 'Socrates' [1926; plate 043]."[18]

Pick's taste may have become somewhat more conservative, but the minutes demonstrate that he continued his long practice of publishing posters in many different styles to suit the varying tastes of his customers. In a meeting of August 8, 1935, for example, he approved a design by Tom Eckersley and Eric Lombers, adding only an injunction that the "necessary wording" needed to be "satisfactory."[19] *By Bus to the Pictures To-night* is the first poster by the twenty-one-year-olds and is indebted to Kauffer's style at the time. On November 13, 1936, Pick approved a surreal design by Man Ray—*Keeps London Going*, which likens the round London Transport logo to the planet Saturn—while rejecting one by Kauffer, *Brings London Home*.

Minutes from 1937 are still more definitive: "The Vice-Chairman referred to the design entitled 'Robinson Crusoe' in the current issue of 'The Studio' and directed Mr. Barman to discuss with Mr. McKnight Kauffer the production of two posters to this standard for the

Board next year; roughs to be submitted. Further formal designs from Mr. McKnight Kauffer not to be sought."[20] Barman seems to have ignored this dictate not to seek new designs from Kauffer, but subsequent works received similar attention from Pick. On March 31, 1938, it was decided that Kauffer be invited to submit "a cheerful Autumn landscape."[21] The injunction produced a pair of posters published that year (fig. 3.8), among Kauffer's last for the Underground, but they lack the tension, energy, and excitement that characterize his best creations for the company.

Although Kauffer's mid-1930s posters for the Underground won markedly less attention than his earlier work, they still attracted notice. *The Tower of London* (fig. 3.7), for example, was held up as an exemplary display of the integration of lettering and design.[22] With the two posters *Treat Yourself to Better Work* and *Treat Yourself to Better Play* (1935; plate 116), LPTB were said to "keep up their reputation for striking posters just a step in advance of current practice."[23]

In a lecture titled "Posters" that Pick gave at the Reimann School in February 1939, he applauded the same 1926 poster that he had commended in the Publicity Committee meeting in December 1935: "In this matter of suggestion one proceeds from the simple to the complex....

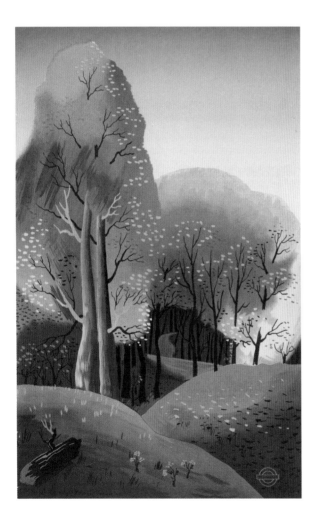

Fleas. Here again Mr. McKnight Kauffer suggests something of the richness of the collections of the Natural History Museum;...something, therefore, which speedily satisfies the visitor." But later in the lecture, after discussing four recent posters by Kauffer, Pick concludes, "There is nothing to be said in favor of these egregious experiments in modern art. They merely represent the exhausted character of the times and are evidence of the poverty of resource behind the current production of posters."[24] That Pick had become specifically hostile to Kauffer, rather than simply to abstract or radical compositions, is suggested by the next section of the lecture, in which he lauds A.M. Cassandre's *L'Intransigeant* (1925), a poster quite similar in style to Kauffer's later work.

So newsworthy were any tensions between Pick and Kauffer that such pronouncements were covered by the press: Pick "had little patience with the Surrealist poster (on this matter even McKnight Kauffer received a knock or two)."[25] Yet despite the eventual distance between the two men, Kauffer's Underground masterpieces are the foundation of his posthumous reputation—and, to some extent, of Pick's as well. As Ashley Havinden concluded after Kauffer's death, "The regard in which the public holds the London Underground is surely due in no small measure to the outstanding series of posters designed for it by Kauffer under the aegis of the late Frank Pick."[26]

20 Minute 739, Poster Committee meeting, September 23, 1937. Transport for London Corporate Archives, LT000606/011.
21 The contents of the minutes are informative about these posters. At a Poster Committee meeting in March 1938, for example, discussing the upcoming program for April 4–December 24, Kauffer's *Autumn* was scheduled for Period IX of that year, running October 3–30. That decision was reaffirmed in a pair of meetings two months later, in a minute reading, "Period 1938 IX 3rd Oct.–30th Oct. Autumn [E. McKnight Kauffer] 1. Outdoor [comp.] 2. Farming [comp.]." See minute 926, Poster Committee meeting, March 31, 1938, and minute 970, Poster Committee meetings of May 25 and 26, 1938. Both citations Transport for London Corporate Archives, LT000606/026.
22 Eliot Hodgkin, "The Lettering: The Onlooker Hits Back," *Commercial Art* 18, no. 106 [April 1935]: 145, 148.

23 *Commercial Art* 19, no. 113 [November 1935]: 200.
24 Frank Pick, "Posters: An Address to the Reimann School of Industrial Art," February 24, 1939, typescript pp. 20, 27, 29–30. Frank Pick Collection, London Transport Museum Archive, PB42.
25 Our London Correspondent, "Mr. Pick on Posters," *Manchester Guardian*, February 25, 1939.
26 Ashley Havinden, "Introduction," *E. McKnight Kauffer: Memorial Exhibition of the Work of E. McKnight Kauffer...*, exh. cat. [London: Lund, Humphries, 1955], n.p. The exhibition was organized by the Society of Industrial Artists, with the support of the Royal Society of Arts, at the Victoria and Albert Museum, London.

3.7 (opposite) Poster, *The Tower of London*, 1934
3.8 Poster, *How Bravely Autumn Paints upon the Sky*, 1938

THE TOWER
OF LONDON

4.1 Frontispiece and title page, for *The Anatomy of Melancholy*
by Robert Burton, 1621, reprint ed., 1925

ILLUSTRATION *as* COMMENTARY: **MODERNIZING** *the* CLASSICS

Julie Pastor

THROUGHOUT HIS LIFE, E. McKNIGHT KAUFFER WAS A VORACIOUS READER. IN LONDON HE SURROUNDED HIMSELF WITH A RICH NETWORK OF PROMINENT AUTHORS, PUBLISHERS, AND PRINTERS, AND WHILE HIS COMMERCIAL POSTERS DISTINGUISHED HIM TO THE PUBLIC, HIS BOOK ILLUSTRATIONS WERE OFTEN MORE PERSONAL PROJECTS, interpreting the work of his friends. He illustrated several poems by T. S. Eliot, for example, who remarked that Kauffer's illustrations were the only ones "[he] could endure," and he designed book covers for Leonard and Virginia Woolf at the Hogarth Press.[1] Having a circle of publisher friends allowed Kauffer freedom in the books he chose to illustrate and in the style of his illustrations. Though he most often addressed contemporary literature, two of his London commissions invigorated classic texts with his modern style. In each case, Kauffer's reading of the texts informed his images, which exhibited a new modernism in English book illustration.

By the 1920s, Kauffer had widely established himself as a poster designer, indeed London's "poster king." In 1924, he edited *The Art of the Poster*, in which he traced the poster's history, evolution, and purpose from its origins to modernism, further highlighting his prominence in the field.[2] As the book's epigraph Kauffer chose *Omne meum, nihil meum*, "All mine, none mine," a phrase by the fifth-century writer Macrobius that appeared on the engraved frontispiece of one of Kauffer's favorite books, Robert Burton's *Anatomy of Melancholy* (1621).[3] Kauffer admired Burton's book to the point where, in 1923, he suggested to his friend Francis Meynell that Meynell's newly established Nonesuch Press publish an edition of it that he would illustrate.[4] Published in 1925, this was Kauffer's first illustrated book (fig. 4.1).[5]

Meynell had founded the Nonesuch Press in 1923 to produce relevant, beautiful, and affordable books. William Morris's Kelmscott

1 T. S. Eliot, quoted in Mark Haworth-Booth, *E. McKnight Kauffer: A Designer and His Public*, 1979 [rev. ed. London: V&A Publications, 2005], 55.
2 Kauffer, *The Art of the Poster: Its Origin, Evolution & Purpose* [London: Cecil Palmer, 1924].
3 See William R. Mueller, "Robert Burton's Frontispiece," *PMLA* 64, no. 5 [December 1949]: 1074.
4 Francis Meynell, letter to Desmond Flower, July 15, 1955. MS Add.9813/B35/1, Correspondence, Memoir of Edward McKnight Kauffer, Compositions by Francis Meynell, Meynell Collection, Cambridge University Library.
5 Meynell had previously asked Kauffer to design a book cover for his anthology *The Week-End Book*, published by Nonesuch in 1924 [plate 024].

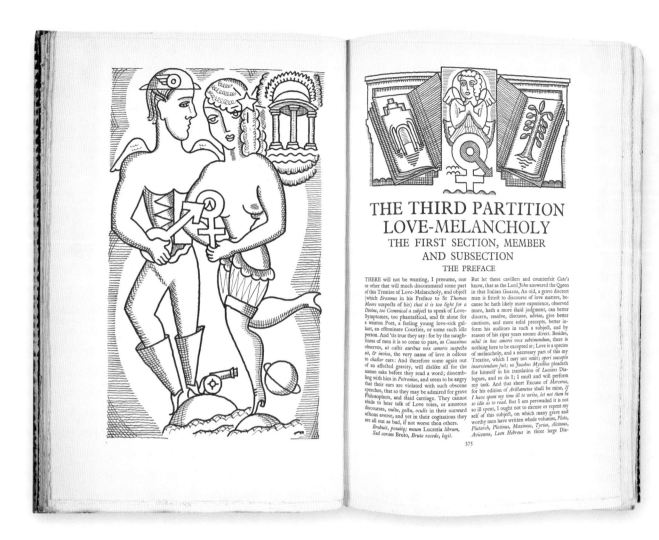

4.2–4.4 Book illustrations, for *The Anatomy of Melancholy* by Robert Burton, 1621, reprint ed., 1925

Press, founded in 1891, had launched a small wave of publishers producing elegant hand-typeset books in limited editions, but Nonesuch publications were aimed at mass consumers rather than connoisseurs.[6] To lower production costs, Meynell used machine typesetting, but his passion for typography ensured that the books he published with his partners Vera Mendel (who soon became his wife) and David Garnett achieved an aesthetic harmony between type, illustration, paper, and binding. Meynell would later recall that he and Kauffer temporarily shared an office at Nonesuch, where their conversations were often stimulating enough to keep them from their work. To rein in these discussions, Meynell and Kauffer went so far as to "[nail] up a list of 'red-herring words' ('functional,' 'the Artist,' and so forth) which were not to be used during office hours on pain of a fine of sixpence for each use."[7]

In these creative conversations, Kauffer often quoted lengthy passages from Burton's *Anatomy*, and Meynell soon agreed to publish a new, illustrated edition.[8] *The Anatomy* was in some ways a strange subject to revisit in the twentieth century, for its satirical yet serious study of melancholy as the root of all human thought and emotion reflected an antiquated mysticism, and although it was rewarding to patient readers, absorption in its difficult prose required dedication. Reviewing the Nonesuch edition in the *Yorkshire Observer*, Robert Lynd remarked that "many men have loved [*The Anatomy*], though not so many as have purchased it and put it on their shelves as an unread masterpiece."[9] A critic in the *Observer* further named it "the [favorite] book of men who are...moody."[10] The description fits Kauffer, who struggled with depression throughout his life.

The Nonesuch edition of *The Anatomy* contains 150 line drawings in a cubist style. Most are small, and all demonstrate careful attention to the pairing of typography and image. For the first time in any edition, the text is set in two columns rather than one, greatly improving its legibility (fig. 4.2).[11] Kauffer's illustrations further relieve the density of the writing, making it easier for the reader to navigate. Several of these images, such as the frontispiece, translate Christof Le Blon's engravings for the classic seventeenth-century edition of *The Anatomy* into a modern style, while others depict entirely new subjects—abstract landscapes or Pablo Picassoesque portraits.[12] For the book's last illustration, Kauffer drew Francis and Vera Meynell from life, inserting his friends and publishers into this personal project (fig. 4.3).[13] In a letter to Kauffer, Meynell asked that he adjust this portrait so that Vera did not appear taller than he and begged for a "lowering of [his] eyebrow, and [his] consequent promotion from the expression of a quarter-wit to that of a half-wit, all [he was] entitled to."[14] Kauffer also drew his own partner, Marion Dorn, as a figure playing the fiddle and turning to stone (fig. 4.4).[15]

Although the book was Kauffer's idea, he was slow delivering his drafts, causing Meynell repeated frustration.[16] In a letter of May 1924, Meynell gently goaded his friend, "By the way, have you heard that you are illustrating Burton's *Anatomy of Melancholy*? The [rumor] has reached me to that effect but the fact that I have not seen any drawings for weeks makes me discredit it."[17] The press reported further delays due to Kauffer's health, citing "overstrain" during his work on the illustrations as the cause of the book's postponement.[18]

The wait may only have heightened anticipation of the Nonesuch *Anatomy*, yet when it finally appeared, many critics attacked Kauffer for illustrations they considered offensive and inappropriate. One derided Kauffer's modern style: "[Cubism] has left a mark on modern design, but as a style its day is already over. It is therefore a pity that an edition which

6 See A. J. A. Symons, "Assessment," in Meynell, *The Nonesuch Century: An Appraisal, a Personal Note and a Bibliography of the First Hundred Books Issued by the Press, 1923–1934* [London: Nonesuch Press, 1936], 10–11.
7 Meynell, "The Personal Element," in ibid., 45.
8 See Haworth-Booth, *A Designer and His Public*, 47.
9 Robert Lynd, "Robert Burton: His Immortal Museum," *Yorkshire Observer*, February 25, 1926.
10 "The Anatomy of Melancholy," *Observer*, n.d. Oversize box 4, scrapbook 2, item 1, Scrapbooks, Editorial Coverage and Published Materials, E. McKnight Kauffer Archive, Cooper Hewitt, Smithsonian Design Museum.
11 See Augustine Burrell, "That Fantastic Old Great Man," *The Nation and the Athenaeum*, February 13, 1926, 679.
12 Christof Le Blon's woodcuts first appeared in the fifth edition of *The Anatomy of Melancholy*, published in 1638.
13 Meynell, "The Personal Element," 45.

14 Meynell, letter to Kauffer, 1926. 131887/MA 1680, Department of Literary and Historical Manuscripts, Pierpont Morgan Library, New York.
15 Ibid.
16 Though Kauffer and Meynell remained friends, Kauffer was often late sending Meynell illustrations. In a letter of 1930 to the American author Carl Van Vechten, Kauffer wrote, "In the meantime I've had an ultimatum from the Nonesuch Press to the effect that if Don Quixote isn't finished by Nov. 1 my delay will seriously impair the immediate future of the concern." Kauffer, letter to Van Vechten, October 5, 1930. In call no. JWJ MSS 1050, box 59, folder 1004, Carl Van Vechten Papers Relating to African American Arts and Letters, Series II Writings, Books *Nigger Heaven* Correspondence, Kauffer, Edward McKnight/1930–1947, Beinecke Rare Book and Manuscript Library, Yale University, New Haven.
17 Meynell, letter to Kauffer, May 5, 1924. 131887/MA 1680, Department of Literary and Historical Manuscripts, Pierpont Morgan Library.
18 "A 'Burton' Postponed," *Daily Chronicle* [UK], April 14, 1925.

has many qualities that might recommend it to collectors should bear the stamp of a temporary taste.... Nothing could be more out of harmony with ... Burton than a style which is the experiment of an age of mechanism."[19] Sir Edmund Gosse wrote a scathing review in the *Sunday Times*, calling Kauffer's illustrations "hideous and irrelevant ... a child would deserve to be smacked for drawing them."[20]

The Bloomsbury Group artist and critic Roger Fry, a friend of Kauffer's, defended him in a heated press exchange with Gosse. For Fry, Kauffer's illustrations offered a contemporary way into an antique work. Writing in *The Burlington Magazine*, he described the illustrations as "a running commentary, like marginal notes written by a reader."[21] They added a self-consciousness to the act of reading Burton in the modern era, placing readers at once in the past and in the present: "While [Kauffer's illustrations] remind us of the past they have the vitality of a contemporary creation. The pedantry is as full of enjoyment and poetic zest as was Burton's own."[22] Meynell similarly described the Nonesuch edition as "Kauffer on Burton," and emphasized Kauffer's expansion of the role of the illustrator: "He may, he should, become in his designs more than a decorator; he should, I believe, become a significant *commentator*."[23] *The Anatomy* proved that divergence between the intentions of the artist and of the author could open a text to new exploration and interpretation.

The book also exemplified the aesthetic qualities that distinguished Nonesuch from other contemporary presses. Most publishers used a limited range of typefaces and printed on machine-made papers, producing books that looked the same despite their authors or contents.[24] But Nonesuch books had great variety and showed tremendous attention to detail, so that reading one was a multisensory experience. Uncut edges on unusual handmade papers, colorful bindings in a range of patterns and textures, a wide selection of type, and a new approach to illustration made these books unlike any others familiar to the public.[25] Their affordable prices also made them easily collectible. Another publisher and printer Kauffer worked with, the Curwen Press, likewise exposed English consumers to the idea of publishing as an art form accessible to a mass audience. These publications, A. J. A. Symons wrote in 1934, were "books that *deserve* to be well produced, books that will be kept and considered in future years."[26] The two presses collaborated to produce some of Kauffer's most beautifully illustrated books.

On the heels of *The Anatomy*, Kauffer was soon commissioned to illustrate more books for various publishers and presses: Herman Melville's *Benito Cereno* (Nonesuch, 1926), Daniel Defoe's *Robinson Crusoe* (Etchells and Macdonald, 1929; plates 059–060), Arnold Bennett's *Elsie and the Child* (Cassell, 1929; plates 052–055), Cervantes's *Don Quixote* (Nonesuch, 1930), and Bennett's *Venus Rising from the Sea* (Cassell, 1931). *Benito Cereno* was Kauffer's first book printed by Curwen, which was helmed at the time by Harold Curwen and Oliver Simon.[27] Founded as a printer of sheet music in 1863, by the 1920s Curwen had established a reputation for print design and for an eagerness to hire experts with new book-making skills.[28]

For Kauffer, that meant the ability to use Curwen's new stenciling department to add color to his book illustrations in ways he had not yet explored. The pochoir stencil process was widely used in French publishing but was practiced less in England; once Kauffer used it to illustrate Melville, he quickly found new ways to approach it, each time achieving different effects. For *Benito Cereno*, Kauffer used stenciled watercolor to complete his drawings by coloring in skin tones or adding accents to clothing. He provided a basic drawing, with color, to the stenciling

19 Books in General, *New Statesman*, February 2, 1925. Oversize box 4, scrapbook 2, item 1, Scrapbooks, Editorial Coverage and Published Materials, E. McKnight Kauffer Archive, Cooper Hewitt.
20 Sir Edmund Gosse, review of Nonesuch Press reprint edition of *The Anatomy of Melancholy*, by Robert Burton, *Sunday Times*, January 14, 1925, The World of Books.
21 Roger Fry, "The Author and the Artist," *The Burlington Magazine for Connoisseurs* 49, no. 280 [July 1926]: 10.
22 Ibid., 12.
23 Meynell, "The Personal Element," 43.
24 See Symons, "Assessment," 11.
25 See John Dreyfus, *A History of the Nonesuch Press* [London: Nonesuch Press, 1981], 191.
26 A. J. A. Symons, "On Curwen Press Books," in *Curwen Press Newsletter* no. 8, [1934]: 4.
27 Haworth-Booth, *A Designer and His Public*, 53.
28 Symons, "On Curwen Press Books," 5.

4.5 (opposite) Print, Illustration for *Don Quixote* by Miguel de Cervantes, 1605/1616, reprint ed., 1930

29 See Desmond Flower, "The Book Illustrations of E. McKnight Kauffer," *Penrose Annual* 50 [1956]: 36.
30 Ibid.
31 Meynell, letter to Flower.
32 Kauffer, letter to Mary Hutchinson, December 11, 1928. Box 17, folder 4, Mary Hutchinson Papers, Harry Ransom Center, University of Texas at Austin.
33 Meynell, letter to Bennett Cerf, 1929, quoted in Dreyfus, *A History of the Nonesuch Press*, 217-18.
34 Meynell, "Bibliography," *The Nonesuch Century*, 72.

department, where skilled craftswomen would use it as a key to apply watercolor through stencils.[29] After the success of this process in *Benito Cereno*, Kauffer quickly began to experiment, adding colors in unusual ways and even, for *Elsie and the Child*, dispensing with a key altogether so that the technicians had to align each stencil with the corner of the page to render the image correctly.[30] While many celebrated this technical innovation in *Elsie*, it is Kauffer's illustrations for *Don Quixote* that best demonstrate the insight that had so distinguished his commentary on *The Anatomy of Melancholy*.

When Meynell commissioned Kauffer to illustrate *Don Quixote*, he knew that the designer had a long-standing interest in the book.[31] Kauffer's rich understanding of Cervantes allowed him to convey an intimate vision of Don Quixote's state of mind (fig. 4.5). Each of his twenty-one illustrations carefully relates to the text. Kauffer experimented with color in his process drawings: the watercolor shadows he applied to the figure of Don Quixote in one set are so prominent that they act almost as a character in the scene, emphasizing the duality of the hero's mind and his inability to see the world as it is (figs. 4.6–4.9). In the final version of this illustration, a blue shadow looms large behind Don Quixote, making him appear small and vulnerable in a dreamlike landscape.

As with *The Anatomy*, Kauffer's tendency to juggle multiple projects at once led him to far exceed his deadline. In a 1928 letter to a friend, he wrote, "In the meantime my 'Quixote' remains a dream. Poor fellow he lies in a heap—of only lines and . . . patterns—none of them yet put together."[32] Meynell expressed his concern in a letter to the American publisher Bennett Cerf: "I'm still desperately hoping for [*Don Quixote*]: but this depends on the utterly undependable Ted. As a result of

4.6–4.10 Prints, Illustrations for *Don Quixote* by Miguel de Cervantes, 1605/1616, reprint ed., 1930

eighteen months' waiting I have four out of the twenty drawings."[33] Once the work was completed, though, Meynell was very pleased with it—he described the frontispiece as "the finest of any modern book that I know."[34]

Throughout the two volumes of *Don Quixote*, Kauffer illustrated the hero's thoughts rather than simply depicting scenes that Cervantes described. Although this treatment of a classic literary work had the potential to upset reviewers, the Nonesuch *Don Quixote* pleased most critics, one of whom described its figural subtleties in the *Times*: "Attitudes and gestures, drawn with the greatest economy, do all the work, so that when a figure has its back turned we can tell from the shape of the back, or the pose of an arm, exactly what sort of person this is" (fig. 4.10).[35] Fry wrote to Kauffer to say that he was overcome by the illustrated *Don Quixote*, adding that he would now "re-read him all through with [Kauffer] as a companion."[36] A review by F. J. Harvey Dayton provided further accolades: "They are not 'illustrations' in any sense at all, but an imaginative projection from the artist's mind.... Kauffer's work goes further, and goes more impressively, than that of any other modern artist in the direction of nonliteral, almost mystical interpretation."[37]

Kauffer most successfully achieved this mystical quality in illustrating books to which he felt a strong connection, where his illustrations expressed his emotional experience of the text. His friend the author Aldous Huxley wrote of his illustrations to *The Anatomy* and *Don Quixote*, "Everywhere the aim is the same: to render the facts of nature in such a way that the rendering shall be, not a copy, but a simplified, formalized and more expressive symbol of the things represented."[38] Kauffer's illustrations for these books demonstrate his almost obsessive reading of them, and his sense of responsibility to literary works that he deeply admired. To the friends who knew him well, his illustrations read like his notes on beloved passages. Rather than aligning them with the authors' intentions, or with the conservative conventions of contemporary English book illustration, he allowed the reader to experience the text as he himself did.

In describing Kauffer's expansion of the role of the illustrator, the artist Paul Nash wrote, "Today we do not illustrate a book—strictly speaking. We make decisions to accompany a story."[39] This modern approach introduced the idea that an illustrator's intelligence could be as valuable as a skillful hand and proved the potential of illustration to change the way contemporary audiences approached and understood the classics.

35 "Two Illustrated Books," *Times* [London], February 5, 1931.
36 Roger Fry, letter to Kauffer, December 22, 1920. 159897/MA 1681, Department of Literary and Historical Manuscripts, Pierpont Morgan Library.
37 F. J. Harvey Dayton, quoted in Flower, "The Book Illustrations of E. McKnight Kauffer," 38.
38 Aldous Huxley, draft for foreword to *Posters by E. McKnight Kauffer*, exh. cat. [New York: The Museum of Modern Art, 1937]. Oversize box 6, scrapbook 3, item 1, Scrapbooks, Published Materials and Editorial Coverage, E. McKnight Kauffer Archive, Cooper Hewitt.
39 Paul Nash, draft for review of the edition of Arnold Bennett's *Elsie and the Child* illustrated by Kauffer, intended for *The Bibliophile's Almanack* but unpublished, 1929. MS Add. 9813_B_35_2_17, Meynell Collection, Printers' Papers, Cambridge University Library.

5.1 Poster (detail), *The Labour Woman*, 1925

FEAR, SEX, MATERNITY, SNOBBISM: KAUFFER *and the* MODERN WOMAN

Aidan O'Connor

FOLLOWING E. McKNIGHT KAUFFER'S DEATH, IN 1954, FELLOW DESIGNER ZERO (BORN HANS SCHLEGER) DESCRIBED HIS FRIEND AS "INFINITELY COMPLEX" IN THE CONTRAST BETWEEN HIS PROFESSIONAL AND HIS PERSONAL LAYERS. "KNOWN TO THE WORLD BY HIS AUSTERE AND MASCU-LINE WORK," ZERO RECALLED, "FRIENDS KNEW HIS FRAIL AND sensitive inner being."[1] This gendered juxtaposition piques curiosity. Was the work of this canonical male modernist simply "masculine," or did he craft more nuanced messages about gender that we have missed? On review of his most famous works, which seldom feature women, an investigation of Kauffer's contributions from a gender-based perspective seems tenuous, but a more holistic design history situates him firmly among vital negotiations shaping and challenging the modern woman in interwar Britain. In exploring Kauffer's remarks, designs, and contexts in relation to shifting realities for women in the 1920s and '30s, the essay proposes a compelling new perspective on his most significant period.

"PRETTY" ADVERTISING

That the human figure plays an important part in the modern poster is only too evident to the most casual observer. The living interest that a figure creates, particularly if it be the "female form divine," is a great asset to the designer, and he is not slow to avail himself of it.
[W. S. Rogers, "The Modern Poster: Its Essentials and Significance," 1914]

Perhaps the most explicit way Kauffer distanced his work from the feminine was through his disdain for the common practice of representational, "pretty" advertising. The female figure was well established as a device in commercial art when Kauffer was emerging as a designer in the 1910s, and certainly by his successful interwar period. Conventionally beautiful

1 Zero [Hans Schleger], quoted in Mark Haworth-Booth, *E. McKnight Kauffer: A Designer and His Public* [London: Gordon Fraser, 1979], 82.

women often graced advertising, whatever its product or purpose. Some became well-known modern characters, such as the independent Kodak Girl, but many were anonymous.[2] Their representation also shifted with ideals of female beauty. In 1931, fashion journalist Madge Garland convened numerous examples from the past quarter century in her article "Some Impressions by famous Poster Artists of the Women of Their Day," from the high-spirited "Gaiety Girl" to the "short-haired boyish miss." Interestingly, Garland mentions Kauffer, a friend of hers, and notes his significance to modern poster art, but concludes that "the woman of to-day awaits a translator who will sum up her essential characteristics in a language which all will understand."[3]

As early as 1922, Kauffer publicly denounced the "pretty" approach, as a matter not of form or principle (for misrepresenting or potentially objectifying women) but of function. Viewing the poster as a work of art but also part of "a contest of wit and persuasion," he blamed advertising executives, rather than artists, for perpetuating an ineffective trope.[4] As a writer on Kauffer remarked that year,

These men are specialists only in name—they buy "art" with very little good taste and a deplorable lack of psychological knowledge. They stick to the pretty-girl poster…but they do not realize that the girl in question distracts attention from the product to her sweetly smiling self. In every one of his own posters there is evidence that Mr. Kauffer practices as well as preaches.[5]

The author goes on to demonstrate Kauffer's principle on this matter with a mysterious example: "In fact, recently he was offered a commission which he refused," she says, "because he could not honestly draw the poster—for a prominent actress in a much-advertised play—and stand by his colors."[6]

In an essay of his own published in *Arts & Decoration* around the same time, Kauffer reinforced the "absurdity of the use of 'pretty' advertising," again placing blame on the (invariably male) advertiser and his "same old dreary 'leg-pull' efforts" for what Kauffer diagnosed as the mediocre standard of contemporary British posters.[7] Emphasizing an economic focus—whether or not an ad has the desired effect—rather than a sociocultural one, he explained, "From a purely technical point of view, this form of advertisement fails because, if one does remember the story, one usually fails to remember what it advertised."[8] In this instance his objections are more concrete, including specific types of women (or "girls") portrayed:

This point of view in regard to the poster is well illustrated in the sentimental printed sheet which manifests itself in the pretty picture with a "human interest" story, the lurid and melodramatic which is used so abundantly in cinema and theatre advertisements, and the would-be humorous. Examples of these efforts to pander to the great public are shown in the brainless-looking mother caressing a celluloid infant, the family doctor pointing his finger at you, telling you to make a man of you…the "lockjaw smile" girl displaying a set of perfect teeth, etc.[9]

With this description, rich with gendered imagery, Kauffer introduces ambiguity to his argument. Were his objections to this style "purely technical," or also personal reactions to the public representation of women? An underlying gendered opposition is perceptible in his rejection of sentimentality on the one hand and on the other his promotion of modernism

2 The Kodak Girl, in her signature blue-and-white-striped dress, appeared in advertising campaigns internationally. She is one of the icons of contemporary advertising included in Frederick Charles Herrick's famous poster for the *International Advertising Exhibition*, London, in 1920.
3 Madge Garland, "Some Impressions by Famous Poster Artists of the Women of Their Day," *Britannia and Eve 3*, no. 8 [August 1931]: 52–53.
4 Kauffer, "Advertising Art: The Designer and the Public," *Journal of the Royal Society of Arts* 87, no. 4488 [November 25, 1938]: 53.
5 Ethel M. Feuerlicht, "Edward McKnight Kauffer's Poster Experience in England and the United States," *The Poster* 13 [January 1922]: 34–35.
6 Ibid., 35.
7 Kauffer, "The Poster," *Arts & Decoration* 16, no. 1 [November 1921]: 42–44.
8 Ibid., 44.
9 Ibid., 42,44.

5.2 (opposite) Poster, *Olympia anciennes, Montagnes Russes, Boulevard des Capucines*, 1892, Jules Chéret

as "a more intelligent and comprehensive [method] that deals in direct action to the mind."[10] More interesting, though, is his apparent frustration with the limitation of women by stereotype—locked jaw and all.

This view is reinforced in Kauffer's comments on the historical origins of the pretty-girl poster. He was a vocal proponent of the modern poster, and of its social place as both a critical business tool and a disseminator of contemporary values. An active educator as well as a practitioner, he often folded the history of the poster into his promotion of the form. These discussions invoked women not as creators (understandably for that time), or even as audience, but rather as visual subjects, and specifically as archetypes Kauffer found problematic.

Like other documenters of graphic-design history, Kauffer saw the 1890s as a period of new achievement in poster art. He particularly acknowledged the technical innovations of Jules Chéret, the art nouveau painter and printmaker often credited as a "father" of the artistic lithographic poster. Nonetheless, he took issue with a defining characteristic of Chéret's work: the portrayal of exuberant women in vibrant, swirling colors (fig. 5.2). In Kauffer's flat assessment, Chéret "formalised his

women until each new design was virtually a repetition of the last," resulting in a lingering "romantic quality." "I do not propose to weary you," he quipped, "with any more of Chéret's designs with a series of repetitions of his feminine beauties."[11]

Kauffer took a much kinder view of Henri de Toulouse-Lautrec, Chéret's fellow father figure in the poster narrative. Both artists were active in late nineteenth-century Paris, and both produced iconic depictions of women (in Lautrec's case often of sex workers), but it was Lautrec whom Kauffer deemed "the greatest of all poster artists of his time."[12] The terms of his praise, though, were stylistic; those posters were "revolutionary in their simplicity—their organised design—their dramatic power."[13] Kauffer made no comment on their subjects. What made Lautrec's fin-de-siècle females so much more palatable to him than Chéret's? Both embodied the much-discussed "New Woman" of this period— active, independent, even emancipated—as epitomized by the dancer Loïe Fuller in Chéret's poster of 1897. But Lautrec's more individuated and sober, even contemplative figures did not irk Kauffer as Chéret's beaming counterparts did. The distinction suggests that Kauffer's objection was not to the modern woman herself, or to her propagation by graphic means, but rather to her visual entrenchment in such limited form.

SPRING CLEANING

Fear, sex, maternity, snobbism, such are the themes of 90 percent of advertising that daily haunt our eyes. Hitting below the belt, appealing to our fears, and undermining our ideals—a vortex of banalities, a rubbish dump of overstatement, corrosives that eat into the daily lives of citizens. [E. McKnight Kauffer, introduction to Paul Rand's *Thoughts on Design*, 1947]

From his early rejection of "pretty" advertising on the grounds of artistic quality and good business, Kauffer extended a broader, gender-inflected critique of design in terms of social impact. "Every good poster, booklet, card," he argued in a lecture at New York's Museum of Modern Art (MoMA) in 1948, "is a protest against the lazy and usual methods of appeal through sex, snobbism, fear and corruptive sentimentality. Indirectly therefore, we make a contribution to more civilizing influences."[14] Vaguely yet firmly, he proposed a public role for the designer, whom he saw as carrying a moral as well as a financial imperative: "the artist in advertising is a new kind of being," he wrote

10 Ibid., 44.
11 Kauffer, "Advertising Art: The Designer and the Public," 55.
12 Ibid., 54.
13 Ibid., 55.
14 Kauffer, lecture given at The Museum of Modern Art, New York, at the symposium "Responsibility for Standards of Taste in a Democratic Society," April 24, 1948. Box 1, folder 14, item 4, Notes, Writings, and Sketches, Personal Papers, E. McKnight Kauffer Archive, Cooper Hewitt, Smithsonian Design Museum. See also the press release for the event, available online at www.moma.org/momaorg/shared/pdfs/docs/press_archives/1255/releases/MOMA_1946-1948_0130_1948-04-14_48414-20.pdf [accessed December 7, 2019].

15 Kauffer, "Advertising Art," 61.
16 See Mica Nava, "Modernity Tamed? Women Shoppers and the Rationalization of Consumption in the Interwar Period," in Margaret R. Andrews and Mary M. Talbot, eds., *All the World and Her Husband: Women in Twentieth-Century Consumer Culture* [London and New York: Cassell, 2000], 26-64.
17 Alfred Harmsworth, quoted in Billie Melman, *Women and the Popular Imagination in the Twenties: Flappers and Nymphs* [London: Macmillan, 1988], 19. See also Virginia Nicholson, *Singled Out: How Two Million British Women Survived without Men after the First World War* [Oxford and New York: Oxford University Press, 2008], 23.
18 Aldous Huxley, "Foreword," in *Posters by E. McKnight Kauffer,* exh. cat. [New York: The Museum of Modern Art, 1937], n.p.
19 Adolphe Armand Braun, "E. McKnight Kauffer," Artists Who Help the Advertiser [No. 7], *Commercial Art 2,* no. 14 [December 1923]: 328.

in 1938. "His responsibilities are to my mind very considerable. It is his business constantly to correct values, to establish new ones, to stimulate advertising and help to make it something worthy of the civilisation that needs it."[15] While his critique was directed at the male-run advertising industry, it rhymed somewhat with that of contemporary moralists who protested what they perceived as the "feminisation" of England in the period after World War I.[16] As modern British women gained more public visibility, economic strength, cultural influence, and political traction (they had won the right to vote in part by 1918 and in full by 1928), they also fueled a powerful anxiety. Women of marriageable and working age heavily outnumbered men after the war, in which so many British men in the same age group had died, and their new freedoms triggered hostility in the popular press and elsewhere. (*Daily Mail* owner Alfred Harmsworth, Lord Northcliffe, referred in 1921 to "Britain's problem of two million superfluous women").[17] Remembered generally as a progressive, Kauffer is unlikely to have aligned himself with these views, but in the absence of a record of his personal politics in this debate, his remarks take on new meaning in its context.

With the exception of modestly sexualized designs in the 1930s for the undergarment company Charnaux (including his only known collaboration with his friend the artist Man Ray), Kauffer maintained a distance from the prevailing logic that sex sells. Instead, he embraced style and symbols for a cleaner approach. Modern design, in the multiple forms into which Kauffer channeled it, offered a visual language that he was confident could speak to a mass audience without appealing to its baser instincts. His friend Aldous Huxley, who wrote the catalog introduction for his exhibition at MoMA in 1937, described his symbols as elevated above the fray of sex-driven design:

Most advertising artists spend their time elaborating symbols that stand for something different from the commodity they are advertising. Soap and refrigerators, scent and automobiles, stockings, holiday resorts, sanitary plumbing and a thousand other articles are advertised by means of representations of young females disporting themselves in opulent surroundings. Sex and money—these would seem to be the two main interests of civilized human beings....

McKnight Kauffer is also a symbolist; but the symbols with which he deals are not symbols of something else; they stand for the particular things which are at the moment under consideration.[18]

The absence of women from Kauffer's posters and advertising is indeed striking. Even in his designs for clients primarily targeting women—Pomeroy Day Cream (fig. 5.3), Eastman and Son Dyers & Cleaners (fig. 5.4), Vigil Silk (fig. 5.5, plates 019–020)—he generally does not materialize the female user. Where women do appear, for example in his Eastman posters of 1923–24, they are stylized, obscured, and rendered historical, rather than relatable (or sexually available) to contemporary consumers (plate 034). This distancing was noted to comic effect during a 1923 Design and Industries Association meeting in which Bernard Smith, advertising manager of Pears soap, reportedly revealed that he "had only discovered that evening that Mr. Kauffer's latest Eastman poster [fig. 5.6] was not a lampshade, but a dress such as the wife of no member present would wear."[19]

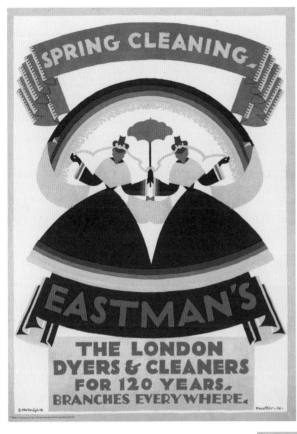

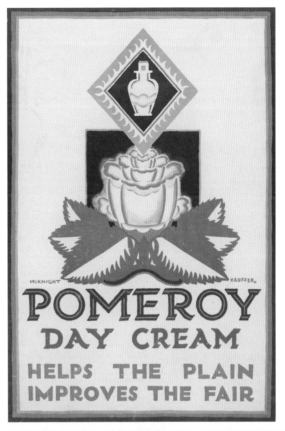

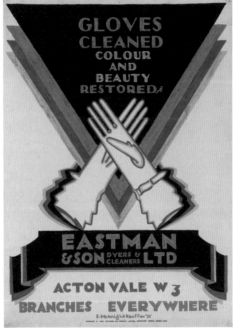

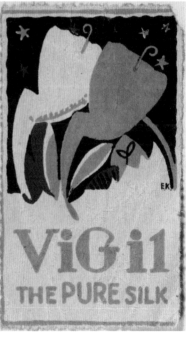

5.3 (top right) Poster, *Pomeroy Day Cream*, 1923
5.4 (bottom left) Poster, *Gloves Cleaned: Eastman & Son Dyers & Cleaners Ltd*, 1922
5.5 (bottom right) Label, Vigil, The Pure Silk, 1919–21
5.6 (top left) Poster, *Spring Cleaning: Eastman's, The London Dyers and Cleaners for 120 Years*, 1924

THE WAY FOR ALL

It can be generally recognized that the public has got beyond the "bathing girl" and "chocolate box" type of poster…this is an advancement for which we can all be grateful. [Ivor Fraser, Underground publicity manager, in "The Present-Day Poster: An Interesting Debate," 1923]

Kauffer designed many posters for the London Underground, where significant numbers of women would have encountered them—an interaction that has not been thoroughly considered. By 1915, when Kauffer was hired by Underground manager Frank Pick, women had been part of the system for decades, not only as passengers but as "fluffers" who dusted the rails at night. They were represented in posters early on, sometimes as characters in the "sentimental" style of ad that Pick began to commission before the end of World War I. (In 1919, artist/polemicist Wyndham Lewis mocked "the sugary poster-couple on the walls of the Tube, who utter their melancholy joke and lure you to the saloons of the Hornsey Furnishing Company.")[20] In other posters women were depicted as casual passengers (generally accompanied by men), their more vibrant fashions helping to communicate the brightness and warmth of the Underground.[21] A notable, bleaker image of the female traveler was provided by Roger Fry in his Omega Workshops mural for Arthur Ruck's house at 4 Berkeley Street in London (1916–17), which featured a single weary woman ascending an Underground staircase.[22]

20 Wyndham Lewis, *Wyndham Lewis the Artist: From "Blast" to Burlington House*, 1939 [repr. ed. New York: Haskell House Publishers, 1971], 311.
21 See, for example, Mervyn Lawrence's *Always Warm and Bright* [1912] and Horace Taylor's *Brightest London Is Best Reached by Underground* [1923].
22 This and other "defeatist" images of Underground travel are described in Haewon Hwang, *London's Underground Spaces: Representing the Victorian City, 1840-1915* [Edinburgh: Edinburgh University Press, 2013], 108.
23 Cheryl Buckley, *Designing Modern Britain* [London: Reaktion Books, 2007], 39.

Through the early twentieth century, women traveling on the Tube were still navigating a decidedly male space, even when war brought more women below ground both as passengers and as uniformed gatewomen, guards, porters, and ticket staff. As "essential components of modernity," British women were increasingly independent, employed, and mobile, but also subject to distinct social tensions.[23] The disruption and discomfort attending them was fodder for cartoonists such as J. H. Dowd, whose wartime "new gallant" offers her seat to another woman (fig. 5.7). Nevertheless, women were vital to the expanding commuter system's bottom line and were courted accordingly. Among the earliest graphic gestures to promote female ridership was Alfred France's poster *The Way for All* (fig. 5.8), whose confident young protagonist actively directs the viewer with eye contact and pointed finger. In these women we see the graphic counterparts to a new cohort of female Tube riders in modern literature, especially that of Virginia Woolf, "the literary inventor of the Tube after 1910."[24] A seasoned Underground traveler herself (and a client of Kauffer's), Woolf embraced the Underground as a site of technological progress as well as of new social, psychological, and sensory experiences. In *The Waves* (1931), her character Jinny likens the Underground experience to being "in the heart of life."[25]

 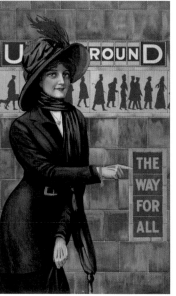

In contrast, women do not feature, for the most part, in the more than 125 posters Kauffer designed for the Underground, but they were the target audience for some of the most famous of these. With several posters promoting "the quiet hours" between 10 a.m. and 4 p.m., he joined a steady effort to encourage off-peak ridership by women. As a 1928 press advertisement explained, "The Shoppers and Pleasure-Seekers are now abroad, and it's the best time too, as the Business Folk are at work and there is more room in the Trains." Some of Kauffer's posters of this type incorporated women as obscured, stylized elements of the composition; others avoid figures entirely. His 1930 poster *The Quiet Hours* (plate 076), with its shaded, disjointed clock parts and key numbers 10 and 4 seeming to zoom off the page, offers no hint to the gender of its intended audience.

24 In Virginia Woolf's fictions "The Mark on the Wall" [1917], *To the Lighthouse* [1927], and *The Waves* [1931], a woman's stream of consciousness is likened to a journey on the Underground. See David Welsh, *Underground Writing: The London Tube from George Gissing to Virginia Woolf* [Liverpool: Liverpool University Press, 2010], 142.
25 Woolf, *The Waves*, 1931 [repr. ed. Oxford: Oxford University Press, 2015], 114.

5.7 (opposite, left) Magazine illustration, The New Gallant:
"Take My Seat, Madam," in *The Bystander*, 1918, J. H. Dowd
5.8 (opposite, right) Poster, *The Way for All*, 1911, Alfred France
5.9 Book cover, *Woman: A Vindication* by Anthony Ludovici, 1923

From around 1900 on, London's growth as a site of leisure was linked to its expanding transport system. Shopping, denigrated in the Victorian era as "a wasteful, indulgent, immoral, and possibly disordered female pleasure," was advanced as legitimately enjoyable and respectable in the interwar era to turn anxieties into profits.[26] In his early 1920s series of *Winter Sales* posters for the Underground (plates 021–023), Kauffer picked up a theme he had first explored for Derry & Toms in 1919 (plate 005): he embraced a muted, atmospheric approach, with his women barely visible behind collars, umbrellas, and a vortex of snow. His curves, angles, and cubist abstractions add dynamism and visual interest, but the compositions remain stately and epitomize Zero's "austere and masculine" categorization.

A VINDICATION?

[Kauffer] belongs to no political party, unless a fierce pity for the underdog makes him a Socialist. He wants to see equality of opportunity established for everyone else, though he has never asked for it himself. [Colin Hurry, 1921] [27]

Aside from his progressive reputation, Kauffer is not remembered as an actively political designer, yet in three noteworthy instances he lent his talents to politically engaged projects related to women. First, Kauffer designed the cover for Anthony Ludovici's book *Woman: A Vindication* (fig. 5.9), one of more than fifty publications through which Ludovici disseminated his extreme views. Though forgotten today, Ludovici was at one time a well-known British public figure who promoted antifeminism ("which should on no account be confused with misogyny") and supported the new attitude prevailing in the Third Reich toward "an ideal of women as wife, mother and domestic mate...only thus can women secure happiness and health."[28] Kauffer's cheerfully colored cover belies the darkness of these views, although interpreting the composition as (spiked) female genitalia may serve as a warning.

Only two years later, Kauffer shifted drastically with a poster promoting *The Labour Woman*, the monthly journal of the Labour party's women members (fig. 5.10). The party had supported women's suffrage since 1912, but in the mid-1920s women were still struggling to define their role in it amid divergent views about class, feminism, and birth control. Nonetheless, their membership grew rapidly and in 1925, when this poster was published, had reached 200,000.

Finally, in 1930 Kauffer contributed the cover design and nine airbrushed illustrations for Frederick Edwin Smith's fascinating forecast *The World in 2030 A.D.* Smith, first Earl of Birkenhead—a former Conservative cabinet minister, leading lawyer, and best friend of Winston Churchill—wrote the book in the year of his death. Amid diverse predictions of a more advanced, rational global society, he dedicated an entire section to "Woman in 2030." While he took for granted women's inferiority to men and the limitation of the "female intellect" (he also stridently opposed women's suffrage), his focus here was the potential of ectogenesis, the growth of an embryo or fetus outside the body. "In 2030, the prospect of woman's liberation from the dangers of childbirth will almost certainly become a matter of general realisation," he claimed. "This evolution, the most serious biological departure since the natural separation of living organisms into two sexes, will vitally transform the whole status of women in society." In Kauffer's illustration (fig. 5.11), a (nonpregnant) woman, her body rounded and contoured, fills the foreground yet appears disengaged, while a flat, featureless male figure holding a sign of some sort (E for Edwin?) "projects" the next generation through her.

26 See Erika D. Rappaport, "'A New Era of Shopping': The Promotion of Women's Pleasure in London's West End, 1909–1914," in Jennifer Scanlon, ed., *The Gender and Consumer Culture Reader* [New York: New York University Press, 2000], 31.
27 Colin Hurry, quoted in Haworth-Booth, *A Designer and His Public*, 25.
28 Anthony Ludovici, quoted in Dan Stone, *Breeding Superman: Nietzsche, Race and Eugenics in Edwardian and Interwar Britain* [Liverpool: Liverpool University Press, 2002], 51.
29 Kauffer, "Responsibility for Standards of Taste in a Democratic Society."

Kauffer's participation in these politically assertive and divergent projects adds a fascinating and little-known layer to his professional engagement with notions of gender. The disparities among them, as well as their dissociation from his more familiar work, suggest a commercial practice detached from content. Yet Kauffer himself, only a few years later, charged the advertising designer with correcting values and establishing new ones. Perhaps he thought this role unnecessary in other areas of design, or his perspective changed with the political shifts of the 1930s. "What we want, and indeed what we need," he remarked at MoMA, "is the recognition of our value as participants in the maintenance of civilized living in community, state, and country."[29] The relationship of the modern woman to this "we" remains, in Zero's terms, "infinitely complex."

5.10 (left) Poster, *The Labour Woman*, 1925
5.11 (right) Book illustration, Woman in 2030, for *The World in 2030 A.D.* by Frederick Edwin Smith, 1930

6.1 Drawing, Stage design: Prologue backdrop for *Checkmate*, 1947

SETTING *the* MODERN **STAGE**

Kristina Parsons

IN OCTOBER OF 1909, A NINETEEN- YEAR- OLD E. McKNIGHT KAUFFER SENT HIS PARENTS IN INDIANA A POSTCARD SHOWING THE BACKDROP HE HAD PAINTED FOR A THEATRICAL PRODUCTION (FIG. 6.4).[1] HE INSCRIBED A BLACK *X* ON THE PHOTOGRAPH, PROUDLY POINTING TO HIS SIGNATURE. KAUFFER HAD RECENTLY LEFT HIS HOMETOWN to paint scenery for a traveling theater company, as he had done for several years at the Evansville Grand Opera House. Even during the most productive periods of his career as a commercial artist, he would remain committed to designing for the stage. In subsequent decades, Kauffer designed scenery and costumes for a traveling theater troupe, London stage productions, the ballet, opera, and even ice-skating shows at Blackpool's Pleasure Beach.

As Kauffer honed the bright, graphic quality of his poster work, he found that his economy of form and bold use of color translated seamlessly into experimental British theater, which was seeking to establish a new identity in the aftermath of the Great War. Across performative media, artists played with sound, lighting, scenery, and costumes to enhance the message of their productions. A number of community-based theatrical troupes emerged across the United Kingdom, presenting new programs with the idealistic aim of digesting the collective experience of the war and using the arts to recalibrate society.[2] In this milieu, Kauffer's designs, which embraced whimsy and symbolism, were readily adopted by those in his London network working on the stage.

One such group was the Arts League of Service (ALS), formed in 1919. Its founders, Eleanor Elder and Ana Berry, wrote of their ambition "to form a nucleus of artists for purposes of co-operation and propaganda, and to offer them a working machinery, which in its various activities will bring them in touch with the general public, and awaken a greater interest in their respective arts."[3] In addressing the desire to

1 E. McKnight Kauffer, letter to Mr. and Mrs. J. M. Rees, October 13, 1909. Box 1, folder 3, item 1, Biographical and Correspondence, Personal Papers, E. McKnight Kauffer Archive, Cooper Hewitt, Smithsonian Design Museum.
2 Many of these groups were inspired by Edward Gordon Craig, who had published a series of articles between 1904 and 1911 calling for the rejection of theatrical representation rooted in realism, instead emphasizing the potential of abstraction to deliver complex narratives.
3 "Programme and Policy of The Arts League of Service," *Bulletin of the Arts League of Service*, 1920, 5.

6.2 (top left) Publicity postcard, *The Proposal* by Anton Chekhov, performed
by the Arts League of Service, 1926, scenery by E. McKnight Kauffer
6.3 (bottom left) Publicity postcard, *Lazarus*, performed by the Arts League of Service, ca. 1927,
costumes by E. McKnight Kauffer
6.4 (top right) Postcard, Theatrical backdrop, 1909, scenery by E. McKnight Kauffer
6.5 (bottom right) Drawing, Costume design: Henry VIII, for *Catherine Parr, or
Alexander's Horse* by Maurice Baring, 1925

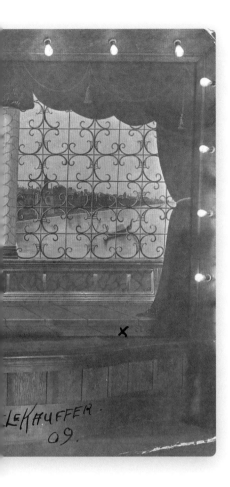

promulgate artists as valuable contributors to society and the economy, the ALS established a distinctly didactic aim for their endeavors: by developing a supportive framework in which artists could work, their output would engage the public in debate on the role of the arts. Kauffer was a principal member of the ALS from the beginning, designing many sets and costumes for its productions, as well as graphic material, including the organization's emblem (plate 014).

Kauffer also wrote several times for the *Arts League of Service Bulletin*, including an essay in the 1923–24 issue, "The Essentials of Poster Design," that described his approach to graphic composition in language echoing that of performance. He asserted, "The kind of design which functions most effectively is centrifugal in character,—thus insisting on a focussing point. Around this central point is built qualifying inventions in pattern, colour and arrangement. By the use of this centrifugal idea and the adjustments of contrasts surrounding this central part the designer has at least obtained attraction."[4] Kauffer's conceptions of poster design and his approach to stage design coalesced, revealing the shared aim of capturing and concentrating an audience's attention within a contained space while providing entertainment and communicating a clear message.

Perhaps the most prolific facet of the organization was the Arts League of Service Travelling Theatre, which crisscrossed the country for nearly two decades executing the ALS motto, "To bring the arts into everyday life," for a broad swath of the British public. The troupe's programs consisted of a revuelike mix of experimental one-act plays, traditional folk songs, mime, classical and avant-garde dance, and poetry. The ALS operated as a nonprofit, charging ticket admissions only to cover costs.[5] Kauffer, already well versed in the practical needs of a traveling theater company, worked within these constraints to produce work that elevated the performative environment. His vivid costumes for productions such as Maurice Baring's *Catherine Parr, or Alexander's Horse* (1925, fig. 6.5) were deliberate in their use of color and pattern to articulate elements of humor and absurdity in the play's narrative. Elder would describe the scenic backdrop that Kauffer designed for another play, Anton Chekhov's *Proposal* (1890), as a "background on which everything was preposterously awry—the table, the canary in the cage, and so forth—in the deliberately distorted perspective of the art of that time" (fig. 6.2).[6] Critics overwhelmingly adored ALS productions, but their programs were not without the occasional controversy. Kauffer's costumes for *Lazarus*, a dramatization of an English folk song, so greatly offended one local crowd that the ALS was never invited back.[7] Elder speculates, "Perhaps it was the angel, who wafts Lazarus to Abraham's bosom, that shocked the villagers, or the Serpent, on whose 'knee' the wicked Diverus is doomed to 'sit,' for these were represented by symbolic figures in the hands of two of the players and were painted according to the period by McKnight Kauffer" (fig. 6.3).[8]

Throughout the 1920s, Kauffer broadened his theatrical clientele to include exclusive members-only clubs such as the Incorporated Stage Society, whose programming was decidedly more avant-garde than that of mainstream London theaters. Through these commissions Kauffer developed a reputation for provocative yet polished work uniquely situated to augment a production's modern message. The appeal of Kauffer's designs expanded beyond this passionate community in 1925, when he designed the scenery and collaborated with the designer Marion Dorn, his partner, on the costumes for the first English translation of Luigi Pirandello's *Henry IV* (1921), performed at the Everyman Theatre in Hampstead.[9]

4 Kauffer, "The Essentials of Poster Design," *Arts League of Service Bulletin 1923-1924*, 1924, 11.
5 Expenses for a given performance averaged £15, or approximately £675 [$869] in the 2020 equivalent. Ticket prices ranged between £2 [$3] and £10.50 [$14] in 2020 values.
6 Eleanor Elder, *Travelling Players: The Story of the Arts League of Service* [London: Frederick Muller, 1939], 138.
7 Marion Dorn is credited with designing a curtain for this program.
8 Elder, *Travelling Players*, 114.
9 Ticket prices for this production ranged from what in 2020 prices would be between £8.50 [$11] and £26 [$33.50].

Critics praised the actors' performances but Kauffer's scenery received mixed reactions. In one review, Edith Shackleton stated her confusion: "Indeed, the entire production is to be praised, but for the two portraits in the throne room, which, since their likeness to people on the stage is of such importance, should have been more representational and less reminiscent of London Group exhibitions."[10] This was a clear jab at Kauffer, a notable former member of the modernist London Group. The disconnect between what critics wanted to see on stage (even beyond the more conservative West End theater neighborhood) and Kauffer's unconventional interpretation of space speaks both to the state of British theater at the time and to the public's perception of it. Three years later, Kauffer's scenery for a revival of Anna Cora Mowatt's comedy *Fashion; or, Life in New York* (1845), staged at the Gate Theatre Studio, was met with much greater enthusiasm. *The Graphic* dedicated an entire spread to images and a review of the production, exclaiming, "Mr McKnight Kauffer's attractive set, which combines the essence of early Victorian decoration with the most modern convention in stage setting, makes an excellent backdrop for the period dresses."[11]

In 1932, the *Times* announced Ernest Milton's upcoming production of Shakespeare's *Othello* (ca. 1603), specifically mentioning the scenery and costumes as "designed by Mr. McKnight Kauffer, the well-known poster artist."[12] Until this point, critics reviewing performances featuring Kauffer's work had focused on the skill of the actors or the merits of the text, rarely discussing sound, lighting, scenery, or costumes; but as producers began capitalizing on these elements to manipulate the audience's experience, reviewers began to take note. It was with *Othello* that Kauffer's designs shifted from playing a supporting role on the stage to becoming a primary element in the production's conception, not to mention a notable publicity draw.

When the play opened, at the St. James's Theatre on April 4, the *Times* reviewer wrote, "This is as bold and challenging a production of *Othello* as has been seen in our time, and will stir up inevitably all the fires of controversy.... Mr. McKnight Kauffer's designs have beauty when one seeks them out; they have also the greater dramatic merit of allowing themselves to be forgotten in the play" (fig. 6.6).[13] Yet the production closed after just seven performances, a financial disaster that critics seemed eager to blame on Milton's portrayal of Othello.[14] Kauffer was paid £20 up front and was due to earn 1 percent of gross box office receipts.[15] In a letter to Kauffer of April 8, Milton expressed his distress over the situation:

> One of the greatest griefs I have arising out of what must be regarded as a disaster, is that it will not return you anything for your loss of time and whatever financial inconvenience your steady devotion to the production may have cost you. I can only hope that it will have created so notable an increase to your reputation as an artist, that automatically some compensation may arise from other quarters.[16]

Indeed, Kauffer's scene and costume designs for the play graced the stage at least thirty-five more times in productions of *Othello*—this time Giuseppe Verdi's opera version, of 1887—presented by Lilian Baylis's company at the Sadler's Wells and Old Vic theaters.[17] The acquisition of Kauffer's scenery and costumes for these theaters was facilitated in part by a letter soliciting donations to purchase them, signed by Winston Churchill, Lord Berners, Lord Balniel, and Kauffer's close friend Mary Hutchinson.[18] It was perhaps the quality of invisibility called out by the

10 Edith Shackleton, "Pirandello's *Henry IV* in English," 1925. Production file for *Henry IV*, Everyman Theatre, 1925, Victoria and Albert Museum, London.
11 The Theatres, *Times* [London], December 6, 1928, 14. The Times Digital Archive.
12 The Theatres, *Times* [London], February 18, 1932, 10. The Times Digital Archive.
13 "St. James's Theatre, 'Othello' by William Shakespeare," *Times* [London], April 6, 1932, 12. The Times Digital Archive.
14 A recurring critique among reviewers was that Ernest Milton's performance of the title role deviated from conventional British portrayals, which often relied on the use of blackface. His performance, too, came shortly after the London stage debut of Paul Robeson, who had played Othello to great acclaim. Robeson was only the second black actor to play Othello on the British stage, following Ira Aldridge's performance in 1825.

15 Jack de Leon [Ernest Milton Productions's general manager], letter to Kauffer, February 26, 1932. Oversize box 4, scrapbook 2, Scrapbooks, Published Materials and Editorial Coverage, E. McKnight Kauffer Archive, Cooper Hewitt, Smithsonian Design Museum. Kauffer's £20 fee is approximately equivalent to £1,405 [$1,809] in 2020.
16 Milton, letter to Kauffer, April 8, 1932. Oversize box 4, scrapbook 2, Scrapbooks, Published Materials and Editorial Coverage, E. McKnight Kauffer Archive, Cooper Hewitt.

6.6 (top right) Publicity still, *Othello* by William Shakespeare, performed at the St. James's Theatre, London, 1932, costumes and scenery by E. McKnight Kauffer
6.7 (bottom left) Photograph, Ninette de Valois, Arthur Bliss, and E. McKnight Kauffer gathered at a chessboard, ca. 1937

17 Both Sadler's Wells and the Old Vic were owned and operated by Lilian Baylis. She purchased and rebuilt Sadler's Wells in 1931, selling tickets starting at just sixpence [roughly equal to £1.50 [$2] in 2020].
18 Sir Winston Churchill, Lord Berners, Lord Balniel, and Mary Hutchinson, draft of letter to subscribers of the Old Vic and Sadler's Wells Theatres, n.d. [1932–33]. Lot #34, "Winston Churchill Old Vic Theater Archive," Rare Autographs, Manuscripts and Aviation Auction, One of a Kind Collectibles Auctions, Coral Gables, October 27, 2016. See www.oakauctions.com/Winston _Churchill_Old_Vic_Theater_Archive -LOT3717.aspx [accessed December 17, 2019].

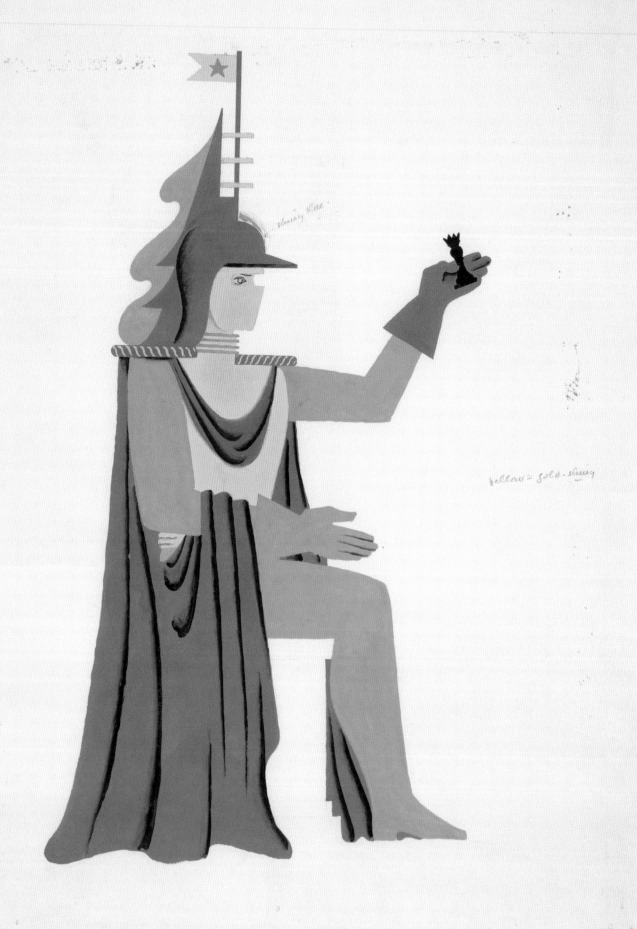

6.8 Drawing, Costume design: Love, for the ballet *Checkmate*, 1947

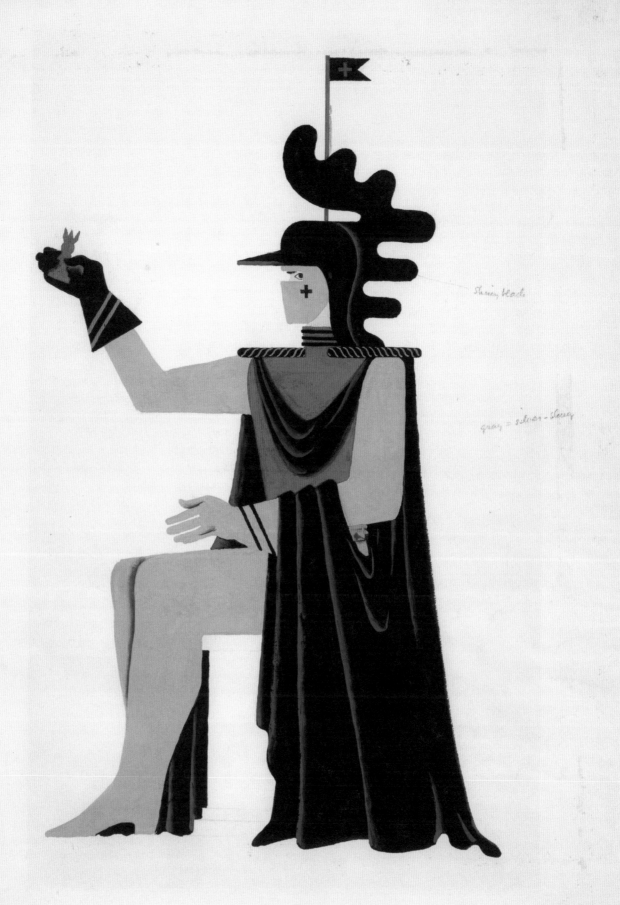

shiny black

gray = silver - stones

Death "Checkmate"
Qurchinjht Kauffer

6.9 Drawing, Costume design: Death, for the ballet *Checkmate*, 1947

Times reviewer that made Kauffer's designs transferable in this way, prolonging their life on the stage and the public's exposure to Kauffer's work. Photographs of the production reveal scenery that is reductive in form, but preliminary sketches and drawings suggest that they would probably have been executed in the vibrant colors that Kauffer so readily embraced.

As British theater continued to evolve, dance followed a parallel trajectory, with Ninette de Valois leading the charge. Inspired by the Ballets Russes, with which she had performed for several years, de Valois sought to develop a British national ballet company. In 1930 she was a key player in establishing the Camargo Society, choreographing and presenting ballet to a subscription audience, and in 1931, with Baylis's support, she founded the Vic-Wells Ballet, which would eventually become the Royal Ballet.

Considering the Vic-Wells the pinnacle of achievement in dance, the British Council invited the company to perform at the 1937 *Exposition Internationale des arts et techniques dans la vie moderne*, in Paris. De Valois's response was to enlist two trusted collaborators, Kauffer and the composer Arthur Bliss, to work on what would become the ballet *Checkmate*.[19] Reflecting on the piece's development, Bliss maintained that while he was the only one of the trio with intimate knowledge of chess, both de Valois and Kauffer brilliantly interpreted the concept through their own media (fig. 6.7). He wrote of Kauffer, "Most contemporary painters are sympathetic to music; some even find it a stimulus to creative effort, when broadcasted. But McKnight Kauffer thinks musically. He has a real love and critical appreciation of it, so that it was possible for us to talk over the whole setting of the ballet in the most sympathetic manner."[20]

Choreography, musical score, scenery (fig. 6.1), and costumes contributed equally to the conceptualization of *Checkmate* as a uniquely British modern performance (plates 134–138). Over the course of a single forty-minute act, allegorical figures of Love and Death (figs. 6.8, 6.9) face off in a dramatic chess game of red and black pieces moving across a checkerboard stage in militaristic formation. Death is ultimately crowned the victor. In the late 1930s, the threat of imminent war was impossible to ignore, and audiences of the period would have had no trouble connecting it with the ballet's ending, despite the work's level of metaphor: as the dance historian Cyril Beaumont wrote in 1939, "*Checkmate* is the first English ballet to have a purely abstract setting."[21] He also praised Kauffer's costume design: "The Pieces are full of invention in their design, for it is not an easy matter to suggest both a Chess Piece and a human being, and yet devise the costume so that it is decorative and one in which the dancer can move with ease" (fig. 6.10).[22] Following a positive reception in Paris, the company debuted *Checkmate* to an enthusiastic London audience on October 5, 1937 (fig. 6.11).

In the spring of 1940, the British Council and the Foreign Office organized a tour of the Vic-Wells Ballet through the Netherlands, giving two months of deferment to any dancers who had been called into military service so that they could perform as would-be political ambassadors. When the German army invaded Holland on May 10, the company was forced to flee mid-tour, abandoning personal belongings as well as the costumes, sets, and musical scores for eight of the company's major ballets, including *Checkmate*. The ballet was not revived until after the war, in a 1947 season at Covent Garden. Although Kauffer was living in New York by then, he redesigned the costumes and set, streamlining the visual appearance to suit the larger venue. After this season, *Checkmate* was shipped across the Atlantic to begin the Vic-Wells's inaugural American tour, commencing with performances at New York's Metropolitan

19 Kauffer was paid £25 for designing the costumes and scenery of *Checkmate,* approximately equivalent to £1,714 [$2,207] in 2020.
20 Arthur Bliss, "Death on Squares," *Great Thoughts,* January 1938, 22.
21 Cyril W. Beaumont, "Ballet: Settings and Costumes in Recent Productions," *The Studio Magazine of Beauty,* April 1939, 147.
22 Ibid.

Opera House. A production that was developed for a single exhibition in 1937 had, just a decade later, become a nationalized representation of what the Vic-Wells pronounced the most British example of ballet. *Checkmate* remains in the Royal Ballet's repertoire today; its longevity demonstrates the immense impact of productions of this period to which Kauffer's designs made essential contributions.

Kauffer's most successful designs for the stage do many of the things for which his posters were widely celebrated. Displayed on billboards, those posters were effective in catching the public's eye with their distinctively rendered compositions, holding attention long enough to make a message memorable. In the theater, Kauffer's designs worked in conjunction with those of like-minded artists to express new conceptions of modernity through music, movement, speech, and light. His work was integral to these immersive experiences of modernity, ushering in a uniquely British identity for performance and expanding beyond British borders to communicate a new national identity on the international stage.

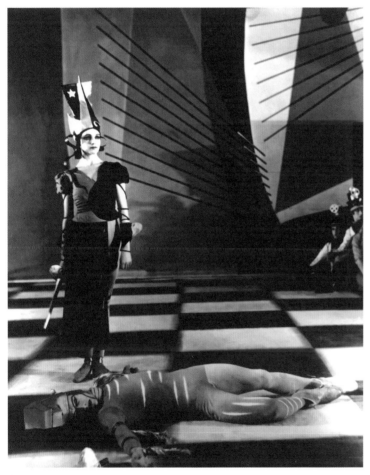 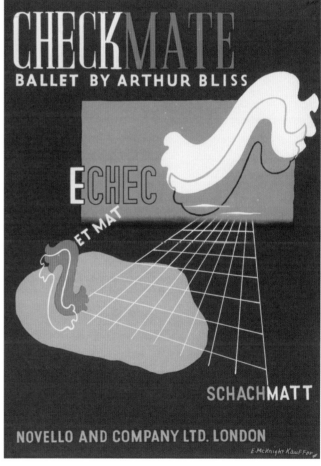

6.10 (left) Photograph, Scene from *Checkmate*, 1937, Photograph by Baron (née Sterling Henry Nahum), costumes and scenery by E. McKnight Kauffer
6.11 (right) Print, Design for musical score for *Checkmate*, 1937

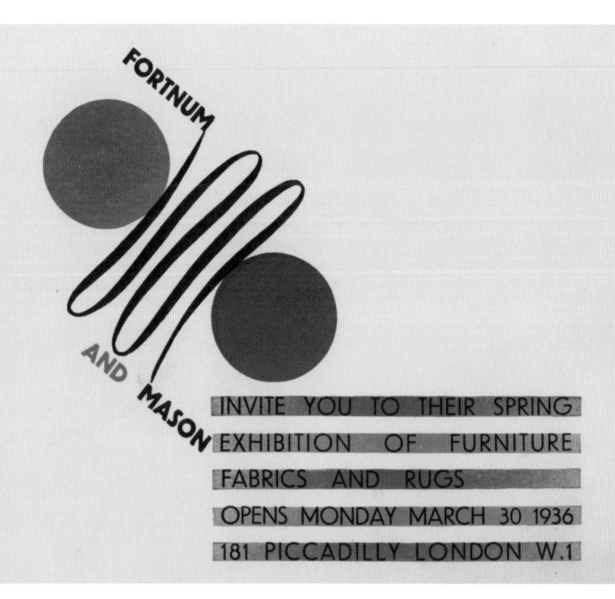

FORTNUM

AND MASON

INVITE YOU TO THEIR SPRING
EXHIBITION OF FURNITURE
FABRICS AND RUGS
OPENS MONDAY MARCH 30 1936
181 PICCADILLY LONDON W.1

7.1 Card, Invitation to spring exhibition, Fortnum and Mason, 1936

EQUIPPING *and* EXHIBITING *the* MODERN INTERIOR

Emily M. Orr

ON JULY 26, 1930, E. McKNIGHT KAUFFER WROTE TO HIS PUBLISHER ALFRED KNOPF THAT "WE HAVE MOVED TO A DIFFERENT PART OF LONDON INTO A NEW BLOCK OF FLATS JUST OVER BAKER STREET STATION [.] THEY ARE :MODERN: FOR LONDON BUT FROM A NEW YORKER'S POINT OF VIEW, AVERAGE: HOWEVER FOR US IT IS A GREAT CHANGE AND quite the opposite to the 'old world' quaintness of the Adelphi."[1] Kauffer and his partner and future wife, Marion Dorn, had relocated from 17 John Street, Bloomsbury—a building in the neoclassical style of the Adelphi neighborhood, built by the Adam brothers in 1768–74—to Chiltern Court, Marylebone, commissioned by the Metropolitan Railway in 1929 and designed by the architect C. W. Clark. Upon their move, Kauffer and Dorn became some of the first Londoners to inhabit a fully modern environment. The building, its interior decoration, and the lifestyle it made possible were all united in simplicity, utility, and contemporary aesthetics.

By 1930, Kauffer and Dorn were playing formative roles in the shaping of London's earliest modern interiors both private and public. Their interior design work was collaborative and roles were not always succinctly defined; Kauffer and Dorn worked jointly with one another and with fellow architects, artists, and designers on many of these projects. They alternated taking the lead on shaping the comprehensive scheme. The couple made an impact with rug designs that sold at art galleries and interior design studios, with private commissions for the apartments of creative professionals in their social circles, and with exhibitions of model rooms. Corporate projects and associations with progressive architects allowed them to expand their work beyond the domestic sphere into offices, hotels, and transport. In the late 1920s and 1930s, Londoners were becoming aware of European avant-garde aesthetics of art and design, including French *art moderne* and cubism, Dutch De Stijl, Italian futurism,

1 E. McKnight Kauffer, letter to Alfred Knopf, July 26, 1930. Series IV, box 719, folder 4, Alfred A. Knopf, Inc., Records, Harry Ransom Center, University of Texas at Austin. In his letter Kauffer emphasized the word "modern" with a curious use of colons before and after the term. Kauffer was working for Knopf at the time, illustrating a deluxe edition of Carl Van Vechten's *Nigger Heaven* [1926] that ultimately went unpublished.

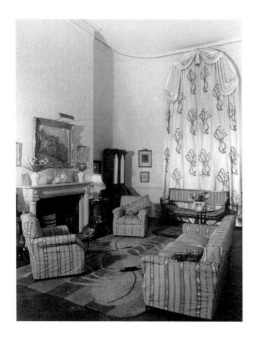

7.2 (opposite) Poster, *Exhibition of New Architecture*, 1937
7.3 (top left) Drawing, Design for a carpet, ca. 1928, Marion Dorn
7.4 (top right) Drawing, Design for a carpet, ca. 1928
7.5 (bottom left) Photograph, Sitting room of Sir Kenneth Clark's house, 1938, Photograph by Alfred Cracknell

and the German Bauhaus.[2] The artist and designer Paul Nash saw the public as "at once anxious to participate and afraid to commit ourselves, wishing to be modern, but uncertain whether that can be consistent with being British."[3] This essay will trace how Kauffer and Dorn provided the British public with design solutions to this challenge.

The couple's roles in the formation of the modern interior were made possible by a matrix of social relationships through which designers, architects, artists, and critics came together with objects and ideas. Kauffer and Dorn benefited from accelerated government sponsorship of design through the founding, in 1930, of the Society of Industrial Artists, a group that recognized them both as honorary fellows. Kauffer produced book covers and promotional ephemera for organizations such as Unit One (founded by Nash in 1933) and MARS (Modern Architecture Research Group, founded by Wells Coates, Maxwell Fry, and F. R. S. Yorke in 1933), which were developing new design solutions for housing (fig. 7.2).[4] Within these circles, Kauffer's incorporation of the avant-garde into graphic art was his first and most attractive quality, but his and Dorn's modern style soon migrated from posters and book covers into architecture.

2 Germany in particular became a stronger influence after the rise of fascism there, which led architects and designers including Marcel Breuer, Walter Gropius, Erich Mendelsohn, and László Moholy-Nagy to immigrate to England in the 1930s. Gropius's *New Architecture and the Bauhaus* was published in English in 1935 [London: Faber and Faber].
3 Paul Nash, *Room and Book* [London: Soncino Press, 1932], 7.
4 See, for instance, the cover for Unit One's sole publication: Herbert Edward Read, *Unit 1: The Modern Movement in English Architecture, Painting and Sculpture* [London: Cassell, 1934].

RUGS AND ROOMS

One of Kauffer and Dorn's primary points of entry to the domestic interior was floor-covering design. In January and February of 1929, they displayed a group of rugs, woven by the Wilton Royal Carpet Company, at London's fashionable Arthur Tooth & Sons gallery. Featuring flat planes of contrasting colors, stylized natural forms (fig. 7.3), and vivid geometric patterns, their designs introduced viewers to the rug as a medium for modern art. Kauffer and Dorn set an early example for the creative potential and commercial success of modern rug design, prompting other artists to experiment. The young Francis Bacon, for example, saw their exhibition at Tooth on returning to London from a long stay in Paris. Himself working as an interior designer during these years, Bacon was inspired by Kauffer and Dorn to send his own rugs to be made at Wilton Royal.[5]

The couple's early rugs embraced a new shape, a narrow rectangle (fig. 7.4) that mirrored the scale and outline of the rows of horizontal windows that dominated the facades of modernist buildings. As Kauffer explained, "The modern window is definitely wide and horizontal in form.... The modern rug should, therefore, by its pattern, suggest the horizontal (which is also the restful) characteristic of interior decoration."[6] Careful consideration of the rug's dimensions in relationship to its surround produced a coordinated living space in which the same shape framed views on the wall (out the window) and on the floor (in a rug).

For clients integrating modernism into an existing decorative scheme and architectural framework, the rug served as a striking focal point around which pieces from a mix of historical backgrounds could be organized. The sitting room of the art historian Sir Kenneth Clark, for example (fig. 7.5), a friend of the couple's, contained a Regency couch, a Queen Anne bureau, contemporary curtains with an abstract vase motif, and a Cézanne painting over the fireplace. These disparate objects were anchored by Dorn's organic rug. Writing in the *Architectural Review*, art critic and *Vogue* contributor Raymond Mortimer described the room as exemplifying "a taste that takes no account of period consistency but utilizes the products of any age—including the modern—where they are compatible in spirit."[7]

In March of 1929, Kauffer eagerly shared with his friend the novelist Arnold Bennett, a future neighbor at Chiltern Court, that "the rugs have been quite a big success—sold about 45."[8] Kauffer and Dorn's

5 Michael Peppiatt, *Francis Bacon: Anatomy of an Enigma* [London: Constable & Robinson, 2008], 57.
6 Kauffer, quoted in "New Designs for Wilton Rugs by E. McK. Kauffer and Marion V. Dorn," *The Studio*, January 1929, 37.
7 Raymond Mortimer, "Modern Period Character Mania," in "Decoration Supplement," *Architectural Review* 83 [January 1938]: 45.
8 Kauffer, letter to Arnold Bennett, March 13, 1929. Container 3.6, Arnold Bennett Collection, Harry Ransom Center, University of Texas at Austin.

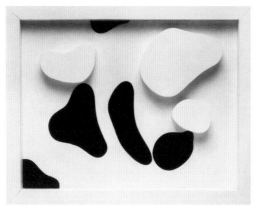

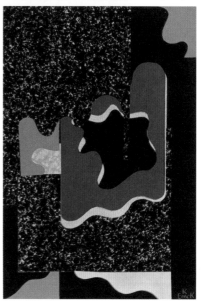

7.6 (top left) Card, Invitation to opening, Curtis Moffat Ltd., 1929
7.7 (top center) Photograph, Crawford's Advertising Agency building, 1930, Photograph by Dell & Wainwright
7.8 (top right) Photograph, Study at 41 Gloucester Square, 1932, Photograph by Dell & Wainwright
7.9 (bottom right) Frontispiece, Design for a panel of mural decoration, for *The New Interior Decoration: An Introduction to Its Principles, and International Survey of Its Methods* by Dorothy Todd and Raymond Mortimer, 1929
7.10 (bottom left) Painted relief, *Constellation selon les lois du hasard (Constellation according to the laws of chance)*, ca. 1930, Jean Arp

rugs were quickly purchased by friends and patrons including the London Group artist J. W. Power, the Shell publicity manager Jack Beddington, the modern-art collector and publisher E. C. Gregory, and Bennett himself.[9] Throughout the 1930s the rugs were sold at stylish galleries and were stocked by interior decorators, notably Ronald Fleming (head of the interior decoration department at Fortnum & Mason; fig. 7.1), Syrie Maugham, and Curtis Moffat. In 1929, the same year as Kauffer and Dorn's exhibition, Moffat had opened a studio on Fitzroy Square, built by Robert Adam in the 1790s; the space had a modern interior of white walls with aluminum and copper accents and steel furniture, all designed by the architect Frederick Etchells.[10] Kauffer designed the invitation for the opening (fig. 7.6), and his and Dorn's rugs were sold in a room dedicated to floor coverings.

As one of the first modern commercial interiors in London, Moffat's studio provided a significant context for Kauffer's work in both graphics and rugs. It also aligned him with Etchells, an early talent in modern architecture. Kauffer was already personally and professionally united with Etchells through their shared contributions to the Omega Workshops, membership in Group X, and association with the vorticists. As a publisher, Etchells had commissioned Kauffer's drawings for an edition of Daniel Defoe's *Robinson Crusoe* in 1929 (plates 059–060).[11] From at least 1927 to 1929, Kauffer worked part-time for the advertising agency W. S. Crawford, whose building in High Holborn Etchells would transform into London's first International Style public structure, complete with a striking glass-and-steel frontage (fig. 7.7).[12] Equally significant were Etchells's English translations of Le Corbusier's *Vers une architecture* (*Towards a New Architecture*, 1927) and *Urbanisme* (*The City of Tomorrow*, 1929), presenting the British public with new concepts of modern life as lived within highly engineered architectural formats and inspired by mechanical modernity.

By March of 1930, Dudley Tooth—son of Arthur Tooth, and working at the namesake gallery where Kauffer and Dorn had their first rug show—had commissioned Kauffer to design floor coverings for his new home.[13] Kauffer completed drawings for rugs for Dudley's dressing room and study, a circular rug for Mrs. Tooth's room, and a rug for the first-floor landing. The design had advanced by April 3, when Kauffer wrote to Tooth, "It would be a pity to rush the last bit of your ensemble and not the least important. In fact, I feel that the rugs properly done can greatly assist the furniture and room colours."[14] Tooth's commissioning of Kauffer to design rugs for his own home demonstrates not only an intersection between a professional and a personal relationship, but also an overlap of the physical spaces associated with each framework: his apartment became a site for the exhibition of modern design, much like the art gallery where the rugs were first shown. The completion of the flat, at 41 Gloucester Square, was overseen by the architect and designer Serge Chermayeff, and in 1932 the space was featured in an article in *Studio International*, showing Kauffer's rug in the study, setting the stage for paintings by Nash and Cedric Morris (fig. 7.8).[15]

Kauffer and Dorn's rugs earned them immediate recognition in one of the era's most significant British texts on design, *The New Interior Decoration* (1929), by Mortimer and Dorothy Todd (editor of British *Vogue* from 1922 to 1926). The book—Kauffer also designed the jacket—aligns their rugs with the architecture of Le Corbusier as exemplars of the potential to break Britain's cycles of period decoration. Kauffer's *Design for a Panel of Mural Decoration* appears in brilliant color as the frontispiece (fig. 7.9); its overlapping biomorphic forms recall the art of Jean Arp, one of whose works Kauffer would own by 1936 (fig. 7.10). Todd and Mortimer

9 "Rugs Sold," 1929. TGA 20106/1/1/18, Correspondence with Marion Dorn, Records of Arthur Tooth & Sons, London, Tate Archive.
10 See Martin Barnes, ed., *Curtis Moffat: Silver Society. Experimental Photography and Design, 1923-1935* [Göttingen, Germany: Steidl, and London: V&A Publishing, 2016], 22–23.
11 Daniel Defoe, *The Life and Strange Surprizing Adventures of Robinson Crusoe of York, Mariner*, ed. Kathleen Campbell [London: Frederick Etchells & Hugh Macdonald, 1929].
12 The architectural historian Sir Nikolaus Pevsner called the Crawford building "a pioneer work in the history of modern architecture in England." See Pevsner and Ian Richmond, *The Buildings of England: London* [Harmondsworth, UK: Penguin, 1957], 1:309.

13 Kauffer, letter to Dudley Tooth, March 22, 1930. TGA 20106/1/1/49, Correspondence between Edward McKnight Kauffer and Dudley Tooth, Records of Arthur Tooth & Sons, London, Tate Archive.
14 Kauffer, letter to Dudley Tooth, April 3, 1930. TGA 20106/1/1/49, Correspondence between Edward McKnight Kauffer and Dudley Tooth, Records of Arthur Tooth & Sons, London, Tate Archive. Two weeks later the two were agreeing on dimensions and prices; see Dudley Tooth, letter to Kauffer, April 17, 1930. TGA 20106/1/1/49, Correspondence between Edward McKnight Kauffer and Dudley Tooth, Records of Arthur Tooth & Sons, London, Tate Archive.
15 See "Pictures in the Modern House: The Newest Phase of Interior Decoration," *Studio International*, July 1932, 48-49.

trace the history of wall decoration in English homes from eighteenth-century wood paneling to the murals of the Omega Workshops, where Kauffer had exhibited his work and executed woodcuts. The book also features a full-page view of a stark modernist (and unfortunately unidentified) interior successfully tied together by Kauffer's mural decoration of layered geometric shapes of various transparencies (fig. 7.11). The caption notes, "The posters of E. McKnight Kauffer are considered by many good judges to be the most important contribution to this field in England to-day.... His experiments in interior decoration are more recent, this mural decoration and the carpets shown on plate 86 being characteristic examples."[16] The plate section sets Kauffer's rugs opposite the energetic textiles of Sonia Delaunay, while Dorn's rugs and a curtain are juxtaposed with French rugs by Fernand Léger and Jean Lurçat.

In the fall of 1930, Kauffer and Dorn undertook a comprehensive decoration scheme for their friend and new neighbor, Arnold Bennett. The couple composed and equipped an interior representative of the "modern" spirit that Kauffer identified with Chiltern Court (fig. 7.12). On September 13, Kauffer wrote to Bennett from Paris that his orders had been placed for custom steel shelves, desk, settee, and chair (by Crossley & Brown); he also drew a plan showing a space divided by rugs of two designs, one "squarish" by the desk, in "Pinkish Etruscan red and gray," and one "runner rug" in front of the settee in "graphite black—naturals to white."[17] The couple's awareness of the modern design available in the marketplace is evident in Kauffer's asking Bennett whether they might have his permission to purchase a "few nice simple modern desk fittings" and a "desk light" that they had seen. Bennett gave his permission for them to purchase anything "attractive and useful," a description epitomizing the tenor of the resulting space.[18]

ROOM AND BOOK

In the 1930s, a cluster of London exhibitions and cultural initiatives built public awareness of modern design through the use of complete interiors and household-scale groupings as display devices, offering relatable formats for domestic fittings in unfamiliar styles. The May 1932 exhibition *Room and Book* (fig. 7.13), at the Zwemmer Gallery (an offshoot of the pioneering art bookshop on Charing Cross Road), celebrated the launch of Nash's book by the same title. The book outlined the challenges that arise when the "young, intelligent architect is commissioned to build and equip a house so that it shall represent the product of English contemporary work in architecture and furnishing."[19] The exhibition was the three-dimensional answer to this provocation, bringing together, as a reviewer wrote in the *Observer*, "the wares assembled in the relationship of the ordinary domestic interior." The journalist praised the show's use of the model room as "the most successful effort of the kind that we have seen, and it is a very good opportunity to test personal reactions to what may be called the twentieth-century style in useful and decorative surroundings."[20] The personal, practical, and intentionally "English" aspects of the exhibition made it stand out from concurrent displays in London, such as the *Ideal Home Exhibition* at the vast Olympia exhibition center. One journalist drew a direct comparison, pointing out that "though it only occupies the area of a single average Olympia stand, the 'Room and Book' Exhibition presents more ideas and a truer picture of what is of value in contemporary English design than the whole of Olympia."[21]

Room and Book staged a carpet by Kauffer in "grey, blue, and geranium," and designs by Dorn for rugs "in pink," with furniture by Chermayeff, lamps by Moffat, pottery by Bernard Leach, paintings by Eric

16 Dorothy Todd and Raymond Mortimer, *The New Interior Decoration: An Introduction to Its Principles, and International Survey of Its Methods* [London: B. T. Batsford, 1929], 31.
17 Kauffer, letter to Arnold Bennett, September 13, 1930. Container 7.12, Arnold Bennett Collection, Harry Ransom Center, University of Texas at Austin. The estimate for the carpets gives a price of eighty-three guineas for both, offering a 10 percent special discount. Kauffer, estimate, October 3, 1930. Container 7.12, Arnold Bennett Collection, Harry Ransom Center, University of Texas at Austin. Wilton Royal Carpet Factory wove the carpets, and the decorations in the flat also included light fixtures by Curtis Moffat, Ltd. See "Trade and Craft," *Architectural Review*, July 1931, lxii.
18 Arnold Bennett, letter to Kauffer, September 18, 1930. MA 1664.13, record ID: 404140, Letters of Arnold Bennett to McKnight Kauffer, Department of Literary and Historical Manuscripts, Pierpont Morgan Library, New York.
19 Nash, *Room and Book*, 10.
20 *Observer*, April 17, 1932, quoted in Nigel Vaux Halliday, *More than a Bookshop: Zwemmer's and Art in the 20th Century* [London: Philip Wilson Publishers, 1991], 102.
21 *Country Life*, April 16, 1932, quoted in ibid., 105.

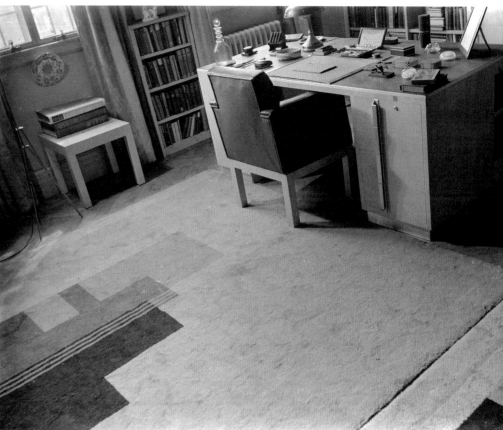

7.11 (top left) Photograph, Unidentified interior, ca. 1929;
Mural design by E. McKnight Kauffer
7.12 (top right) Photograph, Arnold Bennett's study, 1931,
Photograph by Dell & Wainwright
7.13 (bottom) Exhibition brochure, *Room and Book* by J. E. Barton, 1932

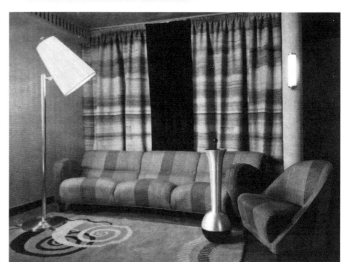

7.14 (top right) Book cover, *BBC Handbook*, 1928
7.15 (left) Photograph, BBC Broadcasting House, 1940, Fred Musto for the Mustograph Agency
7.16 (bottom right) Photograph, BBC Broadcasting House, waiting room on third floor, ca. 1935

Ravilious and Edward Wadsworth, wall coverings printed by Curwen Press, sculpture by Henry Moore, and fabrics by Enid Marx and Ben Nicholson. The ensemble might "suit a small-ish interior" and "may suggest…some new possibilities."[22] Walls were made of plywood by Venesta, an Estonian company that had hired Le Corbusier to design a stand at the *Building Trades* exhibition at Olympia in 1929. The exhibition included books printed by Curwen Press—titles that could well have contained images by Kauffer, who illustrated a number of Curwen books—to signal the modern interior as a livable and comfortable space for thinking and learning.

Just as the objects had been assembled individually for the exhibition, so, too, did Nash's book break down what he called "the room equipped" into a series of specific objects and stylistic considerations.[23] He illustrated a carpet by Kauffer, having solicited a photograph from the designer in a letter praising him on the success of another exhibition at Arthur Tooth & Sons.[24] Kauffer's strong use of geometries must have appealed to Nash, who identified the "chief problem" of composing the room as above all "the exact relationship of mass to space, vertical to horizontal, angle to plane [which] depends on the balance and unity of the room."[25] Modern rug design anchored the room's composition while contributing pattern and texture.

22 "English Furnishings," *New Statesman and Nation,* April 9, 1932, 453, and J. E. Barton, *Room and Book,* exh. pamphlet [London: Curwen Press, 1932], 4.
23 Nash, *Room and Book,* 36. "The Room Equipped" is the title of the book's third chapter.
24 Nash, letter to Kauffer, December 19, 1931. MA 1673, record ID 125730, Autograph letters signed [4]: Sussex and Dorset, to E. McKnight Kauffer, Department of Literary and Historical Manuscripts, Pierpont Morgan Library.
25 Nash, *Room and Book,* 49.
26 Robert Byron, "Broadcasting House," *Architectural Review* 72, no. 429 [August 1932]: 47.
27 See Farouk Hafiz Elgohary, "Wells Coates and His Position in the Beginning of the Modern Movement in England" [PhD diss., University of London], 1966, 166.

ROOMS ON THE RADIO

The British Broadcasting Corporation (BBC) was a client of Kauffer's in 1928 and 1929, when he designed covers for its yearbooks that featured a colorful zigzag radio wave to suggest the company's power of communication and energetic spirit (fig. 7.14). By 1929, Kauffer and Dorn's work for the company had expanded: now the BBC not only promoted itself with contemporary graphics but also made the modern interior a pivotal topic of its radio programs and invested in such interiors for its own offices.

In 1929, construction began on Broadcasting House, the BBC headquarters in Portland Place. Upon its completion three years later, it was the first purpose-built broadcast center in Europe (fig. 7.15). A testament to the influence and popularity of radio and technological advance, the building also functioned as a demonstration of modern interior design, most of it proudly executed by British firms. The architect Raymond McGrath, appointed to outfit the building, pursued a modernist scheme at a time when the style was still not widely adopted for corporate interiors. *Architectural Review* praised the BBC for its courage in embracing the modern:

To see a great public Corporation making some effort, however belated, to use the real talent available in this country was a rare spectacle and one for which, however irritating the procedures of that Corporation in other spheres, it is impossible not to be grateful. Owing to the conscious antagonism between traditionalism and modernism which prevails at the present time, and to the issue of false but none the less influential morality which by some obscure English means has become involved in it, the action of the BBC in employing specially modernist decorators was a courageous one.[26]

The building's rooms had a variety of uses, each making its own demands in terms of function, aesthetics, and comfort. Telephones, signal lights, noiseless door latches, orchestra chairs, door lettering, signage, and technical furniture such as loudspeakers and control tables were some of the customized features.[27] On the third floor was a waiting room fitted out as a comfortable space, domestic in mood and complete with a rug by Dorn (fig. 7.16). The prominence of her rug in this public-facing space is significant: the BBC had chosen her design to make a

statement to visitors about the innovative nature of their corporate brand. Here the setup of a private modern interior had migrated to an office.

In February and March 1932, the BBC invited J. E. Barton, an emerging writer on modern art and the author of the introduction in the *Room and Book* catalog, to give six on-air talks on modern art. Under the title *The Changing World*, the talks included "Do We Use Our Eyes?" and "What Is Taste?" A promotional pamphlet contained an essay by Barton proposing a view of modern art as an aspect of lived experience, manifest in everything from railway architecture to cookware. Barton addressed the space of the modern home as "giving repose and comfort, with severe lines."[28] The caption for an image of a modern interior encouraged the reader to "notice the rug—geometrical ideals have done much for fabric decoration."[29] The pamphlet proclaimed Kauffer a "remarkable British artist," and his poster for the cosmetic Pomeroy Day Cream (plate 033) shared a page spread with images by Léger, Wadsworth, and Giorgio de Chirico. His posters were praised for having "attained purity as a form of art," achieving "masterly simplicity" and "clarion-notes of colour," all terms that could just as well apply to his interior designs.[30]

In the spring of 1933, many of the designers responsible for the objects and interiors in the new BBC studios were featured in a series of radio talks called *Design in Modern Life*. Topics included "The Living-Room and Furniture," by Gordon Russell and Edward Halliday; "Dwellings," by Coates and Geoffrey Boumphrey; "The Printed Word," by Francis Meynell; and "The Meaning and Importance of Design," by Frank Pick, all subjects and people close to Kauffer and Dorn. The series was a component of a larger scheme in the BBC's programming, which had included interviews with leading cultural figures since 1927. The BBC released promotional pamphlets to complement the talks, and in 1933 Kauffer fittingly designed two of these brochures' covers (fig. 7.17), using surrealist lips whose arresting composition foretold a provocative message.

The *Design in Modern Life* series had its own pamphlet, outlining the contents of each Tuesday-night program from April 18 to June 27, 1933. The text acknowledged the learning curve confronting the British public in the face of modern design—"The sheer weight of unfamiliarity is very fatiguing"—and the consequent need for education, but offered that "exhibitions are useful occasions for comparing the standards of design in different modes."[31] The text encouraged readers to "make a point of visiting" the *Exhibition of British Industrial Art in Relation to the Home*, at Dorland Hall on Regent Street, to open on June 20 of that year. Readers who indeed attended that show would have seen a series of rooms including an all-white bedroom (designed by architect Oliver Hill, who oversaw the whole exhibition) featuring a high-pile carpet of concentric crosses and squares by Dorn. Intended to educate consumers, the project also brought together designers and manufacturers to encourage the production of modern design. As Dorn wrote to Hill, "Everybody is raving about your exhibition and I think it's going to be a wonderful help to everyone."[32]

Their design practice now fully immersed both socially and philosophically in the promotion of British modernism, Kauffer and Dorn continued to receive new and important commissions, both jointly and individually, throughout the 1930s, many drawing on the professional connections solidified a few years earlier. The use of the interior as a context for living, selling, display, and travel brought expanding opportunities for their rugs in hotel lobbies, exhibition halls, private apartments, ocean-liner cabins, and more.[33] Personal, private commissions such as a restrained flat for Coates (1934) continued alongside spectacular public commis-

28 J. E. Barton, *The Changing World: A Broadcast Symposium. 6: Modern Art* [London: BBC, 1932], viii.
29 Ibid. The designer of the rug is not identified, but does not appear to be either Kauffer or Dorn.
30 Ibid., xxiii.
31 British Broadcasting Corporation, *Design in Modern Life* [London: BBC, 1933], 11.
32 Dorn, letter to Oliver Hill, 1933. HiO 28/4 [2/2], Oliver Hill Collection, RIBA Archives.

sions, including corridor, landing, and lobby rugs for hotels, among them Claridge's (1932–33) and the Savoy (1933–35).

Kauffer's and Dorn's designs were coveted by a number of the architects active in and around London whose achievements were celebrated in the exhibition *Modern Architecture in England*, at New York's Museum of Modern Art (MoMA) in 1937. The couple's work was indirectly on view here through the inclusion of a number of projects with which they were involved, such as Chermayeff's interiors for the BBC's Broadcasting House in Birmingham, Coates's design for Embassy Court in Brighton, and their work on Coates's private flat. That same year, MoMA opened its seminal monographic exhibition *Posters by E. McKnight Kauffer* (fig. 10.3).

At the same time, MoMA's show of Kauffer's posters was underpinned by a narrative on modernist architecture: new buildings and corporate interiors were central to the rising reputation of a number of clients of Kauffer's who were featured on the posters on view. Charles Holden's offices for the London Underground (1927), for instance, near St. James's Park, were called a "cathedral of modernity";[34] the Shell-Mex and B.P. oil company promoted its Shell-Mex House office complex in the Strand (1931) as a "gesture of commercial optimism" with boldly modern lines;[35] and the distiller W & A Gilbey's Camden offices (1937) were a significant corporate project for Chermayeff. These two exhibitions, on view concurrently and examined side by side, show how Kauffer and Dorn designed at the crux of productive alliances between the worlds of architecture, interior decoration, and the graphic arts. Stylistic, personal, and professional allegiances among these creative fields advanced their careers across sectors and contributed to the achievement of a harmonious modern expression for spaces of life and work.

33 Dorn's projects included, for example, the exhibition *Modern Rugs by Marion Dorn at Arthur Tooth & Sons* [1932], the Midland Hotel, Morecambe [1932-33], and designs for Syrie Maugham's drawing room [1933]. Both Kauffer and Dorn participated in the exhibitions *Artists of Today*, at the Zwemmer Gallery, London [1933], and *British Art in Industry*, at the Royal Academy [1935]. Kauffer alone participated in *Modern Decoration and Design for Walls, Panels and Screens* at Carlisle House [1932] and designed a poster for the MARS Group's exhibition *Elements of Modern Architecture* at the New Burlington Galleries, London [1938].
34 "Housewarming at the Underground: A Cathedral of Modernity," *Observer*, January 12, 1929, 21.
35 Shell-Mex & B.P. Ltd., *Shell-Mex House* [London: Shell-Mex, 1933], 9 10.

7.17 Brochure, *BBC Talks*, 1933

8.1 Drawing, Study for an advertisement, Post Office, 1936

EDUCATIVE PUBLICITY POSTERS *for the* GOVERNMENT

Caroline O'Connell

BEGINNING IN 1926, THE BRIT-
ISH GOVERNMENT MOUNTED
CONSECUTIVE PUBLICITY
CAMPAIGNS FOR TWO STATE
ENTERPRISES: THE EMPIRE
MARKETING BOARD (EMB) AND
THE GENERAL POST OFFICE
(GPO). BOTH CAMPAIGNS
WERE HELMED BY LONGTIME
CIVIL SERVANT SIR STEPHEN
TALLENTS AND SHEPHERDED
BY ADVISORY GROUPS OF ARTS, INDUSTRY, MARKETING and government pioneers. The results
were unprecedented national forays into public messaging that exploited
the ubiquity of advertising during the dynamic interwar years. Advertis-
ing's ascendancy was connected to broader political and socioeconomic
shifts in Britain. Increasing literacy rates, an expanding middle class, and
the recent expansion of voting rights set the stage for a more democ-
ratized populace to engage with information disseminated from private
and public sectors.[1] The EMB and GPO (fig. 8.1) implemented various
strategies, from printed adverts in periodicals to the distribution of edu-
cational pamphlets, displays in trade shows and international expositions,
sponsored competitions, public lectures, school outreach, documentary
films, and, of course, posters. Seeking designs from the best commer-
cial artists of the period, both organizations commissioned work from
E. McKnight Kauffer. But neither campaign was merely advertising. By
employing the visual language of commercial publicity, these initiatives
attempted to educate and energize the British public around government
activities, using design as a tool of persuasion to remind them of their
roles as citizens of a global Empire.

MESSAGE TO THE SHOPPING PUBLIC

Organized at the recommendation of the Imperial Economic Commit-
tee, the Empire Marketing Board (1926–33) was founded to promote
the British Empire, which was at its largest in the years immediately
following World War I. Its purview included funding scientific research,

1 The 1918 Representation of the
People Act extended the right to
vote to all men over the age of
twenty-one and to women over the age
of thirty who met a property qualifi-
cation and/or whose husband did. The
1928 Representation of the People
[Equal Franchise] Act granted equal
voting rights to men and women. On
societal changes and the rise of the
popular press in the early decades
of the twentieth century, see Laura
Beers, "Education or Manipulation?
Labour, Democracy, and the Popular
Press in Interwar Britain," *Journal
of British Studies* 48, no. 1 [Janu-
ary 2009]: 129–30.

2 On the different sectors of the EMB's work, see Stephen Constantine, *Buy and Build* [London: Her Majesty's Stationery Office, 1986], 2-5.
3 Walter Elliot, "The Work of the Empire Marketing Board," *Journal of the Royal Society of Arts* 79, no. 4101 [June 26, 1931]: 736.
4 See Anthony Scott, *Public Relations and the Making of Modern Britain* [Manchester, UK, and New York: Manchester University Press, 2012], 29-62. According to a report of the Imperial Economic Committee, "the EMB will organize and operate the campaign of educative publicity." See "Empire Fruit," *Times* [London], June 11, 1926. The Times Digital Archive.
5 The imperative to educate and better the British public gained momentum in the wake of the Industrial Revolution. It took on ardent moral significance in Victorian cultural discourse on topics ranging from design reform to social Darwinism, which somewhat paradoxically fell within and helped substantiate an imperial worldview.
6 See Stephen Tallents, "Prologue to Empire Experiment," Stephen Tallents Papers, Institute of Commonwealth Studies ICS79/25: 8.

examining marketing efficiency and commodity distribution, and producing related publicity material.[2] As board member Major Walter Elliot explained, the EMB was formed to elucidate the complicated links between the economic and social components of the British Empire.[3] The EMB's Publicity Committee was tasked with encouraging consumers to be judicious citizens of the Empire and to buy from producers within it, smoothing the chain between supply and demand. Tallents, the EMB's secretary, believed that the Board could persuade the public to engage with its cause by drawing on factual data from its research and marketing arms.[4] Good publicity was grounded in education; the public must be taught. Tallents's beliefs formed a moralistic underpinning for the EMB's ambitious messaging campaign.[5] He wanted to appeal to citizens' patriotism and to generate imperial pride. This directive was taken up by the Advisory Board, whose members included Sir William Crawford, head of the advertising agency W. S. Crawford, and Frank Pick, who led the London Underground's Poster Committee subgroup.[6] Both men had working relationships with Kauffer.

In 1927, Kauffer completed a five-part poster set for the EMB: *One Third of the Empire Is in the Tropics* (figs. 8.3–8.7). The posters were designed to be viewed together as an outdoor pentaptych, framed within a massive oaken structure some twenty feet in length (fig. 8.2). Special care was taken to distinguish the EMB's oversized posters from other advertisements, and the grandiose customized frames were crucial to these efforts.[7] The sets generally consisted of three large pictorial posters, measuring forty by sixty inches, interspersed with two smaller, text-heavy posters of forty by twenty-five inches. EMB frames were initially placed at select locations in London and other large British cities, but their popularity led to an expansion, with framed sets installed in hundreds of towns across Britain, and additional copies produced at smaller scales.[8] Themed collections like Kauffer's were changed approximately every three weeks, to ensure sustained interest and offer ongoing educational opportunities. Crawford summarized the care taken by the Poster Committee in an article in *Commercial Art* magazine: "[The Committee] has to remember that whatever it displays bears in a sense the imprimatur of the British Government. For that reason it cannot fall below the best standards of poster art."[9]

7 An article detailing the Prince of Wales's visit to see the first Empire Marketing Board frame erected in London highlights the content and presentation of the posters: "The Prince looked at the posters and the oaken frame with great care and obvious interest." "Products of the Empire," *Times* [London], January 6, 1927. The Times Digital Archive.
8 *Empire Marketing Board, May 1927-May 1928* [London: His Majesty's Stationery Office, June 1928], 37.
9 William S. Crawford, "The Poster Campaign of the Empire Marketing Board," *Commercial Art* 6 [January-June 1929]: 131.

Bananas (fig. 8.7) and *Cocoa Pods* (fig. 8.6), two densely colorful posters, anchor the poles of Kauffer's *Tropics* set. The use of stylized foliage as a decorative framing device is a motif in Kauffer's work of this period; it functions as a symbol of nature's beckon, one that nearly pulsates with rhythmic allure, drawing viewers into the composition. The smaller posters offset the pictorial scenes, substantiating their content with market-based data and fulfilling Tallents's directive to teach and persuade. In the central panel, *Jungles To-day Are Gold Mines To-Morrow: Growing Markets for Our Goods* (fig. 8.3), Kauffer unites text and image, employing curvilinear bands of color and text in the manner of a proscenium arch to showcase two dark-skinned, broadly exoticized figures who flank a set of trade statistics. In his coupling of quixotic imagery and prosaic text, Kauffer captures the essence of the EMB's propaganda campaign: factual economic information swathed in the visual language of commercial art encouraged viewers to buy Empire goods and, more critically, to buy into a reinvigorated British imperial worldview.[10]

10 Matthew G. Stanard has convincingly argued that pro-empire propaganda during the interwar years crossed the boundaries of specific nation-states, manifesting similarly in Britain and other European countries with colonies. The visualization of imperialism relied on overarching tropes that were less concerned with national and cultural specificity than with empire as a concept that could be rendered comprehensibly and persuasively to the public at large. See Stanard, "Interwar Pro-Empire Propaganda and European Colonial Culture: Toward a Comparative Research Agenda," *Journal of Contemporary History* 44, no. 1 [January 2009]: 27-48.

Empire Marketing Board Hoardings

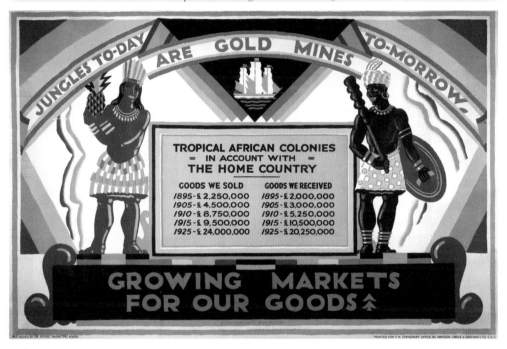

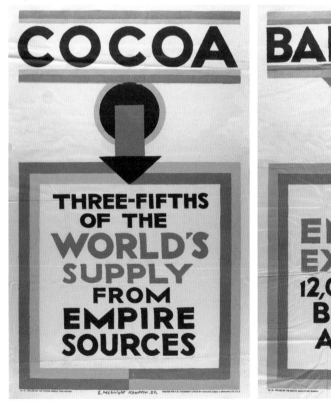

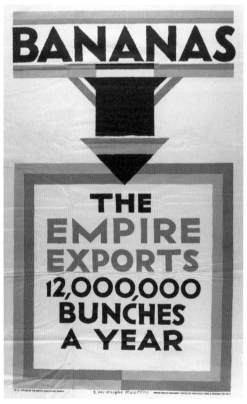

8.2 (top) Photograph, Empire Marketing Board hoarding for E. McKnight Kauffer's poster
series *One Third of the Empire Is in the Tropics*, 1927
8.3 (center) Poster, *Jungles To-Day Are Gold Mines To-Morrow*, 1927
8.4 (bottom left) Poster, *Cocoa: Three-Fifths of the World's Supply from Empire Sources*, 1927
8.5 (bottom right) Poster, *Bananas: The Empire Exports 12,000,000 Bunches a Year*, 1927

PROJECTING THE EMPIRE

Kauffer's *Tropics* pentaptych is among some 800 posters designed for the EMB's Publicity Committee by a coterie of commercial artists of the period. Despite stylistic variations, Kauffer's set is emblematic of the Board's visual language of imperialism.[11] Quite cannily, the EMB seized the momentum of sociopolitical shifts in the metropole, encouraging middle-class white shoppers to look proudly toward the literal and figurative fruits of empire from the standpoint of consumption.[12] In this imperial arrangement, Empire dependencies were prized as producers of rich, unspoiled resources that could feed British buyers and factories.[13] Kauffer visually conveys this supplier/consumer relationship through the verdant forests in *Bananas* and *Cocoa Pods*, which seem to await exploitation and therefore serve as visual counterpoints to depictions of Britain as a powerful modern manufacturer, as seen in other EMB posters.[14] His figures further this juxtaposition: Kauffer shows nonwhite people engaged in manual labor, emphasizing their bodies rather than their faces, which are hardly detailed. They are also minimally clothed in stereotyped costumes that reiterate their exotic and subordinate status.

11 On British imperial propaganda see John M. MacKenzie, *Propaganda and Empire: The Manipulation of British Public Opinion, 1880-1960* [Manchester, UK, and New York: Manchester University Press, 1984], 1-38.
12 The British government was encouraging white British citizens to emigrate to dominion countries and colonies during this period, so the posters may also have targeted potential émigrés.
13 Constantine, *Buy and Build,* 13.
14 For comparison, see Clive Gardiner's 1928 poster *A Blast Furnace* [National Archives, Kew CO 956/260].

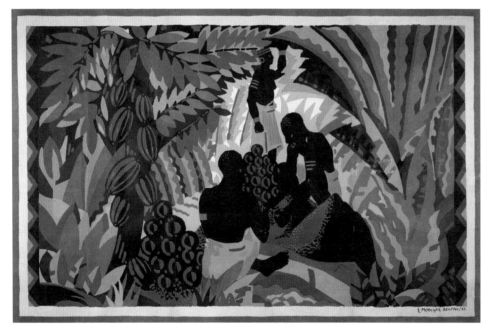

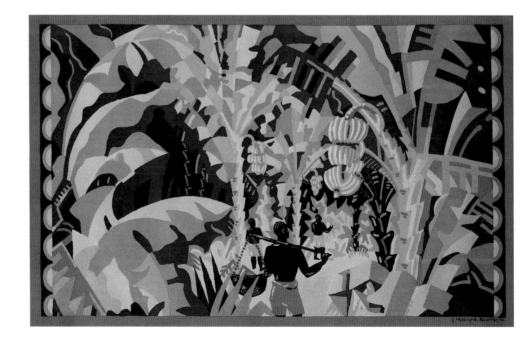

8.6 (top) Poster, *Cocoa Pods*, 1927
8.7 (bottom) Poster, *Bananas*, 1926

These racialized portrayals symbolize intra-Empire "otherness," reminding British consumers of the vast reaches of the Empire and of their privileged place within it. Thus the EMB's posters—many broadly themed by geographical area, such as "the Tropics"—ultimately deal less with the specifics of certain regions or resources, their ostensible concerns, than with a conception of the Empire as a potent and positive economic and social entity. As the EMB's annual report of 1927–28 states, "The Board's task is to advertise an idea, rather than a commodity."[15]

Tellingly, the EMB's campaign was best received in expressly didactic settings. Smaller copies of hundreds of posters were ultimately produced free of charge for use in schools and were accompanied by informational pamphlets that expanded upon their thematic content.[16] The attempt to shape young minds in the classroom was an overtly propagandistic element of the campaign, fulfilling Tallents's sincere belief in promoting Britain's strength as that of its global Empire.[17] Indeed, Tallents's reputation as a pioneer of government public relations, balancing educational aims with promotional goals, was cemented through the school-poster scheme and the EMB's ambitious documentary films. Despite these valiant efforts, the Board's work was the subject of heated debate in Whitehall and won mixed reviews from the public.[18] The EMB succumbed to the bureaucratic axe in 1933 and Tallents moved right into another high-profile government position: public relations officer at the General Post Office.

THE GPO AT WORK

"With a view to establishing closer co-operation between the public and the Post Office, the post of Public Relations Officer has been created.... Sir Stephen's job will be the only one of its kind in Government departments." So began a 1933 *Daily Mail* article announcing Tallents's new role.[19] While the position was new, the GPO, unlike the short-lived EMB, had a long history as a state enterprise, beginning in the seventeenth century. In recent decades it had undergone a vast expansion and modernization and its purview extended beyond the transportation of post and parcels to cover all telephone and telegraph services. Despite improvements in efficiency thanks to wartime requirements for agility and speed, however, the GPO was still considered clumsy and old-fashioned when Tallents arrived.[20] Its status as a monopoly notwithstanding, the organization needed a modern image that reflected its operational scope and could stimulate pride in its technological advances.[21] Like the EMB, it needed to communicate its activities in a way that would persuade the British public not only to use its services but also to appreciate and identify with the sophistication of this government system. To that end, Tallents's publicity campaign generated two types of posters: "prestige" and "selling." The former was meant to leave a strong visual impact, while the latter was intended to market a specific product or service (fig. 8.8).[22] The terms themselves imply a hierarchy of intention, with prestige suggesting a learned complexity that was tied to education and therefore separate from straightforward attempts to merchandize. In this way the GPO's work was distinct from the EMB's, which had attempted to package prestige and selling, moral and economic imperatives, into a single codified advertising strategy.

Of the various advertisements that Kauffer produced for the GPO between 1933 and 1938, one of the most celebrated was his *Outposts of Britain* series (figs. 8.9–8.12), dating from 1937.[23] These posters are decidedly of the "prestige" category, given their graphic treatment and the absence of a textual directive for the public. Each poster centers on a different British location, which is identified in text. These locales

15 *Empire Marketing Board: May 1927-May 1928*, 39.
16 There is no evidence that Kauffer's *Tropics* posters were reproduced for the school poster scheme.
17 See "Projecting the Empire," *Times* [London], May 20, 1932. The Times Digital Archive.
18 Not all critics were convinced of the artistic merit of the EMB's campaign. See "From Our Critic: Details of Exhibitions," *Times* [London], November 3, 1926, The Times Digital Archive.
19 "New GPO Post," *Daily Mail*, September 2, 1933. Daily Mail Historical Archive.
20 See Paul Rennie, *Design: GPO Posters* [Woodbridge, UK: Antique Collectors' Club Ltd., 2011], 7-8.
21 Historically, the GPO had been reticent to engage in any sort of publicity. In a self-defeating attempt to stem financial losses, it had leased all hoarding spaces within post offices to an advertising company. It was not until 1935, when that contract expired, that the GPO decided to focus on publicizing its services in post offices. See "Description of Contents," POST 110 Sub-series, Postal Museum Archives, GB 813 The Royal Mail Archive, Calthorpe House, London.
22 Ibid, xv.
23 Tallents was no longer at the GPO during the later part of this period, having taken a position at the BBC in 1935, but he set up critical infrastructure for the ongoing campaign.

are captured with stark black-and-white photographs in which the land-scape looms large. They appear to be documentary snapshots—a distant postbox, or a postman engaged in his quotidian routine. Three posters capture the beautiful and rugged topography of Northern Ireland, north-ern Scotland, and Lands End, Cornwall, while the fourth shows London Harbor. Kauffer creates a sense of perspective by bordering these flinty photographs with bands of colors. These angular "space frames" give the viewer the sensation of peering into these remote locations, as if looking through a telescope or inspecting an image on a postcard, echoing the type of engagement one might have with a GPO service. Devoid of super-fluous imagery and text, the posters' message is clear: the GPO is always at work and its systems connect the most remote parts of the United King-dom. While Kauffer's EMB posters had deployed exoticized portrayals of faraway landscapes, looking outward to distant lands within the Empire, the *Outposts of Britain* posters invoke the veracity associated with a pho-tographer's lens, seeking to document rather than to narrate, and in so doing look confidently inward to the windy cliffs of the British Isles.[24]

QUICKEST WAY

Where the EMB had made ambitious outdoor posters the centerpiece of its publicity project, the GPO began its "prestige" campaign with smaller posters for schools.[25] An article of 1937 in the London *Times* included a triumphant description of Kauffer's *Outposts of Britain* series: "These posters should prove very acceptable gifts to the 28,000 odd schools throughout the United Kingdom to which they are to be issued," for together with corresponding educational pamphlets they will "enable the coming generation to obtain a working knowledge of the services with which they will come intimately into contact at the outset of their business careers."[26] The GPO's school-poster scheme demonstrated the edifying role of the post office as an institution, employing modern design aesthet-ics and their foremost practitioners to teach the next generation.

Kauffer designed *Outposts* nearly a decade after his work for the EMB. The series exemplifies his stylistic shift in the 1930s, marked by a clever use of photography and bold experiments in balancing word and image. In the few years since the EMB's demise, the geopolitical unrest that would result in another world war was seeping into public conscious-ness. The visual landscape was changing, too. Like the EMB's Poster Committee, the GPO's Poster Advisory Committee comprised cross-industry leaders who already had connection points with Kauffer. They included Sir Kenneth Clark, director of the National Gallery; art critic Clive Bell; Jack Beddington, director of publicity for the oil company Shell-Mex and B.P.; and documentary filmmaker John Grierson.[27] While the members of this erudite committee wanted to teach schoolchildren about the GPO, they were also uncompromising in their championing of modern art and design. The campaign's "prestige" posters, they hoped, could publicize the advances of the GPO while simultaneously familiar-izing the public with cutting-edge design.[28]

The fourth poster (fig. 8.12) in Kauffer's *Outposts of Britain* series retains the graphic style of the other three but instead of depicting a geographical "outpost," it shows a postman in a dinghy in the busy Port of London. Dwarfed by ships' bows and the industrial skyline beyond, this postman allegorizes the sooty reality of imperial trade. The GPO is depicted as a marvel of gritty modern Britain, rather than a product of the Empire.

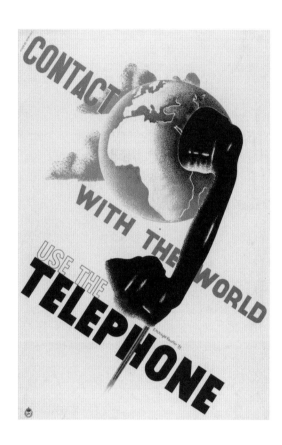

24 Celebrating the GPO's reach by fea-turing varied locations in Great Brit-ain, Scotland, and Northern Ireland, countries that were part of the metro-pole of the British Empire, Kauffer's *Outposts of Britain* series stands in stylistic and thematic contrast to John Vickery's contemporaneous *Out-posts of Empire* posters, also designed for the GPO and featuring exoticizing imagery and a painterly style akin to that used in the EMB campaign.
25 As the dust settled after the EMB's disbandment, the GPO inherited the lists of elementary schools registered to receive EMB posters.
26 "The GPO at Work," *Times* [London], October 19, 1937. The Times Digital Archive.

27 John Grierson's advisory role at the GPO is significant as another example of carryover between the EMB and GPO initiatives. Grierson had been a member of the EMB's film unit; when the EMB was dissolved, the unit was transferred to the GPO. See Thomas Baird, "Films and the Public Services in Great Britain," *Public Opinion Quarterly* 2, no. 1 [January 1938]: 96–99.
28 See Yasuko Suga, "State Patronage of Design?: The Elitism/Commer-cialism Battle in the General Post Office's Graphic Production," *Journal of Design History* 13, no. 1 [2000]: 27.

LINK WITH PUBLIC

Kauffer's work for the publicity campaigns of the EMB and the GPO sheds light on the British government's forays into the interwoven disciplines of education and propaganda, advertising and design. From a waning burst of imperial pride to a celebration of communications infrastructure, the EMB and GPO campaigns illustrate shifting currents in state priorities during the interwar years. In looking to the styles, practitioners, and patrons of commercial art and design, the two organizations tried variously to educate, communicate with, and ultimately influence the public. Their overlapping and evolving efforts reflect the rapidly changing world around them and reveal the central role of design in the conception of a nation's self-image and the projection of its role for the future.

8.8 (opposite) Poster, *Contact with the World, Use the Telephone*, 1934
8.9–8.12 Posters, *Outposts of Britain*, 1937

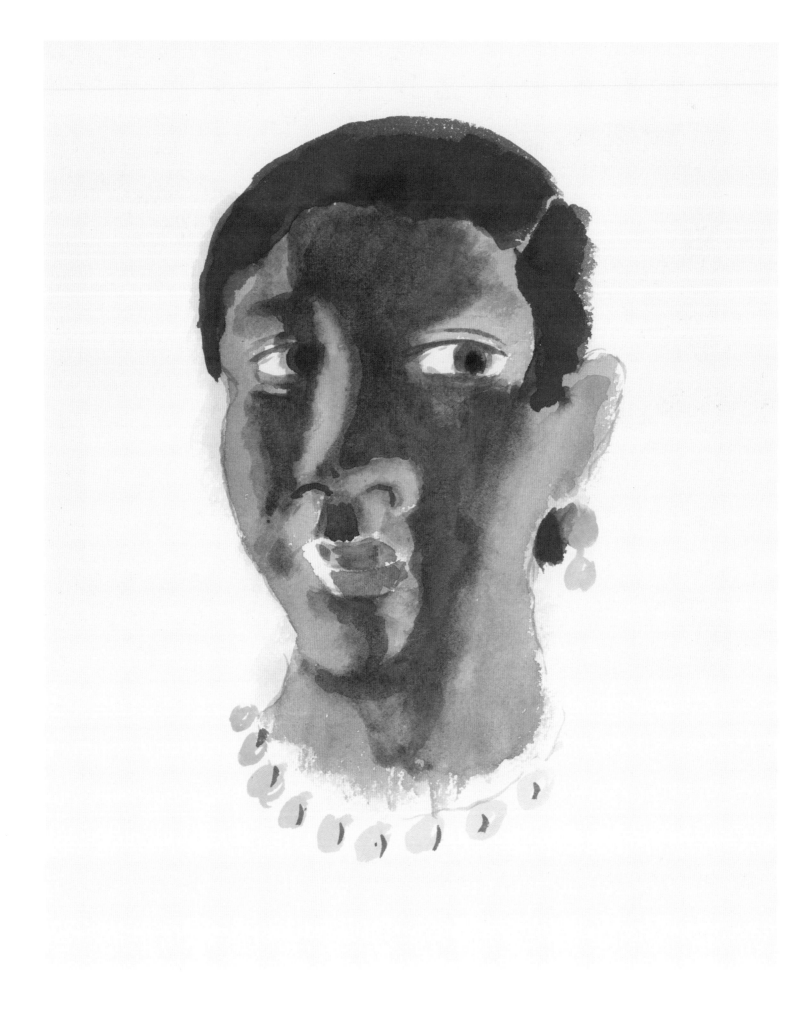

9.1 Drawing, Study for Lasca, Illustration for *Nigger Heaven* by Carl Van Vechten, 1930

ILLUSTRATING **RACE**: KAUFFER *and the* AFRICAN AMERICAN CONNECTION *in* LITERATURE

James Smalls

A GLARING BLIND SPOT IN THE LITERATURE ON E. McKNIGHT KAUFFER IS THE ISSUE OF RACE. YET THE SUBJECT APPEARS IN A NUMBER OF KAUFFER'S WORKS, INCLUDING HIS BOOK COVERS AND ILLUS-TRATIONS FOR HERMAN MELVILLE'S *BENITO CERENO* (1926), CARL VAN VECH-TEN'S *NIGGER HEAVEN* (1930), LANGSTON HUGHES'S *SHAKESPEARE IN HARLEM* (1942), Richard Wright's *Native Son* (1942), and Ralph Ellison's *Invisible Man* (1952), not to mention his posters for Britain's Empire Marketing Board advertising campaign (1926–33). This essay will take just two of these projects, Van Vechten's *Nigger Heaven* and Hughes's *Shakespeare in Harlem*, to explore Kauffer's attitudes toward race while also addressing the ambiguities to which these works gave rise in the period when they were created.

Some of Kauffer's work from the mid-1920s until the late 1940s speaks to equivocal narratives vis-à-vis race, made even more complicated by the professional and social networks he cultivated with influential people in art and literary circles in the United States. He often struck up relationships in which professional and personal loyalties were intimately mixed, including those with Van Vechten and the publisher Alfred A. Knopf, both of whom became close friends of his. Their letters and recollections from the 1930s and '40s allow for an intimate glimpse not only of Kauffer's working methods but also of his personal thoughts and insecurities.[1]

A noteworthy influence on Kauffer's racial outlook, Van Vechten also affected the designer's career, offering the connection to the New York publishing world that he also did for the many African American writers who benefited from their friendship with him. Knopf for his part was one of the handful of powerful white men who dominated the New York publishing industry in these years; he was notorious for cultivating a close circle of literary friends whom he trusted and admired and who

1 See Mark Haworth-Booth, *E. McKnight Kauffer: A Designer and His Public,* 1979 [rev. ed. London: V&A Publications, 2005], 59.

2 Roger Fry, "The Author and the Artist," *The Burlington Magazine for Connoisseurs* 49, no. 280 [July 1926], 10. Quoted here from Mary A. Knighton, "William Faulkner's Illustrious Circles: Double-Dealing Caricatures in Style and Taste," in Jay Watson, Jaime Harker, and James G. Thomas, Jr., eds., *Faulkner and Print Culture* [Jackson: University Press of Mississippi, 2017], 37.
3 Knighton, "William Faulkner's Illustrious Circles," 38.
4 Graham Twemlow, "E. McKnight Kauffer: The Stencilled Book Illustrations," *Parenthesis, the Newsletter of the Fine Press Book Association* 16 [February 2009]: 32.

would recommend to him books to publish. Kauffer's relationships with these two men helped not only to extend his connections in the publishing industry but also to expose him to African American literary themes. Van Vechten and Knopf (along with Knopf's wife, Blanche) served as intermediaries between the white-operated publishing world and the African American authors whose books Kauffer was selected to illustrate. This is not to say that his designs were dictated by these individuals—quite the contrary: Kauffer was given a tremendous amount of latitude in interpreting the texts he encountered.

As the British critic Roger Fry noted, Kauffer was able in his book illustrations "to embroider the author's ideas, or rather to execute variations on the author's theme, which will not pretend to be one with the text but are rather, as it were, a running commentary, like marginal notes written by a reader."[2] He approached his jacket designs similarly, tackling them as "mini-posters, meant to be aesthetically pleasing but also to 'move' the viewer to action."[3] As a poster designer and book illustrator, Kauffer believed in the efficacy of symbols and "impressionistic form" to communicate contemporary urban experience and emotion.[4] His mastery of synthesis, that is to say, his ability to add a layer of signification to an author's text, makes it difficult to discern his attitudes on race from his illustrations alone with any precision.[5] Take, for example, his cover design for the Modern Library edition of Wright's *Native Son* (fig. 9.2). First published in 1940, the novel tells the tragic story of a young black man who accidentally kills a white woman and is punished for it.

The social and psychological pressures of racism are a central theme of the narrative. Kauffer's cover design has a compositional resonance that mirrors the symbolic power of the text that is visually reflected in the slumped posture, the bowed head (suggestive of despondency or tragedy), and the very dark complexion of the figure juxtaposed with the chalky whiteness of his attire.

In 1952, Kauffer was commissioned to design the dust jacket for Random House's first edition of Ralph Ellison's *Invisible Man* (fig. 9.3). Ellison's writings treat race, class, and identity as complex and intricately intertwined, and Kauffer's cover design demonstrates his mastery at translating into visual terms the feeling of the story, even while relegating the "fact" of race to secondary importance. His jacket designs operate to attract the reader visually, emotionally, and intellectually, to speak to the book's general feel, and to sell the narrative. The design itself becomes a souvenir of the reading experience. The *Invisible Man* design is deceptively simple: its restrained use of color is arresting and its clever composition holds the viewer's attention. The deconstructed profile shows cubist and post-expressionist influences and evokes the symbolic notions of visibility and invisibility operative on the interior mind and on physical existence in the urban environment.

NIGGER HEAVEN

Van Vechten's *Nigger Heaven*, published by Knopf in 1926, was a controversial and notoriously salacious piece of writing that generated much criticism for both its title and its content. An instant best seller, it went into several editions, one of which, planned but never published, was intended to be a deluxe version illustrated by Kauffer. (A year before the book's first publication, Van Vechten had tried to get his friend Gertrude Stein to persuade Pablo Picasso to illustrate a deluxe edition; this did not happen and Knopf commissioned Kauffer in 1930.)[6] Penned at a time when primitivism reigned as a popular trend in both literature and social life and black people had become fashionable, the book exploited racial stereotypes

5 See Elizabeth Willson Gordon, "On or About December 1928 the Hogarth Press Changed: E. McKnight Kauffer, Art, Markets and the Hogarth Press, 1928–39," in Helen Southworth, ed., *Leonard and Virginia Woolf: The Hogarth Press and the Networks of Modernism* [Edinburgh: Edinburgh University Press, 2010], 180.
6 Both Kauffer and the Mexican artist Miguel Covarrubias had proposed covers and illustrations for earlier editions of *Nigger Heaven*; the commission to illustrate the first edition, however, had gone to the African American painter and graphic artist Aaron Douglas. See Knighton, "William Faulkner's Illustrious Circles," 49 n. 46.

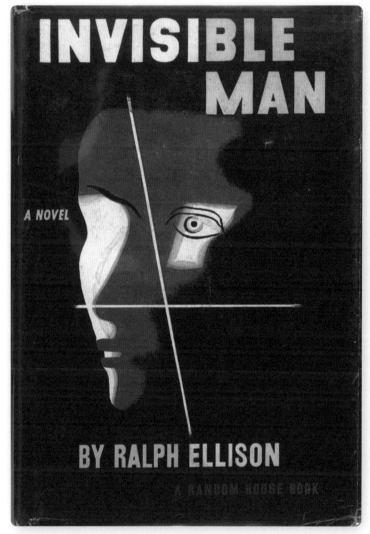

9.2 (left) Book cover, *Native Son* by Richard Wright, 1942
9.3 (right) Book cover, *Invisible Man* by Ralph Ellison, 1952

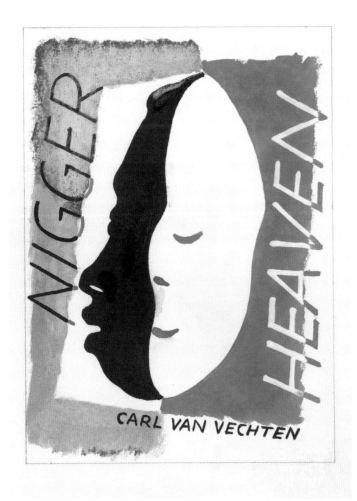

9.4 (left) Drawing, Design for dust jacket for *Nigger Heaven* by Carl Van Vechten, 1931
9.5 (right) Drawing, Adora at a Party, Illustration for *Nigger Heaven* by Carl Van Vechten, 1931

and fostered "negromania"—an obsessive fascination with black people and their culture on the part of whites. Although the movement was all the rage, Kauffer's engagement with it was limited—it influenced him primarily through his acquaintance with Van Vechten, the ultimate primitivist and consummate "negrophile."[7]

The term "nigger heaven" had originated in the segregated churches of the nineteenth century in reference to church balconies, where African Americans sat, while the white members of the congregation sat below. Van Vechten is thought to have intended his book to be a celebration of Harlem, but the title expressed an ambivalence about the place in the context of a largely segregated society. Opinions of the novel diverged along racial lines. Having little to compare *Nigger Heaven* to, many white critics viewed it as an enlightening, forward-thinking text, but the book split the black literary community into warring camps of supporters and detractors.[8] Much of the positive reaction to it came from authors who had friendships with Van Vechten, such as Hughes, James Weldon Johnson, Walter White, Alain Locke, and Nella Larsen. It should come as no surprise that Kauffer's reaction to the novel was similarly enthusiastic.

One Kauffer drawing for the dust jacket for *Nigger Heaven* (fig. 9.4) shows two juxtaposed profiles, one white, the other black. This interracial theme was to recur in altered form in Kauffer's jacket design for Ellison's *Invisible Man*. The focus in both designs is on contrast and balance in terms of form and color. The typography, spelling out Nigger Heaven, is skillfully placed on each side of the page to impart a certain visual tension to an image that might be thought to suggest racial harmony. Most of the other drawings for the project tap into symbolic moments in the text, avoiding, however, the mood of wild abandon associated with primitivism, the cultural context in which Van Vechten's novel was written. Despite their vibrant coloration, Kauffer's drawings forgo unfettered stereotyping to speak instead to a quiet, even idyllic envisioning of African American Harlem (fig. 9.5).

Writing to Van Vechten from London on June 20, 1930, Kauffer expressed his admiration for the author's text: "I am so glad we are to meet. Apart from the fact that we have acquaintances and friends in common—I admire your writing—and I am very pleased to have been asked to do 'Nigger Heaven.'"[9] The two men met in London before the end of the month, having been introduced to each other in writing by Knopf. In a note following that meeting, Kauffer wrote, "I am so glad that I am to do 'Nigger Heaven.' To me a really great event—both an honor and a pleasure. I will make it as fine as I can."[10] In a postscript Kauffer let Van Vechten know that he had started reading the author's earlier novel *The Blind Bow Boy* (1923): "Like other books of yours that I have read I know it will have the mastery of style, the equilibrium of the perfect tight rope walker, whose every step, witty and satirical accomplishes a noble task."[11] Further compliments followed.[12] In one of these letters Kauffer refers to a girl "of color" who "writes me on lavender pink paper—so like their choice in colour. So well does it identify at least in my memory a colored persons [*sic*] sense of the 'rafeened' in stationery."[13] On August 24, 1930, Kauffer told Van Vechten, "The more I study [*Nigger Heaven*] the more I like it."[14] In one of many letters to Alfred Knopf, he revealed that he had found a model to pose for his drawings, whom he described as "a coffee colored girl with that curious green dusty hue of skin (fig. 9.1)."[15] Apparently race for Kauffer was identifiable on the superficial level of skin color; he seems to have had little life experience of black society.

In a letter to Knopf dated September 10, 1930, Kauffer further praised *Nigger Heaven* and revealed his completion of eight drawings, indicating that he had:

7 On Carl Van Vechten's life, career, and influence on African American culture see Emily Bernard, *Carl Van Vechten and the Harlem Renaissance: A Portrait in Black and White* [New Haven and London: Yale University Press, 2012]; Leon Coleman, *Carl Van Vechten and the Harlem Renaissance* [New York and London: Garland Publishing, 1998]; and Bruce Kellner, *Carl Van Vechten and the Irreverent Decades* [Norman: University of Oklahoma Press, 1968].
8 See Robert F. Worth, "Nigger Heaven and the Harlem Renaissance," *African American Review* 29, no. 3 [Autumn 1995]: 462.

9 Kauffer, letter to Van Vechten, June 20, 1930. In call no. JWJ MSS 1050, box 59, folder 1004, Carl Van Vechten Papers Relating to African American Arts and Letters, Series II Writings, Books *Nigger Heaven* Correspondence, Kauffer, Edward McKnight/1930-1947 Beinecke Rare Book and Manuscript Library, Yale University, New Haven. All of the letters from Kauffer to Van Vechten cited subsequently come from the same folder.

10 Kauffer, letter to Van Vechten, June 29, 1930.
11 Ibid.
12 Kauffer, letters to Van Vechten, July 11, 1930, and July 24, 1930.
13 Kauffer, letter to Van Vechten, July 24, 1930.
14 Kauffer, letter to Van Vechten, August 24, 1930.
15 Kauffer, letter to Alfred Knopf, July 26, 1930. Series IV, box 719, folder 4, Alfred A. Knopf, Inc., Records, Harry Ransom Center, University of Texas at Austin. All of the letters between Kauffer and Knopf cited subsequently come from the same folder.

*tried them on several people in London—and some Americans. So far—
enthusiasm. And I will add that so far this is my best book. Ninety % goes
to Carl's book. Following it closely,...I have felt the interior of this book
such as I have not experienced before. It's warm—hot and then delightfully
cool and with the keenest subtle observation. All I have done is to emphasize
these lovely qualities. I also wished to observe the contrasts. You will see a
drawing wherein weeping willows appear [fig. 9.6]. I call this one of Carl's
subtle instructive relationships (the book is full of others) for the weeping
willows—both in sound and form express the mood of Mary at that particu-
lar moment [fig. 9.7]. It is a magnificent book.[16]*

Clearly, Kauffer considered his illustrations perfectly
matched to the ambience of Van Vechten's narrative more than to its racial
content. Perhaps unbeknownst to the designer, in praising Van Vechten's
book he implicated himself in the primitivism craze of the 1920s and '30s,
which tended to further racial stereotypes of African Americans. At the
same time, Kauffer's *Nigger Heaven* drawings can be considered sympa-
thetic to African Americans in their distance from the demeaning carica-
tures prevalent during the period.

Knopf wrote back to Kauffer on September 23, reporting
that Van Vechten had shown him the eight drawings: he found them
"superb" and thought they would "create a sensation."[17] By late Novem-
ber, however, Kauffer had not completed all the drawings planned,
although the contract had called for them by August 15. At this point
Knopf was utterly dismayed by what he called Kauffer's "repeated fail-
ure to keep business promises that are accepted in good faith."[18] Even-
tually the edition went unpublished because Kauffer had taken too long
to deliver.[19] When he eventually turned the drawings in, deluxe editions
were no longer financially viable because of the Depression. In 1942, Van
Vechten donated all the completed illustrations he had (fifteen in all) to
New York's Museum of Modern Art, where they are housed today.

16 Kauffer, letter to Knopf,
September 10, 1930.
17 Knopf, letter to Kauffer,
September 23, 1930.
18 Knopf, letter to Kauffer,
November 21, 1930.
19 In a footnote to one of Van
Vechten's daybook entries dated
September 10, 1930, Bruce Kellner
observes that "Kauffer [eventually]
produced a full set of illustra-
tions for *Nigger Heaven*, but the
long-delayed limited edition was
never published because the
Depression had dried up the market
for expensive books." See Carl Van
Vechten, *The Splendid Drunken
Twenties: Selections from the
Daybooks, 1922-1930*, ed. Bruce
Kellner [Urbana and Chicago:
University of Illinois Press,
2003], 300 n. 1.
20 See Langston Hughes, *Shakespeare
in Harlem* [New York: Alfred A.
Knopf, 1942], n.p.
21 See Arnold Rampersad, *The Life
of Langston Hughes*, vol. 2,
1941-1967: I Dream a World [New
York and Oxford: Oxford University
Press, 1988], 9.
22 Hughes, letter to Sidney Jacobs,
Alfred A. Knopf, Inc., February 6,
1941, quoted in ibid., 10.
23 Rampersad, in ibid., 10.
Rampersad is summarizing the Hughes
letter cited above.

SHAKESPEARE IN HARLEM

Shakespeare in Harlem is a collection of poems by the African American poet Langston Hughes. One of its early pages describes it as "a book of light verse. Afro-Americana in the blues mood. Poems syncopated and variegated in the colors of Harlem, Beale Street, West Dallas, and Chicago's South Side."[20] Hughes did not select Kauffer as his illustrator; the choice was forced on him by Blanche Knopf, to his dismay—he himself had proposed, among others, Elmer Simms Campbell, the first African American cartoonist to be published in nationally distributed magazines such as *Esquire*, *Life*, and *The New Yorker*.[21] And Kauffer's sample sketches upset him, suggesting to him that the designer seemed "not well acquainted with the American Negro types."[22]

Hughes's complaint was based in part on Kauffer's representation of black people's "unstraightened, 'nappy' hair, which was then definitely unfashionable in the black community" (fig. 9.8).[23] Hughes was also adamant that the book not give the impression that all blacks "are of the nightclub and the careless world.... These people work, and work hard, for a living."[24] He had to be careful in voicing his objections to Blanche Knopf, but he wrote less guardedly to his friend the African American poet and novelist Arna Bontemps: "I hope colored folks will like that man's drawings. I wrote to him to be sure and put some hair on their heads because nobody was nappy-headed any more! If he don't, I am ruint."[25] Apparently Hughes believed that the illustrations to his poems were as important to their public reception, and to his reputation, as the poems themselves. The letter also shows that he and Kauffer were in direct communication with one another, but the extent of their relationship is uncertain. I have found no evidence that Kauffer was aware of Hughes's vexation with his drawings, though he may have heard word from a go-between such as Van Vechten.

In another letter to Bontemps, Hughes expressed his dismay at the Knopfs, who, he complained, "keep writing me how beautiful the drawings are and that an artist's conception must be his own emanating from what he sees in the text, etc. If such reasoning be true, then one just can't trust the average white artist to illustrate a Negro book, unless they are known to know Negroes in life—not Uncle Remus—and be sympathetic to the poetry of Negro life—and not to its (to them) humorous and grotesque, amusing and 'quaint' aspects."[26] Ironically, Hughes biographer Arnold Rampersad writes, "when Hughes sought help on this score from Van Vechten, who was informally supervising the production of the book...he found him also unmoved."[27] Indeed, Van Vechten's response was dismissive and somewhat condescending: "it would be quite legitimate, if he wanted to, for Kauffer to illustrate a modern white novel in hair done in the style of Louis XV.... it is hard for editors and painters to understand the ways in which Negroes are touchy, but I understand. Well, I hope the hairs will be okay. The pictures, in any case, are beautiful."[28] In a patronizing manner, Van Vechten dismissed Hughes's concerns about the sensitive topic of black representation, arguing that the aesthetics of the drawings trumped any concerns over the depiction of race.

24 Hughes, letter to Jacobs.
25 Hughes, letter to Arna Bontemps, March 22, 1941, quoted in Rampersad, *I Dream a World*, 10. See also *Arna Bontemps-Langston Hughes Letters: 1925-1967*, ed. Charles H. Nichols [New York: Dodd Mead, 1980], 78.
26 Hughes, letter to Bontemps, November 8, 1941, quoted in Rampersad, *I Dream a World*, 34. See also *Arna Bontemps-Langston Hughes Letters: 1925-1967*, ed. Nichols, 96. The remark is telling in suggesting that Hughes saw Kauffer as an outsider, removed from intimate knowledge of and sympathy with African Americans.
27 Rampersad, *I Dream a World*, 34.
28 Van Vechten, letter to Hughes, November 17, 1941, quoted in *Remember Me to Harlem: The Letters of Langston Hughes and Carl Van Vechten, 1925-1964*, ed. Emily Bernard [New York: Alfred A. Knopf, 2001], 200-201.

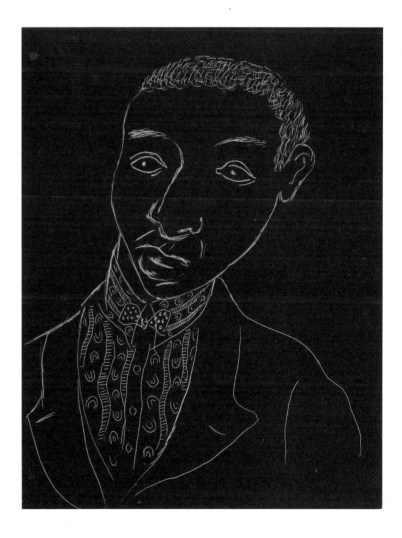

9.6 (opposite, left) Drawing, Study for Adora's House in the Country. Mary at Window, Illustration for *Nigger Heaven* by Carl Van Vechten, 1930
9.7 (opposite, right) Drawing, Adora's House in the Country. Mary at Window, Illustration for *Nigger Heaven* by Carl Van Vechten, 1931
9.8 (above) Drawing, Illustration for *Shakespeare in Harlem* by Langston Hughes, 1942

When *Shakespeare in Harlem* was published, Hughes to some degree reconciled himself to Kauffer's illustrations but remained skeptical of a white artist's ability to illustrate his book with racial sensitivity and honesty. In a letter to Van Vechten of March 18, 1942, he wrote, "I am delighted that you continue to like *Shakespeare in Harlem* as it now appears between covers.... I like the appearance of the book very much. But am a bit sorry some colored people are not liking the dice on the jacket, so I am taking it off for readings before Negro audiences (fig. 9.9)."[29] In a sudden change of heart, Sujata Iyengar writes, Hughes "found himself delighted with both the 'bold type' and with the images, comforting himself with the thought that 'nappy' hair would one day become fashionable again" and that "his own work, like Shakespeare's, would be read long into the future."[30] Yet he clearly maintained the belief that Kauffer, as a white artist, was incapable of sympathetic portrayal of black people.

For Kauffer biographer Mark Haworth-Booth, the artist's drawings, in white line against a black ground throughout the book, "relate well in visual 'weight' to the letterpress of Hughes's poetry" (fig. 9.10).[31] Moreover, the designer seems to have picked up on the lyricism of the poetry through the drawings' expressive linear rhythm. The white-black configuration, suggestive of interracial harmony, is coupled with a seamless symbolic convergence of poems and illustrations, leading

29 Bernard notes, "Hughes complained to Arna Bontemps in a January 27, 1942, letter: 'Knopf, added to my other troubles, have put a wishbone and a dice on my book jacket! They think it's charming.' Later in the year, he asked Blanche [Knopf] either to put out a new edition in a plain cover, or in 'anything but dice and wishbones.'" In ibid., 206, n. 2.
30 Sujata Iyengar, "Introduction to Shakespeare and African American Poetics: An Essay Cluster Published in Association with the *Langston Hughes Review*," *Borrowers and Lenders: The Journal of Shakespeare and Appropriation 7*, no. 2 [Fall 2012/Winter 2013]: 2. Available online at www.borrowers.uga.edu/463/show [accessed November 25, 2019].
31 Haworth-Booth, *A Designer and His Public*, 102.

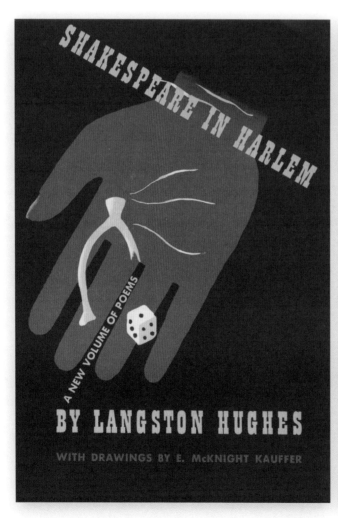

9.9 (left) Book cover, *Shakespeare in Harlem* by Langston Hughes, 1942
9.10 (right) Book illustration, for *Shakespeare in Harlem* by Langston Hughes, 1942

Haworth-Booth to suggest that Kauffer must have been "fond of Harlem and its Negro population."[32] Indeed, there is evidence to support the claim that he enjoyed Harlem's nightspots with young English friends such as Jeremy Nicolas Hutchinson and Tom Driberg.[33]

Speaking at a conference of the Committee on Art Education of The Museum of Modern Art in April 1948, Kauffer remarked, "New forms of education, social problems of re-adjustment, racial discrimination and the Negro problem for which there is now an urgent necessity for intelligent and human co-operation, the activities of municipal public services, state problems and finally national problems, all of these need the services of intelligent thinkers, capable writers and the best designers."[34] Here, Kauffer evokes intellect, literature, and design as creative tools for combating social ills including racism. He was an artist of his time in shouldering what he perhaps considered a sympathy for racial concerns, sincerely believing in his art as part of a quest for both modernity and racial justice. Like Van Vechten, he may have felt that he was doing good in promoting compassionate outlooks toward black people, even while failing to question his explicit or implicit participation in the legacies of primitivism, exoticism, negromania, and all that that engagement entailed.

On face value, Kauffer's illustrations for *Nigger Heaven* and *Shakespeare in Harlem* appear neither to indulge in demeaning racial stereotyping nor to have been explicitly made, at least not consciously, to evoke sympathy for the African American themes they illustrate. Instead, Kauffer is adept at applying various modern visual languages expressive of line and color to interpret the text before him symbolically. That approach tends to neutralize any critical perspective on race, obscuring Kauffer's personal views on the matter. However, his close personal and professional associations with the likes of Van Vechten and the Knopfs implicated him in contexts in which matters of race were fraught with complexities. By producing book illustrations and covers by noted African American writers, as well as by white authors on racial subjects,[35] Kauffer entered into the messy and uncomfortable realities of race and the complicated tangle of black and white in the United States. Although he was an expatriate for most of his career, he was American and was surely anything but ignorant about the country's tense racial dynamics. His racial attitudes, however, are far from obvious and remain open to debate, but this by no means diminishes the brilliance, power, and elegance of his designs.

32 Ibid., 101.
33 In a letter to Mary Hutchinson [Jeremy Hutchinson's mother] of November 10, 1941, Marion Dorn, Kauffer's wife, describes Kauffer, Jeremy, Tom Driberg, and herself making a trip to Harlem. Hutchinson and Driberg ventured out "from one end of N.Y. to the other—Greenwich Village to Harlem." Driberg, she notes, "seemed to know who all the famous black performers are." Dorn, letter to Mary Hutchinson, November 10, 1941. Simon Rendall Collection, London. [Many thanks to Caitlin Condell for bringing this primary source to my attention.]
34 Kauffer, lecture given at The Museum of Modern Art, New York, at the symposium "Responsibility for Standards of Taste in a Democratic Society," April 24, 1948. Box 1, folder 14, item 4, Notes, Writings, and Sketches, Personal Papers, E. McKnight Kauffer Archive, Cooper Hewitt, Smithsonian Design Museum.
35 Pivotal projects in this regard are Herman Melville's *Benito Cereno* [1926] and cover illustrations for Faulkner's *Intruder in the Dust* [1948]. See Mary A. Knighton, "Strange Fruit and Patriotic Flowers: E. McKnight Kauffer's Illustrated South," *Southern Culture* 25, no. 4 [Winter 2019]: 54–81.

10.1 Brochure cover (detail), *Organic Design in Home Furnishings*, 1941

KAUFFER *and* THE MUSEUM *of* MODERN ART, NEW YORK

Juliet Kinchin

"I SHOULD HAVE WRITTEN TO TELL YOU THAT THE EXHIBITION IN NEW YORK GAVE ME A MOMENT IN MY LIFE THAT I SHALL ALWAYS REMEMBER," WROTE E. McKNIGHT KAUFFER IN MAY 1937 TO ALFRED H. BARR, JR., FOUNDING DIRECTOR OF THE MUSEUM OF MODERN ART (MOMA), THOUGH KAUFFER IMMEDIATELY QUALIFIED WITH A characteristic note of self-doubt: "My feelings were mixed—sometimes pride and sometimes a sense that I had done so little that was worthwhile."[1] Yet Kauffer's retrospective at MoMA was undoubtedly a critical success, highlighting the achievements of his career in Britain and preparing the way for his return to the United States, in 1940. The show, its catalog, and a subsequent nationwide tour effectively introduced Kauffer to American audiences with little or no idea of his work. Over the following decade, he became MoMA's most exhibited and collected commercial artist, featuring in a wide variety of group shows, traveling exhibitions, and educational projects that affirmed his stature within Barr's multidisciplinary narrative of modern art. Kauffer's identification with MoMA was underlined by his involvement with several different curators, and by a steady stream of 1940s commissions for the design of Museum publications and publicity materials. Paradoxically, this association with a powerful institution also served to fossilize his reputation, masking the unraveling of his career after his relocation to New York. "In some quarters, he finds himself in the position of a museum piece," wrote Frank Zachary in *Portfolio* magazine in 1950; "—admired, even revered, but considered too individual for every-day use."[2]

Barr already had Kauffer in his sights as "the most distinguished poster artist in England" before MoMA opened, in October 1929.[3] Kauffer appealed as a widely read artist who was culturally sensitized to modern media such as film and photography, and who approached the poster as an art form. As a teacher at Wellesley College, Massachusetts,

1 E. McKnight Kauffer, letter to Alfred H. Barr, Jr., May 18, 1937. Exhibition file 59.2, The Museum of Modern Art Archives, New York.
2 Frank Zachary, "E. McKnight Kauffer: Poster Designer," *Portfolio* 1, no. 1 [1950]: n.p.
3 [Barr], wall-label text from the exhibition *Modern European Posters and Commercial Typography*, Wellesley College, May 1929. Art Museum Exhibition file, Wellesley College Archives.

Barr had acquired Kauffer's posters and books for his personal collection and had included the artist in his challenging course Tradition and Revolt in Modern Painting, which encouraged students to understand their time through appreciation of modern art's infiltration of daily life, whether as film, jazz, automobile design, or advertising. In May 1929 at the Wellesley College Art Museum, Barr curated *Modern European Posters and Commercial Typography*, an exhibition consisting largely of material he had assembled in 1927–28 during sabbatical travels in England, the Netherlands, France, Germany, and the Soviet Union. The trip opened Barr's eyes to a revolution in graphic design that was emerging in many countries simultaneously. Many of the materials he acquired, including pieces by Kauffer, would appear later in MoMA exhibitions, and some eventually found their way into the museum's permanent collection, library, or archives. It is unclear whether Barr met Kauffer during the trip, but he certainly encountered friends and collaborators of the designer's, such as Paul Nash and Wyndham Lewis. Nash, amused by the idea of Barr as a kind of Columbus on a reverse expedition from America to explore the art of England, gave advice about studios, galleries, and art publishers to visit in London.[4] Barr considered a poster campaign to which Kauffer

contributed, the London Transport series masterminded by Frank Pick, "one of the largest and finest in Europe or America."[5] More posters Kauffer designed, for the Empire Marketing Board, were just beginning to appear on custom-designed billboards around Britain; Barr acquired one of these, *Bananas* (fig. 8.7), and later gave it to MoMA.[6] And he sought out a copy of a new book edited by Kauffer, and dedicated to Pick: *The Art of the Poster: Its Origins, Evolution & Purpose.*[7]

On returning to Wellesley, Barr set Kauffer's *From Winters Gloom to Summers Joy* (fig. 10.2) at the center of a group of London Underground posters in the exhibition *Modern European Posters and Commercial Typography*. Labels emphasized connections between modern art and "the utilitarian ends of modern life," drawing attention to the influence of cubism on the poster's flat, angular patterns and to Kauffer's "ingenious development" of the subject matter—the seasonal change from dark and bulky winter clothing to sunny tennis whites.[8] A reviewer in *The Wellesley News* noted that Kauffer's book covers in the exhibition showed "the same abstract geometric tendencies."[9]

In stretching conventional definitions of art, Barr's exhibition and curriculum were an anticipatory microcosm of his vision for MoMA. The same principles appeared writ large in the museum's 1936 exhibition *Cubism and Abstract Art*, in which *From Winters Gloom to Summers Joy* reappeared—this time displayed over the words "The Influence of Cubism" spelled out on the wall in embossed capital letters. Barr's groundbreaking show included a far wider range of materials than the Wellesley one—nearly 400 works of painting, drawing, printmaking, sculpture, architecture, furniture, and theater design, as well as posters and typography—but the overarching idea of charting stylistic similarities among media, and a formalist analysis of the drive to abstraction that had started with painting and sculpture before filtering into "applied" art forms such as posters, was the same. In the catalog, Barr declared that the day's most adventurous artists "had grown bored with painting facts. By a common and powerful impulse they were driven to abandon the imitation of natural appearance."[10]

A monographic Kauffer exhibition at MoMA was under discussion by 1936, and that September he wrote anxiously to Barr asking for confirmation of dates and advance publicity: "several people are asking, particularly my wife, known under the professional name of Marion

4 Paul Nash, letter to Barr, August 2, 1927. Alfred H. Barr, Jr., Papers, VI.B.8, The Museum of Modern Art Archives.
5 [Barr], wall-label text from the exhibition *Modern European Posters and Commercial Typography*. Art Museum Exhibition file, Wellesley College Archives. Barr may have seen the exhibition *British Posters* at the Brooklyn Museum, New York, in 1925, which included several Kauffer designs for London Transport.
6 *Bananas* [MoMA object no. 1275.1968, Gift of Mr. and Mrs. Alfred H. Barr, Jr.] was one part of the five-part poster installation *One Third of the Empire Is in the Tropics*.
7 Kauffer, ed., *The Art of the Poster: Its Origin, Evolution & Purpose* [London: Cecil Palmer, 1924].
8 "Wellesley College Art Museum," *Wellesley News*, May 2, 1929, 7.
9 "European Poster Exhibit," *Wellesley News*, May 16, 1929, 5.
10 Barr, "Introduction," *Cubism and Abstract Art*, exh. cat. [New York: The Museum of Modern Art, 1936], 11.

10.2 (opposite) Poster, *From Winters Gloom to Summers Joy*, 1927

from WINTERS
GLOOM
to SUMMERS
JOY

E. McKnight Kauffer

Dorn."[11] The exhibition of eighty-five posters was in fact being prepared at breakneck speed by Ernestine Fantl, a protégé of Barr's and former Wellesley student who had taken charge of the Department of Architecture and Industrial Art in 1934, when Philip Johnson left the museum to devote himself to the fascist cause. Fantl's first exhibition, in 1935—*European Commercial Printing of Today*—once again represented Kauffer as the most significant exemplar of modern British design.[12] The following year Fantl organized the museum's first monographic poster exhibition, on A. M. Cassandre. Kauffer followed, with the artist himself designing a suitably modern and abstract cover for the catalog (fig. 10.3), writing biographical notes and commentary on his creative process, and getting his friend the novelist Aldous Huxley to provide a foreword. The latter could have been penned by Barr in its description of Kauffer's "affinity with all artists who have ever aimed at expressiveness through simplification, distortion and transposition, and especially with the Post-Impressionists and Cubists.... It is McKnight Kauffer's distinction that he was among the first, as he still remains among the best, of the interesting and significant contemporary artists to apply these principles to the design of advertisements."[13]

11 Kauffer, letter to Barr, September 8, 1936. Exhibition file 59.2, The Museum of Modern Art Archives.
12 "A Museum of Typography–Eight Nations Represented in Comprehensive Display," *Emporia Daily Gazette* [Kansas], June 4, 1935, 5.
13 Aldous Huxley, "Foreword," in *Posters by E. McKnight Kauffer*, exh. cat. [New York: The Museum of Modern Art, 1937], n.p.
14 Kauffer, letter to Barr, May 18, 1937; George Allen & Unwin, letter to the Director of Publications, The Museum of Modern Art, April 5, 1937. Exhibition file 59.2, The Museum of Modern Art Archives.
15 Kauffer, telegram to The Museum of Modern Art, April 2, 1937. Exhibition file 59.2, The Museum of Modern Art Archives.
16 Fantl wrote to Barr on April 5, 1937, about the "Huxley-Kauffer situation. Marion Dorn says Huxley is sailing on the Normandie and will ask the museum to cease selling the book on the exhibition...breach contract-nothing of this was ever mentioned...so sorry about all this." Nevertheless she soon counted Kauffer and Dorn among her close friends in London. See Ernestine Carter, *With Tongue in Chic* [London: Michael Joseph, 1974], 51.
17 Kauffer, letter to Barr, May 18, 1937. Exhibition file 59.2, The Museum of Modern Art Archives.

Kauffer was unable to oversee the production of the catalog from England and problems arose when he discovered that it would be sold there, breaching Huxley's contract with London publishers George Allen & Unwin.[14] Being also hypersensitive about how British audiences might react to his unexpurgated personal history, he fired off a furious telegram to MoMA: "announcement of publication in england of catalog to my exhibition in literary supplement stop under no circumstances whatsoever can i permit this stop my biographical notes were sent to be edited and not printed as published in new york."[15] Fantl, who had meantime married an Englishman and had just moved to London, eventually managed to smooth things over.[16] Kauffer wrote to Barr that he liked Fantl very much: "She is an asset to England and I hope she will be employed in some similar capacity here to what she was doing with you in New York. However, England is barricaded against enterprise such as your Museum of Modern Art.... The English have no sense of beauty or subtlety—they sing but out of tune."[17]

MoMA circulated a condensed version of the exhibition around the United States, and by 1939 Kauffer was clearly sufficiently mollified to gift a total of 100 posters to the museum. Together with those already in the collection, which included Kauffer's earlier gift of five posters as well as substantial groups of his work for London Transport and the oil company Shell-Mex and B.P., this 1939 donation not only weighted the poster collection toward British material but made Kauffer the artist with the most works in MoMA's permanent collection by far. In 1940–42, selections of his work appeared in a further spate of circulating exhibitions and educational projects, the most important being *A History of the Modern Poster*, organized by Elodie Courter, which circulated to ten cities before appearing at MoMA in 1941.[18] A press release listed Kauffer as representative of "England" rather than grouping him with Americans Lester Beall, Ben Shahn, and Frank Greco, although by this time he was back in New York for good.[19] In October 1941, the Katharine Kuh Gallery in Chicago featured Kauffer in *Advance Guard of Advertising Artists*, an exhibition of US-based graphic designers that transferred to New York's A-D Gallery the following year. Kuh wrote of the need to nurture this group of émigré and native-born talents: "Those of us living in the United States have come to realize that rich art forms are inevitably emerging from our vast industrial and commercial development. Now that the

18 Circulating Exhibition 134, containing four posters by Kauffer out of thirty-seven. At least five of the posters by other artists had appeared in Barr's Wellesley College exhibition.
19 "New York to See Two Exhibitions Shown in Seventeen Other Cities," June 10, 1941. Available online at https://www.moma.org/documents/moma_press-release_325236.pdf [accessed November 5, 2019].

10.3 (opposite, left) Brochure cover, *Posters by E. McKnight Kauffer*, 1937
10.4 (opposite, center) Brochure cover, *Film Library, The Museum of Modern Art*, New York, ca. 1940
10.5 (opposite, right) Book cover, *Americans 1942: 18 Artists from 9 States*, 1942

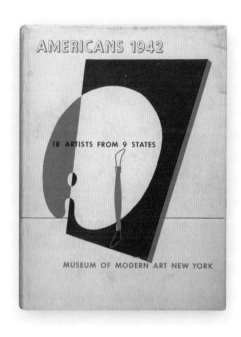

world is at war and it is increasingly difficult for us in America to maintain an intelligent and critical contact with the European art scene, we must concentrate our attention at home."[20] Despite such exposure, however, Kauffer was struggling to make ends meet in the United States. Holed up in Reno, Nevada, he wrote to his friend the MoMA curator Monroe Wheeler in June 1942, "I have no enquiries from New York and staying here means small expenditure."[21]

Kauffer's friendship with Wheeler, whose estimation he appears to have valued above all others, dominated his relationship with MoMA in the 1940s. In their correspondence he referred repeatedly to "your most faithful friendship—one that always sustains and adds luster to my life. To know you is to love you—the two go together. Since my return to New York you have aided me in more ways than I can say—with affection, encouragement and often practical ways."[22] The two had met in the late 1920s or early 1930s when Wheeler was running Harrison of Paris, a Paris publishing house producing limited-edition books. At this time Kauffer gave Wheeler a set of cotton-bale labels he had designed for the Manchester textile firm Steinthal & Co. (plates 009–011); Wheeler passed this set on to MoMA in 1960.[23]

Wheeler moved back to the United States in 1934 and organized a couple of exhibitions of artists' books at MoMA as a guest curator. In the catalog of *Modern Painters and Sculptors as Illustrators* (1936), he illustrated Kauffer's edition of Robert Burton's *Anatomy of Melancholy* (1621), published by Nonesuch Press in 1925, and featured additional drawings and watercolors in the show itself.[24] It was as MoMA's Director of Exhibitions and Publications, however, a post created in 1941, that Wheeler was able to offer Kauffer a lifeline, a steady trickle of commissions for MoMA posters, preview cards, and catalog covers, including those for *Organic Design in Home Furnishings* (fig. 10.1), a Film Library brochure (fig. 10.4), *Britain at War*, *La pintura contemporánea norteamericana* (a traveling exhibition in South America), and *Americans 1942: 18 Artists from 9 States* (all in 1941–42) (fig. 10.5). Wheeler transformed

20 Katharine Kuh, "Introduction," *Advance Guard of Advertising Artists*, exh. cat. [Chicago: Katharine Kuh Gallery, 1941], n.p. [4]. Other artists represented included Frank Barr, Herbert Bayer, Lester Beall, György Kepes, Herbert Matter, László Moholy-Nagy, Paul Rand, and Ladislav Sutnar.
21 Kauffer, letter to Monroe Wheeler, June 20, 1942. Monroe Wheeler Papers, Series 1, Correspondence, Kauffer, E. McKnight, 1940-52, box 5, folder 156, Beinecke Rare Book and Manuscript Library, Yale University, New Haven.
22 Kauffer, letter to Wheeler, January 4, 1943. Glenway Wescott Papers, Series 1, Correspondence, Kauffer, E. McKnight, 1941-51, box 60, folder 871, Beinecke Rare Book and Manuscript Library.
23 A memo from Wheeler in the acquisition file for these labels [MoMA object nos. SC 166-86.2010, held in MoMA's Department of Architecture and Design] indicates that he received them from Kauffer around 1930.
24 The exhibition included Kauffer's illustrations for Daniel Defoe's *Life and Strange Surprizing Adventures of Robinson Crusoe of York, Mariner*, ed. Kathleen Campbell [Frederick Etchells & Hugh Macdonald, 1929] and Miguel de Cervantes's *Don Quixote* [Nonesuch Press, 1930].

10.6 (left) Flyer, Museum of Modern Art Publications, n.d. [after 1946]
10.7 (top right) Card, Invitation to *Brazil Builds*, 1943
10.8 (bottom right) Book cover, *Brazil Builds*, 1943

the production and distribution of MoMA publications (fig. 10.6) and publicity materials, not least through his conviction that a catalog "must be designed to sell itself. It must have a cover or jacket of unusual design that will catch the customer's eye and arouse his interest or curiosity."[25] In 1943 he brought Kauffer together with architectural photographer G. E. Kidder Smith to design the cover and dust jacket for *Brazil Builds* (fig. 10.8).[26] Kauffer also designed the invitation card for the exhibition (fig. 10.7). (That same year Kidder Smith gave MoMA a collection of posters, including thirteen designed by Kauffer.) Wheeler also helped to showcase Kauffer's versatility by including his photograph of T. S. Eliot in *20th Century Portraits* and one of his rugs in the exhibition *New Rugs by American Artists*, both in 1942.[27]

Barr had been criticized for focusing too exclusively on European modernism in the 1930s, and his model of modern art was gradually updated to accommodate the idea of American art and design coming into their own, invigorated by a transfusion of European modernism, as the nation emerged from war. Having studied and worked in Europe and then returned to the United States, Kauffer was an ideal fit for this ongoing story. "In the United States we have been backward in poster design until the last few years," wrote Wheeler in a catalog essay for *Art in Progress* (1944), mentioning "our own repatriated Kauffer" as one of those refreshing the American scene. At the same time, Kauffer was linked with early modernism in Wheeler's choice of his *Early Bird* of 1918 as the illustration with which to close his essay.[28]

In an interview in 1950, Kauffer spoke of recognizing himself in the novelist Arnold Bennett's description of him "as a bird, forever in flight, forever searching for a place to come to rest."[29] On some level it is possible to view the 1937 exhibition at MoMA, and Kauffer's deepening relationship with the institution, as a homecoming. The museum became a sanctuary that validated him as an artist, as well as providing a recourse when he was immobilized by depression and self-doubt. "To be able to pass in proudly with one's membership card does great things for one's morale," he wrote to Wheeler.[30] This was particularly important in a city that he found increasingly difficult to negotiate. "New York becomes tougher for me as time goes on," he confided in 1949 to the poet Glenway Wescott, Wheeler's partner, adding, "I am wrongly cast, I guess—or perhaps my talent (for whatever it is) has become more dissipated—I realize that my years in England ill-suited me for the American adventure."[31] Wheeler had just commissioned him to design the graphic identity for *The 28th Annual Exhibition of Advertising and Editorial Art of the New York Art Directors Club*, but it is telling that Kauffer was not represented in that exhibition. An organization like MoMA comprises a shifting cast of characters with different, sometimes competing agendas, but arguably Kauffer's relationship with curators Barr, Fantl, Courter, and Wheeler provided a catalyst for the international acceptance of and enthusiasm for his work in the latter half of the twentieth century and beyond.

25 Monroe Wheeler, "The Art Museum and the Art Book Trade," *Museum News* 24, no. 2 [1946]: 8.
26 In ibid., Wheeler picked out *Brazil Builds* for its design, and as one of the museum's best sellers.
27 Wheeler, *20th Century Portraits*, exh. cat. [New York: The Museum of Modern Art, 1942], 92. Kauffer was one of ten "well-known American artists" to participate in *New Rugs by American Artists*, curated by Alice Carson.
28 Wheeler, "Posters," in *Art in Progress: A Survey Prepared for the Fifteenth Anniversary of the Museum of Modern Art, New York* [New York: The Museum of Modern Art, 1944], 203.
29 Zachary, "E. McKnight Kauffer: Poster Designer," n.p.
30 Kauffer, letter to Wheeler, January 17, 1942. Monroe Wheeler Papers, Series 1, Correspondence, Kauffer, E. McKnight, 1940-52, box 5, folder 156, Beinecke Rare Book and Manuscript Library.
31 Kauffer, letter to Glenway Wescott, May 12, 1949. Glenway Wescott Papers, Series 1, Correspondence, Kauffer, E. McKnight, 1941-51, box 60, folder 871, Beinecke Rare Book and Manuscript Library.

11.1 Textile, Leaves of Grass, 1946, Marion Dorn, made by Silkar Studios Inc.

DESIGN HERE *Is* LIVING: MARION DORN *in* NEW YORK

Kimberly Randall

IN 1940, MARION DORN AND HER PARTNER AND FUTURE HUSBAND, E. McKNIGHT KAUFFER, DEPARTED ENGLAND IN HASTE: THE COUNTRY WAS AT WAR, AND THE US EMBASSY HAD ISSUED STARK WARNINGS THAT AMERICAN CITIZENS WERE UNSAFE THERE.[1] PROFESSIONAL OPPORTUNITIES HAD DRIED UP FOR THE COUPLE. They both left behind thriving prewar careers and the considerable esteem of their colleagues. The challenges upon returning to the United States after lengthy absences were substantial; Kauffer had left the country in 1913, Dorn in 1923. Kauffer struggled to gain his footing in the alternately crass and conservative advertising business, and his mental and physical decline appears to have started soon after their arrival in New York. He would die in 1954. Dorn proved more adaptable, employing a combination of talent, experience, dedication, and grit, as well as a positive and flexible approach, to meet the demands of the American design business.

Dorn would eventually achieve professional success and respect in New York, but starting over required an unrelenting commitment to work that left little time for travel or leisure. In comments to the *New York Times*, she compared her experiences in England and the United States, explaining without cynicism that while in the England of the 1920s a designer needed a patron, a "social leader" (the examples she gives are aristocrats) who would naturally expect right of approval over any other clients, in post–World War II America the design industry was controlled by the big corporations. When she added that even the most "hard-headed" businessmen could be found at The Metropolitan Museum of Art on any given Sunday afternoon, she was alluding to New York's status as the center of the American textile design industry, a position that encouraged collaboration between designers and the museums committed to modern design.[2] Dorn concluded, "Design here is living. I see it all around me and not for the few but available to everyone."[3] This suggests

1 See Mark Haworth-Booth, *E. McKnight Kauffer: A Designer and His Public*, 1979 [rev. ed. London: V&A Publications, 2005], 93-95. Although the couple had long resided in London, they never became British citizens. Their decision to leave remains on some level opaque: financial pressures and the war don't seem to fully explain it.
2 Faith Corrigan, "English Honor Designer for Influence in Field," *New York Times*, February 7, 1957. The Museum of Modern Art, New York, exhibited modern textiles throughout the 1950s, notably in the *Good Design* series of exhibitions. See, e.g., www.moma.org/momaorg/shared/pdfs/docs/press_archives/1472/releases/MOMA_1950_0081_1950-11-16_501116-70.pdf for the museum's press release on its first *Good Design* exhibition, in 1950; a good deal more of such information is available on the museum's website. Documents on the important exhibitions *American Fabrics* and *Textiles USA* [both 1956] can also be found on the MoMA website.

that despite the demands of her profession, Dorn valued its goal to make good design readily available to all. Yet just five years after these remarks, she closed her design studio on East 54th Street and left for Tangier, Morocco, intending to open another studio there with her business partner, Louis Fischer.[4]

Educated at Stanford, Dorn had worked as a fine artist before shifting to textile design after her marriage to Henry Varnum Poor, in 1919. The couple's move to New York allowed Dorn to look to museums for exhibition opportunities and to mine their collections for sources of inspiration, ideas that she would return to in the 1940s. She participated in the well-established design contests run by *Women's Wear*, organized and promoted since 1916 by M. D. C. Crawford, then the research editor for the magazine and research associate at the American Museum of Natural History.[5] Dorn was included in the Met's *Fifth Exhibition of American Industrial Art*, which included a plain gray jacquard brocade she designed for H. R. Mallinson & Company.[6] In an interview in 1951, Dorn said that she had taken a course at the American Museum of Natural History that culminated with her prizewinning textile design and a three-month position at a fabric house, presumably H. R. Mallinson.[7]

Like many of her contemporaries, Dorn expanded her design practice by learning the popular batik process. A 1921 announcement in *Women's Wear* stated that she, Poor, and Hermann Rosse had developed a resist process closely related to batik that produced textiles in volume without compromising the integrity of the designer's hand.[8] That same year she was hired as a textile designer for *The Pilgrim Spirit*, a 1,400-performer pageant celebrating the tercentenary of the landing at Plymouth Rock. Noting that the costumes had demanded 3,000 yards of fabric, a journalist added that "no account of this aspect of the pageant would be complete without mention of Mrs. Marion Poor, whose marvelous batik work produces out of homely materials the most wonderful effects of rich satins and velvets."[9]

In early 1923, Dorn and Poor separated and Dorn moved to Paris, where she reconnected with Kauffer, having first met him in New York in 1921.[10] The two became romantically involved and she joined him in London. Working in the home they shared, she created dramatic and theatrical batiks that soon caught the attention of an editor's assistant at British *Vogue*, and by the early 1930s she was producing bold designs for textiles and carpets that garnered a significant amount of positive attention in the press.[11] In 1934, she opened Marion Dorn Ltd., where she continued to design for both private and commercial clients. The successes of the 1930s ended abruptly with England's entry into World War II and the apparent failure of Dorn's design business.[12] Upon returning to New York in 1940, Dorn immediately started working to rebuild her career, designing printed scarves, some of which she patented.[13] But it was difficult for her to find steady clients, especially while the wartime restrictions on materials were still in place. In correspondence with friends in England, Kauffer described the challenges of New York during this period, when Marion "worked every minute, peddled Seventh Avenue and made scarves."[14]

A consistent challenge in evaluating Dorn's post-1940 work is its surprising absence from American museums. There is a sad irony in this observation: Dorn's later designs are rife with art-historical references that clearly show her absorption in the vital cultural offerings available to designers in New York. Regrettably, the designs most often seen as defining her career after 1940 are her oversized floral patterns for textiles and wallpapers. She had already internalized the American preference for florals (fig. 11.2) when she wrote to a friend in 1941, "I painted roses and lilies, hyacinths, tulips and Etruscan horses, but mostly flowers because

3 Dorn, quoted in Corrigan, "English Honor Designer for Influence in Field."
4 Marion V. Dorn and Louis Fischer announced their partnership in 1959. Dorn and Fischer Inc. was located at 8 East 54th Street, New York. "Address Book," *Interiors*, September 1959, 182.
5 Dorn won first prize in 1920 for her poster design for the following year's competition [1921], which was never held; see M. D. C. Crawford, "Design Contest Brings Out Artistic Textile Patterns," *Dry Goods Guide* 46, no. 5 [November 1920]: 8; "93 Prizes Awarded to Women's Wear Designers," *New-York Tribune*, November 21, 1920; and M. D. C. Crawford, "Names of Winners Are Announced in Women's Wear Design Contest," *Women's Wear*, November 15, 1920, 1, 34. *Women's Wear* would become *Women's Wear Daily* in 1927.
6 M. D. C. Crawford, "Fifth Annual Industrial Art Exhibit Opens at Metropolitan Museum Tomorrow," *Women's Wear*, December 14, 1920, 20.

7 Marilyn Hoffman, "New York Textile Designer Emphasizes Flair for Originality in Carpet," *Christian Science Monitor*, December 26, 1951, 6. Dorn received Honorable Mention in the Textile Design Contest of 1920; See "Textile Design Competition," *Silk*, December 1920, 80.
8 *Women's Wear*, March 25, 1921, 33.
9 "Pilgrim Fathers, in Plymouth's Pageant, Not Dour Greybeards but Fine, Sensible Young 'Liberals,'" *St. Louis Post-Dispatch*, July 10, 1921.
10 Haworth-Booth, *A Designer and His Public*, 37.
11 See Christine Boydell, "Batik in America and Britain 1920-1930: The Early Career of Marion Dorn," *Text: For the Study of Textile Art Design & History* 24 [Winter 1996]: 6.
12 In a letter of September 1939, Dorn expressed worries about her financial obligations and fears about losing her showroom by Christmas of that year. Dorn, letter to Mary Hutchinson, September 28, 1939. Mary Hutchinson Papers, 17.5, Harry Ransom Center, University of Texas at Austin.

13 Patents for Designs 123,385, 123,386, 123,387, 123,545, filed on October 3, 1940. *Official Gazette of the United States Patent Office*, 1940, 240, 520.
14 E. McKnight Kauffer, letter to Jack Beddington, February 23, 1941, quoted in Haworth-Booth, *A Designer and His Public*, 97. Dorn did receive some early attention in 1942, when *House & Garden* introduced her as an American returning to New York during the war. "Four Outstanding American Designers," *House & Garden*, May 1942, 43.

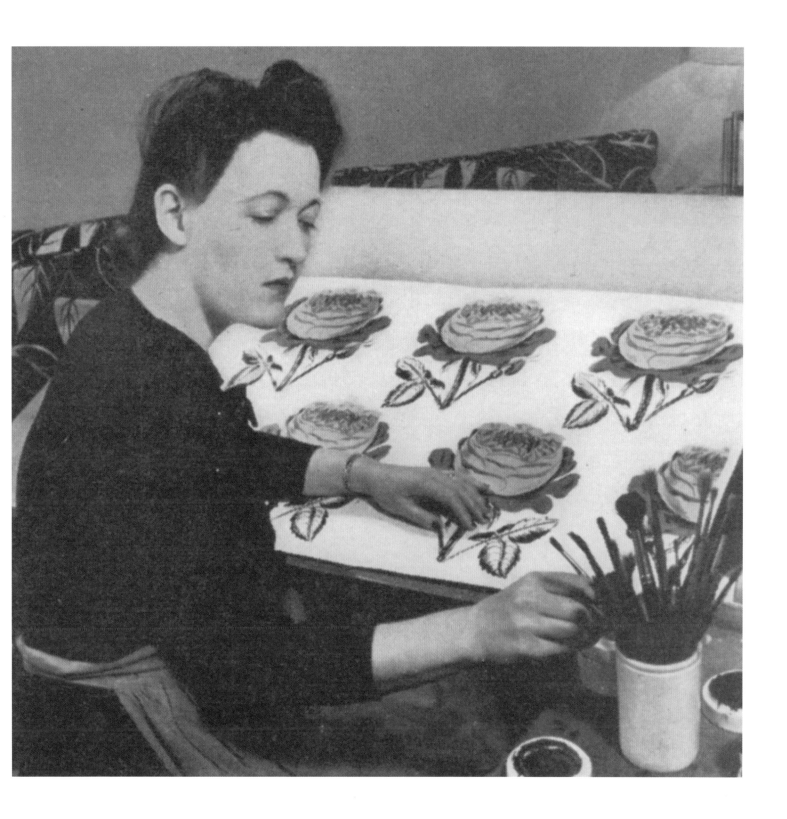

11.2 Photograph, Marion Dorn at her drafting table, 1942

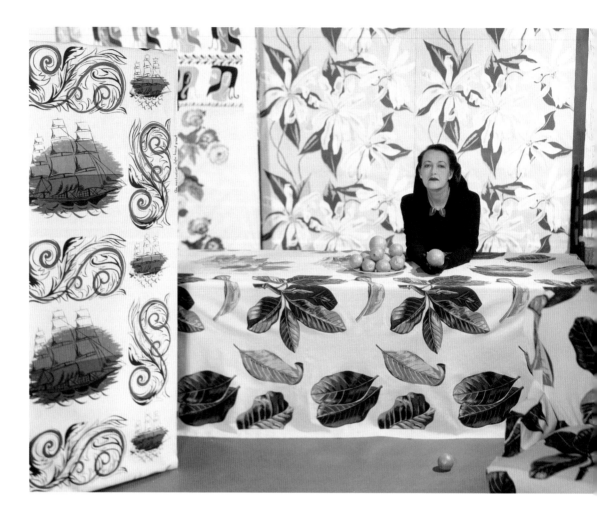

11.3 (this page, top) Photograph, Marion Dorn surrounded by her textile designs, 1947, Photograph by Horst P. Horst
11.4 (opposite, right) Carpet, Walking on Air, 1951, Marion Dorn, made by Edward Fields, Inc.
11.5 (opposite, left) Photograph, Equivalent, 1925, Alfred Stieglitz
11.6 (this page, bottom left) Textile, Yellow Driftwood, 1949–51, Marion Dorn, made by Jud Williams, Inc.
11.7 (this page, bottom right) Magazine cover, *Interiors*, June 1949, Harry Schulke

that is what Americans like."[15] A striking 1947 photograph by Horst only reinforces this notion, showing her surrounded and dwarfed by her floral designs (fig. 11.3). References to her work after 1940 do appear in magazines and newspapers, demonstrating how tirelessly she worked to reestablish her career in New York, but the images are often black and white, poorly photographed and printed, and only briefly described.

The floral designs in any case formed only a small part of Dorn's output. A pivot away from them came when she began to look to New York museums, libraries, and galleries for fresh ideas. An opportunity to use historical sources arrived in 1948, when the Prints Division of the New York Public Library invited artists and designers to mine its collections for inspiration for its exhibition *The Designer Begins Here*. Dorn contributed a printed silk with a design of Greek coins, intended for neckties, as well as a boldly patterned scarf inspired by a history of Greek vases.[16]

Dorn's work of the early 1950s shows her ranging more widely in seeking out ideas for her textile and wall-covering designs. In 1951, The Museum of Modern Art presented an exhibition called *Abstraction in Photography* featuring distorted, apparently nonrepresentational images, many actually from nature, that curator Edward Steichen selected to challenge the audience's ideas about abstraction.[17] This would have appealed to the cerebral Dorn, who was using her own abstracted interpretations of nature in the carpets she was designing for the Edward Fields company that year.[18] A carpet titled Walking on Air (fig. 11.4) may have been inspired by the eight of Alfred Stieglitz's Equivalents (fig. 11.5), a series of photographs of clouds, included in Steichen's show.[19] The design stands out in a collection that mostly looked downward for inspiration, to marble floors, parquetry, and flagstones; a journalist singled it out for its "note of whimsy."[20] A visually aware designer, Dorn may well have seen *Equivalents* on other occasions, but her interest in the MoMA exhibition seems borne out by Yellow Driftwood (fig. 11.6), an unusual fabric designed for Jud Williams, Inc., in the same period: showing isolated pieces of grayish driftwood on a light yellow ground, the design bears an uncanny resemblance to a June 1949 cover of *Interiors* magazine (fig. 11.7) designed by Harry Schulke, a young artist also represented in *Abstraction in Photography*. Dorn's interest in the unique shapes and incised grooves of the driftwood is evident. In 1951, *House Beautiful* featured Yellow Driftwood in a special section devoted

15 Dorn, letter to Hutchinson, October 9, 1941. Collection of Simon Rendall, London.
16 "Designers Haunt Public Libraries," *Montreal Gazette,* June 8, 1948, 51.
17 See "Abstract Images: Display Arranged by Steichen Includes Variety of Experimental Work," *New York Times,* May 6, 1951.
18 Hoffman, "New York Textile Designer Emphasizes Flair for Originality in Carpet," 6.
19 Marion Dorn, "Textures to Live With: Design Inspired by Natural Forms Touched with Abstraction for Modern Interiors," *Craft Horizons,* September-October 1952, 27-28.
20 Betty Pepis, "New Rugs Inspired by Ancient Motifs," *New York Times,* November 20, 1951.

11.8 (top left) Sidewall, Master Drawings, 1951, Marion Dorn, made by Katzenbach & Warren, Inc.
11.9 (top right) Sidewall, Cameo, 1949, Marion Dorn, made by Katzenbach & Warren, Inc.
11.10 (bottom right) Photograph, Marion Dorn holding a cameo, 1949, Photograph by Herbert Matter

21 "House Beautiful's Forecast for
the Styles of the Fifties," *House
Beautiful*, November 1951, 195.
22 See Ann Pringle, "Classical Draw-
ings Reproduced on Series of Pin-Up
Wallpapers," *New York Herald Tribune*,
August 18, 1949.
23 "About the House," On and Off the
Avenue, *The New Yorker*, November 5,
1949, 101.
24 "Decorating Ideas: White-Room
Revival; Siamese Colours," *Vogue*,
April 15, 1951, 82.
25 "Only in the U.S.A.," *House & Gar-
den*, July 1949, 31.
26 Advertisement, *Interiors*, November
1952, 37.
27 "Merchandise Cues," *Interiors*,
September 1959, 170.
28 See George Karo, "Etruscan Art,"
Graphis 11, no. 60 [April 1, 1955]:
333, 335.

to forecasting the styles of the 1950s, and noting that ordinary, natural landscape patterns were now preferable to the traditional and idealized blossoms of the past.[21]

Dorn's shift away from florals in the late 1940s would continue into the early 1950s with her embrace of more direct art-historical approaches. She developed some of her more conservative and formal designs for the wallpaper manufacturer Katzenbach & Warren, using imagery from historical drawings, Greco-Roman artifacts, and classical architectural elements in novel ways. In 1949, for its Trompe L'oeil collection, Katzenbach & Warren introduced Dorn's Master Drawings, Cameo, and Ginger Lilies.[22] Master Drawings reproduced drawings by Jacopo Bellini, Albrecht Dürer, Domenico Ghirlandaio, Fra Filippo Lippi, and Leonardo da Vinci as though they were actual drawings pinned to the wall, complete with curling edges that cast shadows for a trompe l'oeil effect (fig. 11.8).[23] The bold design of this paper demanded restraint; indeed, in *Vogue*'s 1951 feature on all-white rooms inspired by the 1930s style of Syrie Maugham, Master Drawings was used to cover a folding screen next to the sofa.[24] Cameo was a striking wallpaper with carved pink Greco-Roman cameos set in gold against a dark blue ground, the cameos casting dark shadows as well (fig. 11.9). Their arrangement suggests a museum setting, where they might be secured to a board inside a vitrine. In July 1949, *House & Garden* ran a photograph of Dorn with a cameo (fig. 11.10), and she told the magazine that "classicism will soon reappear in a rare and spirited form."[25] The stylized modernism of her 1930s work had all but disappeared, replaced by new interpretations and treatments of historical designs. In 1952, she set the classical architectural form of the obelisk within rectangles, some marble or stone with ormolu, others with contrasting stone and marble inlay patterns, for another Katzenbach & Warren wallpaper; an advertisement described the design as "inspired by classic documents of the French Empire period."[26] Her design for Etruscan (fig. 11.11) was described by *Interiors* magazine as inspired by the tomb paintings at Tarquinia, Italy.[27] Dorn may have relied on photographs of tomb paintings published in *Graphis* magazine in connection with a popular exhibition on Etruscan art that traveled to major European cities starting in 1955 (fig. 11.12).[28]

A smaller client of Dorn's was Silkar Studios, Inc., for which she designed several textiles (fig. 11.1). Plaque Toltec (fig. 11.13) was inspired by a Mexican pre-Columbian jade carving (fig. 11.14) from the Brummer Gallery on East 57th Street, not far from where Dorn lived and worked.[29] Another ancient stone carving inspired Zapotec (ca. 1950), her gray-and-white fabric for a sofa in Harvey Probber's Nuclear collection.[30] These designs may reflect Dorn's reaction to the mid-century popularity of fabrics inspired by pre-Columbian motifs. Just two years later, however, she mocked "the inverted snobbery in an industrial age of imitating peasant or handmade effects."[31] In a decided evolution since 1950, she had come to see direct imitation as unsuitable to contemporary architecture and furniture.

In 1949, Dorn began one of her most successful and enduring design collaborations, joining carpet maker Edward Fields, Inc., where she served intermittently as creative director.[32] She later hired Fischer to assist her there, and the two of them produced carpet designs for Edward Fields until the early 1960s. One early and expansive collection, which debuted in 1951, boasted several sources of inspiration and a range of motifs. Raised pile in geometric shapes echoed Egyptian and pre-Columbian influences and emphasized the importance of texture, while other tufted carpets employed marbleized stone effects. Some carpets were named after Italian cities, which Dorn acknowledged as an influ-

29 Advertisement, *Interiors*, March
1950, 177. The Brummer Gallery papers
are now at The Metropolitan Museum
of Art; see www.metmuseum.org/art/
libraries-and-research-centers/
watson-digital-collections/cloisters-
archives-collections/the-brummer-
gallery-records [accessed December 6,
2019].
30 Harriet Morrison, "Today's Living:
Modern Pieces Made to Match," *New York
Herald Tribune*, November 28, 1950;
"Newest Version of an Adaptable Sofa,"
New York Times, November 27, 1950.
31 Dorn, "Textures to Live With," 27.
Dorn's designs are not so different
in spirit from those of Ruth Reeves,
a contemporary who reprinted her pre-
Columbian and Latin American-inspired
designs of the 1930s with Morley-
Fletcher, Inc., in the late 1940s.
Dorn similarly chose to reintroduce
Etruscan Heads, a fabric from the late
1930s that gives a flat, geometrical
treatment to the heads of Etruscan
votive statues. The furniture company
Sloane's used the design on an arm-
chair in 1948.
32 Jessica Olshen, *Edward Fields:
Carpet Makers*, vol. 1, 4. New York:
Edward Fields, n.d. Company literature
available in Edward Fields showroom,
New York.

ence more suitable for the American market than "sterile left-overs" of the Bauhaus or the "prim un-American designs of northern Europe."[33] These cultural references, accessible in museum collection galleries, become increasingly pronounced in her work.

In late 1957, Dorn released a group of carpets uncharacteristic of her 1950s style under the name Louis D'Or.[34] The materials that she consulted in her research for this new, flatter style of rug included seventeenth-century tapestries, Aubusson carpets, medals, and carved motifs of the Louis XIV period, of which she said that the "basic designs have a richness we are seeking today."[35] For these carpets Dorn used thirty-five variations of the color gold, emphasizing the motifs of the court of Louis XIV for carpets featuring *trophées*, a radiating sun, and ribbon garlands. One design for a round carpet was taken directly from the Louis d'or gold coin.[36]

In 1961, an opportunity for travel arrived when Dorn and Fischer were preparing their Classic Collection for Edward Fields — eighteen designs that again took inspiration from mosaic floors, ancient tile patterns, olive branches, scrolls and shells, and variations on the Greek key motif.[37] To research the subject they visited Italy, Greece, Egypt, and Turkey, and also stopped in Tangier, Morocco, where Dorn encountered the small English expat community, including several old friends from her time in London. The following year, energized by her travels, she wrote an article on Islamic art for *Interior Design* that emphasized the Islamic mastery of geometrical form and the rhythmic stylization of Arabic inscriptions.[38] She illustrated her analysis of Islamic art with objects from New York museums, including Cooper Union Museum for the Arts of Decoration.

In that same year of 1962, Dorn, no longer in the best of health, moved to Tangier and opened a new studio with Fischer. She traveled back to New York in 1963, using her time there to distribute Kauffer's archive among several museums such as the Cooper Union Museum (today the Cooper Hewitt, Smithsonian Design Museum) and the Philadelphia Museum of Art. She later returned to Tangier and died there in 1964. It is assumed that Fischer took possession of her archive, which later was lost in a fire at his home in the mid-1960s.[39]

On their return to New York in 1940, both Dorn and Kauffer were criticized for being "too European" in their work. Dorn herself noted the American reaction against abstracted forms when she stated, "We in America like to recognize familiar forms in design, and so a fresh treatment of a rose will elicit more response than will an abstraction."[40] Even *House & Garden*, while praising her earlier work in England, added that her tendency toward abstraction had been moderated for "the American taste, where nostalgic affection for flowers combines with exuberant preference for bright colors."[41] Dorn reacted by embracing art-historical references and gently abstracted natural forms to create a new approach. Perhaps no longer trusting the modernist spirit that had guided her in the 1930s, she intuited that museums and libraries might be a more secure source of inspiration, enabling her to produce designs that minimized her contemporary European flair and appealed to customers who appreciated the cultural references now pervasive in her work.

33 Dorn, "Textures to Live With," 28.
34 "Thick-Rug Man Shows Flat Ones," *New York Times*, December 6, 1957.
35 "'Louis D'Or' Rugs Shown by Fields," *New York Herald Tribune*, December 26, 1957.
36 "Opulent New Edward Fields Rugs by Marion Dorn Bow to the Sun King," *Interiors*, February 1958, 120. Dorn's conservative translations of classic French iconography likely influenced the White House in its decision to commission a carpet from her for its Diplomatic Reception Room. The carpet incorporated the seals of the fifty states as well as the Great Seal of the United States.
37 Harriet Morrison, "New Area Rugs Introduced," *New York Herald Tribune*, February 16, 1962; Marilyn Hoffman, "Rugs Revive the Past: Mediterranean Décor - No. 1," *The Christian Science Monitor*, October 24, 1962.
38 Marion Dorn, "Islamic Art," *Interior Design*, September 1962, 132-34.
39 Christine Boydell, interview with Louis Fischer, November 22, 1986, New York City.
40 "Design and Color Quorum on Decorative Fabrics," *American Fabrics* no. 5 [Winter 1948]: 123.
41 "1947: Design Year in the U.S.A. Dorn: Her Designs, Abstract and Floral, are Keyed to the American Scene," *House and Garden*, July 1947, 36.

11.11 (opposite, top left) Sidewall, Etruscan, 1959, Marion Dorn, made by Katzenbach & Warren, Inc.
11.12 (opposite, bottom left) Photograph, Tomb of the Triclinium (detail), Tarquinia, Italy, ca. 470 BCE
11.13 (opposite, bottom right) Magazine advertisement, Plaque Toltec, a textile design by Marion Dorn, 1950
11.14 (opposite, top right) Ornament, Mexico or Central America, Maya style, greenstone, 250–900 CE

PLAQUE TOLTEC by *Marion Dorn.*
A very fine example of jade carving. It formerly belonged to the famous Brummer collection.
Colors: *California Gold, Grey, Coral.*

12.1 Book cover (detail), *The Sleepwalkers* by Hermann Broch, 1947

A PARABLE *of* UNCOMPROMISE: KAUFFER *in* NEW YORK

Steven Heller

THE OBITUARY PUBLISHED IN THE *NEW YORK TIMES* ON OCTOBER 23, 1954, THE DAY AFTER E. McKNIGHT KAUFFER DIED, WAS A DIS- PASSIONATE NEWS STORY ABOUT A LIFE PASSED RATHER THAN A CELEBRATORY ODE TO A LIFE LIVED IN ART. THIS THREE-HUNDRED-WORD UNSIGNED RÉSUMÉ-AS- NARRATIVE MAY SEEM AN INAUSPICIOUS SEND-OFF for the sixty-three-year-old artist/designer, who was then, as he is today, considered a twentieth-century pioneer of modern design. But rather than lament the brevity of the story (which, though, was prominently displayed at the top of the page, with a photograph by no less than Arnold Newman), what is important to appreciate is that Kauffer received the *Times* obit in the first place.

Edward Kauffer, Poster Designer
Book Illustrator Who Worked in England
for Many Years Dead in Hospital Here [1]

Kauffer was one of very few graphic designers given an obit in the newspaper in those days and for over a decade to follow.[2] Not even such poster maestros as A. M. Cassandre, Ludwig Hohlwein, and, as late as 1997, Jean Carlu received *Times* obits of any size. Commercial artists were routinely snubbed by the *Times*'s obit editors.

"Ted" Kauffer, however, was not so easily dismissed. He had earned an international reputation for his particular brand of abstract, dynamic, and symbolic advertising posters, and his work was enthusiastically supported by a circle of significant writer, poet, and artist collaborators and friends, including T. S. Eliot, Aldous Huxley, and Marianne Moore. Ten years earlier, a *New Yorker* Talk of the Town story had begun, "One of the greatest problems of capsule journalism is getting ahold of some arresting fact to quickly gain the reader's wavering attention. This is

1 "Edward Kauffer, Poster Designer: Book Illustrator Who Worked in England for Many Years Dead in Hospital Here," *New York Times*, October 23, 1954.
2 Until the 1990s the *Times* often used the term "graphics designer" in its obits.

simple in the case of McKnight Kauffer, who is pretty generally accepted as the best poster artist in the world."[3] This was neither perfunctory nor hyperbole. In England, Kauffer was even renowned beyond his profession: "*The Manchester Guardian*, which doesn't shoot off its mouth thoughtlessly," reported *The New Yorker*, "once said that Kauffer's personality was as much impressed on our time as Noel Coward's."[4] In Europe, unlike in the United States, "poster artist" was not a second-tier vocation—think Henri de Toulouse-Lautrec, for instance. Posters were street art, information, and entertainment rolled into one.

By 1944, when *The New Yorker* published its Talk of the Town piece—in which Kauffer not-so-facetiously admitted that he had picked his career, after training as a painter, because "I find I can be less of a hypocrite making posters"—he had already had a critically praised solo exhibition of eighty-five posters at New York's Museum of Modern Art (MoMA), in 1937, the second show that museum had ever dedicated to advertising work.[5] (The first was Cassandre's, in 1936.) This show had proved once and for all that Kauffer had bridged the disputed no-man's-land between fine and applied art, and it was logically assumed that this validation would ignite a blast-off career in New York when he returned there from London in 1940.

Kauffer was well covered by both the mainstream and the advertising-trade press in Europe and the United States. Of all the American publications on his accomplishments, the most surprising—given its focus on advertising and its publication in an advertising backwater—may have been "Advertising with a Mission," in the *Courier-Journal* of Louisville, Kentucky, in August of 1944. The author, Hamilton Howard, reported, "Mr. Kauffer believes good design can produce more emotional response than even sex appeal or sentimental pictures glorifying motherhood.... He thinks advertising art can and should move forward to keep pace with other progressive American works. He thinks the people are ready for better art but the advertisers haven't yet been shown what good design can do."[6]

To win this emotional response, Kauffer did not rely on artistic intuition alone. He built a design language out of fundamental concepts that he referred to as "pattern," "form," and "description," and rooted his precepts in geometry—the square, circle, triangle, sphere and cylinder.[7] He played with these elements often, replacing diagonal layouts with rectilinear ones, crushing his type into parallelograms, and using positive/negative lettering. Another important step was to take up the airbrush, achieving a streamlined effect that underscored the modernity of his work. Kauffer developed a strong theoretical footing: "Values in design are not measurable," he wrote on various pages of random notes filled with quotations from the philosophers that he admired, such as John Dewey, "but certain standards are observable as belonging to accepted traditions and have been found to contain something unalterable and constant. Such virtues or qualities give us not a fixed rule to be guided by but remain as experience and no matter how often repeated continue to satisfy our critical sense."[8]

Kauffer was involved with the modern medium of photomontage and developed the so-called space frame, the imposition of an invisible window that appears to float in space, enabling the viewer to see an illusion of multiple perspectives on a single picture plane and combining realism and surrealism. He viewed all the arts as fair game for the graphic designer and challenged the schism between fine and applied art. "He could see no reason for conflict between good art work and good salesmanship," said Frank Zachary, editor of the short-lived but influential American design magazine *Portfolio* of 1949–51.[9] Nonetheless, advertising executives were not known for taking the kinds of risks Kauffer embraced.

3 "Kauffer," Talk of the Town, *The New Yorker* 20, no. 10 [April 22, 1944]: 19.
4 Ibid.
5 Ibid.
6 Hamilton Howard, "Advertising with a Mission," *Courier-Journal* [Louisville, KY], August 13, 1944.
7 E. McKnight Kauffer, memorandum, ca. 1924. Box 1, folder 14, item 8, Notes, Writings, and Sketches, Personal Papers, E. McKnight Kauffer Archive, Cooper Hewitt, Smithsonian Design Museum.
8 Kauffer, "Notes for a Philosophy of Design," ca. 1924. Box 1, folder 14, item 27, Notes, Writings, and Sketches, Personal Papers, E. McKnight Kauffer Archive, Cooper Hewitt.
9 Frank Zachary, in an interview with the author, September 1988.

12.2 (opposite) Magazine cover, *Seminar*, August 1944

Kauffer attracted a number of design and illustration jobs in New York, yet the move from the United Kingdom took an emotional and professional toll. Although he was honored by New York's elite professional clubs, he was a stranger to the business world. "Kauffer is a new name to most American advertisers," wrote Zachary. "In some quarters, he finds himself in the position of a museum piece—admired, even revered, but considered too individual for everyday use."[10] His working life in the city was conditioned by qualified accolades like this one, in *American Artist* magazine: "Now it remains to be seen how America will receive this gifted American."[11]

Indeed, Kauffer's fortunes in New York were not nor ever would be as stable as he wished or deserved. He lived frugally, working in a relatively spartan studio on East 57th Street and living in an apartment on Central Park South. He had been reluctant to uproot himself from London but at the start of World War II, he and the textile designer Marion Dorn, his romantic partner since 1923, booked passage on the SS *Washington*, the last passenger ship for America, leaving all their possessions behind in order to make a fresh start.[12] Kauffer particularly regretted abandoning his only daughter, Ann, who lived with his estranged wife, Grace McKnight Kauffer, a concert pianist. He did not see Ann throughout the war, and losing paternal relations with her plagued him.

Advertising in the United States was aesthetically regressive. Before the "Creative Revolution" of the mid-1950s, the white-shoe advertising industry was for the most part hawking wares through hard-sell copy and graphics, rather than through the abstract artfulness and conceptual nuance that Kauffer brought to a few small but decidedly creative agencies: Dan Rhodes Johnson, Frank A. Lavaty, Wm. H. Weintraub & Co. (where the younger American designer Paul Rand was art director), Geyer, Cornell & Newell, and N. W. Ayer & Son. One of Kauffer's best advertisements, published in 1942 in *Life* magazine, was produced for Stetson hats: the flat shape of a man's head—a silhouette cut out from a blueprint—wearing a photograph of a hat is set against a surreal industrial landscape (fig. 12.3). This smartly produced image was what was called an "institutional ad," intended not to sell a specific product but to keep a brand name in the public's consciousness while addressing another purpose: here, Stetson cautioned that loose talk would aid the enemy. Yet as innovative as it was, this modern stylistic approach did not change the preference of Madison Avenue's conservative account execs for literalism and cliché.

So Kauffer gravitated toward projects that allowed freedom, including ads for pharmaceutical companies that targeted medical professionals with sophisticated modern design. These included the journals *Seminar* (fig. 12.2) (published by Sharp & Dohme, today Merck & Co.) and *What's New* (fig. 12.4), published by Abbott Laboratories, which supplied medicines to the military and also produced war-related art for public displays. Earlier on, Kauffer also worked with war-relief agencies, including the United Committee of South-Slavic Americans, for which he designed a quintessentially modern poster featuring a photo of the anti-Nazi Communist resistance leader and future Yugoslav president Josip Broz Tito (plate 139). Like many Kauffer posters, this one echoed Russian constructivist compositions without slavishly copying them. Tito's profile is framed by arrows, one of Kauffer's favorite tropes, and sans serif type in startling black and red. Kauffer's main commissions at this time were limited to cultural or political work that allowed more creative liberties. Although he had some enlightened allies in the advertising community in New York, his output never quite rose to the level of his career in the United Kingdom.

10 Frank Zachary, "E. McKnight Kauffer: Poster Designer," *Portfolio* 1, no. 1 (1950): n.p.
11 "E. McKnight Kauffer Has Come Back to His Native Land," *American Artist*, April 1941, 12.
12 Kauffer and Marion Dorn would marry in 1950. For Dorn's obituary see "Miss Marion V. Dorn, Carpet Designer, 65," *New York Times*, January 29, 1964.

12.3 (left) Print, *Keep It under Your Stetson*, 1942
12.4 (right) Magazine cover, *What's New*, 1942
12.5 (opposite) Drawing, Give, ca. 1944

KEEP YOUR — RED CROSS AT HIS SIDE

GIVE

Of course, Kauffer adamantly refused to accept low standards. "I cannot capture my audience by threat, intimidation or fear, and it repels me to intensify an inferiority complex by stressing human insecurity in areas of wealth, sex or prestige," Kauffer once said.[13] He desired, rather, to call attention to a product or situation by a simple, authoritative statement, as illustrated by his forceful Red Cross Appeal poster with a straight bold arrow pointing to the single word at the bottom of the image: "Give" (fig. 12.5).

Spending the war as a New York civilian in the advertising business doubtless weighed on Kauffer's conscience. Looking back in 1948, in a lecture for MoMA's Committee on Art Education, he spoke of the necessity of strong propaganda, announcing that as artists "we submerge our personal 'ists' and 'isms' so that we may become an intensive group of people working for a common purpose." Looking toward the postwar future, he added that "it is easier to see where we designers can fit into the activities of postwar plans. New forms of education, social programs of re-adjustment, racial discrimination and the Negro problem for which there is now an urgent necessity for intelligent and human co-operation...."[14]

In 1950, Zachary wrote a career-defining profile in *Portfolio* no. 1 (art-directed by Alexey Brodovitch, famous for his work at *Harper's Bazaar* and cofounder of *Portfolio* with Zachary and George S. Rosenthal) to help Kauffer reach a larger audience of art directors and art buyers. Zachary was not a Kauffer intimate, but the tone of his article evidences his avid admiration. "'It is a matter of chagrin that the posters of McKnight Kauffer should have remained unknown to us until this exhibition,'" Zachary quoted an unnamed writer on the 1937 MoMA exhibition; he added, "Since his return, Kauffer's signature has been widely displayed throughout the U.S. on posters for relief agencies, medical houses, transportation systems, and business and industrial corporations. Still, it vexes him somewhat that he is far more widely known for his magnificent illustrations and book jackets than for his work in the poster."[15]

Kauffer's complaint was something of a paradox: at the time of his return to the United States, book jackets were his bread and butter, his notable customers including his close friend Alfred Knopf as well as Harcourt, Brace, Harper & Brothers, Pantheon Books, the Bollingen Series, and Random House. He was the principal designer-illustrator for the Mod-

13 Kauffer, quoted in Bernard Waldman, "E. McKnight Kauffer: The Poster as an Art Form," draft for a lecture given at *E. McKnight Kauffer Memorial Exhibition*, Victoria and Albert Museum, London, 1955. Box 2, folder 22, item 3, Waldman/ Schulman Files, Personal Papers, E. McKnight Kauffer Archive, Cooper Hewitt.
14 Kauffer, lecture given at The Museum of Modern Art, New York, at the symposium "Responsibility for Standards of Taste in a Democratic Society," April 24, 1948. Box 1, folder 14, item 4, Notes, Writings, and Sketches, Personal Papers, E. McKnight Kauffer Archive, Cooper Hewitt. See also the press release for the event, available online at www.moma .org/momaorg/shared/pdfs/docs /press_archives/1255/releases /MOMA_1946-1948_0130_1948 -04-14_48414-20.pdf [accessed December 7, 2019].
15 Zachary, "E. McKnight Kauffer: Poster Designer," n.p.

ern Library, an imprint of Random House, also known as "The Modern Library of the World's Best Books" for its inexpensive reprints of classic and modern European titles, plus new editions of works by a few significant contemporary Americans. In an article announcing Kauffer's return to New York's publishing industry, *American Artist* noted, "Already he is being sought after by those who are looking for newness—something different…[that] violates the conventional concepts of book jacket design…. you cannot pay Kauffer to be conventional."[16]

Although Kauffer's signature symbolic/surrealistic style helped to define the Modern Library persona, his covers for this house and others often look like sketches for larger posters. The consummate artist and professional, he had a knack for designing posterlike images in the book jacket's limited space. In 1948, he participated in the first exhibition of the Book Jacket Designers Guild, founded the previous year for "the purpose of promoting and stimulating interest in the art of book jacket design."[17] Kauffer was included with younger midcentury moderns, including Rand, Gene Federico, and Alvin Lustig. Of the works he showed, his 1941 jacket for Ben Robertson's *I Saw England* (fig. 12.6) echoed his symbolic illustrative British poster style, while the cover for the 1947 reprint of Hermann Broch's novel *The Sleepwalkers* (fig. 12.1) was more exclusively typographic, with a touch of abstraction—all consistent with the styles that the Guild was promoting. Still, although Kauffer experimented with different approaches, he grew increasingly wary of the direction his work was taking. As an example, in his cover for MacKinlay Kantor's 1949 oater *Wicked Water* (fig. 12.7), he came perilously close to genre kitsch in a landscape of a Western town with the book's title scrawled on an old wooden sign (a common cliché in book-jacket design).

There was at least one masterwork in this genre, his most enduring typographic jacket: the 1949 Modern Library edition of *Ulysses* (1922) (fig. 12.8), designed years after Random House won its case in the Supreme Court to lift an obscenity ban on James Joyce's opus. Being designed to work in juxtaposition with his illustration, Kauffer's type and lettering were generally not the most nuanced; they were often rendered with a heavy hand, and often followed certain fashionable modernist and modernistic tropes. For *Ulysses* he turned these traits to advantage, exaggerating the relationships of type size and color. An elongated *U* fading off at the top, and sitting next to a condensed *L*, was consistent with the asymmetrical trend of 1920s–'30s "New Typography," and created a mnemonic that became, and remains, a veritable brand for the book. (Although it has been redesigned a few times since, Kauffer's version is the memorable one.)

On occasion Kauffer worked closely with author friends such as Huxley and S. J. Perelman. In 1946, on a Modern Library edition of *Brave New World* (1932) (fig. 12.9), he received Huxley's own art-directorial notes—a bit of gall that would make any other designer apoplectic with rage: "My feeling is that the sketch I have marked A is the better of the two as regards proportion of the colours and lettering," Huxley asserted. "But I am wondering whether it would not be possible to incorporate into it the embryo motif of sketch B. Instead of the sphere and scroll of sketch A, might be [*sic*] not have an egg or, better, a bottle on its side, occupying the same amount of space, with the hint of an embryo appearing, as it does from the upright egg in sketch 2.B? I envisage the bottle as a kind of gourd-shaped…object."[18] Kauffer took the suggestion in stride.

Kauffer will be remembered for book jackets, if only because he did so many of them; and as his membership in the Book Jacket Designers Guild implied, he fit into the category of designers who had influenced the "trends and developments of this specialized field."[19] Yet

16 "E. McKnight Kauffer Has Come Back to His Native Land," 12.
17 Book Jacket Designers Guild, ed., "Introduction," in *First Annual Exhibition: Book Jacket Designers Guild* [New York: A-D Gallery, 1948], n.p.
18 Aldous Huxley, letter to Kauffer, May 14, 1946. 101170 MA 1668, Department of Literary and Historical Manuscripts, Pierpont Morgan Library, New York.
19 Book Jacket Designers Guild, ed., *First Annual Exhibition: Book Jacket Designers Guild*, n.p.

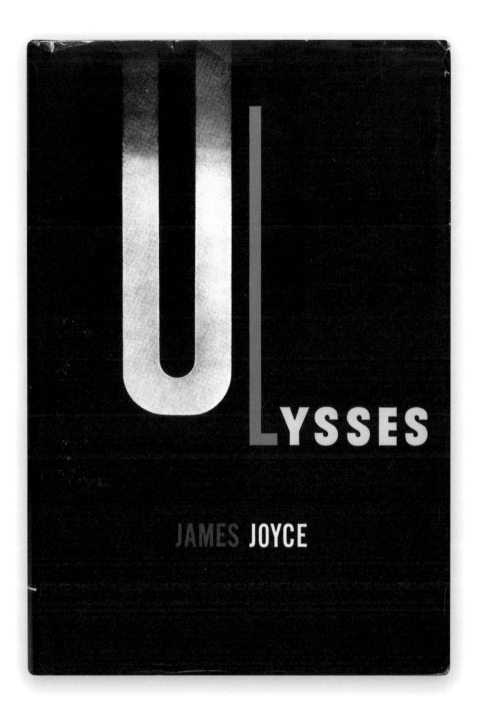

12.6 (opposite) Book cover, *I Saw England* by Ben Robertson, 1941
12.7 (bottom left) Book cover, *Wicked Water* by MacKinlay Kantor, 1949
12.8 (top right) Book cover, *Ulysses* by James Joyce, 1949
12.9 (top left) Book cover, *Brave New World* by Aldous Huxley, 1946

this did not mean he earned special treatment: even a month before his death, Kauffer produced some cover sketches for Random House, only to have them rejected with an explanation more typical of the advertising trade but indicative of the influence that marketing was having on design: "Our salesmen have asked that we take an entirely different approach from our original one on the jacket for Gulliver's Travels. This will mean a layout not in your domain.... We're very sorry.... Please send us a small bill for the work you did."[20]

Kauffer's New York book jackets include his design for Langston Hughes's *Shakespeare in Harlem* (fig. 9.9), one of Hughes's most famous collections of poetry, for which Kauffer also provided a frontispiece and twelve full-page illustrations. The stunningly memorable cover conforms to his Modern Library style of a symbolic image (a brown hand holding a die and a broken wishbone), but the line drawings, done in white line on black, are uncharacteristically rough, leaning in a curious way on George Grosz's 1920s sketches of Berlin. *The Borzoi Poe* (1946), an exquisite two-volume boxed set of Edgar Allan Poe's stories and poems designed by type designer and calligrapher W. A. Dwiggins, featured twelve full-page color paintings by Kauffer, rendered in a darkly colorful watercolor expressionist style, and eight line drawings, including brooding portraits of Poe that resembled the writer's visage and evoked his tortured soul (plates 147–148). The illustrations for the 1944 publication of W. H. Hudson's *Green Mansions* (fig. 12.10), printed in color lithography, were rendered in his smooth, ethereal, airbrush color style. But while his book illustrations and designs exemplify his talents, it is difficult to deny that Kauffer's true métier was the poster.

Kauffer's fortunes in New York improved in 1943, when type enthusiast Paul Hollister introduced him to Bernard Waldman, a Polish émigré and the founder and president of the Modern Merchandising Bureau, an advertising agency specializing in women's apparel.[21] Waldman and Kauffer were cut from the same cloth. Waldman was an impassioned maverick who was working to bring the European poster tradition to the United States and trying to introduce his fresh creative principles to modern advertising art. "My efforts were not met with immediate enthusiasm; advertisers were slow in accepting this new, intelligent approach to selling products," he later wrote, but he persevered "with increasing success."[22] The first campaign Waldman commissioned from Kauffer was for American Silk Mills (fig. 12.11), and ran in the *New York Times* in 1943. To get the work accepted, Waldman told the client that whether he approved the drawing or not, the ad was going to appear. "I told him if he doesn't get a satisfactory reaction, he would not have to pay for the ad."[23] The ad was a tremendous success.

That synced the trust and friendship between Waldman and Kauffer. So when Waldman pitched Kauffer as the poster artist for an American Airlines campaign, he once again took the risk: "If you don't like them, you do not pay for them. Three years later, the then president of American Airlines wrote me and said they were the best posters they ever had."[24] This was saying a lot, since travel posters for ships and planes had reached a high level of excellence in the 1920s and '30s. Another American Airlines poster by Kauffer, *Fashions in Flight* (fig. 1.11), was simple yet powerful and authoritative. Waldman noted, "I was able to interest him to make posters and symbols and simplest forms. His credo in communication was distinctiveness and simplicity.... This work led to a close and deep friendship which was truly an inspiration."[25] Waldman next commissioned Kauffer to design posters for American Airlines promoting Arizona, California (fig. 12.12), New Mexico, and Texas (and later other destinations)

20 Regina Spirito, Random House, letter to Kauffer, September 17, 1954. Box 1, folder 4, item 28, Biographical and Correspondence, Personal Papers, E. McKnight Kauffer Archive, Cooper Hewitt.
21 Paul Hollister was the author of *American Alphabets* [New York: Harper & Brothers, 1930], a book designed by W. A. Dwiggins that was a sampling of contemporary typefaces.
22 Waldman, draft for a lecture given at *E. McKnight Kauffer Memorial Exhibition*, Victoria and Albert Museum, 1955. Box 2, folder 20, item 4, Waldman/Schulman Files, Personal Papers, E. McKnight Kauffer Archive, Cooper Hewitt.
23 Ibid.
24 Ibid.
25 Waldman, draft for a lecture given at *E. McKnight Kauffer Memorial Exhibition*, Victoria and Albert Museum, 1955. Box 2, folder 20, item 1, Waldman/Schulman Files, Personal Papers, E. McKnight Kauffer Archive, Cooper Hewitt.

12.10 Book illustration, for *Green Mansions* by W. H. Hudson, 1944
12.11 (opposite) Magazine advertisement, American Silk Mills, *New York Times Magazine*, March 21, 1943

as "sun country," necessitating trips that allowed for the duo's shared experience to grow into comradery. "Ted was in his proper environment. For weeks, months and years he talked about the West, which to him was more America than New York City, a place he called a 'depressing canyon of mortar, steel, bricks and glass.'"[26]

These and related commissions generated surreal yet lyrical landscapes recalling the railway posters that Kauffer had produced in England early in his career. Continuing until 1953, they represent some of his best New York work. (American travel posters were generally hard-sell destination imagery, not done with Kauffer's light touch.) No surprise that a poster for Montana (fig. 12.13), his native state, produced for the Container Corporation of America, is one of the most beautiful, painted in his naturalist manner. These posters helped him to regain confidence, albeit briefly, and he came alive in the sun, mountains, and deserts of Arizona in particular. "The subsequent poster series, based on [his and my father's] trips," wrote Waldman's daughter, the poet Grace Schulman (who as a teenager became Kauffer's surrogate daughter and literary mentee), "were the finest and most extensive from his New York period."[27] The range of graphic techniques—from painted and airbrushed streamlined symbolic structures and landscapes to photomontage and collage renderings—look as fresh today as they did then. Each image had a promotional function yet transcended that too. As was his wont in England, Kauffer had both a naturalist and streamlined/symbolic style for the American Airlines posters that he continued to use when Harold Laird, who handled display for the company, moved to Pan American and Kauffer and Waldman continued to make posters for him there.

Marianne Moore called Kauffer "a parable of uncompromise," and Kauffer underscored this pronouncement in a speech before the Art Directors Club of New York in 1941.[28] "Advertising design cannot be disassociated from culture," he said, "because it implies taste and selection

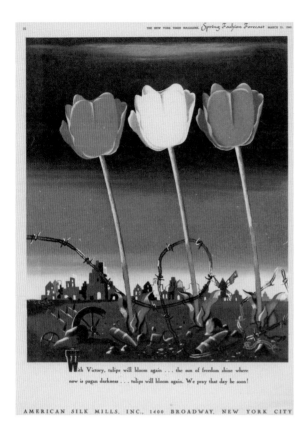

guided by intelligence.... The spirited and deep concern that the Art Directors Club proves to have for design-in-advertising implies through its distribution of coveted appraisal that our subject is not regarded as a lesser art, but as one of the major influences in the social fabric of our time."[29] A few years later, however, even this thread of optimism was frayed: "I would say that the two chief causes for our undistinguished productions are fright and overorganized departments ... between client (the beginning) and designer (the end) a whole complex system intervenes. This in-between world of research, rationalization, and sales talk no doubt gives the client faith and courage—but it generally kills the designer's value," Kauffer wrote in his 1947 introduction to *Thoughts on Design*, the first monograph by Rand, another iconoclast who was then a prominent advertising art director and, like Kauffer, rebelled against the status quo.[30]

Kauffer probably intuited that despite his respected status in the design world, he would be unable to re-create the level of fulfillment he had won in London. He was right. Although he was invited to show in two exhibitions in 1941—at the Katharine Kuh Gallery in Chicago and the A-D Gallery in New York, the latter titled the *Advance Guard of Advertising Artists*—he suffered a breakdown that year from which he never totally recovered. Zachary would recall that "Ted was a lost soul. Here was the most civilized, urbane man I ever met, and the top designer in England, unable to acclimatize himself to New York and American advertising."[31] Ten years after their return to the United States, he and Dorn married, then separated. His despair gave way to deep depression and his New York friends, including Moore, MoMA curator Monroe Wheeler, and poet Glenway Wescott, did their best to impede it from taking over. "In the extreme competitiveness

26 Waldman, letter to Mark Haworth-Booth, November 21, 1973, quoted in Haworth-Booth, *E. McKnight Kauffer: A Designer and His Public* [London: Gordon Fraser, 1979], 89.
27 Grace Schulman, "Gift from a Lost World," *Yale Review* 85, no. 4 [October 1997]: 125.
28 Marianne Moore, "Introduction," in Kauffer, *Drawings for the Ballet and the Original Illustrations for Edgar Allan Poe*, exh. cat. [New York: American British Art Gallery, 1949], n.p. [1].
29 Kauffer, "Advertising Art Now," *A-D* 8, no. 2 [December-January 1941-42]: n.p. [3, 8].
30 Kauffer, "Introduction," in Paul Rand, *Thoughts on Design* [New York: Wittenborn, 1947], vii.
31 Zachary, interview with the author.

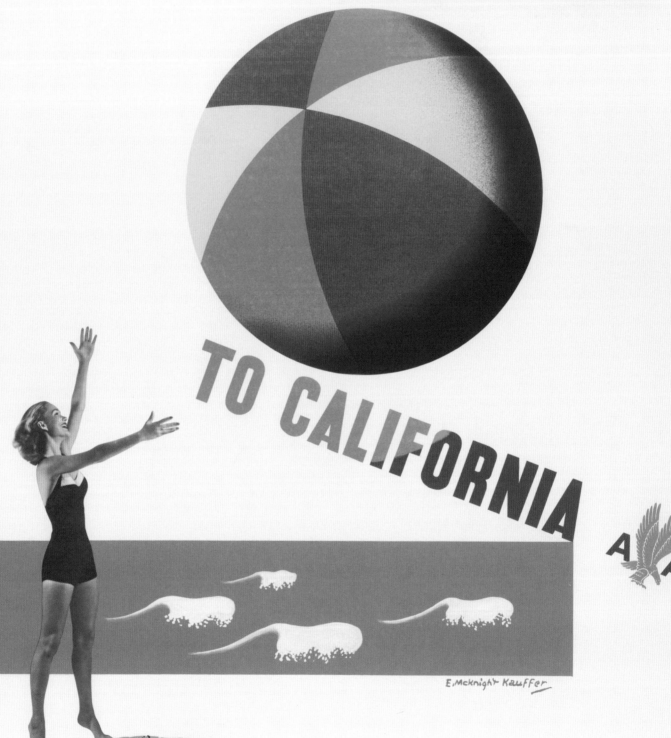

AMERICAN AIRLINES

TO CALIFORNIA

E. McKnight Kauffer

of New York advertising," Dorn would later observe, Kauffer "found it difficult to sell his work because he was no longer confident enough to sell himself."[32] He slid into the abyss of alcoholism, suffered from cirrhosis, fell into a coma, and died in 1954 at Lenox Hill Hospital.

In a speech at a memorial exhibition for Kauffer at London's Victoria and Albert Museum in 1955, Waldman said that the show symbolized "the incongruity of America's failure to recognize a Montana-born artist whom Europe considers the world's leading poster designer." He explained that "the main reason why his modern symbolism did not make a wide-reaching impression on his 'beloved America' is that advertisers were not ready to accept the poster as an art form—long accustomed to the tried and true, and therefore safe, approach to graphic art [i.e. hard-sell billboards], they found Kauffer's work too daring, too simple to be acceptable."[33]

"Kauffer knows that the America he seeks isn't New York," Zachary had written in his *Portfolio* profile. "He finds New York a sad and anxious city. He has glimpsed his America in reading—'I admire the America of Walt Whitman, Herman Melville, Thoreau, Emily Dickinson.'"[34] It seemed to Zachary that Kauffer's interest in advertising was on the wane after 1953.[35] As art director of *Holiday* magazine, he conceived a project that would pair Kauffer and his old friend T. S. Eliot on a riverboat journey down the Mississippi, a trip they would record in pictures and words. The plan was never realized.

"Kauffer's last years were bleak.... Exactness was his hallmark," wrote Schulman in a reminiscence for the *Yale Review*.[36] This included both his work ethic and sartorial style (he was always well attired). But self-discipline did not spare him from emotional pain. Schulman's mother wrote in a letter, "Poor Ted. He has emptied his life of everything but his work, and when that fails him he is lost."[37] "According to my father," Schulman adds, "Ted was downcast by the research he did for his illustrations of the *Borzoi Poe*. He had spent some weeks in Richmond and in Baltimore pursuing Poe's heavy footsteps."[38] Kauffer's investigation of Poe's emotional issues resulted in dark, emotionally haunting portraits of the poet. He related personally to Poe's hopelessness and fear of inevitable insanity.[39]

It is difficult not to look at Kauffer's New York oeuvre and see—even feel—the yawning chasm between the work he could do and the work he could not do in that city. Work itself might have been impossible in war-torn London, but peaceful New York did not provide solace. At once passionate about his art and frustrated by the demands of his clients, Kauffer wrote that Americans "are romantic and imaginative, responsive to the drama of presentation," and that America was a country of "intense light and dark contrasts, a wide, rich canvas against which to work."[40] He wanted dearly to be a part of it, yet the industry in which he worked tended toward impersonal, factory-style production and unadventurous forms that snubbed what he offered. A tribute by Moore summed up Kauffer's ethos much better than his *New York Times* obituary: "E. McKnight Kauffer is a very great artist. Instinctiveness, imagination, and the 'sense of artistic difficulty' with him, have interacted.... Mr. Kauffer's posters, book-jackets and illustrations, partake of one attitude which is affirmative in all directions, so that here if nowhere else in the world, 'street art' is art."[41]

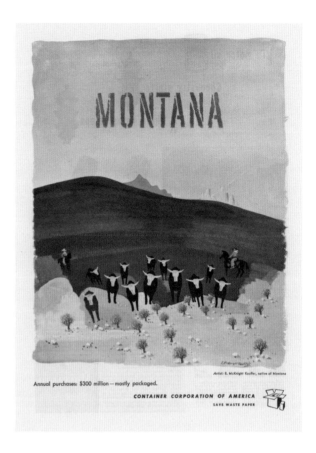

Annual purchases: $300 million—mostly packaged.

CONTAINER CORPORATION OF AMERICA
SAVE WASTE PAPER

32 Dorn, paraphrased in Haworth-Booth, *A Designer and His Public*, 86.
33 Waldman, speech notes, 1955. Box 2, folder 20, item 8, Waldman/Schulman Files, Personal Papers, E. McKnight Kauffer Archive, Cooper Hewitt.
34 Zachary, "E. McKnight Kauffer: Poster Designer," n.p.
35 Zachary, interview with the author.
36 Schulman, "Gift from a Lost World," 131, 127.
37 Marcella Waldman, quoted in Haworth-Booth, *A Designer and His Public*, 94.
38 Schulman, "Gift from a Lost World," 125.
39 See Desmond Flower, "The Book Illustrations of E. McKnight Kauffer," *Penrose Annual* 50 [1956]: 35–40.
40 Zachary, "E. McKnight Kauffer: Poster Designer," n.p.
41 Moore, introduction, in Kauffer, *Drawings for the Ballet and the Original Illustrations for Edgar Allan Poe*, n.p. [1].

12.12 (opposite) Poster, *American Airlines to California*, 1948
12.13 Print, *Montana*, ca. 1948, Container Corporation of America

1890 Edward Kauffer is born on December 14 in Great Falls, Montana, to Anna Johnson Kauffer and John Kauffer, a traveling musician. Shortly after his birth, the family returns to Evansville, Indiana, where his paternal grandmother lives.

1893 Kauffer's parents divorce. His mother finds work as a laundress for the St. George Hotel, Evansville, and puts Kauffer in an orphanage for the next two years.

1899 Anna Kauffer marries John M. Rees, a miner, who supports Kauffer's interest in drawing.

1904 Before the age of fourteen, Kauffer leaves school and finds work as a scene painter at Evansville's Grand Opera House.

1907 Kauffer joins a traveling repertory theater, working as a painter. He adopts the middle name Leland.

1909 Kauffer sends his parents a postcard with a photograph depicting one of his stage designs, the earliest recorded—a curtain for a theatrical production. He meets actor Frank Bacon, who invites him to work on Bacon's fruit ranch in California. Kauffer remains on the ranch for approximately six months.

1910 Kauffer moves to San Francisco. By day he works at a bookstore, Paul Elder & Company, while taking evening classes at the Mark Hopkins Institute of Art.

1912 Joseph McKnight, a patron of Elder's bookshop and a professor of elementary education at the University of Utah, is impressed by Kauffer's artistic abilities and offers to pay for his travel to Paris for further study. In tribute to him, Kauffer adopts the name McKnight. Before Kauffer's departure in August, Elder hosts a small exhibition of Kauffer's paintings in the bookshop's gallery. En route to Paris, Kauffer stops over in Chicago and begins formal studies in Antique at the Art Institute of Chicago. He exhibits several works in the *Twentieth Annual Exhibition of the Art Students' League of Chicago.*

1913 Kauffer concludes his studies at the Art Institute of Chicago. While in the city he sees the Armory Show. He leaves the United States by ship from Baltimore, passing through Algiers, Naples, and Venice before arriving in Munich to study for the summer. He arrives in Paris in the autumn and begins classes at the Académie Moderne.

1914 On July 7, he marries Grace Ehrlich, an American pianist studying at the Paris Conservatoire. Within weeks, World War I breaks out in Europe. Kauffer and his wife leave France for Durham, England, where they stay with Maria Zimmern Petrie, an artist with whom Grace McKnight Kauffer had shared a Paris apartment. Kauffer unsuccessfully seeks work as a poster and textile artist and works in a canteen.

1915 Kauffer establishes himself in London and pursues still life and landscape painting, examples of which are published in *Colour* magazine and exhibited at London's Chelsea Art Stores.

After a fortuitous meeting with Frank Pick, publicity manager of the Underground Electric Railways Company of London (UERL), he receives his first commission, for two posters advertising travel on the company's trains to some of London's rural surroundings. This results in a client relationship that will last through 1939.

1916 In May, Kauffer's first solo exhibition in England opens at Hampshire House, Hammersmith, London. The show features thirty-four paintings and drawings and six poster designs for the Underground; photographer Alvin Langdon Coburn writes the introduction to the catalog. During the summer, Kauffer and his wife stay in a cottage in Blewbury, Berkshire. Their neighbors include Coburn, children's-book writer Kenneth Grahame (author of *The Wind in the Willows*), and children's-book illustrator Susan Beatrice Webster. In June, two of Kauffer's paintings are included in the fourth London Group exhibition, at Goupil Gallery. In the fall, he becomes an official member of the London Group, and later its secretary; he will exhibit with the group a total of seven times between 1916 and 1919, at the Goupil and Mansard Galleries. He also joins the Cumberland Market Group. Kauffer is commissioned by William Zimmern, cousin of Maria Zimmern Petrie, to design a set of cotton-bale labels for Manchester textile company Steinthal & Co., intended for use on exports to South America. He creates a total of thirty-six labels over the next twelve years.

1917 Kauffer's design of eight birds in flight against a yellow background is published in a monthly feature in *Colour* magazine, Our Poster Gallery. A second design is purchased by the department store Derry & Toms, for which Kauffer will create five advertising posters over two years. Bloomsbury Group artist and critic Roger Fry writes the introduction to Kauffer's monographic show at the Royal Birmingham Society of Arts and brings the show to London for inclusion in his exhibition *The New Movement in Art*. Fry also keeps Kauffer's drawings available for sale at the Omega Workshop. Kauffer designs the first book jacket of his career, a vorticist figure in motion for D. H. Lawrence's *Look! We Have Come Through!*

1918 To save money, the Kauffers stay with Petrie in Edinburgh. On November 11, an armistice between Germany and the Allied powers is signed, ending World War I.

1919 After the tenth London Group exhibition, Kauffer resigns from the group, but will continue to create posters and promotional materials for its exhibitions through 1925. He becomes a founding member of the Arts League of Service (ALS), created to bring art, music, and theater to the masses through lectures, traveling stage productions, and more. Kauffer designs the ALS symbol as well as several theater sets and costumes. At the Twenty-One Gallery in London, the group organizes the *Arts League of Service Exhibition of Practical Arts,*

which features Kauffer's work. Francis Meynell, printer and editor of the *Daily Herald*, purchases Kauffer's *Flight* design and adapts it for an advertising campaign for the newspaper, *Soaring to Success! Daily Herald—the Early Bird*.

1920 Kauffer's only child, Ann, is born in October. The artist Wyndham Lewis forms the British avant-garde Group X, comprising himself, Kauffer, Jessica Dismorr, Frank Dobson, Frederick Etchells, Charles Ginner, Cuthbert Hamilton, William Roberts, John Turnbull, and Edward Wadsworth; they exhibit together once, at Mansard Gallery, before disbanding. Although Kauffer continues to exhibit paintings, and will return to painting as a largely personal pursuit throughout his life, he begins to focus more on commercial art. In November, American journalist Robert Allerton Parker meets him at his studio and designates him "A Commercial Artist with Ideals" in an article published in the journal *Arts & Decoration*. The UERL issues another group of Kauffer's posters.

1921 Kauffer creates a series of paintings for display outside headquarters of the oil company Shell. In the fall, he travels to New York for the exhibition *An American Poster Artist*, a selection of 100 of his works at the Arts and Decoration Gallery. During his visit he meets Marion Dorn, a textile designer from the San Francisco Bay Area. He designs posters for the New York Theatre Guild and becomes a council member of the ALS, along with the poet T. S. Eliot.

1922 Kauffer becomes Director of Pictorial and Poster Advertising for Gerard Meynell's Westminster Press, a printing company with high-profile clients including cosmetics manufacturer Pomeroy and pharmaceutical company J. C. Eno. Kauffer continues to design set, stage, and publicity materials for various theatrical productions. *Flight* is included in *Contemporary English Woodcuts* at the British Museum. Kauffer creates his first posters for the UERL's Museum poster series, advertising cultural institutions around London that are accessible by the railway.

1923 Kauffer designs the first of many dust jackets for Francis Meynell's new publishing company, Nonesuch Press—an edition of *The Week-End Book: A Sociable Anthology*, which will be published the following year. In the summer, Kauffer meets Dorn in Paris. They return to London together and Kauffer leaves his wife and daughter. Kauffer and Dorn take an apartment at 17 John Street, in London's Adelphi neighborhood.

1924 Kauffer edits *The Art of the Poster: Its Origin, Evolution & Purpose*, illustrating the history of poster making and serving as a manual for contemporary designers. He writes the introduction and dedicates the book to Pick. He designs more posters for the ALS, and writes an essay, "The Essentials of Poster Design," for the organization's annual bulletin. He also publishes "The Poster and Symbolism" in the *Penrose Annual*. He designs scenery for the play *Progress* at the New Theatre and directs *The Adding Machine* at The Strand, both presented by the Incorporated Stage Society in London.

1925 The Nonesuch Press commissions Kauffer to illustrate his first book, Robert Burton's *Anatomy of Melancholy* (1621). Kauffer also rents a studio from Francis Meynell at 16 Great James Street in Bloomsbury. Along with Ivor Montagu he is a founding member of London's Film Society, which aims to promote experimental cinema. He receives one of his first interior design commissions, an office for printer T. B. Lawrence. He designs a poster promoting *The Labour Woman*, the monthly journal of the Labour Party's women members. In May, the ALS holds a retrospective of Kauffer's posters, preparatory drawings, book jackets, and more in its London gallery, a show that subsequently travels to the Ashmolean Museum in Oxford. Kauffer designs the scenery and, with Dorn, the costumes for a production of the first English translation of Luigi Pirandello's *Henry IV* (1921), performed at the Everyman Theatre.

1926 Kauffer designs the main titles for Alfred Hitchcock's film *The Lodger*. He also designs two posters for the film, which are rejected, and a poster for Fritz Lang's *Metropolis* that is never produced. He experiments with using a stenciled watercolor technique to add color to his illustrations for Nonesuch's edition of Herman Melville's *Benito Cereno* (1855), which is printed by Curwen Press. A newly established government department, the Empire Marketing Board, commissions Kauffer to design a five-part billboard that promotes buying from intra-Empire producers.

1927 Kauffer joins the W. S. Crawford advertising agency, directed by Ashley Havinden, where he remains as a part-time designer for several years. New clients include Villiers motorcycles and Chrysler Motors. Kauffer illustrates "The Journey of the Magi," the first poem in Eliot's Ariel series, as well as several book jackets for its publisher, Faber & Gwyer Ltd.

1928 A London Group retrospective at the New Burlington Galleries includes two Kauffer paintings, while his posters appear in the exhibition *Twenty-One Years of Underground Posters* at the same venue. Kauffer and Dorn begin work on a group of carpet designs to be woven by the Wilton Royal Carpet Factory. Kauffer designs covers for a series of crime novels published by Victor Gollancz and scenery for a Gate Theatre Studio revival of *Fashion; or, Life in New York* (1845).

1929 The Arthur Tooth & Sons gallery holds an exhibition of Kauffer and Dorn's completed rugs, woven by Wilton Royal. Kauffer establishes a relationship with Jack Beddington, publicity manager of Shell. He creates his first lorry bill design, intended for display on the sides of a truck; it is featured in Shell's stand at London's *International Aero Exhibition*. This client relationship will last through 1939. Kauffer illustrates Arnold Bennett's

Elsie and the Child—Bennett has become a close friend—for Cassell and Daniel Defoe's *Robinson Crusoe* for Etchells & Macdonald.

1930 Kauffer is appointed art director of the printing company Percy Lund, Humphries & Co. He designs the carpets for the new home of Arthur Tooth's son, Dudley Tooth, at 41 Gloucester Square. Kauffer and Dorn move to 49 Chiltern Court, in Marylebone, London. In the fall, they collaborate on designs for Bennett's neighboring apartment, at 152 Chiltern Court. Kauffer's illustrations appear in editions of Cervantes's *Don Quixote* (1605/1616; Nonesuch), Eliot's *Marina* (Faber & Faber), and *The World in 2030 A.D.* by Frederick Edwin Smith (Hodder & Stoughton). He is commissioned by the New York publisher Alfred A. Knopf to illustrate Carl Van Vechten's *Nigger Heaven* (1926). Kauffer and Dorn are recognized as honorary fellows of the newly founded Society of Industrial Arts.

1931 Kauffer is included in *Exhibition of British and Foreign Posters* at London's Victoria and Albert Museum, the first major British museum exhibition devoted exclusively to poster art. Kauffer and Dorn move to the newly built Swan Court apartment building on Manor Street in Chelsea, London, establishing a studio in no. 139 with their living quarters in no. 141. Their neighbors include photographer Francis Bruguière and E. C. (Peter) Gregory, the managing director of Percy Lund, Humphries. Kauffer's work is included in *An Exhibition of Modern Pictorial Advertising by Shell*, at the New Burlington Galleries, London.

1932 Sidney Garrad applies to serve as Kauffer's studio assistant at Swan Court. Maintaining the post through 1940, he will handle most of the lettering on Kauffer's posters. Kauffer receives his first commission from Great Western Railway for six posters advertising travel to Devon and Cornwall. He designs the sets and costumes for Ernest Milton's production of Shakespeare's *Othello* at the St. James's Theatre. Kauffer and Dorn's rugs appear in the exhibition *Room and Book*, at the Zwemmer Gallery, and a tapestry by Kauffer is shown in *Modern Decoration and Design for Walls, Panels and Screens,* at Carlisle House.

1933 In December, *An Exhibition of Photographs by Francis Bruguière in Collaboration with E. McKnight Kauffer* opens at Lund, Humphries Galleries, a space that highlighted important contemporary designers including Zero (Hans Schleger) and Jan Tschichold. Kauffer is commissioned by the General Post Office (GPO) to create promotional posters about the mail, telephone, and telegraph services.

1934 Kauffer is made an honorary fellow of the Council for Art and Industry, chaired by Pick. Along with Man Ray and Bruguière, he creates catalogs and advertisements for corset manufacturer Charnaux. He designs a cover for Dashiell Hammett's novel *The Maltese Falcon* (1930), the first of many he will create for the Modern Library, New York, up until the year of his death.

Kauffer designs scenery and costumes for *Queen of Scots* at the New Theatre.

1935 Kauffer assists Wells Coates in the design of Embassy Court in Brighton, creating a large mural that combines photography and painting in the entrance hall. Colin Anderson hires Kauffer to design for the *Orion*, a new Orient Line vessel; his work includes a mirror for the dining room, luggage labels, and various printed matter, while Dorn contributes carpets and curtains for many of the first-class social spaces. Kauffer designs book jackets *5 On Revolutionary Art*, edited by Betty Rea (Wishart) and H. G. Wells's *Things to Come* (Cresset Press). His work appears in the first exhibition curated by Ernestine Fantl at New York's Museum of Modern Art (MoMA), *European Commercial Printing of Today*. Lund, Humphries Galleries organizes a solo exhibition, *The Work of E. McKnight Kauffer*. Kauffer joins the Advisory Council of the Victoria and Albert Museum.

1936 Kauffer temporarily separates from Dorn, staying first at London's Mount Royal Hotel, then moving to a hotel in Aix-en-Provence, France. Garrad maintains Kauffer's studio at Lund, Humphries. Kauffer continues to experiment with photography, creating photomurals for Earl's Court Tube station. His work is included in two exhibitions at MoMA, *Cubism and Abstract Art* (organized by Alfred H. Barr, Jr., the museum's founding director) and *Modern Painters and Sculptors as Illustrators* (organized by Monroe Wheeler), which features Kauffer's book illustrations.

1937 MoMA presents *Posters by E. McKnight Kauffer*, the institution's first monographic exhibition of an American graphic designer, featuring eighty-five posters. Huxley writes the foreword to the catalog. Kauffer collaborates with choreographer Ninette de Valois and composer Arthur Bliss to create a ballet, *Checkmate*, which premieres at the *Exposition Internationale des arts et techniques dans la vie moderne* in Paris before opening in London at the Sadler's Wells Theatre. Kauffer and Dorn design promotional brochures, textiles, and carpets for a second Orient Line vessel, *Orcades*. Kauffer designs a poster for the Spanish Medical Aid Committee soliciting aid from the British public in response to the Spanish Civil War. Britain's Royal Society of Arts gives Kauffer the distinction Honorary Royal Designer for Industry.

1938 Kauffer and Dorn lease the White House in Northend, Buckinghamshire. Kauffer designs a series of ice-skating costumes and a program cover for *Dashing Blades*, at Blackpool Pleasure Beach's Ice Drome. He designs posters for various war-relief organizations, including posters for Air Raid Precautions and the International Brigade Dependants and Wounded Aid Committee. His work is featured in *Exhibition of Pictures in Advertising by Shell-Mex & B.P. Ltd.* at Shell-Mex House in London.

1939 Kauffer designs posters and printed materials for the Festival of Music for the People, a political

event organized both to bring together disparate groups of left-wing artists and intellectuals and to raise funds in support of Republican forces in the Spanish Civil War. On September 3, two days after Germany invades Poland, Britain and France declare war on Germany.

1940 Kauffer designs a cover for *Harper's Bazaar, Advance Paris Fashions*. That summer, he and Dorn leave England for New York on the SS *Washington*. Kauffer immediately undertakes the design of posters in support of the war effort for organizations including Britain's Ministry of Information. He begins to design book covers steadily for Alfred A. Knopf, a client relationship that will last through 1949.

1941 Kauffer gives an address at the Art Directors Club of New York. Monroe Wheeler commissions Kauffer to design posters, invitation cards, and catalog covers for MoMA exhibitions, including *Organic Design in Home Furnishings* and *Britain at War*. In the fall, Kauffer is featured in the exhibition *The Advance Guard of Advertising Artists*, at the Katharine Kuh Gallery, Chicago, alongside Frank Barr, Herbert Bayer, Lester Beall, Jean Carlu, György Kepes, Herbert Matter, László Moholy-Nagy, Paul Rand, and Ladislav Sutnar. Kauffer suffers a mental breakdown as the year ends.

1942 Kauffer and Dorn move to 40 Central Park South. The Ringling Bros. and Barnum & Bailey circus becomes a new client for Kauffer. He designs the cover and illustrations for Langston Hughes's *Shakespeare in Harlem* (Alfred A. Knopf), as well as his first book jackets for Random House, including *Farewell Pretty Ladies* by Chris Massie, beginning a client relationship that will last through 1951.

1943 Kauffer's war-relief work continues with posters for Friends of Greece, American Friends of Norway, the Office of Civilian Defense, and the CAA War Training Service. He receives a certificate from the US Treasury Department "for distinguished services rendered on behalf of the War Savings Program." He meets Bernard Waldman, founder and president of the Modern Merchandising Bureau, who engages him to design an advertisement for American Silk Mills that will be printed in the *New York Times*. Waldman then commissions Kauffer's first poster series for American Airlines. Kauffer designs the book jacket for Erich Kähler's *Man the Measure: A New Approach to History*, his first for Pantheon Books, beginning a client relationship that will last until 1952.

1945 May 8, V-E Day (Victory in Europe Day), marks Germany's surrender in World War II. Kauffer receives a Certificate of Honor from the American Red Cross for his posters for their contribution campaign, the most notable of which was *Give*. The Container Corporation of America commissions a depiction of Montana, where Kauffer was born, for a magazine series on the American states. Kauffer travels west with Waldman for inspiration.

1946 Kauffer illustrates two volumes of *The Complete Poems and Stories of Edgar Allan Poe* for Knopf, traveling to visit Poe's archive for research.

1947 Kauffer revisits his *Checkmate* designs for a revival of the ballet, which is presented first at Covent Garden in London and later used in venues across the United States on the Vic-Wells ballet company's inaugural American tour. He is made an honorary advisor to the United Nations' Department of Public Information and designs posters for the newly formed unit. New York Subways Advertising Co. Inc. becomes a client. Kauffer writes the introduction to the American designer Paul Rand's book *Thoughts on Design*.

1948 Kauffer speaks at the annual conference of MoMA's Committee on Art Education. He designs travel posters for Pan American World Airways while continuing to produce posters for American Airlines promoting travel to destinations across North America and Europe. Several of Kauffer's book jackets are included in the first exhibition of the Book Jacket Designers Guild, at the A-D Gallery in New York.

1949 *Art for All: London Transport Posters 1908–1949* opens at London's Victoria and Albert Museum; the exhibition juxtaposes original designs with completed posters made by Kauffer and other artists throughout the UERL's history.

1950 Dorn and Kauffer marry at City Hall, New York. He travels to the Southwest with Waldman. Alexey Brodovitch, art director of *Harper's Bazaar*, includes a profile on Kauffer, authored by Frank Zachary, in his short-lived quarterly *Portfolio*.

1952 In January, Kauffer's mother dies in Los Angeles. Kauffer receives an honorary diploma from London's Royal College of Art "in recognition of Distinguished Services to Design for Industry." Kauffer designs the dust jacket for Ralph Ellison's *Invisible Man* (Random House).

1954 Kauffer continues his work for the Modern Library with Théophile Gautier's *Mademoiselle de Maupin*. His final poster is *Japan via Pan American* and his final book jacket is for Marianne Moore's *Fables of La Fontaine* (Viking Press). In the summer, Kauffer is admitted to Lenox Hill Hospital. On October 13, he returns to the hospital, where he dies on the 22nd of the month. He is buried at Woodlawn Cemetery in the Bronx, New York. On October 23, Kauffer's obituary, headlined "Edward McKnight Kauffer, Poster Designer," appears in the *New York Times*.

E. McKnight Kauffer

Attraction, interest, and stimulation are the three cardinal points to be considered in the designing of posters. Whatever material the designer is given it is used in much the same way as the baker uses flour, water and minor ingredients for the making of bread. That is to say, a poster is composed of message, picture or symbol and the use of design with which the designer makes manifest attraction, interest and stimulation. This being the case the designer uses what ever [*sic*] his craft can give him, and no means are too arbitrary or too classical. He may do any conceivable thing, make any new departure, provided these means justify the end.

E. McKnight Kauffer, "The Essentials of Poster Design,"
Arts League of Service Bulletin 1923–1924

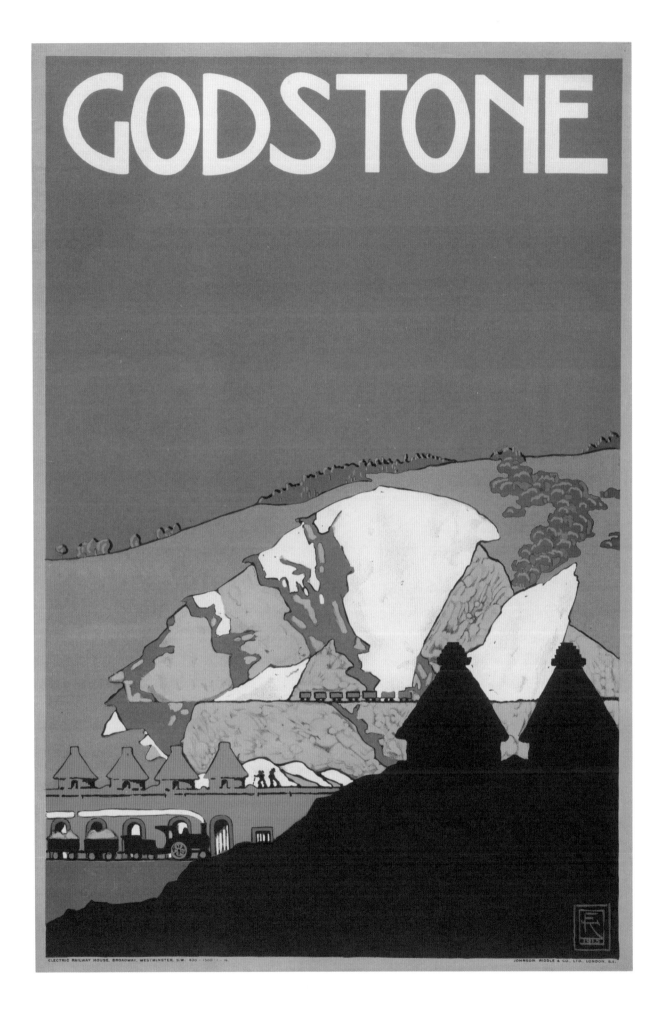

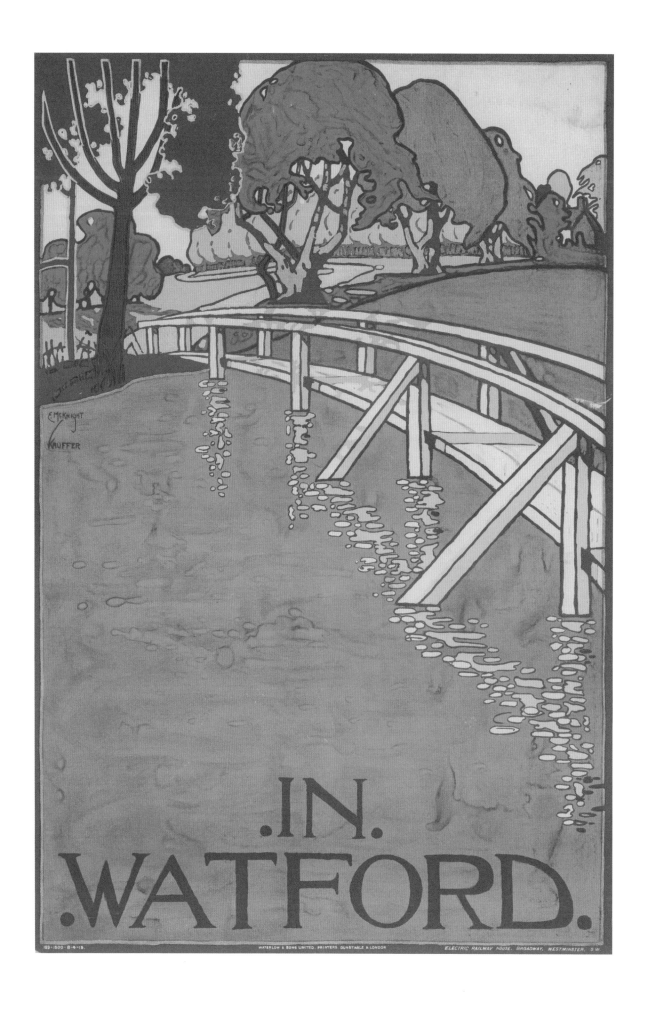

.IN.
WATFORD.

003 Poster, *In Watford*, 1915

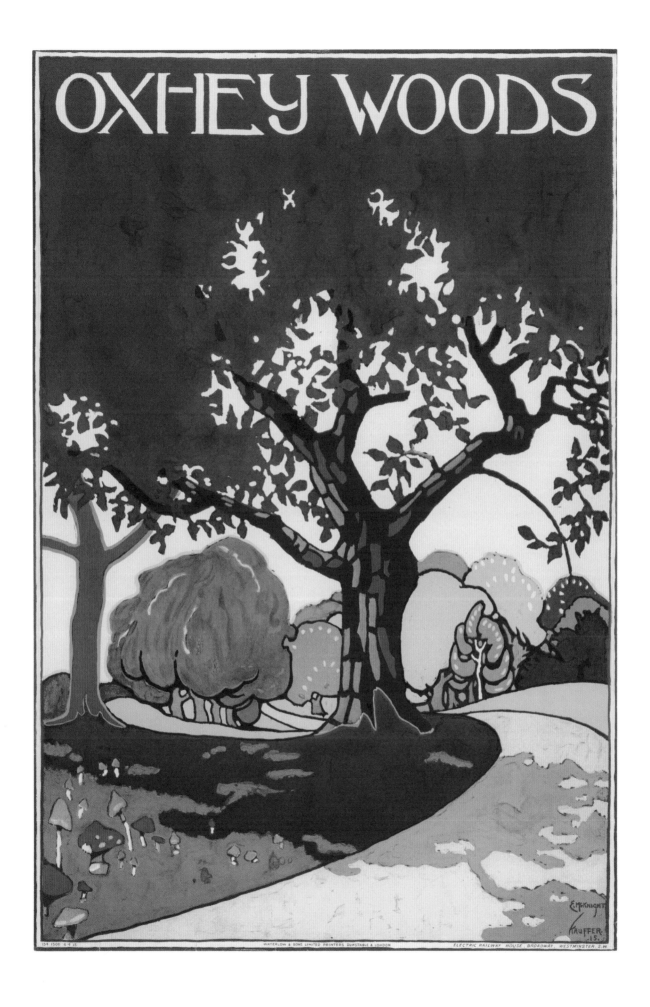

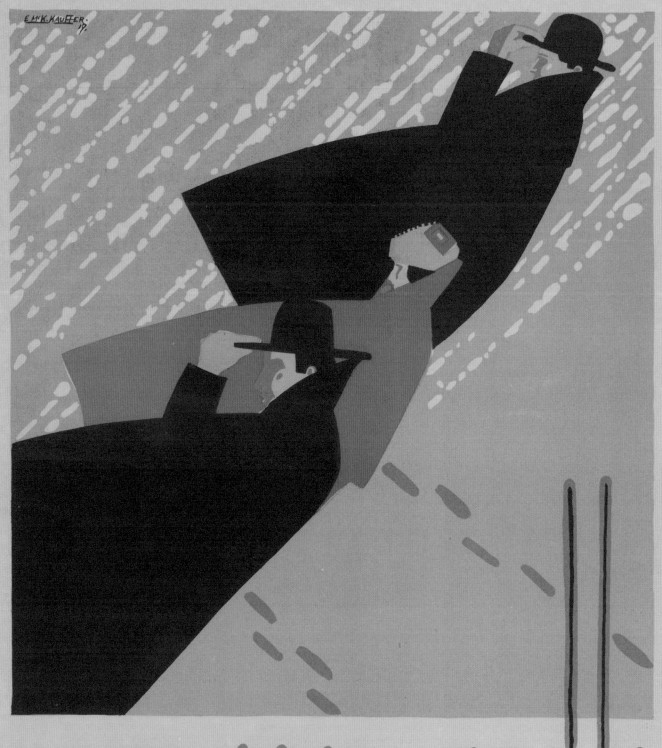

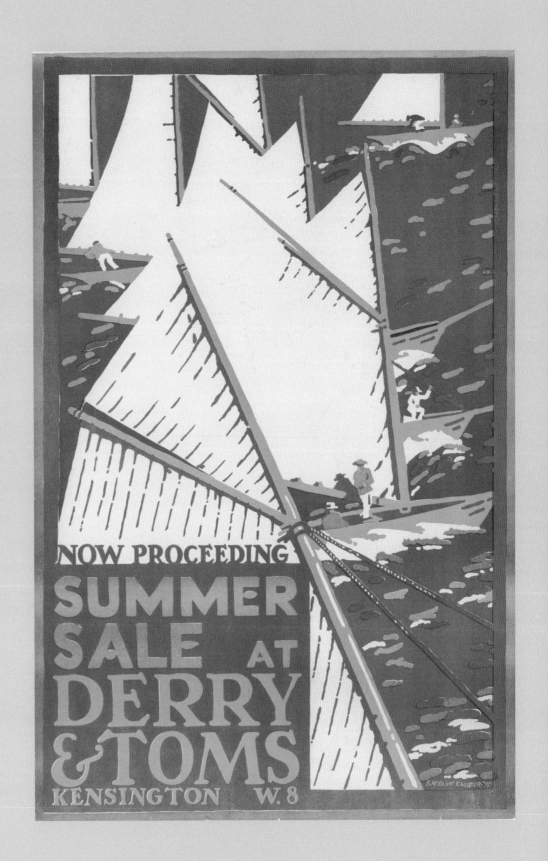

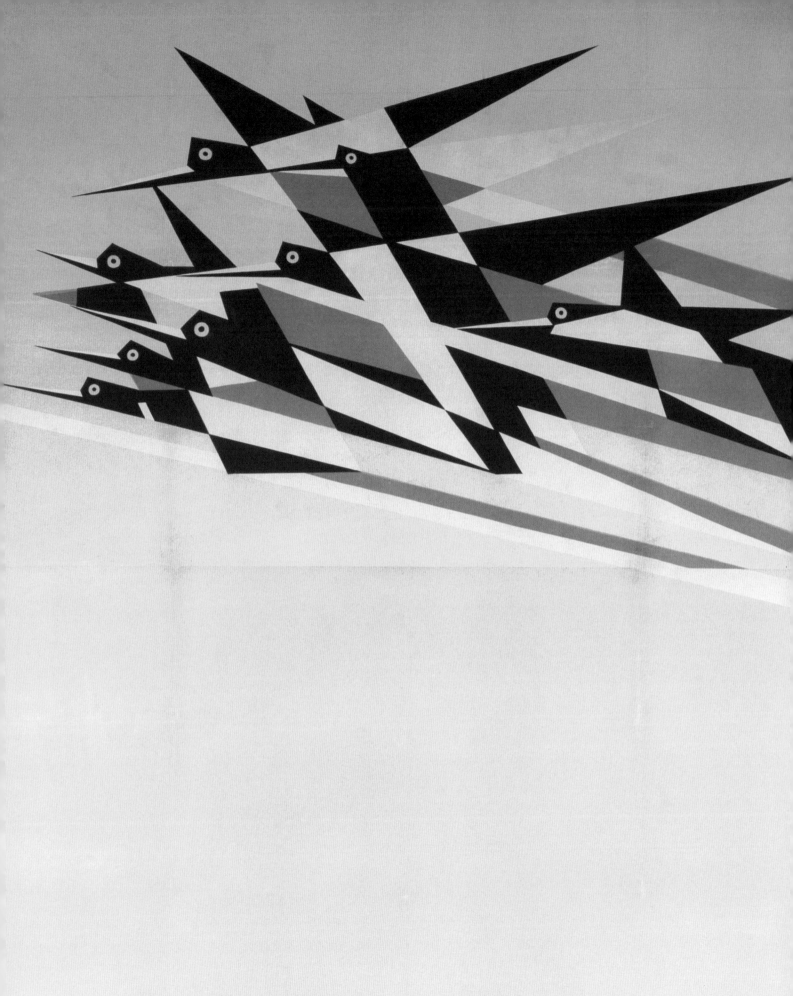

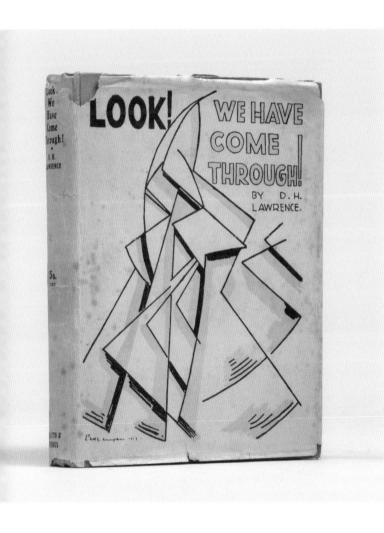

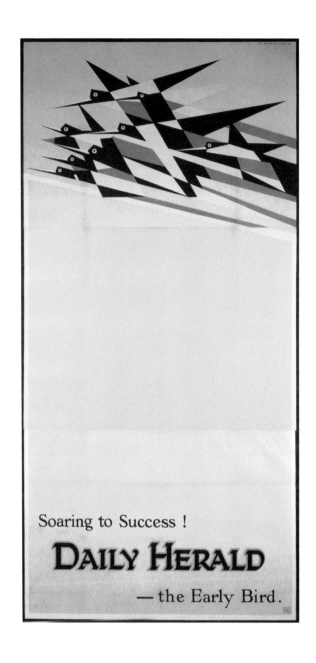

EL PROGRESO

NO MTS YDS

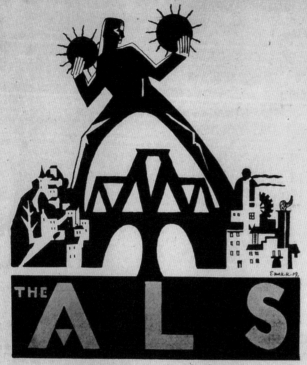

THE ARTS LEAGUE OF SERVICE

A Course of Lectures on

MODERN TENDENCIES IN ART

at 8.45 p.m.

CENTRAL BUILDINGS
WESTMINSTER

Wednesday, Oct. 22 **"PAINTING"** WYNDHAM LEWIS
Chairman: GEORGE BERNARD SHAW

Tuesday, Oct. 28 **"POETRY"** T. S. ELIOT
Chairman: LAURENCE BINYON

Wednesday, Nov. 12 **"DANCING"** MARGARET MORRIS

Thursday, Nov. 27 **"MUSIC"** EUGÈNE GOOSSENS

Single Tickets, 5s. (Members, 50°/₀ reduction). Apply 1 Robert Street, Adelphi, W.C.2 (Tel. No. Regent 779)

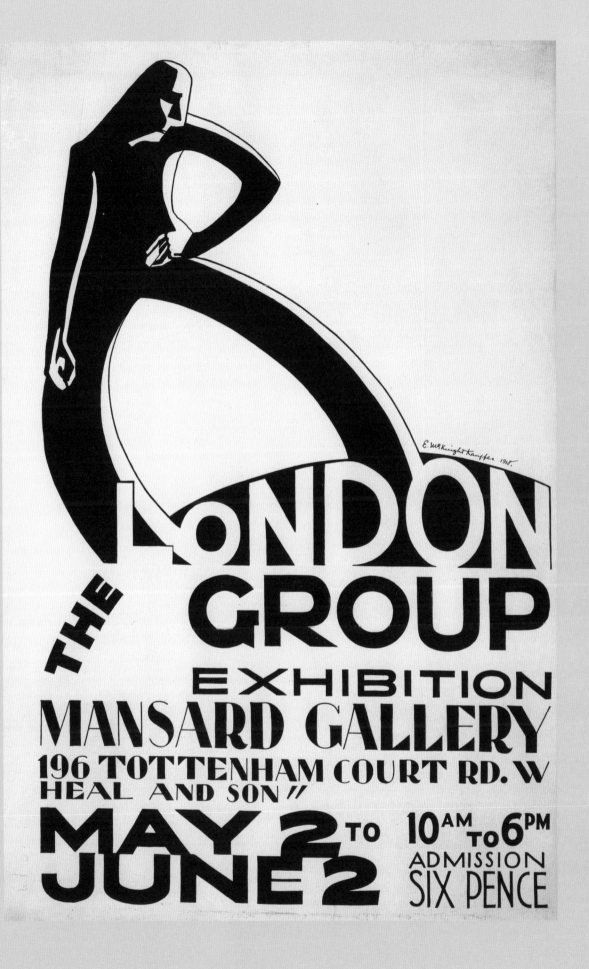

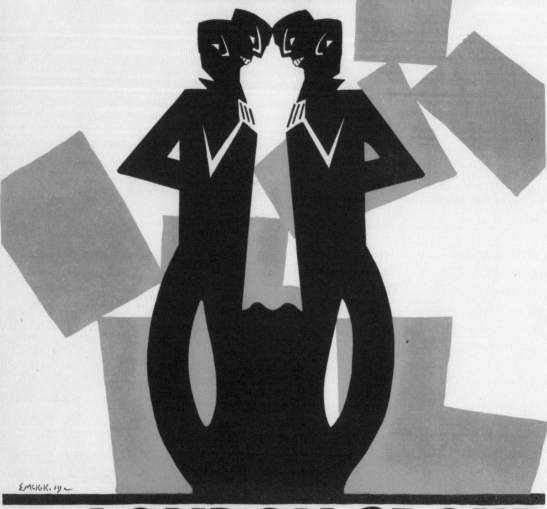

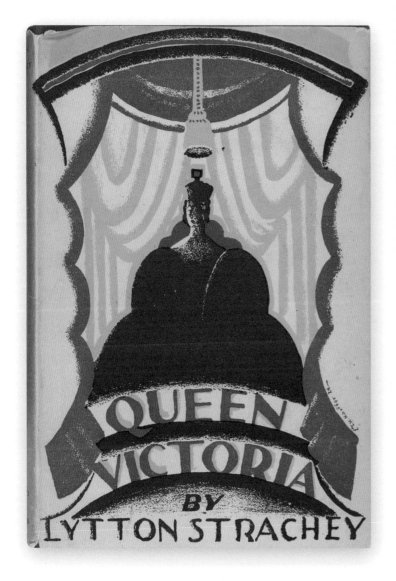

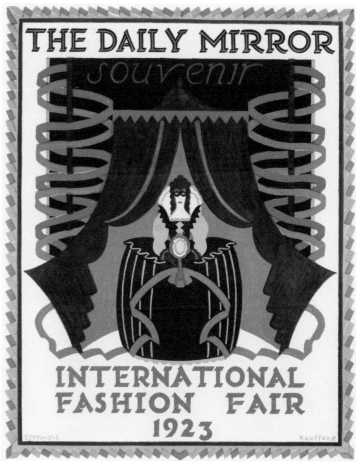

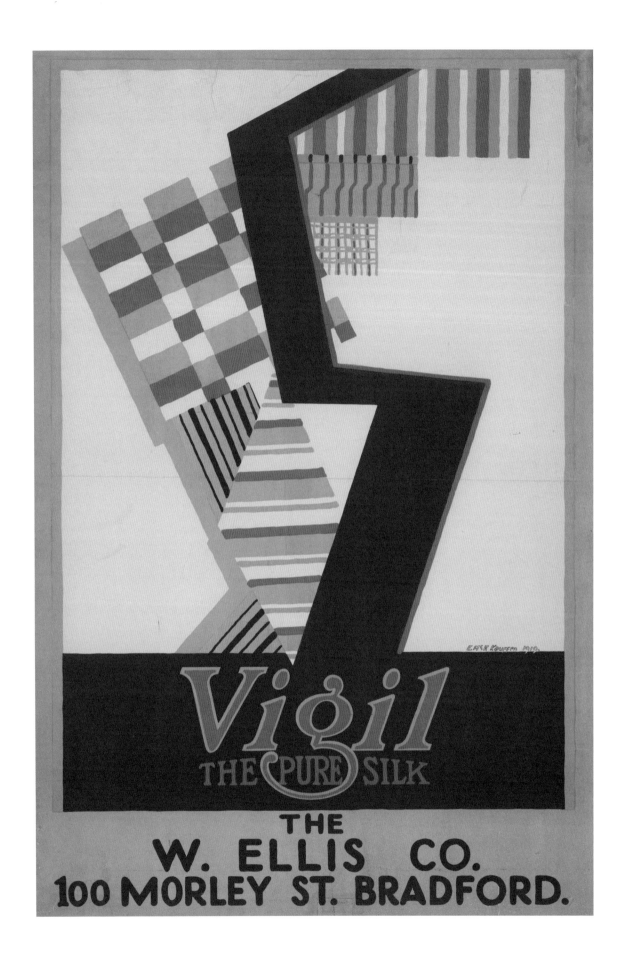

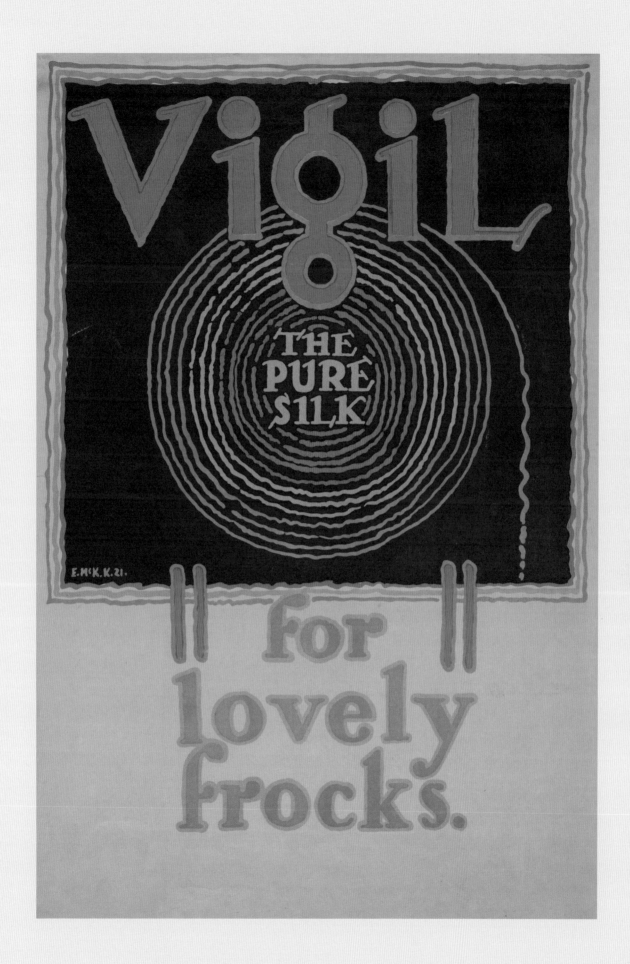

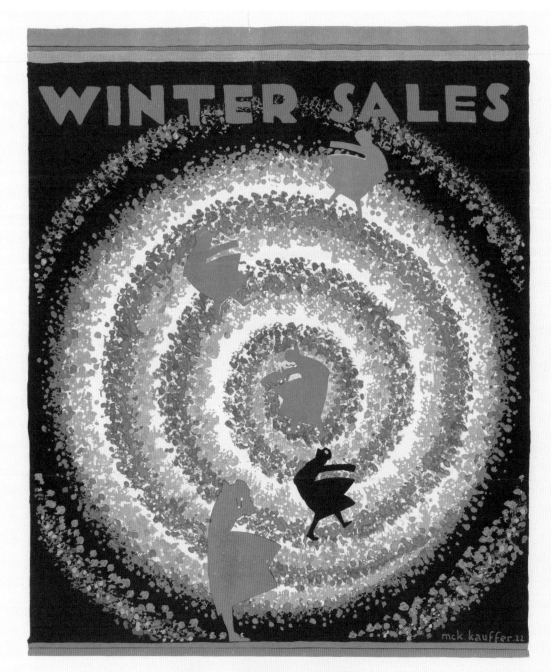

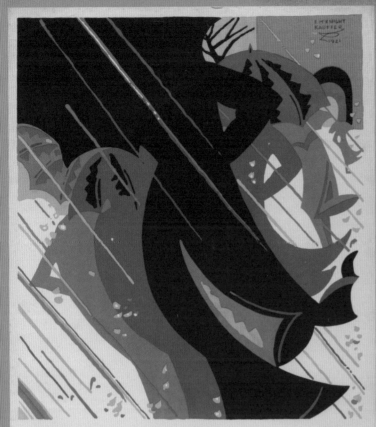

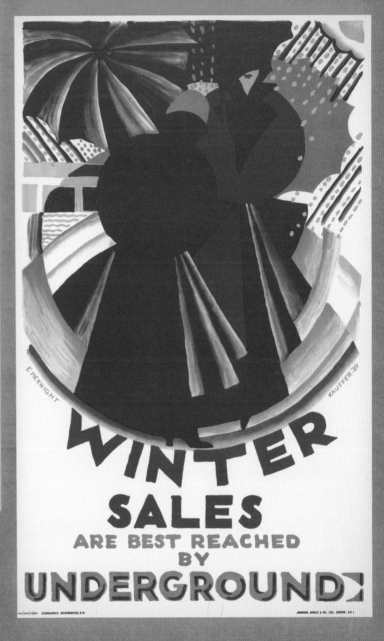

022 (left) Poster, *Winter Sales Are Best Reached by Underground*, 1921 023 (right) Poster, *Winter Sales Are Best Reached by Underground*, 1924

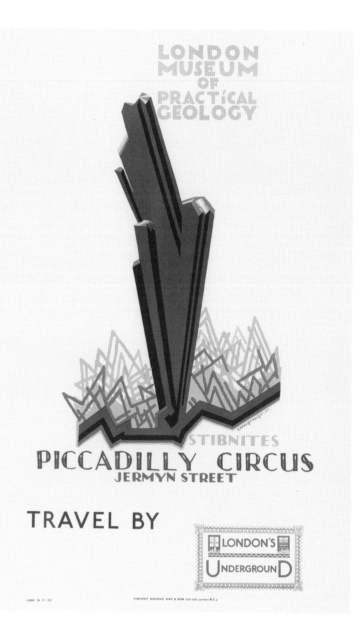

024 (left) Book cover, *The Week-End Book: A Sociable Anthology* by Vera Mendel and Francis Meynell, eds., 1924
025 (right) Poster, *London Museum of Practical Geology*, 1921, printed 1922
026 (opposite) Journal cover, *The Chapbook, A Monthly Miscellany* by Harold Munro (ed.), April 1923

Number 36] THE [April 1923

CHAPBOOK

(A MONTHLY MISCELLANY)

NEW AMERICAN POEMS

ONE SHILLING NET

VIM

VIM—WOW!—IT'S WILD WHEN DIRT
GETS IN ITS WAY IS VIM ★ VIM
CLEANS POTS · PANS · CUTLERY ·
CROCKERY · BATHS AND SINKS · TILES
AND PORCELAIN · GLAZED AND
ENAMELLED SURFACES · FLOORS
AND TABLES · DISHES · COOKING
VESSELS · COOKING STOVES AND
ALL KITCHEN UTENSILS : MAKES
THEM LIKE NEW ★ VIM WHIZZES
DIRT AWAY ★ LEVER BROTHERS
LIMITED · PORT SUNLIGHT

027 (opposite) Print, *VIM*, ca. 1923
028 Book cover, *The Modern Movement in Art* by R. H. Wilenski, 1927
029 (overleaf) Poster, *London History at the London Museum*, 1922, printed 1923

LONDON HISTORY AT THE

LONDON MUSEUM

DOVER STREET

OR ST. JAMES'S PARK STATION.

E.McK. KAUFFER. 22

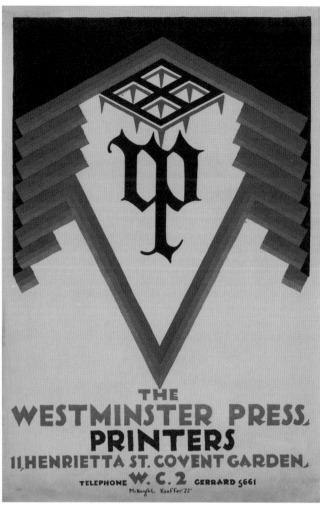

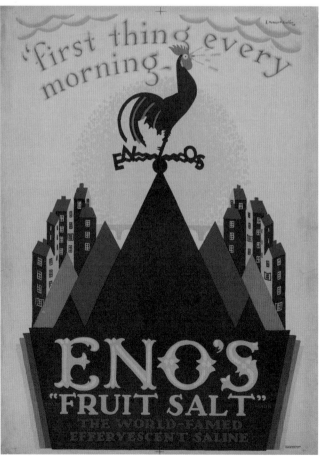

SUMMERTIME,
PLEASURES ~ BY
UNDERGROUND

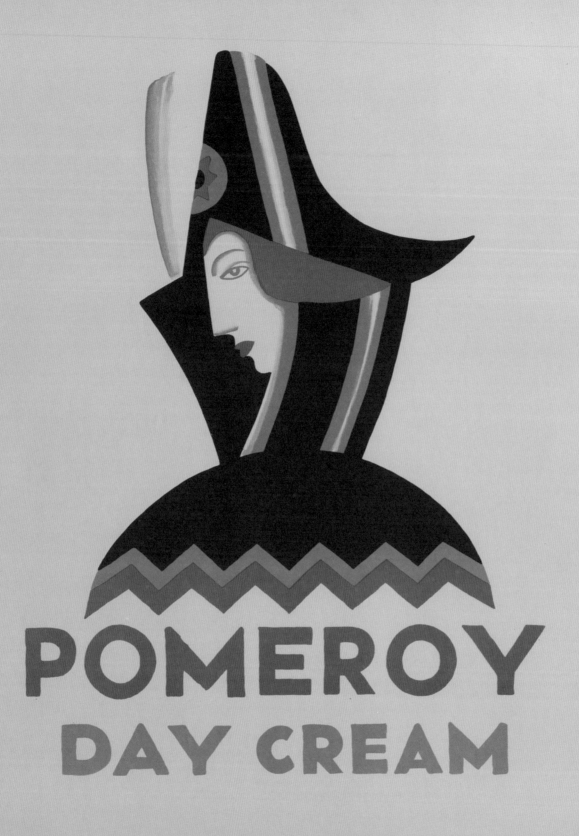

POMEROY
DAY CREAM

HELPS THE PLAIN
IMPROVES THE FAIR

kauffer. 1922

THE WESTMINSTER PRESS HARROW ROAD W 2

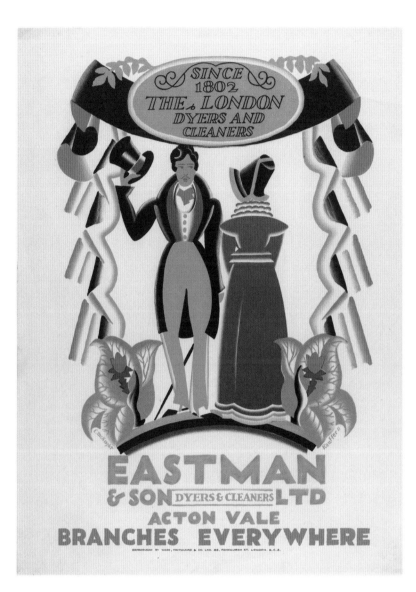

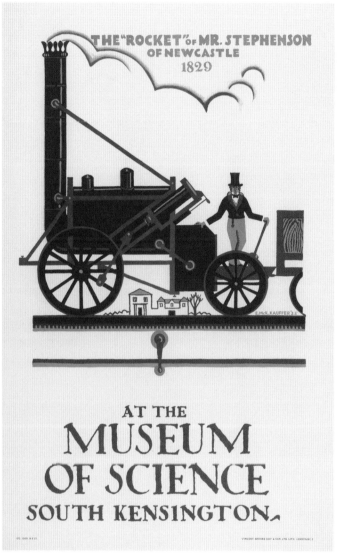

033 (opposite) Poster, *Pomeroy Day Cream*, 1922
034 (left) Poster, *Eastman & Son Ltd., Since 1802, The London Dyers and Cleaners*, 1923
035 (right) Poster, *The "Rocket" of Mr. Stephenson of Newcastle at the Museum of Science*, 1922, printed 1923

036 (left) Bookplate, The Play's the Thing, Ifan Kyrle Fletcher, ca. 1920
037 (right) Book cover, *Babel* by John Cournos, 1928
038 (opposite) Poster, *Eastman and Son, The London Dyers and Cleaners*, 1927

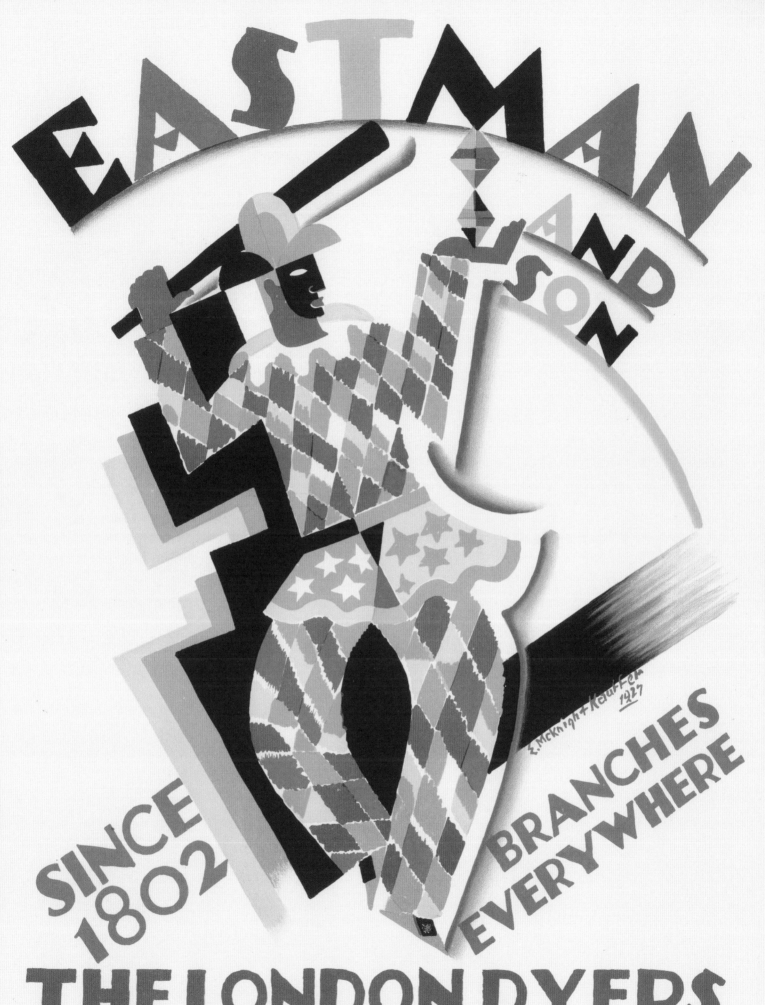

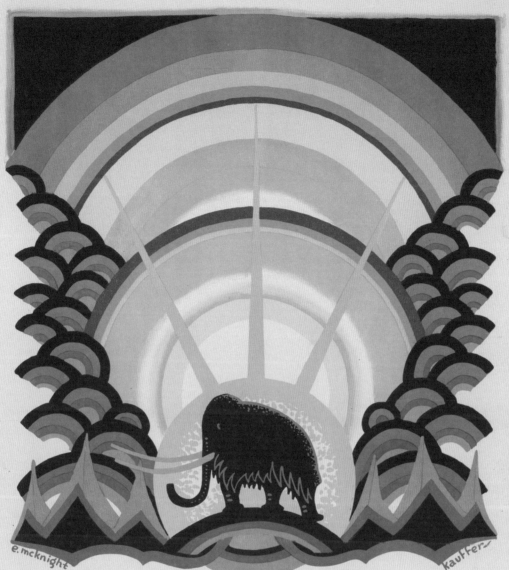

MUSEUM OF
NATURAL
HISTORY
SOUTH KENSINGTON

THE LODGER

E. Mcknight Kauffer '26

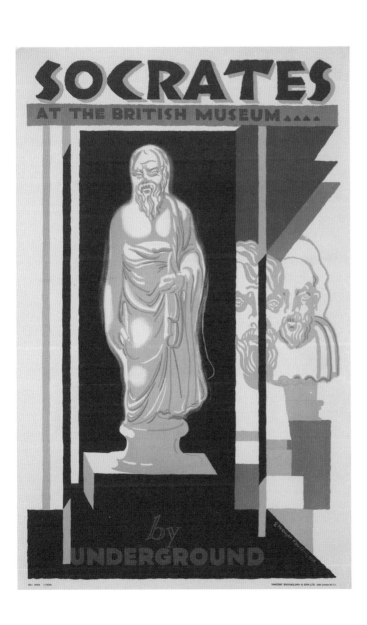

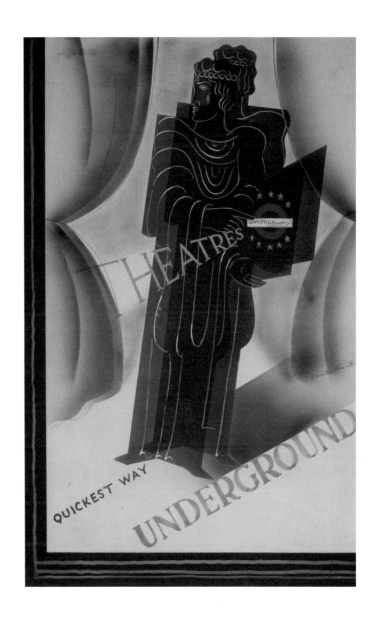

042 (opposite) Drawing, Design for *The Lodger* by Alfred Hitchcock, 1926
043 (left) Poster, *Socrates at the British Museum*, 1926

044 (right) Drawing, Design for *Theatres, Quickest Way Underground*, 1930
045 (overleaf) Poster, *Power, The Nerve Centre of London's Underground*, 1930, printed 1931

THE

NERVE CENTRE
OF LONDON'S

UNDERGROUND

EMcKnight Kauffer 1930.

17. 1500. 1/31

THE GATE THEATRE STUDIO

JANUARY 29TH
AT 9 UNTIL
FEBRUARY 16TH

12,000

FROM THE GERMAN OF BRUNO FRANK

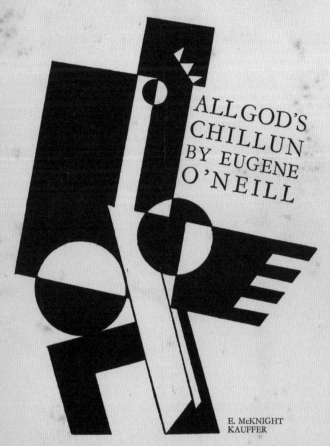

THE GATE THEATRE STUDIO

PETER GODFREY, LTD., 16a, VILLIERS STREET, STRAND, W.C. 2

ALL GOD'S
CHILLUN
BY EUGENE
O'NEILL

E. McKNIGHT
KAUFFER

ON TUESDAY, THE TWENTIETH OF NOVEMBER, AND NIGHTLY
AT NINE UNTIL SATURDAY, THE FIFTEENTH OF DECEMBER

046 (left) Brochure, *12,000, The Gate Theatre Studio*, 1928
047 (right) Brochure, *All God's Chillun, The Gate Theatre Studio*, 1929
048 (opposite) Drawing, Study for two figures embracing, 1930s

182

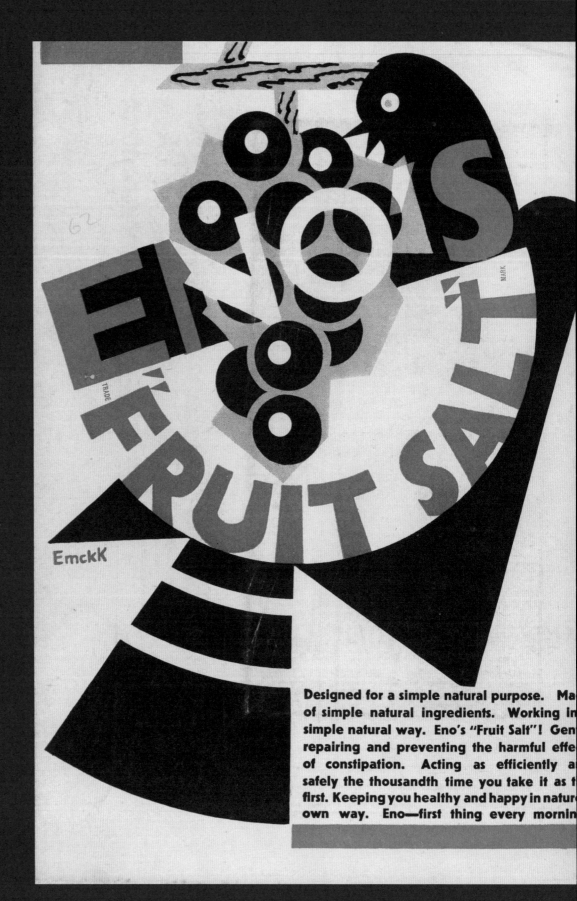

Designed for a simple natural purpose. Ma[de]
of simple natural ingredients. Working in [a]
simple natural way. Eno's "Fruit Salt"! Gen[tly]
repairing and preventing the harmful effe[cts]
of constipation. Acting as efficiently a[nd]
safely the thousandth time you take it as t[he]
first. Keeping you healthy and happy in natur[e's]
own way. Eno—first thing every mornin[g]

THE STUDIO

FOUNDED IN 1893

VOL. 97 NO. 430

JANUARY

1929

2s. net

THE

MIRROR OF ACHIEVEMENT

049 (opposite) Magazine cover (verso), Eno's Fruit Salt, *The Studio*, January 1929
050 Magazine cover (recto), *The Studio*, January 1929

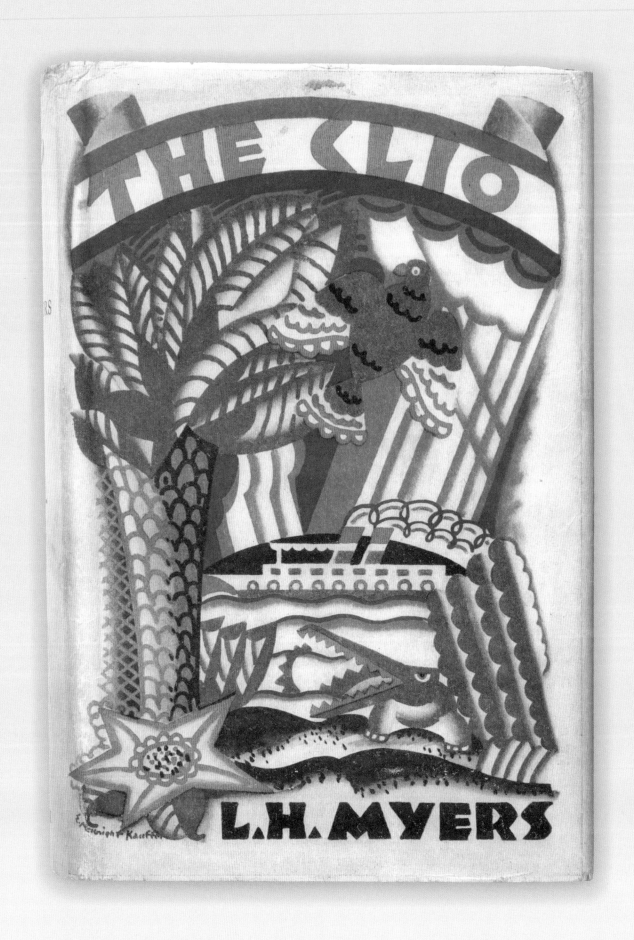

051 (opposite) Book cover, *The Clio* by L. H. Myers, 1925
052 (top left) Book cover, *Elsie and the Child* by Arnold Bennett, 1929
053–055 Prints, Illustrations for *Elsie and the Child* by Arnold Bennett, 1929

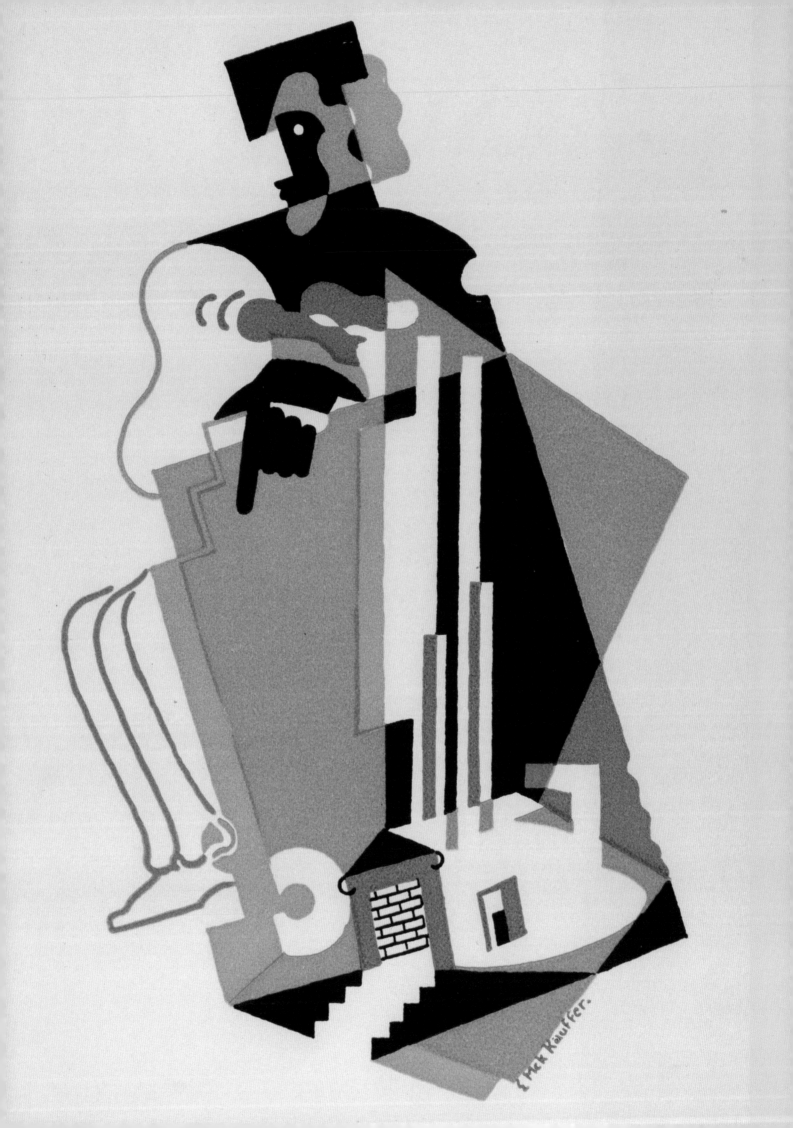

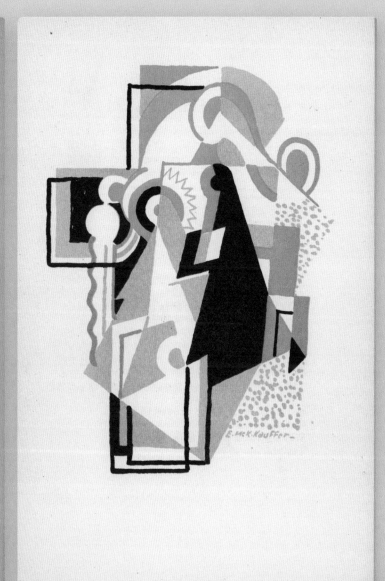

056 (opposite) Book illustration, *A Song for Simeon* by T. S. Eliot, 1928
057 (left) Book cover, *Journey of the Magi* by T. S. Eliot, 1927
058 (right) Book illustration, *Journey of the Magi* by T. S. Eliot, 1927

189

059–060 Prints, Illustrations for *Robinson Crusoe* by Daniel Defoe, 1929
061 (opposite) Drawing, Illustration for *Marina* by T. S. Eliot, 1930

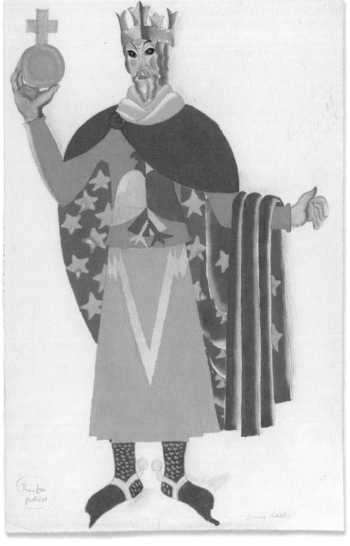

062 (left) Drawing, Costume design: Berthold for *Henry IV* by Luigi Pirandello, 1925
063 (right) Drawing, Costume design: Henry IV for *Henry IV* by Luigi Pirandello, 1925
064 (opposite) Drawing, Costume design: Caliban for *The Tempest* by William Shakespeare, ca. 1932

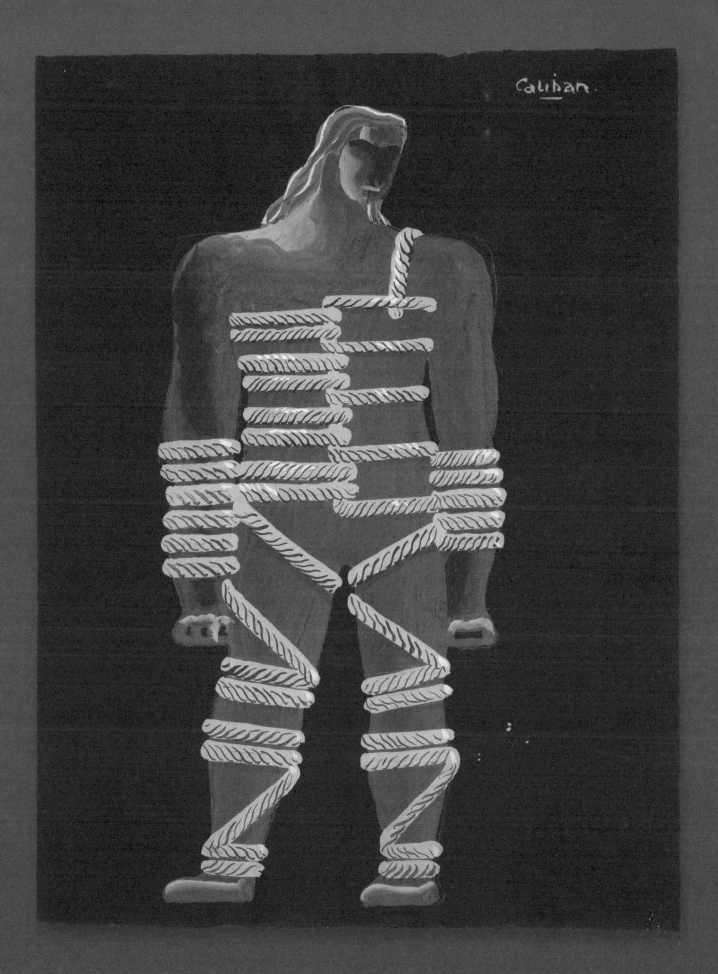

Caliban.

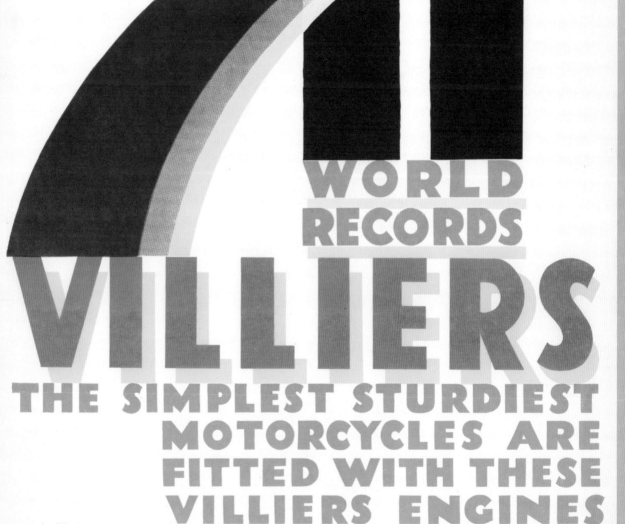

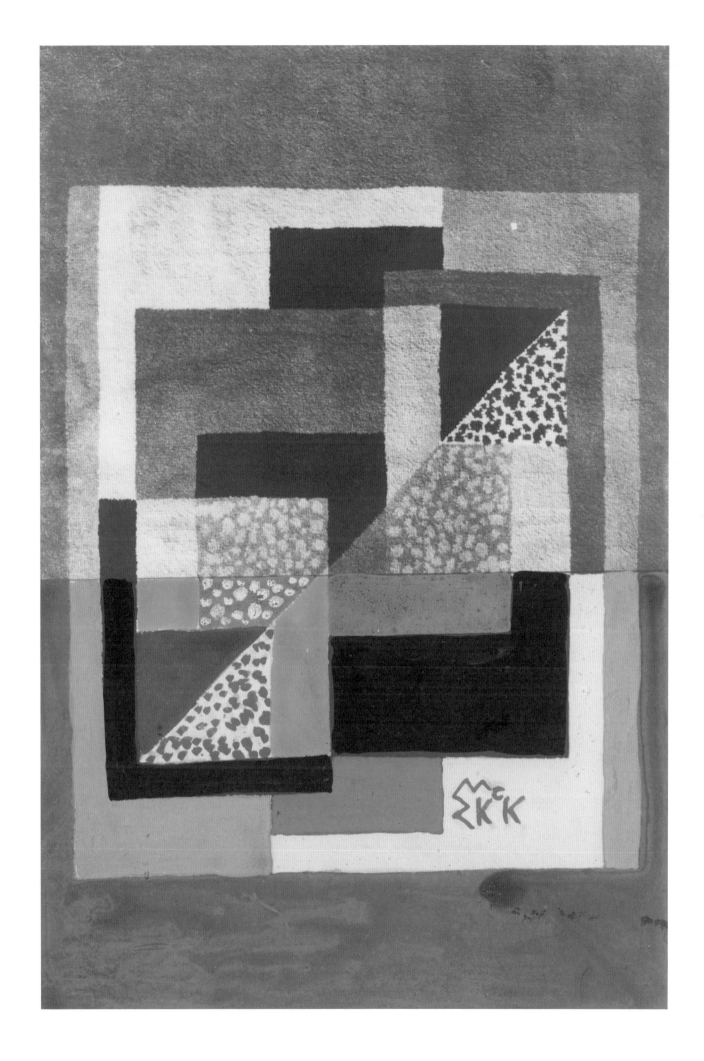

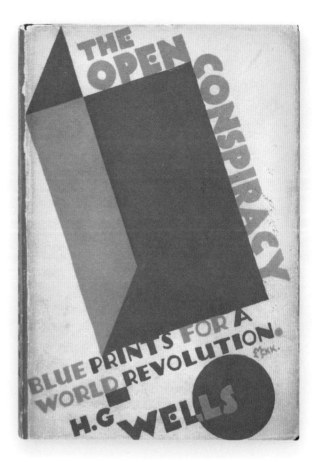

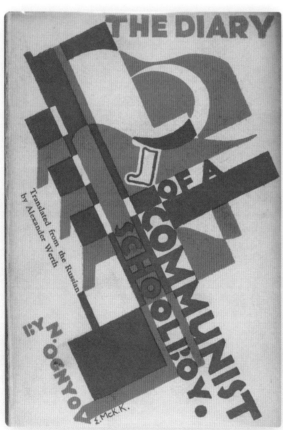

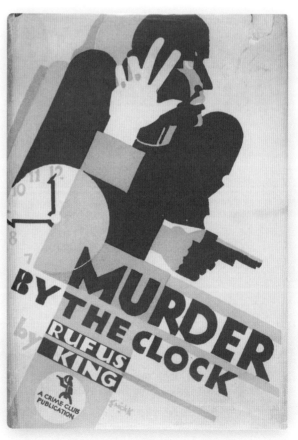

070 (top left) Book cover, *Expressionism* by Hermann Bahr, 1925
071 (top right) Book cover, *The Open Conspiracy* by H. G. Wells, 1928
072 (bottom right) Book cover, *Murder by the Clock* by Rufus King, 1929
073 (bottom left) Book cover, *The Diary of a Communist Schoolboy* by Nikolai Ognyov, 1928

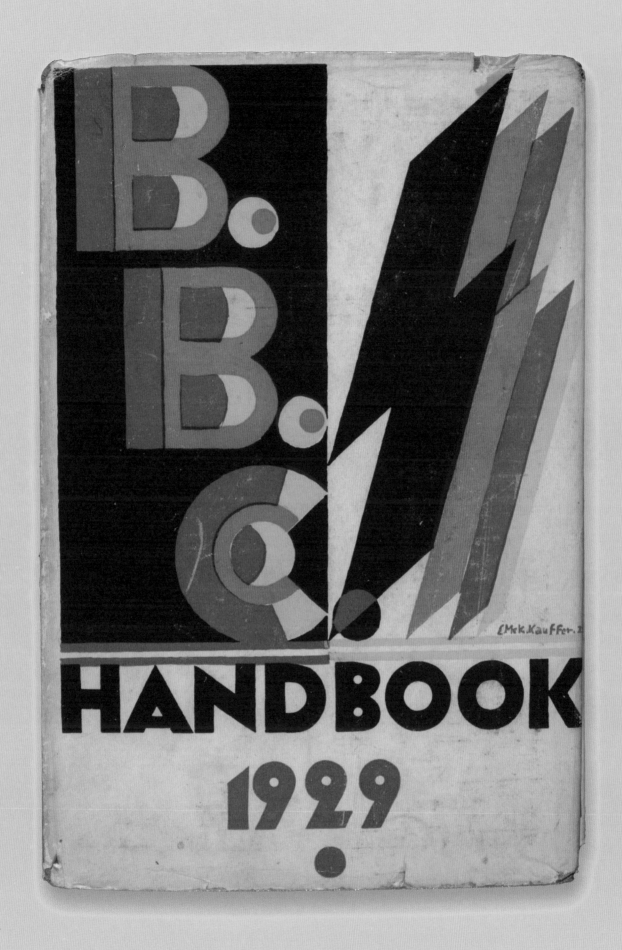

074 Book cover, *BBC Handbook*, 1929
075 (overleaf) Drawing, Design for Eno's Fruit Salt, 1931

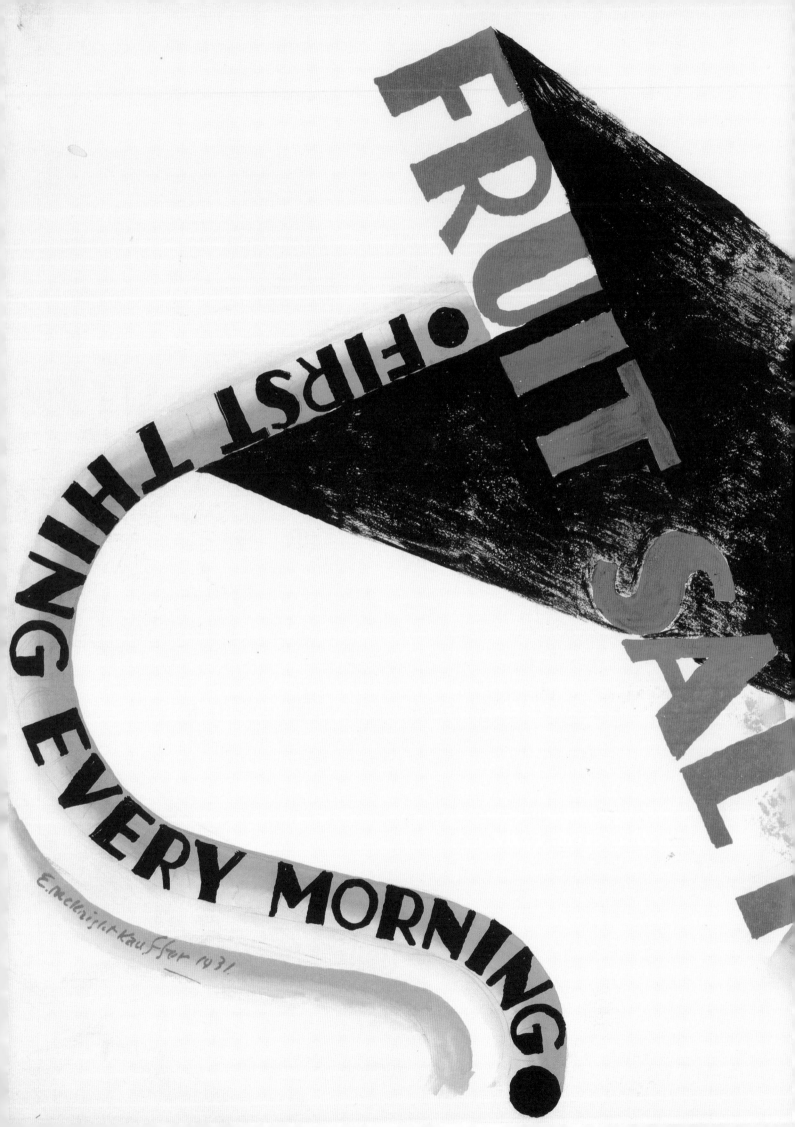

SHOP

BETWEEN

10 AND 4

THE QUIET HOURS

AND BY
UNDERGROUND

E McKnight Kauffur 1930.

B. 1500. I/31 VINCENT BROOKS, DAY & SON, Lᵀᴰ LITH. LONDON, W.C.2.

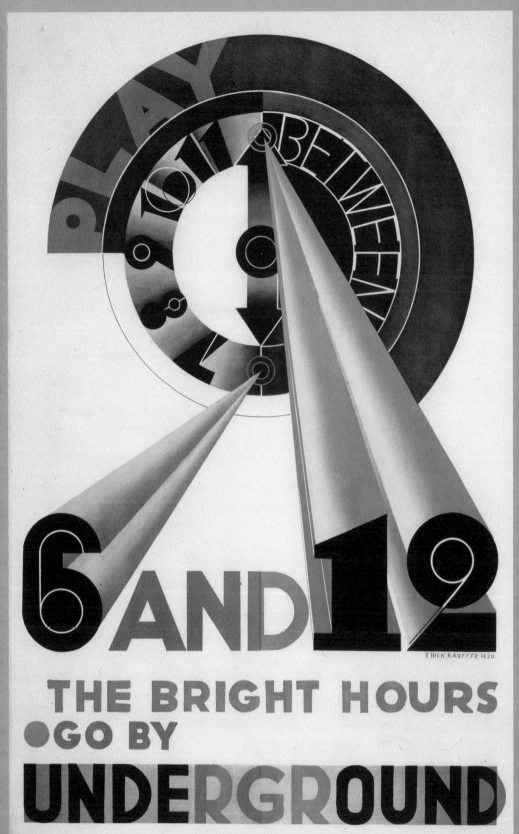

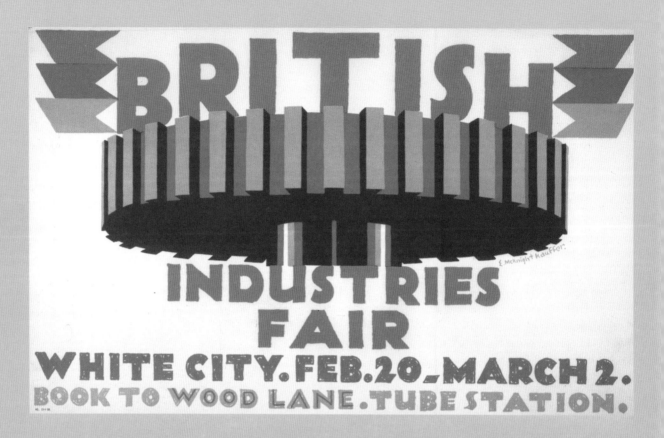

078 (bottom) Brochure, *The Chrysler 72*, 1928 **079** (top) Poster, *British Industries Fair*, 1928 **080** (opposite) Poster, *Piccadilly Extension*, 1932

PICCADILLY

EXTENSION

OPENING
SEPTEMBER 19TH.

FINSBURY PARK
MANOR HOUSE - TURNPIKE LANE
WOOD GREEN - BOUNDS GREEN
TO ARNOS GROVE

084 (left) Drawing, Design for an advertisement, ca. 1940 085 (right) Book cover, *Poems* by Dunstan Thompson, 1943

fortnum & mason ltd
182 piccadilly, london. w. 1

092 (left) Book cover, *Batsford's Pictorial Guides, No. 1, Amsterdam*, ca. 1934
093 (right) Book cover, *Batsford's Pictorial Guides, No. 2, Copenhagen*, ca. 1934
094 (opposite, left) Book cover, *Batsford's Pictorial Guides, No. 3, Stockholm*, ca. 1934
095 (opposite, right) Book cover, *Batsford's Pictorial Guides, No. 4, Hamburg*, ca. 1934

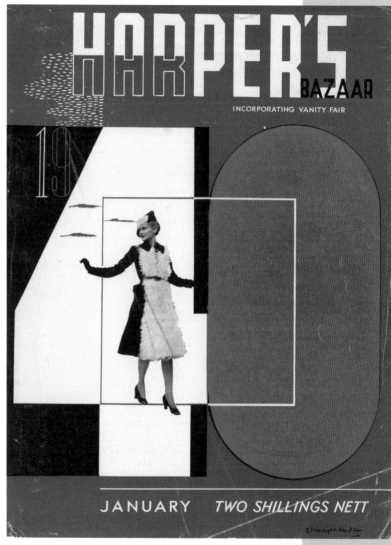

097 (left) Poster, *Tea Drives Away the Droops*, 1936 **098** (right) Magazine cover, *Harper's Bazaar*, January 1940

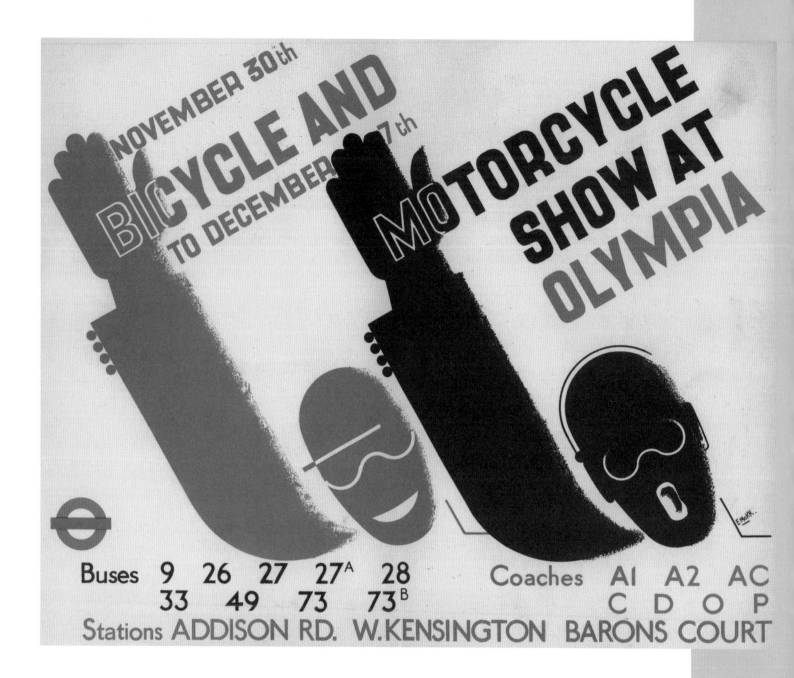

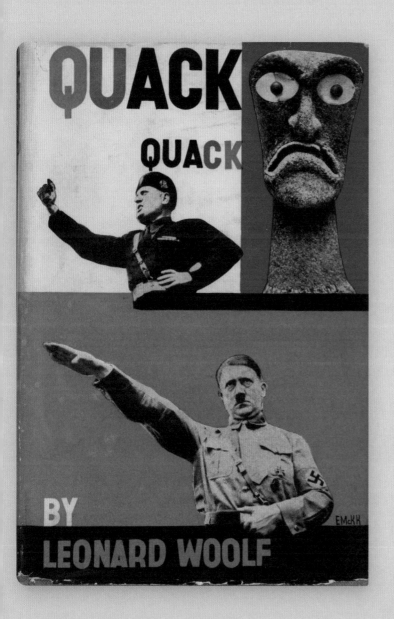

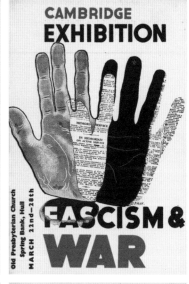
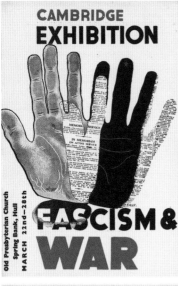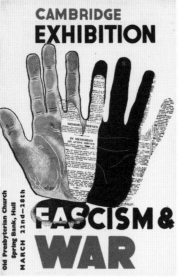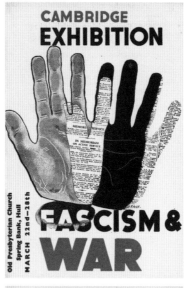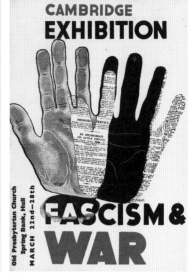
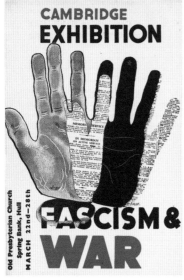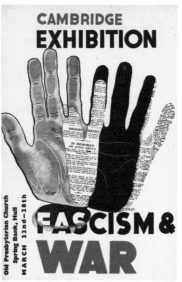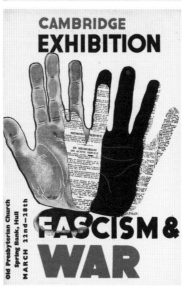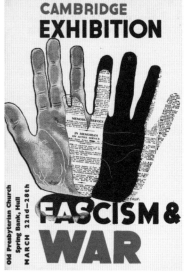

109 (in repeat) Brochure, *Cambridge Exhibition, Fascism & War*, 1934 **110** (opposite) Drawing, Study for *Cambridge Exhibition, Fascism & War*, 1934

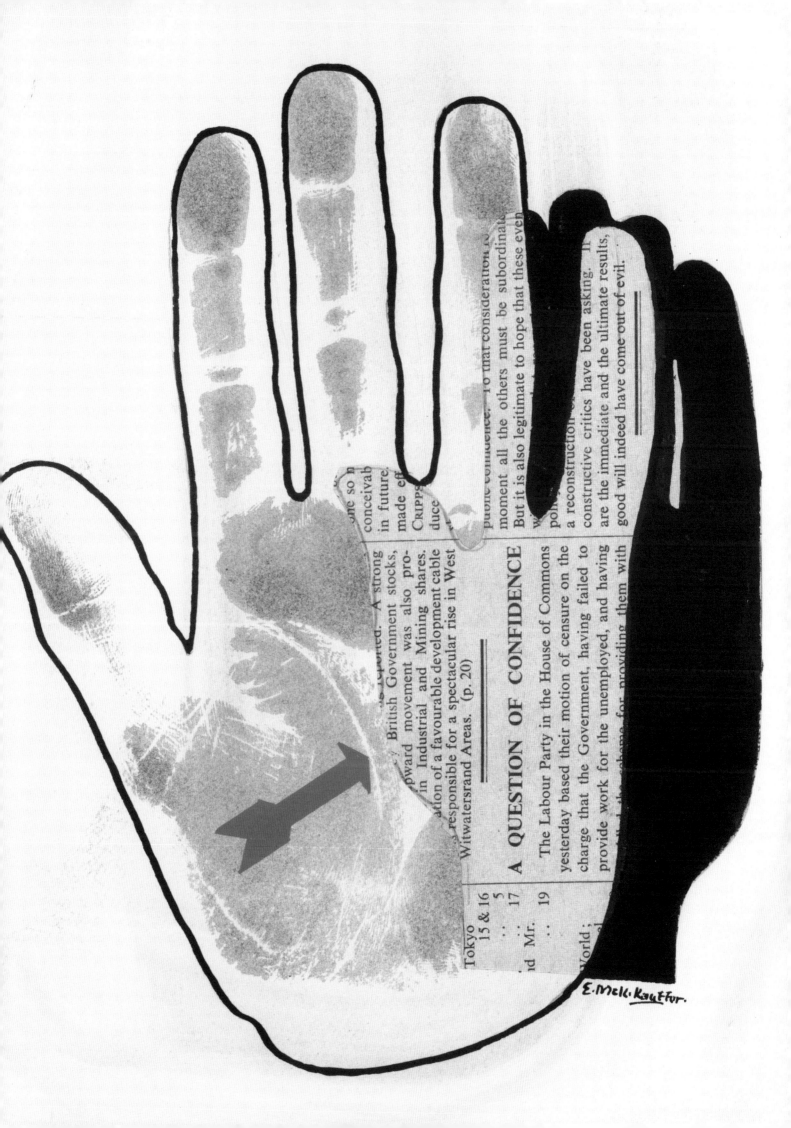

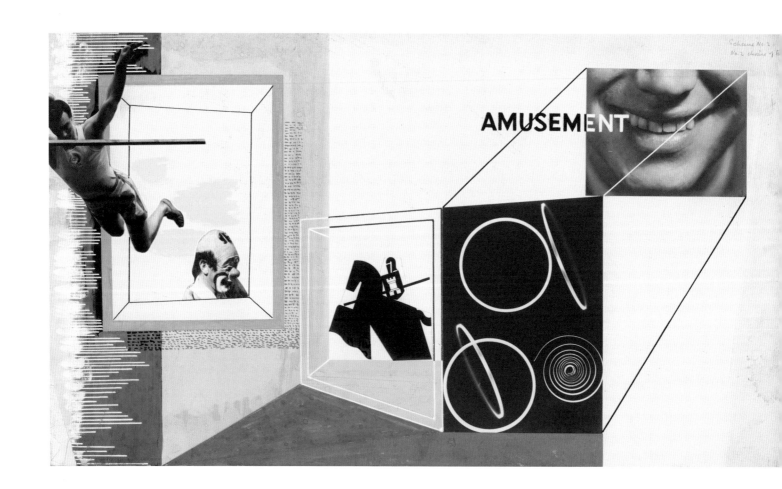

AMUSEMENT

111 (top) Drawing, London's new entertainment center, 1936 112 (bottom) Book cover, *Art Now* by Herbert Read, 1933 **228**

115 Drawing, Design for Lumium, 1935

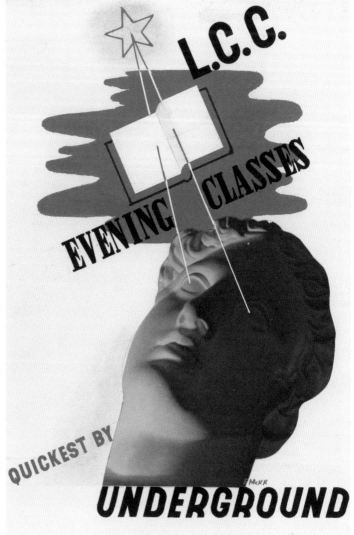

116 (left) Poster, *Treat Yourself to Better Play*, 1935
117 (right) Drawing, Design for *L.C.C. Evening Classes, Quickest by Underground*, ca. 1935
118 (opposite) Drawing, Design for *Train Yourself to Better Play*, 1935

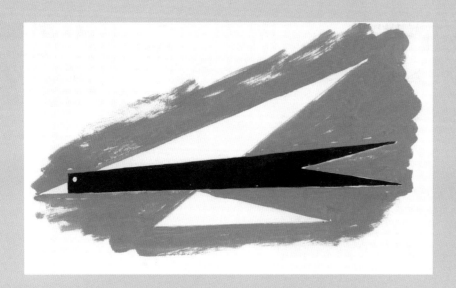

119 (top) Drawing, Study for *Quickest Way by Air Mail*, 1935
120 (center) Drawing, Study for *Quickest Way by Air Mail*, 1935
121 (bottom) Drawing, Study for *Quickest Way by Air Mail*, 1935

QUICKEST WAY BY

AIR MAIL

ASK AT YOUR NEAREST POST OFFICE

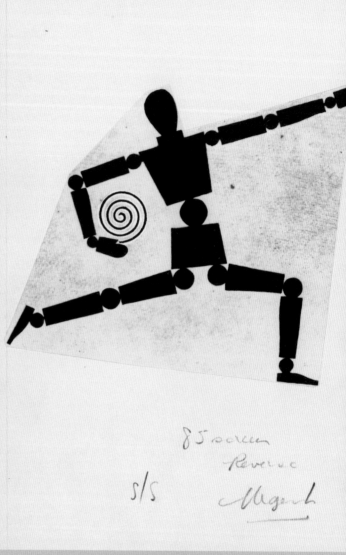

On the right, a book cover:

5

ON REVOLUTIONARY ART

CONTRIBUTORS

1 HERBERT READ

2 F. D. KLINGENDER

3 ERIC GILL

4 A. L. LLOYD

5 ALICK WEST

PUBLISHED BY WISHART

EMcKK

125 (left) Drawing, Study for a book cover, *5 On Revolutionary Art*, 1935 **126** (right) Book cover, *5 On Revolutionary Art* by Betty Rea, ed., 1935

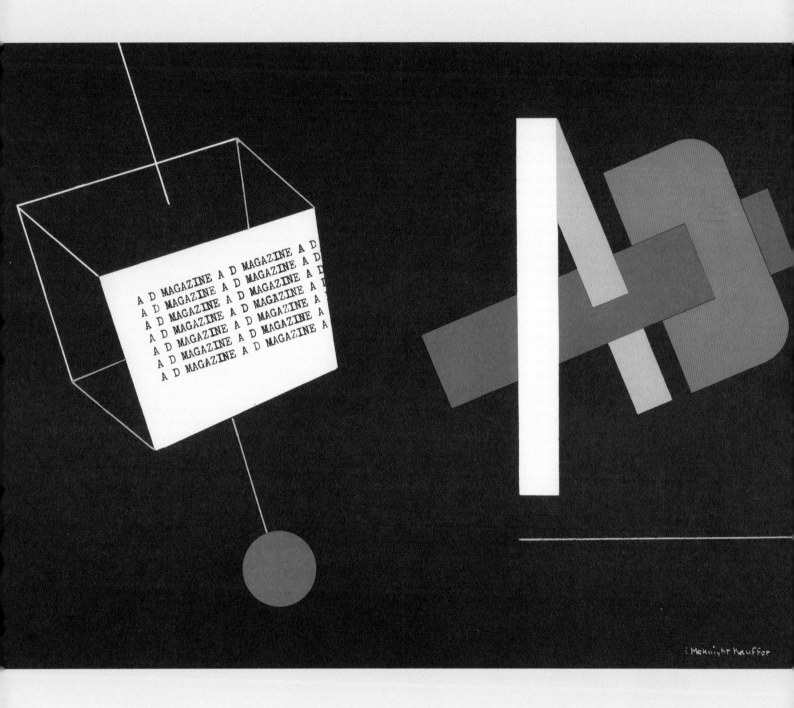

The image contains the repeated text "A D MAGAZINE" and the signature "McKnight Kauffer".

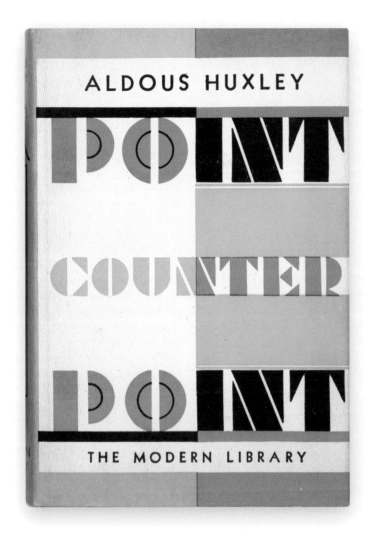

128 (left) Book cover, *Point Counter Point* by Aldous Huxley, 1942 129 (right) Book cover, *Winesburg, Ohio* by Sherwood Anderson, 1936

130 (left) Drawing, Costume design: surrealist figure with red eye, early 1940s
131 (right) Drawing, Design for an advertisement, Behind Room Beauty, 1948

132 (left) Poster, *28th Annual National Exhibition of Advertising and Editorial Art,* 1949
133 (right) Magazine cover, *Ringling Bros and Barnum & Bailey, Circus Magazine & Program*, 1949
134 (overleaf) Drawing, Stage design: backdrop for *Checkmate*, ca. 1947

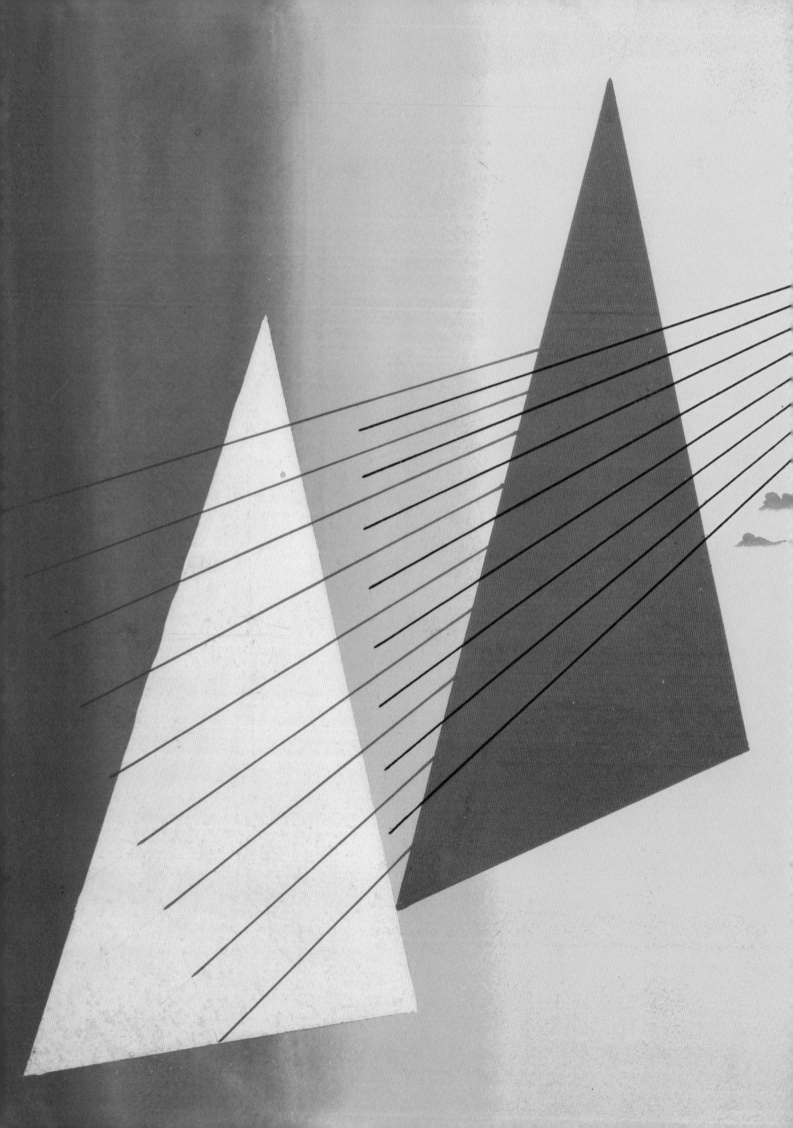

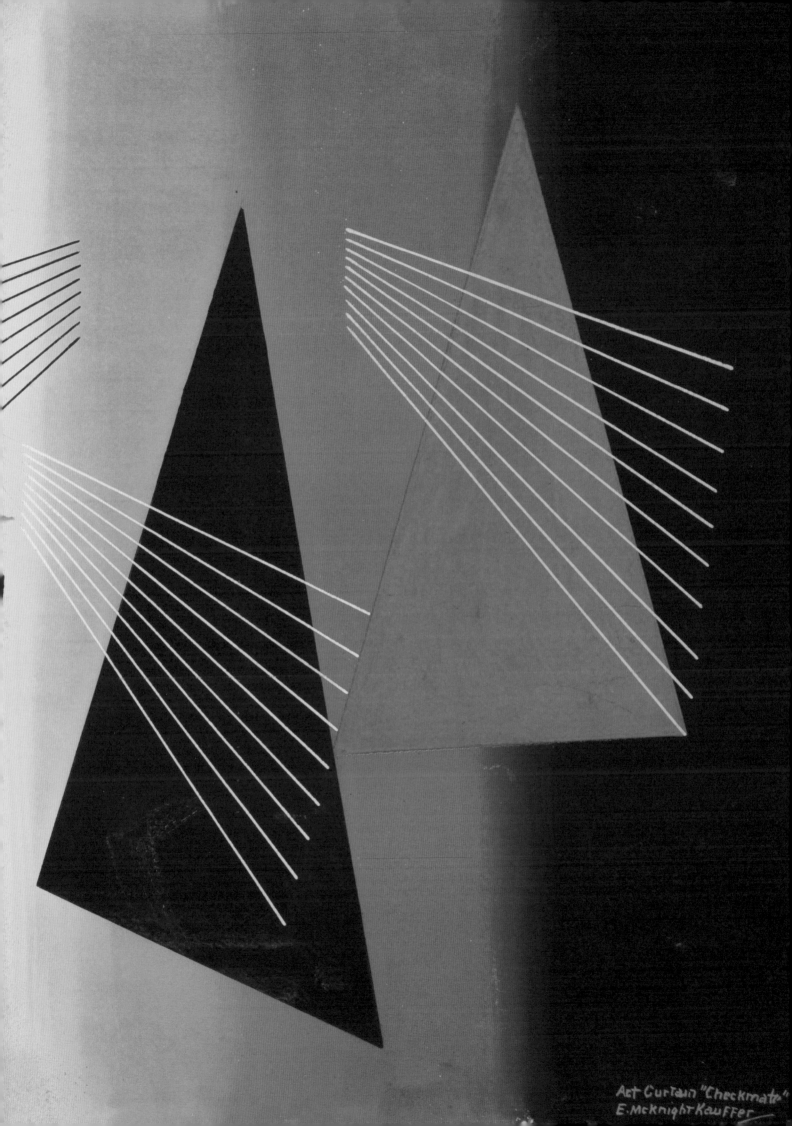

Act Curtain "Checkmate"
E. McKnight Kauffer

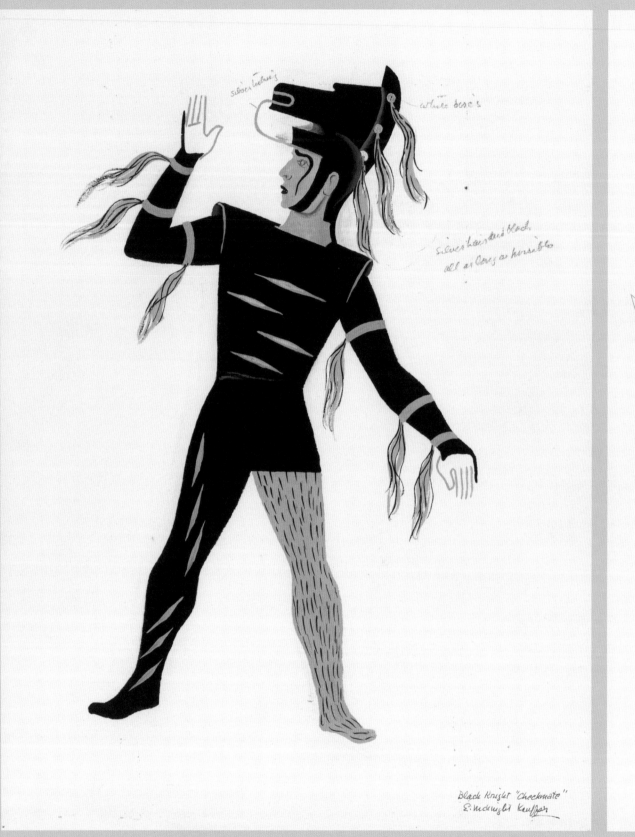

135 (left) Drawing, Costume design: Black Knight, for *Checkmate*, ca. 1947
136 (right) Drawing, Costume design: Red Castle, for *Checkmate*, ca. 1947

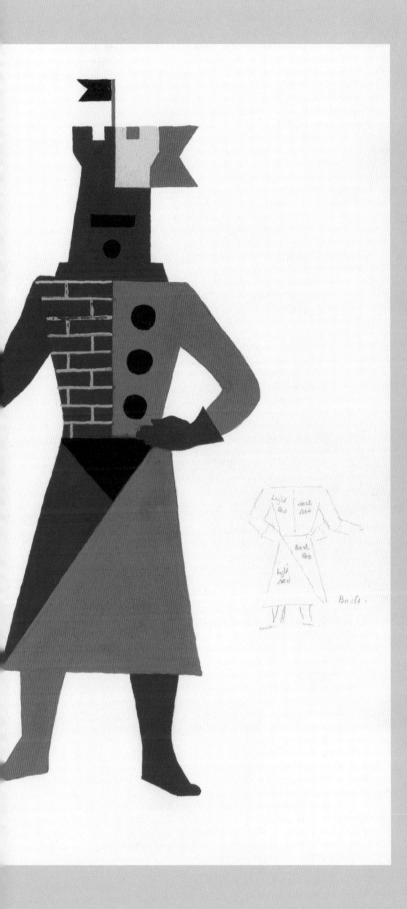

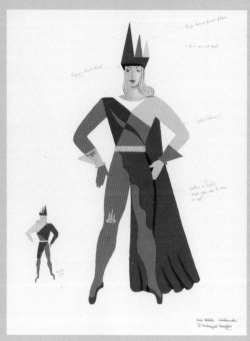

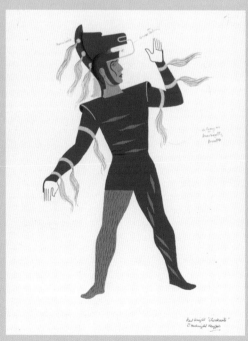

137 (top) Drawing, Costume design: Red Queen, for *Checkmate*, ca. 1947
138 (bottom) Drawing, Costume design: Red Knight, for *Checkmate*, ca. 1947

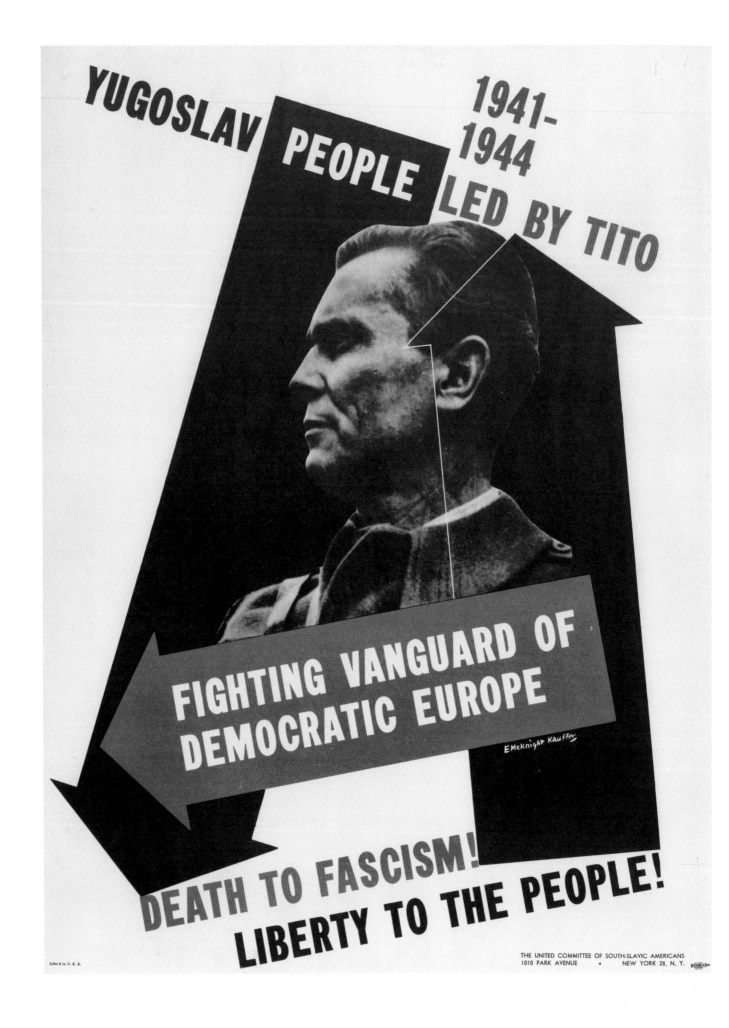

YUGOSLAV PEOPLE 1941–1944 LED BY TITO

FIGHTING VANGUARD OF DEMOCRATIC EUROPE

E McKnight Kauffer

DEATH TO FASCISM! LIBERTY TO THE PEOPLE!

THE UNITED COMMITTEE OF SOUTH-SLAVIC AMERICANS
1010 PARK AVENUE • NEW YORK 28, N. Y.

Litho'd in U. S. A.

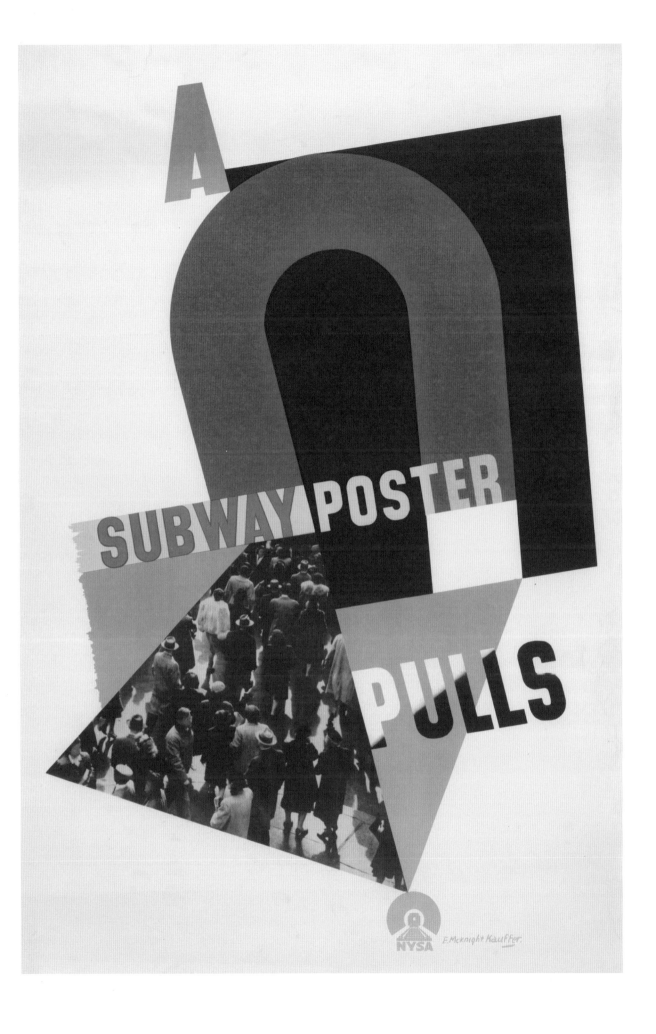

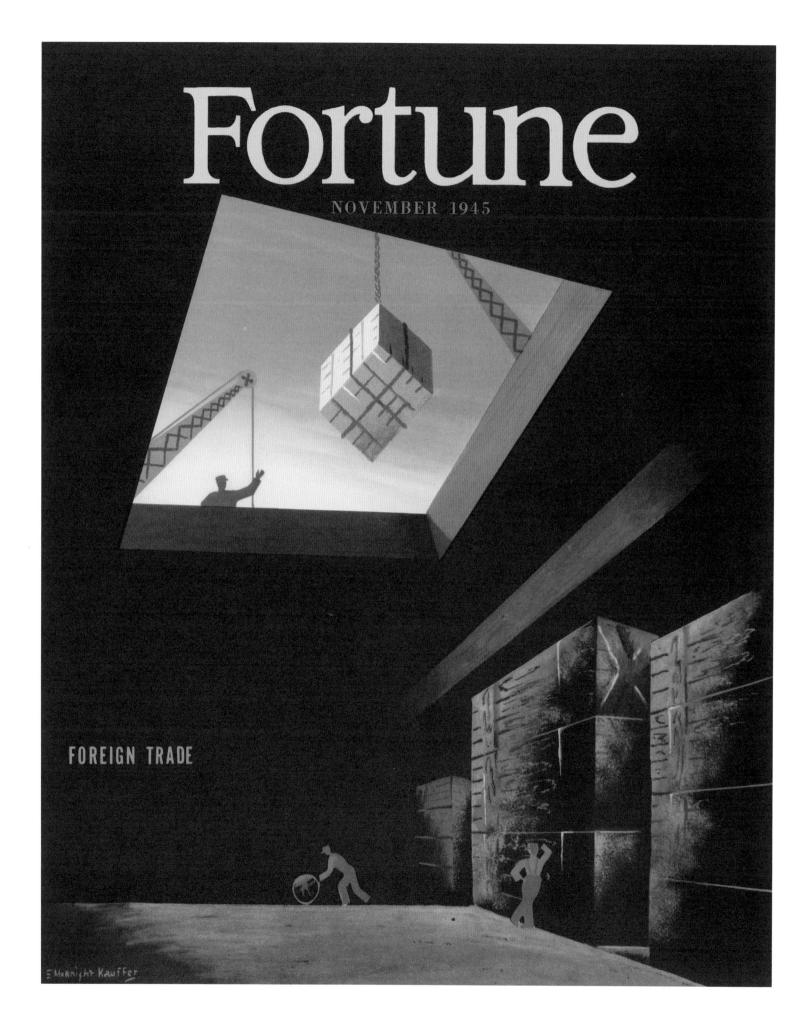

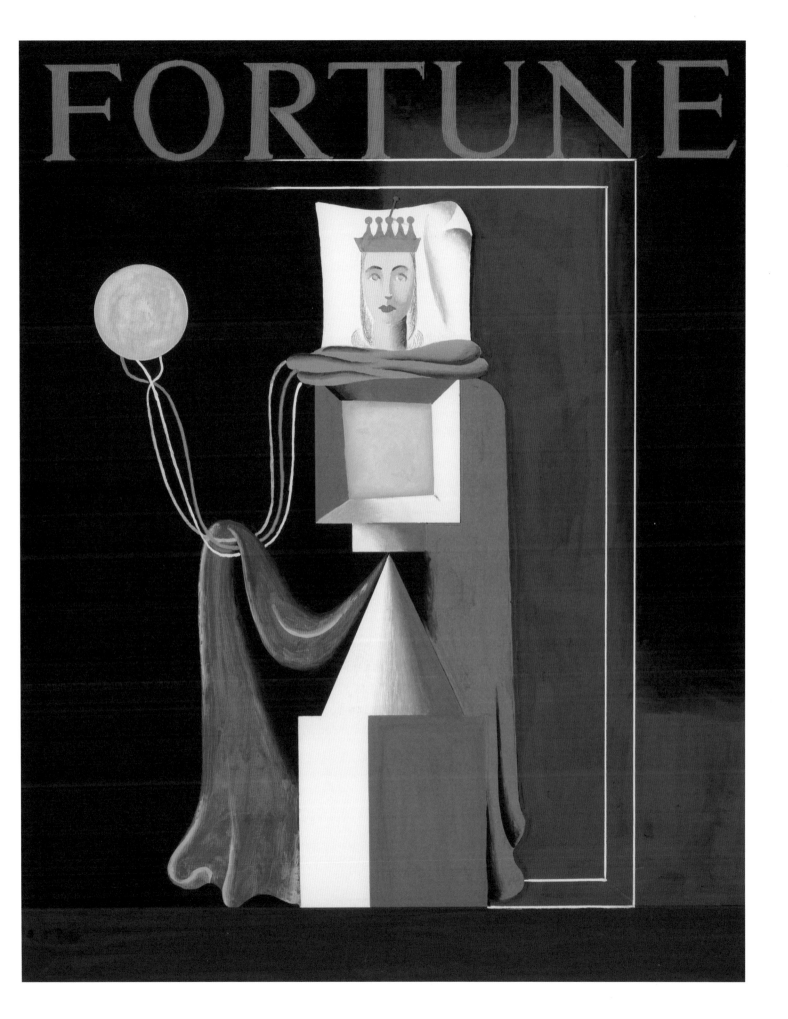

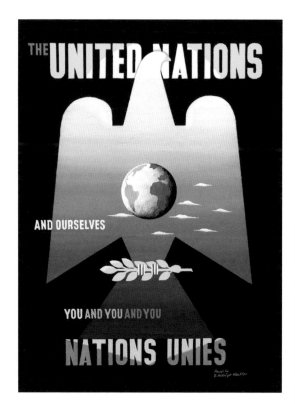

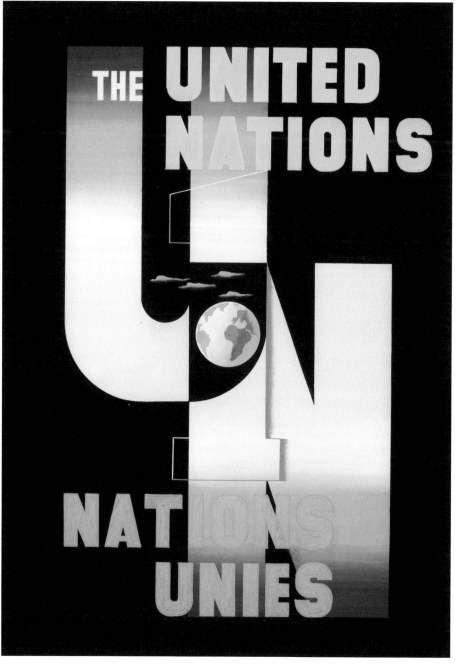

143 (left) Drawing, Design for *The United Nations*, 1945 **144** (right) Drawing, Design for *The United Nations*, 1946

NINETEEN

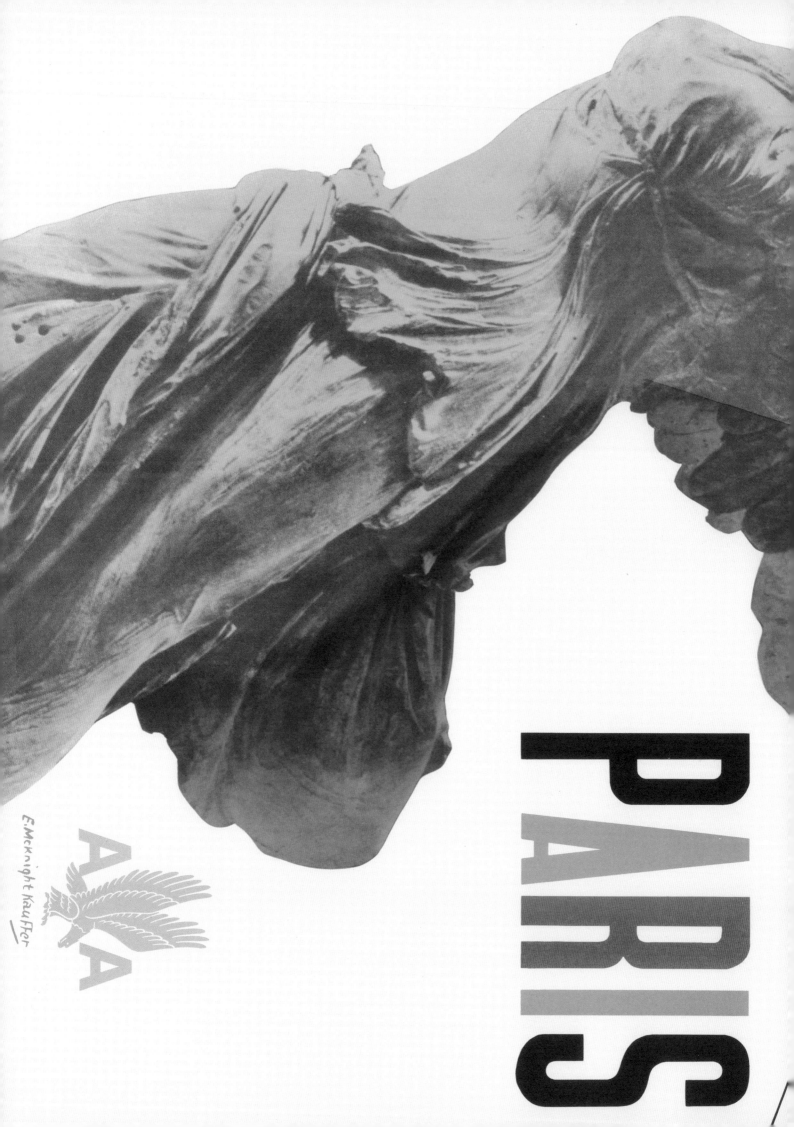

PARIS

E. McKnight Kauffer

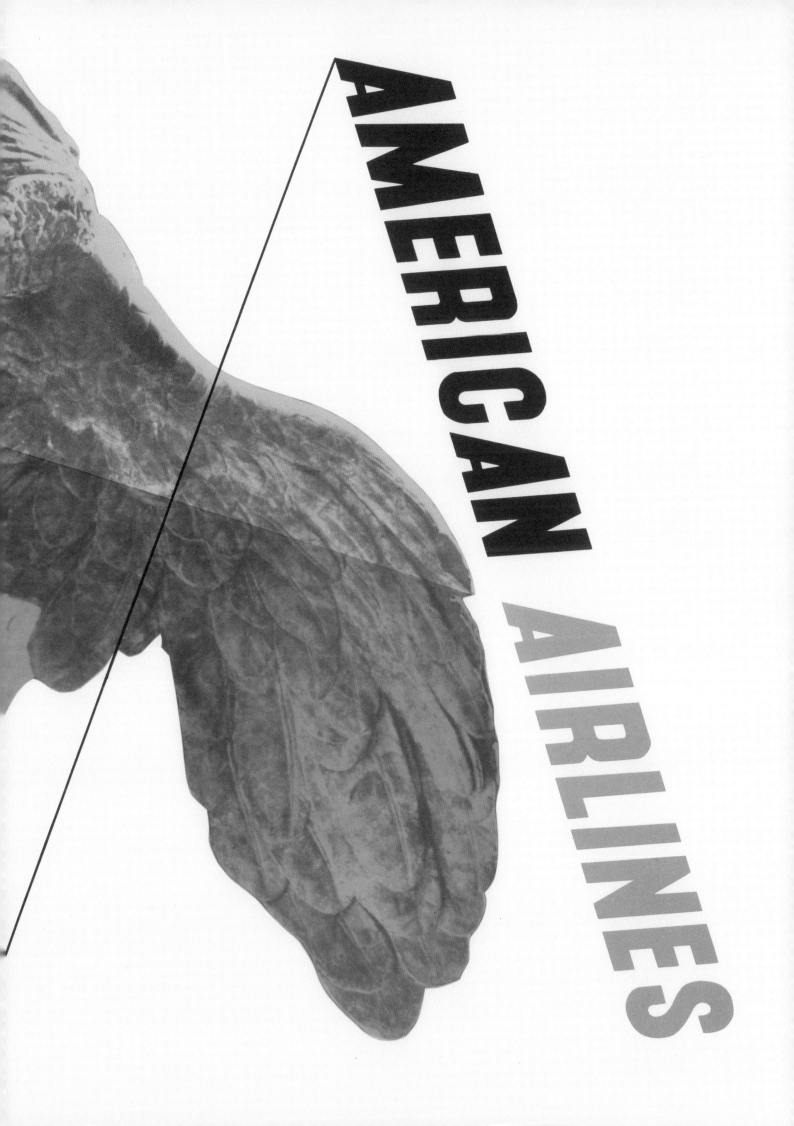

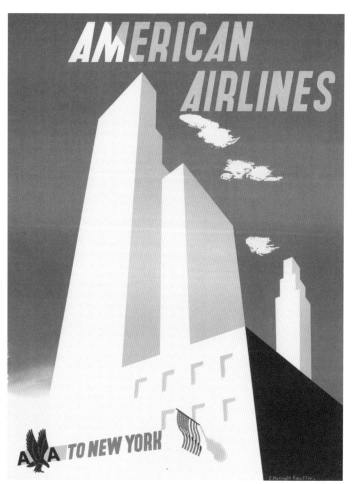

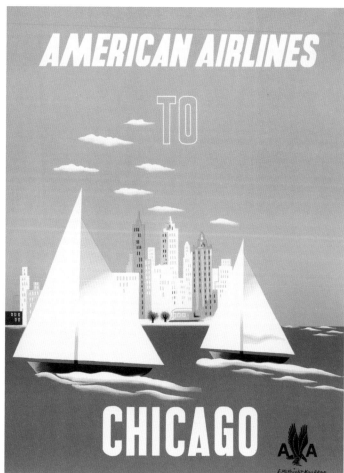

152 (left) Poster, *American Airlines to New York*, 1948 153 (right) Poster, *American Airlines to Chicago*, 1950 154 (opposite) Poster, *American Airlines to Europe*, 1948

WORKS ILLUSTRATED

PHOTOGRAPHY CREDIT KEY

Unless otherwise noted, all work by E. McKnight Kauffer © Simon Rendall. Photographs of works from the Simon Rendall Collection and Private Collection are by Hugh Gilbert. Photographs of works in the collections of Smithsonian Institution Libraries, Barbara Jakobson, and Grace Schulman are by Matt Flynn © Smithsonian Institution.

The institutional and photography credits below are identified throughout the captions by the following shortening conventions:

CH / SI: Cooper Hewitt, Smithsonian Design Museum; Photo by Matt Flynn © Smithsonian Institution
EMcKK / SI: E. McKnight Kauffer Archive, Cooper Hewitt, Smithsonian Design Museum; Photo by Matt Flynn © Smithsonian Institution
MoMA: The Museum of Modern Art; Image copyright © The Museum of Modern Art. Image source: Art Resource, NY
V&A: Victoria and Albert Musem, London
LTM: London Transport Museum; © TfI from the London Transport Museum Collection

FRONTISPIECES

Page 2 Detail: Poster, *Vigil, The Pure Silk*, 1919; Published by Vigil Silks (Dewsbury, England); Printed by Dangerfield Printing Company Ltd. (London, England); Lithograph; 91.3 × 60.5 cm (35¹⁵⁄₁₆ × 23¹³⁄₁₆ in.); Gift of Mrs. E. McKnight Kauffer, 1963-39-18, CH / SI

Page 3 Detail: Poster, *Winter Sale at Derry & Toms*, 1919; Published by Messrs Derry & Toms (London, England); Lithograph; 149.2 × 96.5 cm (58¾ × 38 in.); Private Collection

Page 4 Detail: Poster, *Near Walthamcross by Tram*, 1924; Published by Underground Electric Railways Company of London Ltd. (London, England); Printed by Sanders Phillips and Company, Ltd. (London, England); Lithograph; 76.1 × 50.5 cm (29¹⁵⁄₁₆ × 19⅞ in.); Gift of Mrs. E. McKnight Kauffer, 1963-39-29, CH / SI

Page 5 Detail: Book cover, *Journey Into Fear* by Eric Ambler (New York: Alfred A. Knopf, 1940); 19.6 × 13.5 cm (7¹¹⁄₁₆ × 5⁵⁄₁₆ in.); Gift of Mrs. E. McKnight Kauffer, 1963-39-1294, CH / SI

Page 6 Detail: Drawing, Study for an advertisement, High Point, ca. 1936; Brush and gouache, graphite; 22.7 × 18.9 cm (8¹⁵⁄₁₆ × 7⁷⁄₁₆ in.); Gift of Mrs. E. McKnight Kauffer, 1963-39-703, CH / SI

Page 7 Detail: Poster, *Well Done! 11 World Records, Villiers*, ca. 1928; Designed at W. S. Crawford Ltd. (London, England); Published by The Villiers Engineering Company (Wolverhampton, England); Lithograph; 76.1 × 50.7 cm (29¹⁵⁄₁₆ × 19¹⁵⁄₁₆ in.); Gift of Mrs. E. McKnight Kauffer, 1963-39-75, CH / SI

Page 8 Detail: Poster, *American Airlines to Paris*, 1950; Published by American Airlines (Fort Worth, Texas, USA); Lithograph; 107.1 × 79 cm (42³⁄₁₆ × 31⅛ in.); Gift of Mrs. E. McKnight Kauffer, 1963-39-141, CH / SI

Page 9 Detail: Drawing, Design for a motif with hand and drafting triangle, 1935–38; Brush and gouache, graphite; 31.4 × 21.9 cm (12⅜ × 8⅝ in.); Gift of Mrs. E. McKnight Kauffer, 1963-39-963, CH / SI

FIGURE ILLUSTRATIONS

Introduction: A Commercial Artist with Ideals

1.1 Photograph, E. McKnight Kauffer, ca. 1920; Photograph by Maud B. Davis; Gelatin silver print; 20.3 × 15.2 cm (8 × 6 in.); Simon Rendall Collection

1.2 Photograph, Dog Party, 1935; Photographer unknown; Gelatin silver print; dimensions unknown; Simon Rendall Collection

1.3 Poster, *"First Thing Every Morning," Eno's "Fruit Salt,"* 1924; Published by Eno's Fruit Salt (Newcastle, England); Printed by The Westminster Press (London, England); Lithograph; 113.7 × 77.5 cm (44¾ × 30½ in.); Merrill C. Berman Collection

1.4 Journal cover, *Shelf Appeal*, July 1934; 30.3 × 22.5 cm (11¹⁵⁄₁₆ × 8⅞ in.); Private Collection

1.5 Book cover, *The Art of the Poster: Its Origin, Evolution & Purpose*, edited by E. McKnight Kauffer (London: Cecil Palmer, 1924); 31.1 × 22.9 cm (12¼ × 9 in.); Simon Rendall Collection

1.6 Drawing, Design for *Metropolis* by Fritz Lang, 1926; Brush and gouache; 43.2 × 74.9 cm (17 × 29½ in.); Given anonymously, 78.1961, MoMA

1.7 Print, Design for *Eminent Victorians* by Lytton Strachey (London: Chatto & Windus, 1921); Lithograph; 41 × 26 cm (16⅛ × 10¼ in.); Gift of Mrs. E. McKnight Kauffer, 1963-39-289, CH / SI

1.8 Frontispiece, *Cornelian* by Harold Acton (London: Chatto & Windus, 1928); Lithograph; approx. 20 × 11.5 cm (7⅞ × 4½ in.); Simon Rendall Collection

1.9 Poster, *BP Ethyl*, 1933; Published by Shell-Mex and B.P. Ltd. (London, England); Lithograph; 76.2 × 114.3 cm (30 × 45 in.); Merrill C. Berman Collection

1.10 Poster, *Fashions in Flight*, 1946; Published by American Airlines (Fort Worth, Texas, USA); Lithograph; 86.7 × 60.8 cm (34⅛ × 23¹⁵⁄₁₆ in.); Gift of Mrs. E. McKnight Kauffer, 1963-39-132, CH / SI

1.11 Drawing, Design for *The Telephone at Your Service*, 1937; Brush and gouache, graphite; 26.6 × 17.8 cm (10½ × 7 in.); Gift of Mrs. E. McKnight Kauffer, 1963-39-524, CH / SI

1.12 Drawing, Design for a tapestry, ca. 1935; Drafted by Sidney Garrad (British); Brush and gouache, graphite; 30.5 × 10.2 cm (12 × 4 in.); E. 3247-1980, V&A

1.13 Card, Moving announcement for Percy Lund, Humphries & Co., 1932; Lithograph; 15.1 × 15.8 cm (5¹⁵⁄₁₆ × 6¼ in.); EMcKK / SI

1.14 Book cover, *The Greater Britain* by Oswald Mosley (London: British Union of Fascists, 1932); 19 × 13 cm (7½ × 5⅛ in.); Simon Rendall Collection

1.15 Brochure, *In Defense of Freedom: Writers Declare against Fascism*, 1938; Lithograph; 25.5 × 21 cm (10¹⁄₁₆ × 8¼ in.); Archive of Art and Design, V&A

1.16 Photograph, E. McKnight Kauffer and Marion Dorn, mid-1920s; Photographer unknown; Gelatin silver print; approx. 12.7 × 17.8 cm (5 × 7 in.); Simon Rendall Collection

Rebel Artist

2.1 Print, *Self-Portrait*, 1920; Woodcut; dimensions unknown; Reproduced in *Group X* exhibition catalog; EMcKK / SI

2.2 Painting, *Trees, Normandy*, 1914; Oil on canvas; 45.7 × 54.6 cm (18 × 21½ in.); Private collection; Image © 2006 Christie's Images Limited

2.3 Painting, *Hoeing*, 1914; Oil on panel; 13.5 × 17 cm (5⁵⁄₁₆ × 6¹¹⁄₁₆ in.); Present location of painting unknown; Reproduced from reference photograph in Simon Rendall Collection

2.4 Poster, *The North Downs*, 1915, printed 1916; Published by Underground Electric Railways Company of London Ltd. (London, England); Printed by Johnson, Riddle & Company, Ltd. (London, England); Lithograph; 76.2 × 51.2 cm (30 × 20³⁄₁₆ in.); Gift of Mrs. E. McKnight Kauffer, 1963-39-15, CH / SI

2.5 Painting, *Wood Interior*, 1915; Oil on canvas; 41 × 35.5 cm (16⅛ × 14 in.); Government Art Collection; Image © Crown Copyright: UK Government Art Collection

2.6 Painting, *Berkshire Landscape*, 1916; Oil on panel; 30.5 × 35 cm (12 × 13¾ in.); Southampton City Art Gallery

2.7 Painting, Untitled, 1916; Oil on canvas or panel; dimensions unknown; Reproduced in *Colour*, June 1916; Archive of Art and Design, V&A

2.8 Print, *Housetops*, 1916; Linocut; 10.4 × 12.8 cm (4⅛ × 5¹⁄₁₆ in.); Gift of Campbell Dodgson, E.3300-1980, V&A

2.9 Print, *Flight*, 1916; Woodcut; 13.7 × 22.9 cm (5⅜ × 9 in.); Donated by Campbell Dodgson, 1939, 0228.8, British Museum; Image © The Trustees of the British Museum

2.10 Drawing, Oldland Mill, Ditchling, Sussex, 1917; Watercolor and graphite; dimensions unknown; Reproduced in Gerard T. Meynell, ed., *Illustration: A Quarterly Magazine devoted to the Craft of Mechanical Reproduction and thereby dealing with Art and Workmanship in Prints, and Science in Advertising and Commerce* 7, no. 15 (London: The Sun Engraving Co. Ltd., 1917); Private Collection

2.11 Drawing, Still Life, 1918; Watercolor and graphite; approx. 29.7 × 21 cm (11¹¹⁄₁₆ × 8¼ in.); Simon Rendall Collection

2.12 Print, *The Thames*, 1917; Lithograph; approx. 21 × 29.7 cm (8¼ × 11¹¹⁄₁₆ in.); Simon Rendall Collection

2.13 Poster, *Mittelmeer-Fahrten: Norddeutscher Lloyd Bremen*, 1913; Designed by Ludwig Hohlwein (German, 1874–1949); Lithograph; 10 × 12.5 cm (3¹⁵⁄₁₆ × 4¹⁵⁄₁₆ in.); Reproduced in *Das Plakat: Mitteilungen des Vereins der Plakatfreunde* (Berlin: Verlag Max Schildberger, 1913); OCLC 01762452, Library Special Collections, Minneapolis College of Art and Design

2.14 Poster, *Derry & Toms — Economy and Smartness in Men's Wear*, 1917; Published by Messrs Derry & Toms (London, England); Printed by The Avenue Press (London, England); Lithograph; 149.2 × 101.6 cm (58¾ × 40 in.); The Reading Room / Alamy Stock Photo

2.15 Invitation card, London Group, 1917; Lithograph; 14 × 8.8 cm (5½ × 3⁷⁄₁₆ in.); Archive of Art and Design, V&A

2.16 Painting, *Sunflowers*, 1917; Oil on canvas; 90 × 71 cm (35⁷⁄₁₆ × 27¹⁵⁄₁₆ in.); Government Art Collection; Image © Crown Copyright: UK Government Art Collection

2.17 Poster, *The London Group*, 1917; Lithograph; Published by The London Group (London, England); 76.8 × 50.2 cm (30¼ × 19¾ in.); Gift of the artist, 451.1939, MoMA

2.18 Drawing, Untitled, 1917–18; Medium and dimensions unknown; Reproduced in Our Poster Gallery in *Colour*, January 1918; Archive of Art and Design, V&A

2.19 Drawing, Vigil, The Pure Silk, 1919; Published by Vigil Silks (Dewsbury, England); Gouache; 41.2 × 30.5 cm (16¼ × 12 in.); E.3222-1980, V&A

2.20 Drawing, *Enclosure*, 1915; Edward Alexander Wadsworth (English, 1889–1949); Gouache, ink, pencil, and painted paper; 70.9 × 54.7 cm (27¹⁵⁄₁₆ × 21⁹⁄₁₆ in.); Museum purchase funded by The Brown Foundation, Inc., 77.277, Museum of Fine Arts, Houston

2.21 Print, *Village*, 1920; Medium and dimensions unknown; Reproduced in *Group X* exhibition catalog; EMcKK / SI

2.22 Poster, *Group X*, 1920; Published by Group X (London, England); Printed by Dangerfield Printing Company Ltd. (London, England); Lithograph; 75.9 × 50.5 cm (29⅞ × 19⅞ in.); Gift of the designer, 438.1939, MoMA

The Underground's Alchemist of the Modern

3.1 Poster (detail), *London History at the London Museum*, 1922, printed 1923; Published by Underground Electric Railways Company of London Ltd. (London, England); Printed by Vincent Brooks, Day & Son (London, England); Lithograph; 101.9 × 59.8 cm (40⅛ × 23 9⁄16 in.); Gift of Mrs. E. McKnight Kauffer, 1963-39-24, CH / SI

3.2 Poster, *Route 160 Reigate*, 1915; Published by Underground Electric Railways Company of London Ltd. (London, England); Printed by Johnson, Riddle & Company Ltd. (London, England); Lithograph; approx. 76.2 × 50.8 cm (30 × 20 in.); Simon Rendall Collection

3.3 Poster, *The Flea at the Natural History Museum*, 1926; Published by Underground Electric Railways Company of London Ltd. (London, England); Printed by Vincent Brooks, Day & Son Ltd. (London, England); Lithograph; 100.5 × 62.8 cm (39 9⁄16 × 24¾ in.); Gift of Mrs. E. McKnight Kauffer, 1963-39-39, CH / SI

3.4 Poster, *Regatta Time*, 1923; Published by Underground Electric Railways Company of London Ltd. (London, England); 38.1 × 22.9 cm (15 × 9 in.); 1983/4/730, LTM

3.5 Poster, *Twickenham by Tram*, 1924; Published by Underground Electric Railways Company of London Ltd. (London, England); Printed by Sanders Phillips and Company Ltd. at The Baynard Press (London, England); Lithograph; 72 × 44.3 cm (28⅜ × 17 7⁄16 in.); Gift of Mrs. E. McKnight Kauffer, 1963-39-28, CH / SI

3.6 Poster, *Whitsuntide Pleasures by Underground*, 1925; Published by Underground Electric Railways Company of London Ltd. (London, England); Printed by Vincent Brooks, Day & Son Ltd. (London, England); Lithograph; 110.8 × 63.2 cm (43⅝ × 24⅞ in.); Gift of Mrs. E. McKnight Kauffer, 1963-39-32, CH / SI

3.7 Poster, *The Tower of London*, 1934; Published by London Passenger Transport Board (London, England); Printed by Vincent Brooks, Day & Son Ltd. (London, England); Lithograph; 101.4 × 63.3 cm (39 15⁄16 × 24 15⁄16 in.); Gift of Mrs. E. McKnight Kauffer, 1963-39-53, CH / SI

3.8 Poster, *How Bravely Autumn Paints upon the Sky*, 1938; Published by London Passenger Transport Board (London, England); Printed at The Baynard Press (London, England); Lithograph; 109 × 69 cm (42 15⁄16 × 27 3⁄16 in.); Gift of Mrs. E. McKnight Kauffer, 1963-39-99, CH / SI

Illustration as Commentary: Modernizing the Classics

4.1 Frontispiece and title page, *The Anatomy of Melancholy* by Robert Burton, 1621 (reprint ed. London: Nonesuch Press, 1925); Letterpress; 30.5 × 38.5 cm (12 × 15 3⁄16 in.); Grace Schulman Collection

4.2 Book illustration, for *The Anatomy of Melancholy* by Robert Burton, 1621 (reprint ed. London: Nonesuch Press, 1925); Letterpress; 30.5 × 38.5 cm (12 × 15 3⁄16 in.); Grace Schulman Collection

4.3 Book illustration, for *The Anatomy of Melancholy* by Robert Burton, 1621 (reprint ed. London: Nonesuch Press, 1925); Letterpress; 10.2 × 6.4 cm (4 × 2½ in.); Grace Schulman Collection

4.4 Book illustration, for *The Anatomy of Melancholy* by Robert Burton, 1621 (reprint ed. London: Nonesuch Press, 1925); Letterpress; 13.7 × 14 cm (5⅜ × 5½ in.); Grace Schulman Collection

4.5 Print, Illustration for *Don Quixote* by Miguel de Cervantes, 1605/1616 (reprint ed. London: Nonesuch Press, 1930); Printed by Curwen Press (London, England); Lithograph with hand-colored additions in brush and watercolor; 22.9 × 14.2 cm (9 × 5 9⁄16 in.); Gift of Mrs. E. McKnight Kauffer, 1963-39-362-b, CH / SI

4.6 Print, Illustration for *Don Quixote* by Miguel de Cervantes, 1605/1616 (reprint ed. London: Nonesuch Press, 1930); Printed by Curwen Press (London, England); Lithograph with hand-colored additions in

brush and watercolor; 22.9 × 14.2 cm (9 × 5 9⁄16 in.); Gift of Mrs. E. McKnight Kauffer, 1963-39-349-b, CH / SI

4.7 Print, Illustration for *Don Quixote* by Miguel de Cervantes, 1605/1616 (reprint ed. London: Nonesuch Press, 1930); Printed by Curwen Press (London, England); Lithograph with hand-colored additions in brush and watercolor; 22.9 × 14.2 cm (9 × 5 9⁄16 in.); Gift of Mrs. E. McKnight Kauffer, 1963-39-350-b, CH / SI

4.8 Print, Illustration for *Don Quixote* by Miguel de Cervantes, 1605/1616 (reprint ed. London: Nonesuch Press, 1930); Printed by Curwen Press (London, England); Lithograph with hand-colored additions in brush and watercolor; 22.9 × 14.2 cm (9 × 5 9⁄16 in.); Gift of Mrs. E. McKnight Kauffer, 1963-39-350-c, CH / SI

4.9 Print, Illustration for *Don Quixote* by Miguel de Cervantes, 1605/1616 (reprint ed. London: Nonesuch Press, 1930); Printed by Curwen Press (London, England); Lithograph with hand-colored additions in brush and watercolor; 22.9 × 14.2 cm (9 × 5 9⁄16 in.); Gift of Mrs. E. McKnight Kauffer, 1963-39-351-b, CH / SI

4.10 Print, Illustration for *Don Quixote* by Miguel de Cervantes, 1605/1616 (reprint ed. London: Nonesuch Press, 1930); Printed by Curwen Press (London, England); Lithograph with hand-colored additions in brush and watercolor; 22.9 × 14.2 cm (9 × 5 9⁄16 in.); Gift of Mrs. E. McKnight Kauffer, 1963-39-367-b, CH / SI

Fear, Sex, Maternity, Snobbism: Kauffer and the Modern Woman

5.1 Poster (detail), *The Labour Woman*, 1925; Published by Woman's Labour League, Labour Party (England); Printed by London Caledonian Press Ltd. (London, England); Lithograph; 71.8 × 50.8 cm (28¼ × 20 in.); Simon Rendall Collection

5.2 Poster, *Olympia anciennes, Montagnes Russes, Boulevard des Capucines*, 1892; Designed by Jules Chéret (French, 1836–1932); Published by Olympia (Paris, France); Printed by Imp. Chaix (Ateliers Chéret) (Paris, France); Lithograph; 124.4 × 87.3 cm (49 × 34⅜ in.); Given anonymously, 575.1954, MoMA

5.3 Poster, *Pomeroy Day Cream*, 1923; Published by Mrs. Pomeroy Ltd. (London, England); Lithograph; 75.9 × 50.6 cm (29⅞ × 19 15⁄16 in.); Given by Underground Electric Railways Company of London, Ltd. (London, England), E.637-1923, V&A

5.4 Poster, *Gloves Cleaned: Eastman & Son Dyers & Cleaners Ltd.*, 1922; Published by Eastman and Son (London, England); Printed by Wass, Pritchard & Co., Ltd. (London, England); Lithograph; 56.5 × 40.6 cm (22¼ × 16 in.); Gift of the designer, 463.1939, MoMA

5.5 Label, Vigil, The Pure Silk, 1919–21; Published by Vigil Silks (Dewsbury, England); Print on cloth; approx. 5 × 3 cm (1 15⁄16 × 1 3⁄16 in.); Simon Rendall Collection

5.6 Poster, *Spring Cleaning: Eastman's, The London Dyers & Cleaners for 120 Years*, 1924; Published by Eastman and Son (London, England); Lithograph; 58.4 × 41.9 cm (23 × 16½ in.); Presented by Messrs. Eastman and Son, Ltd., E.626-1925, V&A

5.7 Magazine illustration, The New Gallant: "Take My Seat, Madam," *The Bystander*, 1918; Illustrated by J. H. Dowd (British, 1883–1956); © Illustrated London News Ltd. / Mary Evans

5.8 Poster, *The Way for All*, 1911; Designed by Alfred France (British); Published by Underground Electric Railways Company of London Ltd. (London, England); Printed by Johnson, Riddle & Company, Ltd. (London, England); Lithograph; 100.5 × 62.8 cm (39 9⁄16 × 24¾ in.); 1983/4/124, LTM

5.9 Book cover, *Woman: A Vindication* by Anthony Ludovici (London: Constable & Co., 1923); 22.9 × 15.2 cm (9 × 6 in.); Peter Harrington Books

5.10 Poster, *The Labour Woman*, 1925; Published by

Woman's Labour League, Labour Party (England); Printed by London Caledonian Press Ltd. (London, England); Lithograph; 71.8 × 50.8 cm (28¼ × 20 in.); Simon Rendall Collection

5.11 Book illustration, Woman in 2030 for *The World in 2030 A.D.* by Frederick Edwin Smith (London: Hodder & Stoughton, 1930); Lithograph; 24 × 16.9 cm (9 7⁄15 × 6⅝ in.); Barbara Jakobson Collection

Setting the Modern Stage

6.1 Drawing, Stage design: Prologue backdrop for *Checkmate*, 1947; Designed for the Royal Opera House (London, England); Produced and choreographed by Ninette de Valois (Irish, 1898–2001); Brush and gouache; 34 × 54.5 cm (13⅜ × 21 7⁄16 in.); Gift of Mrs. E. McKnight Kauffer, 1963-39-271, CH / SI

6.2 Publicity postcard, *The Proposal* by Anton Chekhov, performed by the Arts League of Service, 1926; Scenery by E. McKnight Kauffer; Gelatin silver print; 9 × 14 cm (3 9⁄16 × 5½ in.); Private Collection

6.3 Publicity postcard, *Lazarus*, performed by the Arts League of Service, ca. 1927; Costumes by E. McKnight Kauffer; Gelatin silver print; 9 × 14 cm (3 9⁄16 × 5½ in.); Private Collection

6.4 Postcard, Theatrical backdrop, 1909; Scenery by E. McKnight Kauffer; Gelatin silver print; 8.5 × 13.5 cm (3 5⁄16 × 5 5⁄16 in.); EMcKK / SI

6.5 Drawing, Costume design: Henry VIII for *Catherine Parr, or Alexander's Horse* by Maurice Baring, 1925; Brush and gouache, graphite; 47.3 × 31 cm (18⅝ × 12 3⁄16 in.); Gift of Mrs. E. McKnight Kauffer, 1963-39-170, CH / SI

6.6 Publicity still, *Othello* by William Shakespeare, performed at the St. James's Theatre, London, 1932; Costumes and scenery by E. McKnight Kauffer; Reproduced in "Interesting New Shakespeareans," in *The Illustrated Sporting and Dramatic News*, April 9, 1932; EMcKK / SI

6.7 Photograph, Ninette de Valois, Arthur Bliss, and E. McKnight Kauffer gathered at a chessboard, ca. 1937; Photographer unknown; Gelatin silver print; Royal Opera House / ArenaPAL

6.8 Drawing, Costume design: Love, for the ballet *Checkmate* by Ninette de Valois, 1947; Brush and gouache, graphite; 51 × 30.3 cm (20 1⁄16 × 15 7⁄16 in.); Gift of Mrs. E. McKnight Kauffer, 1963-39-274, CH / SI

6.9 Drawing, Costume design: Death, for the ballet *Checkmate* by Ninette de Valois, 1947; Brush and gouache, graphite; 51 × 38.3 cm (20 1⁄16 × 15 1⁄16 in.); Gift of Mrs. E. McKnight Kauffer, 1963-39-275, CH / SI

6.10 Photograph, Scene from *Checkmate*, performed by the Sadler's Wells Ballet, 1937; Photograph by Baron (née Sterling Henry Nahum, British, 1906–1956); Costumes and scenery by E. McKnight Kauffer; Gelatin silver print; Royal Opera House

6.11 Print, Design for musical score for *Checkmate*, 1937; Published by Novello and Company, Ltd. (London, England); Lithograph; 32 × 23.7 cm (12⅝ × 9 5⁄16 in.); Gift of Mrs. E. McKnight Kauffer, 1963-39-288, CH / SI

Equipping and Exhibiting the Modern Interior

7.1. Card, Invitation to spring exhibition, 1936; Published by Fortnum & Mason (London, England); Halftone, line block, and letterpress printing; 13.3 × 18.3 cm (5¼ × 7 3⁄16 in.); E.503-1980, V&A

7.2 Poster, *Exhibition of New Architecture*, 1937; Published by MARS Group (London, England); Lithograph; 76.2 × 50.6 cm (30 × 19 15⁄16 in.); Gift of Mrs. E. McKnight Kauffer, 1963-39-97, CH / SI

7.3 Drawing, Design for a carpet, ca. 1928; Designed by Marion Dorn (American, 1896–1964); Brush and watercolor, gouache on photostat; 20.9 × 14.8 cm (8¼ × 5 13⁄16 in.); Gift of Daren Pierce, 1982-79-17-5, CH / SI

7.4 Drawing, Design for a carpet, ca. 1928; Brush and watercolor, gouache on photostat; 20.9 × 14.8 cm (8 ¼ × 5¹³⁄₁₆ in.); Gift of Daren Pierce, 1982-79-17-12, CH / SI

7.5 Photograph, Sitting room of Sir Kenneth Clark's house, 30 Portland Place, London, 1938; Photograph by Alfred Cracknell (British, active ca. 1938–59); Carpets by Marion Dorn; Photoprint; Architectural Press Archive / RIBA Collections, AP81/139

7.6 Card, Invitation to opening, Curtis Moffat Ltd., London, 1929; Published by Curtis Moffat Ltd. (London, England); Letterpress; 15.1 × 17.7 cm (5¹⁵⁄₁₆ × 6¹⁵⁄₁₆ in.); Gift of Mrs. E. McKnight Kauffer, 1963-39-1271, CH / SI

7.7 Photograph, Crawford's Advertising Agency building, 233 High Holborn, London, 1930; Photograph by Dell & Wainwright (London, England); Negative; Architectural Press Archive / RIBA Collections, DWN1883

7.8 Photograph, Study at 41 Gloucester Square; Reproduced in "Pictures in the Modern House: The Newest Phase of Interior Decoration," Studio International, July 1932; Photograph by Dell & Wainwright (London, England); British Library / Granger, all rights reserved

7.9 Frontispiece, Design for a panel of mural decoration, The New Interior Decoration: An Introduction to Its Principles, and International Survey of Its Methods by Dorothy Todd and Raymond Mortimer (London: B. T. Batsford Ltd., 1929); Private Collection

7.10 Painted relief, Constellation selon les lois du hasard (Constellation according to the laws of chance), ca. 1930; Jean Arp (French, 1886–1996); Painted wood; 54.9 × 69.8 cm (21⅝ × 27½ in.); Bequeathed by E. C. Gregory 1959, T00242, Tate; Photo © Tate

7.11 Photograph, Unidentified interior, ca. 1929; Mural design by E. McKnight Kauffer; Reproduced in The New Interior Decoration: An Introduction to Its Principles, and International Survey of Its Methods by Dorothy Todd and Raymond Mortimer (London: B. T. Batsford Ltd., 1929); Private Collection

7.12 Photograph, Arnold Bennett's study, Chiltern Court, Baker Street, London, 1931; Photograph by Dell & Wainwright (London, England); Interior design by Marion Dorn and E. McKnight Kauffer; Carpets by E. McKnight Kauffer; Furniture by Crossley & Brown; Negative; Architectural Press Archive / RIBA Collections

7.13 Exhibition brochure, Room and Book by J. E. Barton, 1932; Published by Zwemmer Gallery (London, England); Printed by Curwen Press (London, England); Lithograph; approx. 21.6 × 14 cm (8½ × 5½ in.); National Art Library, V&A

7.14 Book cover, BBC Handbook (London: BBC, 1928); 19 × 12.5 cm (7½ × 4¹⁵⁄₁₆ in.); Private Collection

7.15 Photograph, BBC Broadcasting House, 1940; Photograph by Fred Musto for the Mustograph Agency (London, England); Gelatin silver print; Mary Evans Picture Library

7.16 Photograph, BBC Broadcasting House, waiting room on third floor, ca. 1935; Reproduced in The Scottish Field, May 1935; Mary Evans Picture Library

7.17 Brochure, BBC Talks (London: BBC, 1933); 21.5 × 13.9 cm (8⁷⁄₁₆ × 5½ in.); Private collection

Educative Publicity: Posters for the Government

8.1 Drawing, Study for an advertisement, Post Office, 1936; Published by British General Post Office (London, England); Brush and gouache, graphite; 17.5 × 19.5 cm (6⅞ × 7¹¹⁄₁₆ in.); Gift of Mrs. E. McKnight Kauffer, 1963-39-523, CH / SI

8.2 Photograph, Empire Marketing Board hoarding One Third of the Empire Is in the Tropics, 1927; Reproduced in Commercial Art, February 1928; National Art Library, V&A

8.3 Poster, Jungles To-Day Are Gold Mines To-Morrow, 1927; Published by H. M. Stationery Office (London, England) for Empire Marketing Board (London, England); Printed by Haycock, Cadle & Graham Ltd. (London, England); Lithograph; 95 × 141 cm (37⅜ × 55½ in.); CO956/501, The National Archives

8.4 Poster, Cocoa: Three-Fifths of the World's Supply from Empire Sources, 1927; Published by H. M. Stationery Office (London, England) for Empire Marketing Board (London, England); Printed by Haycock, Cadle & Graham Ltd. (London, England); Lithograph; 100 × 62 cm (39⅜ × 24⁷⁄₁₆ in.); CO956/500, The National Archives

8.5 Poster, Bananas: The Empire Exports 12,000,000 Bunches a Year, 1927; Published by H. M. Stationery Office (London, England) for Empire Marketing Board (London, England); Printed by Haycock, Cadle & Graham Ltd. (London, England); Lithograph; 100 × 62 cm (39⅜ × 24⁷⁄₁₆ in.); CO956/502, The National Archives

8.6 Poster, Cocoa Pods, 1927; Published by H. M. Stationery Office (London, England) for Empire Marketing Board (London, England); Printed by Haycock, Cadle & Graham Ltd. (London, England); Lithograph; 95 × 141 cm (37⅜ × 55½ in.); CO 956/499, The National Archives

8.7 Poster, Bananas, 1926; Published by H. M. Stationery Office (London, England) for Empire Marketing Board (London, England); Printed by Haycock, Cadle & Graham Ltd. (London, England); Lithograph; approx. 101.6 × 152.4 cm (40 × 60 in.); Gift of Mr. and Mrs. Alfred H. Barr, Jr., 1275.1968, MoMA

8.8 Poster, Contact with the World, Use the Telephone, 1934; Published by British General Post Office (London, England); Lithograph; 74.9 × 49.2 cm (29½ × 19⅜ in.); Gift of Mrs. E. McKnight Kauffer, 1963-39-62, CH / SI

8.9 Poster, Posting Box at Lands End, Outposts of Britain, 1937; Published by British General Post Office (London, England); Lithograph; 50.9 × 63.6 cm (20¹⁄₁₆ × 25¹⁄₁₆ in.); Gift of Mrs. E. McKnight Kauffer, 1963-39-88, CH / SI

8.10 Poster, A Postman in Northern Ireland, Outposts of Britain, 1937; Published by British General Post Office (London, England); Lithograph; 51.8 × 63.6 cm (20⅜ × 25¹⁄₁₆ in.); Gift of Mrs. E. McKnight Kauffer, 1963-39-90, CH / SI

8.11 Poster, A Postman in the Pool of London, Outposts of Britain, 1937; Published by British General Post Office (London, England); Lithograph; 50.9 × 63.5 cm (20¹⁄₁₆ × 25 in.); Gift of Mrs. E. McKnight Kauffer, 1963-39-87, CH / SI

8.12 Poster, A Postman in Northern Scotland, Outposts of Britain, 1937; Published by British General Post Office (London, England); Lithograph; 50.8 × 63.6 cm (20 × 25¹⁄₁₆ in.); Gift of Mrs. E. McKnight Kauffer, 1963-39-89, CH / SI

Illustrating Race: Kauffer and the African American Connection in Literature

9.1 Drawing, Study for Lasca, Illustration for Nigger Heaven by Carl Van Vechten, 1926 (reprint ed. unpublished New York: Alfred A. Knopf, 1930); Drawing executed in 1930; Brush and watercolor; 33 × 25.2 cm (13 × 9¹⁵⁄₁₆ in.); Gift of Mrs. E. McKnight Kauffer, 1963-39-322, CH / SI

9.2 Book cover, Native Son by Richard Wright, 1940 (reprint ed. New York: Modern Library, 1942); 18.3 × 12.5 cm (7³⁄₁₆ × 4¹⁵⁄₁₆ in.); Private collection

9.3 Book cover, Invisible Man by Ralph Ellison (New York: Random House, 1952); 21.5 × 14.5 cm (8⁷⁄₁₆ × 5¹¹⁄₁₆ in.); Barbara Jakobson Collection

9.4 Drawing, Design for dust jacket for Nigger Heaven by Carl Van Vechten, 1926 (reprint ed. unpublished New York: Alfred A. Knopf, 1930); Drawing executed in 1931; Gouache and pencil; 55.9 × 38.7 cm (22 × 15¼ in.); Gift of Carl Van Vechten, 738.1978.5, MoMA

9.5 Drawing, Adora at a Party, Illustration for Nigger Heaven by Carl Van Vechten, 1926 (reprint ed. unpublished New York: Alfred A. Knopf, 1930); Drawing executed in 1931; Gouache and pencil; 55.9 × 38.7 cm (22 × 15¼ in.); Gift of Carl Van Vechten, 738.1978.6, MoMA

9.6 Drawing, Study for Adora's House in the Country. Mary at Window, Illustration for Nigger Heaven by Carl Van Vechten, 1926 (reprint ed. unpublished New York: Alfred A. Knopf, 1930); Drawing executed in 1930; Brush and watercolor, graphite; 33.6 × 25.1 cm (13¼ × 9⅞ in.); Gift of Mrs. E. McKnight Kauffer, 1963-39-317, CH / SI

9.7 Drawing, Adora's House in the Country. Mary at Window, Illustration for Nigger Heaven by Carl Van Vechten, 1926 (reprint ed. unpublished New York: Alfred A. Knopf, 1930); Drawing executed in 1931; Gouache and pencil; 55.9 × 38.7 cm (22 × 15¼ in.); Gift of Carl Van Vechten, 738.1978.11, MoMA

9.8 Drawing, Illustration for Shakespeare in Harlem by Langston Hughes (New York: Alfred A. Knopf, 1942); Stylus on scratchboard; 20.1 × 14.3 cm (7¹⁵⁄₁₆ × 5⅝ in.); EMcKK / SI

9.9 Book cover, Shakespeare in Harlem by Langston Hughes (New York: Alfred A. Knopf, 1942); 21.5 × 15 cm (8½ × 6 in.); Simon Rendall Collection

9.10 Book illustration, for Shakespeare in Harlem by Langston Hughes (New York: Alfred A. Knopf, 1942); Lithograph; approx. 21.5 × 15 cm (8½ × 6 in.); Simon Rendall Collection

Kauffer and The Museum of Modern Art, New York

10.1 Brochure cover (detail), Organic Design in Home Furnishings (New York: The Museum of Modern Art, 1941); 25.2 × 19 cm (9¹⁵⁄₁₆ × 7½ in.); Barbara Jakobson Collection

10.2 Poster, From Winters Gloom to Summers Joy, 1927; Published by Underground Electric Railways Company of London Ltd. (London, England); Printed by Vincent Brooks, Day & Son, Ltd. (London, England); Lithograph; 102 × 63.5 cm (40³⁄₁₆ × 25 in.); Gift of Mrs. E. McKnight Kauffer, 1963-39-40, CH / SI

10.3 Brochure cover, Posters by E. McKnight Kauffer by Aldous Huxley et al. (New York: The Museum of Modern Art, 1937); 25.3 × 19.1 cm (9¹⁵⁄₁₆ × 7½ in.); Gift of Margery Masinter, NC1850.K3N4X, Smithsonian Libraries

10.4 Brochure cover, Film Library, The Museum of Modern Art, ca. 1940; Published by The Museum of Modern Art (New York, New York, USA); Lithograph; 22.6 × 10.1 cm (8⅞ × 4 in.); EMcKK / SI

10.5 Book cover, Americans 1942: 18 Artists from 9 States (New York: The Museum of Modern Art, 1942); 25.9 × 19.8 cm (10³⁄₁₆ × 7¹³⁄₁₆ in.); Barbara Jakobson Collection

10.6 Flyer, Museum of Modern Art Publications, n.d. [after 1946]; Published by The Museum of Modern Art (New York, New York, USA); Lithograph; 23.2 × 10.2 cm (9⅛ × 4 in.); EMcKK / SI

10.7 Card, Invitation to exhibition opening of Brazil Builds, 1943; Published by The Museum of Modern Art (New York, New York, USA); Lithograph; 11.5 × 15.9 cm (4½ × 6¼ in.); EMcKK / SI

10.8 Book cover, Brazil Builds (New York: The Museum of Modern Art, 1943); Designed by E. McKnight Kauffer and G. E. Kidder Smith (American, 1913–1997); 28.3 × 21 cm (11⅛ × 8¼ in.); MoMA

Design Here Is Living: Marion Dorn in New York

11.1 Textile, Leaves of Grass, 1946; Designed by Marion Dorn (American, 1896–1964); Manufactured by Silkar Studios, Inc. (New York, New York, USA); Silk; 365.8 × 124.5 cm (12 ft. × 49 in.); Museum purchase from General Acquisitions Endowment Fund, 2018-17-1, CH / SI

11.2 Photograph, Marion Dorn at her drafting table, 1942; Reproduced in *House & Garden*, May 1942; NA7100. H6X, Smithsonian Libraries

11.3 Photograph, Marion Dorn surrounded by her textile designs, July 1, 1947; Photograph by Horst P. Horst (German, 1906–1999); Gelatin silver print; Horst P. Horst / Condé Nast via Getty Images

11.4 Carpet, Walking on Air, 1951; Designed by Marion Dorn (American, 1896–1964); Manufactured by Edward Fields, Inc. (New York, New York, USA); Dimensions unknown; Reproduced in *Craft Horizons*, September/October 1952; NK1.C885, Smithsonian Libraries

11.5 Photograph, Equivalent, 1925; Photograph by Alfred Stieglitz (American, 1864–1946); Gelatin silver print; 11.7 × 9.2 cm (4⅝ × 3⅝ in.); Anonymous gift, 92.1943.5, MoMA

11.6 Textile, Yellow Driftwood, 1949–51; Designed by Marion Dorn (American, 1896–1964); Manufactured by Jud Williams, Inc. (New York, New York, USA); Cotton, mohair, screen printed on satin weave; 121.9 × 168.9 cm (48 × 66½ in.); Edgar J. Lownes Fund and Museum Acquisition Fund, 2004.2.1, RISD Museum, Courtesy of the RISD Museum, Providence, RI

11.7 Magazine cover, *Interiors*, June 1949; Featuring photograph by Harry Schulke (American, active ca. 1940–60); 30 × 21.9 cm (11¹³⁄₁₆ × 8⅝ in.); NK1700.I613, Smithsonian Libraries

11.8 Sidewall, Master Drawings, 1951; Designed by Marion Dorn (American, 1896–1964); Made by Katzenbach & Warren, Inc. (New Canaan, Connecticut, USA); Screen-printed paper; 67 × 76 cm (26⅜ × 29¹⁵⁄₁₆ in.); Gift of Katzenbach & Warren, Inc., 1952-88-5, CH/SI

11.9 Sidewall, Cameo, 1949; Designed by Marion Dorn (American, 1896–1964); Made by Katzenbach & Warren, Inc. (New Canaan, Connecticut, USA); Screen-printed paper; Dimensions unknown; Herbert Matter Papers, Stanford University; Photograph by Herbert Matter

11.10 Photograph, Marion Dorn holding a cameo, 1949; Photograph by Herbert Matter (American, born Switzerland, 1907–1984); Negative; Herbert Matter Papers, Stanford University

11.11 Sidewall, Etruscan, from The American Court Collection—The Beige Collection, Vol. D, 1959; Designed by Marion Dorn (American, 1896–1964); Made by Katzenbach & Warren, Inc. (New Canaan, Connecticut, USA); Screen-printed, mezzotone; Gift of Unknown Donor, 1980-77-6-36, CH/SI

11.12 Photograph, Tomb of the Triclinium (detail), Tarquinia, Italy, ca. 470 BCE; Reproduced in "Etruscan Art" by George Karo, *Graphis* 11, no. 60, April 1, 1955; NC997. A1 G73, Smithsonian Libraries

11.13 Magazine advertisement, Plaque Toltec, a textile design by Marion Dorn, 1950; Reproduced in *Interiors*, March 1950; NK1700.I613, Smithsonian Libraries

11.14 Ornament, Mexico or Central America, Maya style, 250–900 CE; Greenstone; 4.8 × 8 cm (1⅞ × 3⅛ in.); In memory of Mr. and Mrs. Henry Humphreys, gift of their daughter Helen, 1950.153, Cleveland Museum of Art

A Parable of Uncompromise: Kauffer in New York

12.1 Book cover (detail), *The Sleepwalkers* by Hermann Broch, 1932 (reprint ed. New York: Pantheon, 1947); Lithograph; 23.3 × 54 cm (9³⁄₁₆ × 21¼ in.); Gift of Mrs. E. McKnight Kauffer, 1963-39-1197, CH/SI

12.2 Magazine cover, *Seminar* (Philadelphia: Sharp & Dohme, August 1944); 27.6 × 21.5 cm (10⅞ × 8⁷⁄₁₆ in.); EMcKK/SI

12.3 Print, *Keep It under Your Stetson*, 1942; Published by The John B. Stetson Company (USA); Lithograph; 32.5 × 25.2 cm (12¹³⁄₁₆ × 9¹⁵⁄₁₆ in.); Gift of Mrs. E. McKnight Kauffer, 1963-39-726, CH/SI

12.4 Magazine cover, *What's New* (Chicago: Abbott Laboratories, December 1942); 31.7 × 24.9 cm (12½ × 9¹³⁄₁₆ in.); Gift of Mrs. E. McKnight Kauffer, 1963-39-605, CH/SI

12.5 Drawing, Give, ca. 1944; Design for American Red Cross (USA); Brush and gouache, graphite; 25.2 × 44.6 cm (9¹⁵⁄₁₆ × 17⁹⁄₁₆ in.); Gift of Mrs. E. McKnight Kauffer, 1963-39-599, CH/SI

12.6 Book cover, *I Saw England* by Ben Robertson (New York: Alfred A. Knopf, 1941); 20.2 × 14.5 cm (7¹⁵⁄₁₆ × 5¹¹⁄₁₆ in.); Gift of Mrs. E. McKnight Kauffer, 1963-39-1316, CH/SI

12.7 Book cover, *Wicked Water* by MacKinlay Kantor (New York: Random House, 1949); 21.5 × 14.5 cm (8⁷⁄₁₆ × 5¹¹⁄₁₆ in.); Gift of Mrs. E. McKnight Kauffer, 1963-39-1339, CH/SI

12.8 Book cover, *Ulysses* by James Joyce, 1922 (reprint ed. New York: Random House, 1949); 21.2 × 14.5 cm (8¼ × 5¾ in.); Barbara Jakobson Collection

12.9 Book cover, *Brave New World* by Aldous Huxley, 1932 (reprint ed. New York: Harper & Brothers, 1946); 21.3 × 14.5 cm (8¼ × 5¾ in.); Barbara Jakobson Collection

12.10 Book illustration, for *Green Mansions* by W. H. Hudson, 1904 (reprint ed. New York: Random House, 1944); Lithograph; 18.9 × 12 cm (7⁷⁄₁₆ × 4¾ in.); Gift of Mrs. E. McKnight Kauffer, 1963-39-434, CH/SI

12.11 Magazine advertisement, American Silk Mills, 1943; Reproduced in *New York Times Magazine*, March 21, 1943; Gift of Mrs. E. McKnight Kauffer, 1963-39-728, CH/SI

12.12 Poster, *American Airlines to California*, 1948; Published by American Airlines (Fort Worth, Texas, USA); Lithograph; 104.4 × 78.5 cm (41⅛ × 30⅞ in.); Gift of Mrs. E. McKnight Kauffer, 1963-39-131, CH/SI

12.13 Print, *Montana*, ca. 1948; Published by Container Corporation of America (Chicago, Illinois, USA); Lithograph; 28.2 × 20.9 cm (11⅛ × 8¼ in.); Gift of Mrs. E. McKnight Kauffer, 1963-39-736, CH/SI

PLATES SECTION

001 Card, Season's Greetings, 1953, 1952; Screenprint; 17.8 × 26 cm (7 × 10¼ in.); Gift of Mrs. Alfons Bach, 1997-7-1, CH/SI

002 Poster, *Godstone*, 1915, printed 1916; Published by Underground Electric Railways Company of London Ltd. (London, England); Printed by Johnson, Riddle & Company, Ltd. (London, England); Lithograph; 76.3 × 51 cm (30¹⁄₁₆ × 20¹⁄₁₆ in.); Gift of Mrs. E. McKnight Kauffer, 1963-39-14, CH/SI

003 Poster, *In Watford*, 1915; Published by Underground Electric Railways Company of London Ltd. (London, England); Printed by Waterlow & Sons, Ltd. (London, England); Lithograph; 76.2 × 50.8 cm (30 × 20 in.); 1983/4/592, LTM

004 Poster, *Oxhey Woods*, 1915; Published by Underground Electric Railways Company of London Ltd. (London, England); Printed by Waterlow & Sons, Ltd. (London, England); Lithograph; 75.9 × 50.5 cm (29⅞ × 19⅞ in.); Gift of Mrs. E. McKnight Kauffer, 1963-39-13, CH/SI

005 Poster, *Winter Sale at Derry & Toms*, 1919; Published by Messrs Derry & Toms (London, England); Lithograph; 149.2 × 96.5 cm (58¾ × 38 in.); Private Collection

006 Poster, *Summer Sale at Derry & Toms*, 1919; Published by Messrs Derry & Toms (London, England); Lithograph; 74.9 × 49.7 cm (29½ × 19⁹⁄₁₆ in.); Gift of Mrs. E. McKnight Kauffer, 1963-39-16, CH/SI

007 Book cover, *Look! We Have Come Through!* by D. H. Lawrence, (London: Chatto & Windus, 1917); 22.1 × 17.9 cm (8¹¹⁄₁₆ × 7¹⁄₁₆ in.); Peter Harrington Booksellers

008 Poster, *Soaring to Success! Daily Herald—the Early Bird*, 1918–19; Published by *The Daily Herald* (London, England); Lithograph; 297.7 × 152.2 cm (117³⁄₁₆ × 59¹⁵⁄₁₆ in.); Given by Ogilvy Benson & Mather Ltd., E.35-1973, V&A

009 Label, El Progreso, 1921; Published by Steinthal & Co. (Manchester, England); Lithograph; 14.9 × 10.2 cm (5⅞ × 4 in.); Gift of Monroe Wheeler, SC174.2010, MoMA

010 Label, Rompe Espina, 1916; Published by Steinthal & Co. (Manchester, England); Lithograph; 16.8 × 10.5 cm (6⅝ × 4⅛ in.); Gift of Monroe Wheeler, SC186.2010, MoMA

011 Label, Murciélago, ca. 1921; Published by Steinthal & Co. (Manchester, England); Lithograph; 14.9 × 10.3 cm (5⅞ × 4¹⁄₁₆ in.); Gift of Monroe Wheeler, SC180.2010, MoMA

012 Poster, *Epping Forest by Motor Bus*, 1920; Published by Underground Electric Railways Company of London Ltd. (London, England); Printed by Dangerfield Printing Company Ltd. (London, England); Lithograph; 74.7 × 49.6 cm (29⁷⁄₁₆ × 19½ in.); Simon Rendall Collection

013 Poster, *Hatfield by Motor Bus*, 1919, printed 1920; Published by Underground Electric Railways Company of London Ltd. (London, England); Printed by Dangerfield Printing Company Ltd. (London, England); Lithograph; 76.4 × 50.6 cm (30¹⁄₁₆ × 19¹⁵⁄₁₆ in.); Simon Rendall Collection

014 Poster, *The Arts League of Service: A Course of Lectures on Modern Tendencies in Art*, 1919; Lithograph; 76.5 × 50.6 cm (30⅛ × 19¹⁵⁄₁₆ in.); Courtesy of AntikBar Original Vintage Posters

015 Poster, *The London Group Exhibition, Mansard Gallery*, 1918; Published by The London Group (London, England); Lithograph; 75.6 × 50.8 cm (29¾ × 20 in.); Gift of the artist, 371.1939, MoMA

016 Poster, *Exhibition of Modern Art, The London Group*, Mansard Gallery, 1919; Published by The London Group (London, England); Printed by Dangerfield Printing Company Ltd. (London, England); Lithograph; 76 × 50.5 cm (29¹⁵⁄₁₆ × 19⅞ in.); Gift of Mrs. E. McKnight Kauffer, 1963-39-17, CH/SI

017 Book cover, *Queen Victoria* by Lytton Strachey, 1921 (reprint ed. London: Chatto & Windus, 1924); 19.7 × 13 cm (7¾ × 5⅛ in.); Private Collection

018 Print, *The Daily Mirror International Fashion Fair*, 1923; Lithograph; Dimensions unknown; Archive of Art and Design, V&A

019 Poster, *Vigil, The Pure Silk*, 1919; Published by Vigil Silks (Dewsbury, England); Printed by Dangerfield Printing Company Ltd. (London, England); Lithograph; 91.3 × 60.5 cm (35¹⁵⁄₁₆ × 23¹³⁄₁₆ in.); Gift of Mrs. E. McKnight Kauffer, 1963-39-18, CH/SI

020 Poster, *Vigil for Lovely Frocks*, 1921; Published by Vigil Silks (Dewsbury, England); Printed by Dangerfield Printing Company Ltd. (London, England); Lithograph; 74.9 × 49.5 cm (29½ × 19½ in.); Gift of the designer, 433.1939, MoMA

021 Poster, *Winter Sales Are Best Reached by the Underground*, 1922; Published by Underground Electric Railways Company of London Ltd. (London, England); Printed by Vincent Brooks, Day & Son (London, England); Lithograph; 101.8 × 63.4 cm (40¹⁄₁₆ × 24¹⁵⁄₁₆ in.); Gift of Mrs. E. McKnight Kauffer, 1963-39-22, CH/SI

022 Poster, *Winter Sales Are Best Reached by Underground*, 1921; Published by Underground Electric Railways Company of London Ltd. (London, England); Printed by Vincent Brooks, Day & Son (London, England); Lithograph; 101 × 62.8 cm (39¾ × 24¾ in.); Merrill C. Berman Collection

023 Poster, *Winter Sales Are Best Reached by Underground*, 1924; Published by Underground Electric Railways Company of London Ltd. (London, England);

Printed by Johnson, Riddle & Company Ltd. (London, England); Lithograph: 110.2 × 64 cm (43⅜ × 25³⁄₁₆ in.); Gift of Mrs. E. McKnight Kauffer, 1963-39-30, CH/SI

024 Book cover, *The Week-End Book: A Sociable Anthology* by Vera Mendel and Francis Meynell, eds. (London: Nonesuch Press, 1924); 20 × 12.5 cm (7⅞ × 5 in.); Private Collection

025 Poster, *London Museum of Practical Geology*, 1921, printed 1922; Published by Underground Electric Railways Company of London Ltd. (London, England); Printed by Vincent Brooks, Day & Son (London, England); Lithograph; 101.9 × 63.2 cm (40⅛ × 24⅞ in.); Gift of Mrs. E. McKnight Kauffer, 1963-39-19, CH/SI

026 Journal cover, *The Chapbook, A Monthly Miscellany* by Harold Munro (ed.), no. 36, April 1923; Published by The Poetry Bookshop (London, England); Letterpress; 22.5 × 17.5 cm (8⅞ × 7 in.); Private Collection

027 Print, *VIM*, ca. 1923; Letterpress; 95 × 24 cm (9½ × 3⅘ in.); Reproduced from *Typography of Newspaper Advertisements* by Francis Meynell (London: Ernest Benn Ltd., 1929); Private Collection

028 Book cover, *The Modern Movement in Art* by R. H. Wilenski (London: Faber & Gwyer, 1927); 22.5 × 15.7 cm (8⅞ × 6³⁄₁₆ in.); Archive of Art and Design, V&A

029 Poster, *London History at the London Museum*, 1922, printed 1923; Published by Underground Electric Railways Company of London Ltd. (London, England); Printed by Vincent Brooks, Day & Son (London, England); Lithograph; 101.9 × 59.8 cm (40⅛ × 23⁹⁄₁₆ in.); Gift of Mrs. E. McKnight Kauffer, 1963-39-24, CH/SI

030 Poster, *The Westminster Press*, 1922; Published and printed by The Westminster Press (London, England); Lithograph; 75 × 50.2 cm (29½ × 19¾ in.); Gift of the designer, 469.1939, MoMA

031 Poster, *Eno's "Fruit Salt,"* 1924; Published by Eno's Fruit Salt (Newcastle, England); Printed by The Westminster Press (London, England); Lithograph; 77.5 × 56.5 cm (30½ × 22¼ in.); Gift of the designer, 382.1939, MoMA

032 Poster, *Summertime, Pleasures by Underground*, 1925; Published by Underground Electric Railways Company of London Ltd. (London, England); Printed by Vincent Brooks, Day & Son (London, England); Lithograph; 101.6 × 61.9 cm (40 × 24⅜ in.); Simon Rendall Collection

033 Poster, *Pomeroy Day Cream*, 1922; Published by Mrs. Pomeroy Ltd. (London, England); Printed by The Westminster Press (London, England); Lithograph; 76.2 × 50.7 cm (30 × 19¹⁵⁄₁₆ in.); M/B65, Courtesy of the British Council Collection; Photo © The British Council, all rights reserved

034 Poster, *Eastman & Son Ltd., Since 1802, The London Dyers and Cleaners,* 1923; Published by Eastman and Son (London, England); Printed by Wass, Pritchard & Co., Ltd. (London, England); Lithograph; 57.1 × 42.1 cm (22⁷⁄₁₆ × 16⁹⁄₁₆ in.); Gift of Mrs. E. McKnight Kauffer, 1963-39-42, CH/SI

035 Poster, *The "Rocket" of Mr. Stephenson of Newcastle at the Museum of Science*, 1922, printed 1923; Published by Underground Electric Railways Company of London Ltd. (London, England); Printed by Vincent Brooks, Day & Son Ltd. (London, England); Lithograph; 98.9 × 61.4 cm (38¹⁵⁄₁₆ × 24³⁄₁₆ in.); Gift of Mrs. E. McKnight Kauffer, 1963-39-23, CH/SI

036 Bookplate, The Play's the Thing, Ifan Kyrle Fletcher, ca. 1920; Lithograph; 13.5 × 9 cm (5½ × 3½ in.); Private Collection

037 Book cover, *Babel* by John Cournos, 1922 (reprint ed. London: Victor Gollancz Ltd., 1928); 19.1 × 13 cm (7½ × 5⅛ in.); PS3505.O8855B3, Purchase from the Margery Masinter Endowment, Smithsonian Institution Libraries

038 Poster, *Eastman and Son, The London Dyers and Cleaners*, 1927; Published by Eastman and Son (London,

England); Lithograph; 57.1 × 41.8 cm (22½ × 16⁷⁄₁₆ in.); Gift of Mrs. E. McKnight Kauffer, 1963-39-43, CH/SI

039 Poster, *Near Walthamcross by Tram*, 1924; Published by Underground Electric Railways Company of London Ltd. (London, England); Printed by Sanders Phillips and Company, Ltd. (London, England); Lithograph; 76.1 × 50.5 cm (29¹⁵⁄₁₆ × 19⅞ in.); Gift of Mrs. E. McKnight Kauffer, 1963-39-29, CH/SI

040 Poster, *Hadley Wood by Tram*, 1924; Published by Underground Electric Railways Company of London Ltd. (London, England); Printed by Vincent Brooks, Day & Son (London, England); Lithograph; 76.5 × 50.5 cm (30⅛ × 19⅞ in.); Gift of Mrs. E. McKnight Kauffer, 1963-39-26, CH/SI

041 Poster, *Museum of Natural History*, 1923; Published by Underground Electric Railways Company of London Ltd. (London, England); Printed by Vincent Brooks, Day & Son (London, England); Lithograph; 96.4 × 61.5 cm (37¹⁵⁄₁₆ × 24³⁄₁₆ in.); Gift of Mrs. E. McKnight Kauffer, 1963-39-25, CH/SI

042 Drawing, Design for *The Lodger* by Alfred Hitchcock, 1926; Tempera; 74.3 × 55.2 cm (29¼ × 21¾ in.); Gift of the artist, 389.1939, MoMA

043 Poster, *Socrates at the British Museum*, 1926; Published by Underground Electric Railways Company of London Ltd. (London, England); Printed by Vincent Brooks, Day & Son (London, England); Lithograph; 110 × 63.4 cm (43⁵⁄₁₆ × 24¹⁵⁄₁₆ in.); Gift of Mrs. E. McKnight Kauffer, 1963-39-38, CH/SI

044 Drawing, Design for *Theatres, Quickest Way Underground*, 1930; Designed for Underground Electric Railways Company of London Ltd. (London, England); Stencil and airbrush, pencil and gouache; 54.6 × 34.3 cm (21½ × 13½ in.); Given by Mr. E. C. Gregory, E.5-1957, V&A

045 Poster, *Power, The Nerve Centre of London's Underground*, 1930, printed 1931; Published by Transport for London (London, England); Printed by Vincent Brooks, Day & Son (London, England); Lithograph; 101.6 × 61.4 cm (40 × 24³⁄₁₆ in.); Gift of Mrs. E. McKnight Kauffer, 1963-39-45, CH/SI

046 Brochure, *12,000, The Gate Theatre Studio*, 1928; Published by Gate Theatre Studio (London, England); Printed by Euston Press (London, England); Letterpress; 28 × 19 cm (11 × 7½ in.); Private Collection

047 Brochure, *All God's Chillun, The Gate Theatre Studio*, 1929; Published by Gate Theatre Studio (London, England); Printed by Euston Press (London, England); Letterpress; 28 × 19 cm (11 × 7½ in.); Private Collection

048 Drawing, Study for two figures embracing, 1930s; Brush and black ink; 30.4 × 22.7 cm (11¹⁵⁄₁₆ × 8¹⁵⁄₁₆ in.); Gift of Mrs. E. McKnight Kauffer, 1963-39-799, CH/SI

049 Magazine cover (verso), Eno's Fruit Salt, *The Studio*, Vol. 97, no. 430, January 1929; Letterpress; 29 × 19 cm (11⅜ × 8¼ in.); Private Collection

050 Magazine cover (recto), *The Studio*, Vol. 97, no. 430, January 1929; Letterpress; 29 × 19 cm (11⅜ × 8¼ in.); Private Collection

051 Book cover, *The Clio* by L. H. Myers (London and New York: Putnam, 1925); 20 × 13 cm (7⅞ × 5⅛ in.); PR6025.Y94 C58, Smithsonian Institution Libraries

052 Book cover, *Elsie and the Child* by Arnold Bennett (London: Cassell & Co., 1929); 26 × 20 cm (10¼ × 8 in.); Private Collection

053 Print, Illustration for *Elsie and the Child* by Arnold Bennett, 1929; Published by Cassell & Co. (London, England); Printed by Curwen Press (London, England); Lithograph, brush and gouache; 24.9 × 19.2 cm (9¹³⁄₁₆ × 7⁹⁄₁₆ in.); Gift of Mrs. E. McKnight Kauffer, 1963-39-333, CH/SI

054 Print, Illustration for *Elsie and the Child* by Arnold Bennett, 1929; Published by Cassell & Co. (London,

England); Printed by Curwen Press (London, England); Lithograph, brush and gouache; 24.9 × 19.2 cm (9¹³⁄₁₆ × 7⁹⁄₁₆ in.); Gift of Mrs. E. McKnight Kauffer, 1963-39-332, CH/SI

055 Print, Illustration for *Elsie and the Child* by Arnold Bennett, 1929; Published by Cassell & Co. (London, England); Printed by Curwen Press (London, England); Lithograph, brush and gouache; 24.9 × 19.2 cm (9¹³⁄₁₆ × 7⁹⁄₁₆ in.); Gift of Mrs. E. McKnight Kauffer, 1963-39-330, CH/SI

056 Book illustration, *A Song for Simeon* by T. S. Eliot (London: Faber & Gwyer, 1928); Printed by Curwen Press (London, England); Lithograph; approx. 18.2 × 12.2 cm (7³⁄₁₆ × 4¹³⁄₁₆ in.); Simon Rendall Collection

057 Book cover, *Journey of the Magi* by T. S. Eliot (London: Faber & Gwyer, 1927); Printed by Curwen Press (London, England); approx. 18.2 × 12.2 cm (7³⁄₁₆ × 4¹³⁄₁₆ in.); Simon Rendall Collection

058 Book illustration, *Journey of the Magi* by T. S. Eliot (London: Faber & Gwyer, 1927); Printed by Curwen Press (London, England); Lithograph; approx. 18.2 × 12.2 cm (7³⁄₁₆ × 4¹³⁄₁₆ in.); Simon Rendall Collection

059 Print, Illustration for *Robinson Crusoe* by Daniel Defoe, 1929; Published by Haslewood Books Ltd. (London, England); Printed by Curwen Press (London, England) and the Glasgow University Press (Glasgow, Scotland); Lithograph, brush and white gouache; 25 × 18.6 cm (9¹³⁄₁₆ × 7⁵⁄₁₆ in.); Gift of Mrs. E. McKnight Kauffer, 1963-39-340, CH/SI

060 Print, Illustration for *Robinson Crusoe* by Daniel Defoe, 1929; Published by Haslewood Books Ltd. (London, England); Printed by Curwen Press (London, England) and the Glasgow University Press (Glasgow, Scotland); Lithograph, brush and white gouache; 25 × 18.6 cm (9¹³⁄₁₆ × 7⁵⁄₁₆ in.); Gift of Mrs. E. McKnight Kauffer, 1963-39-344, CH/SI

061 Drawing, Illustration for *Marina* by T. S. Eliot, 1930; Brush and blue and black gouache; 40.9 × 31.2 cm (16⅛ × 12⁵⁄₁₆ in.); Gift of Mrs. E. McKnight Kauffer, 1963-39-326, CH/SI

062 Drawing, Costume design: Berthold for *Henry IV* by Luigi Pirandello, 1925; Designed for Everyman Theatre (London, England); Produced by A. E. Filmer; Brush and gouache, graphite; 48.3 × 31.5 cm (19 × 12⅜ in.); Gift of Mrs. E. McKnight Kauffer, 1963-39-172, CH/SI

063 Drawing, Costume design: Henry IV for *Henry IV* by Luigi Pirandello, 1925; Designed for Everyman Theatre (London, England); Produced by A. E. Filmer; Brush and gouache, graphite; 48.4 × 31.6 cm (19¹⁄₁₆ × 12⁷⁄₁₆ in.); Gift of Mrs. E. McKnight Kauffer, 1963-39-171, CH/SI

064 Drawing, Costume design: Caliban for *The Tempest* by William Shakespeare, ca. 1932; Brush and gouache; 31.5 × 24 cm (12⅜ × 9⁷⁄₁₆ in.); Gift of Mrs. E. McKnight Kauffer, 1963-39-208, CH/SI

065 Book cover, *The Meditations of a Profane Man* by "H" (London: Cecil Palmer, 1925); 17.1 × 10.8 × 1.3 cm (6¾ × 4¼ × ½ in.); Courtesy of Shapero Rare Books

066 Book cover, *Murder by Latitude* by Rufus King (Garden City, New York: Doubleday, Doran & Company, 1930); 19.5 × 12.9 cm (7¹¹⁄₁₆ × 5¹⁄₁₆ in.); PS3521.I5425M87, Purchase from the Margery Masinter Endowment, Smithsonian Libraries

067 Poster, *Well Done! 11 World Records, Villiers*, ca. 1928; Designed at W. S. Crawford Ltd. (London, England); Published by The Villiers Engineering Company (Wolverhampton, England); Lithograph; 76.1 × 50.7 cm (29¹⁵⁄₁₆ × 19¹⁵⁄₁₆ in.); Gift of Mrs. E. McKnight Kauffer, 1963-39-75, CH/SI

068 Carpet, ca. 1929; Produced by Wilton Royal Carpet Factory (Wilton, England); Wool and jute; 210.2 × 117.2 cm (82¾ × 46⅛ in.); The Cynthia Hazen Polsky Fund, 1992.64, Metropolitan Museum of Art; Image

copyright © The Metropolitan Museum of Art; Image source: Art Resource, NY

069 Drawing, Design for a carpet, ca. 1928; Brush and watercolor, gouache on photostat; 32.4 × 24.4 cm (12¾ × 9⅝ in.); Gift of Daren Pierce, 1982-79-17-6, CH/SI

070 Book cover, *Expressionism* by Hermann Bahr, 1916 (reprint ed. London: Frank Henderson, 1925); 19.5 × 13 cm (7¹¹⁄₁₆ × 5⅛ in.); Simon Rendall Collection

071 Book cover, *The Open Conspiracy* by H. G. Wells (London: Victor Gollancz Ltd., 1928); 19 × 13 cm (7½ × 5⅛ in.); HX811.W45 1928, Smithsonian Libraries

072 Book cover, *Murder by the Clock* by Rufus King (Garden City, New York: Doubleday, Doran & Company, 1929); 19.5 × 13.5 cm (7½ × 5¼ in.); Private Collection

073 Book cover, *The Diary of a Communist Schoolboy* by Nikolai Ognyov (London: Victor Gollancz Ltd., 1928); 19 × 13.5 cm (7½ × 5¼ in.); Private Collection

074 Book cover, *BBC Handbook* (London: BBC, 1929); 18.7 × 12.5 cm (7³⁄₈ × 4¹⁵⁄₁₆ in.); Morrill C. Berman Collection

075 Drawing, Design for Eno's Fruit Salt, 1931; Designed for Eno's Fruit Salt (Newcastle, England); Brush and gouache, graphite; 45.2 × 33.2 cm (17¹³⁄₁₆ × 13¹⁄₁₆ in.); Gift of Mrs. E. McKnight Kauffer, 1963-39-167, CH/SI

076 Poster, *Shop between 10 and 4, the Quiet Hours*, 1930; Published by Underground Electric Railways Company of London Ltd. (London, England); Printed by Vincent Brooks, Day & Son (London, England); Lithograph; 101 × 62 cm (39¾ × 24⅜ in.); Merrill C. Berman Collection

077 Poster, *Play between 6 and 12, the Bright Hours*, 1931; Published by Underground Electric Railways Company of London Ltd. (London, England); Printed by Vincent Brooks, Day & Son (London, England); Lithograph; 101.6 × 63.5 cm (40 × 25 in.); 1983/4/2999, LTM

078 Brochure, *The Chrysler 72*, 1928; Published by Chrysler Company mbH (Berlin-Johannisthal); Letterpress; 25.9 × 25.4 cm (10³⁄₁₆ × 10 in.); Purchase from the Margery Masinter Endowment, Smithsonian Libraries

079 Poster, *British Industries Fair*, 1928; Published by Underground Electric Railways Company of London Ltd. (London, England); Printed by Vincent Brooks, Day & Son (London, England); Lithograph; 29.2 × 47 cm (11½ × 18¼ in.); 1903/4/8641, LTM

080 Poster, *Piccadilly Extension*, 1932; Published by Underground Electric Railways Company of London Ltd. (London, England); Printed by Vincent Brooks, Day & Son (London, England); Lithograph; 100.8 × 63.3 cm (39¹¹⁄₁₆ × 24¹⁵⁄₁₆ in.); Gift of Mrs. E. McKnight Kauffer, 1963-39-51, CH/SI

081 Poster, *Actors Prefer Shell, You Can Be Sure of Shell*, 1933; Published by Shell-Mex and B.P. Ltd. (London, England); Lithograph; 74 × 109.5 cm (29 × 43½ in.); Private Collection

082 Poster, *Magicians Prefer Shell, You Can Be Sure of Shell*, 1934; Published by Shell-Mex and B.P. Ltd. (London, England); Lithograph; 75.9 × 113.7 cm (29⅞ × 44¾ in.); Merrill C. Berman Collection

083 Poster, *Aeroshell Lubricating Oil*, 1932; Published by Shell-Mex and B.P. Ltd. (London, England); Printed by Chorley & Pickersgill, Ltd. (London, England); Lithograph; 76.2 × 114.3 cm (30 × 45 in.); Merrill C. Berman Collection

084 Drawing, Design for an advertisement, glove with morning glory, ca. 1940; Brush and gouache; 43.4 × 35 cm (17¹⁄₁₆ × 13¾ in.); Gift of Grace Schulman, 1997-134-4, CH/SI

085 Book cover, *Poems* by Dunstan Thompson (New York: Simon and Schuster, 1943); 22.2 × 16.3 (8¾ × 6⁷⁄₁₆ in.); Barbara Jakobson Collection

086 Drawing, Study for *Keep Well* poster, 1934; Designed for Eno's Fruit Salt (Newcastle, England);

Airbrush and white and blue gouache; 19.2 × 23 cm (7⁹⁄₁₆ × 9¹⁄₁₆ in.); Gift of Mrs. E. McKnight Kauffer, 1963-39-960, CH/SI

087 Booklet cover (recto and verso), *Fortnum & Mason*, ca. 1931; Published by Fortnum & Mason (London, England); Letterpress; 21.1 × 29 cm (8⁵⁄₁₆ × 11⁷⁄₁₆ in.); EMcKK/SI

088 Poster, *Great Western to Cornwall*, 1932; Published by Great Western Railway (London, England); Printed by William Brown & Company, Ltd. (London, England); Lithograph; 100.5 × 61.9 cm (39⁹⁄₁₆ × 24⅜ in.); Gift of Mrs. E. McKnight Kauffer, 1963-39-59, CH/SI

089 Poster, *Great Western to Devon's Moors*, 1932; Published by Great Western Railway (London, England); Printed by William Brown & Company, Ltd. (London, England); Lithograph; 100.1 × 61.3 cm (39⁷⁄₁₆ × 24⅛ in.); Gift of Mrs. E. McKnight Kauffer, 1963-39-58, CH/SI

090 Poster, *A Pillar'd Shade*, 1932; Published by Underground Electric Railways Company of London Ltd. (London, England); Printed by Vincent Brooks, Day & Son (London, England); Lithograph; 101.3 × 64 cm (39⅞ × 25³⁄₁₆ in.); 1963-39-49, CH/SI

091 Poster, *Stonehenge, See Britain First on Shell!*, 1932; Published by Shell-Mex and B.P. Ltd. (London, England); Printed by Vincent Brooks, Day & Son (London, England); Lithograph; 79 × 115 cm (31⅛ × 45¼ in.); Museum purchase from Friends of Drawings and Prints Fund, 1989-90-1, CH/SI

092 Book cover, *Batsford's Pictorial Guides, No. 1, Amsterdam* (London: B. T. Batsford Ltd., ca. 1934); Featuring photography by Geoffry Gilbert; 21.2 × 17.2 cm (8⅜ × 7 in.); Private Collection

093 Book cover, *Batsford's Pictorial Guides, No. 2, Copenhagen* (London: B. T. Batsford Ltd., ca. 1934); Featuring photography by Geoffrey Gilbert; 21.2 × 17.2 cm (8⅜ × 7 in.); Private Collection

094 Book cover, *Batsford's Pictorial Guides, No. 3, Stockholm* (London: B. T. Batsford Ltd., ca. 1934); Featuring photography by Geoffrey Gilbert; 21.2 × 17.2 cm (8⅜ × 7 in.); Private Collection

095 Book cover, *Batsford's Pictorial Guides, No. 4, Hamburg* (London: B. T. Batsford Ltd., ca. 1934); Featuring photography by Geoffrey Gilbert; 21.2 × 17.2 cm (8⅜ × 7 in.); Private Collection

096 Card, 1934, 1933; Lithograph; 17 × 22.6 cm (6¹¹⁄₁₆ × 8⅞ in.); EMcKK/SI

097 Poster, *Tea Drives Away the Droops*, 1936; Published by Empire Tea Market-Expansion Board (England); Lithograph; 75.9 × 50.2 cm (29⅞ × 19¾ in.); Gift of Mrs. E. McKnight Kauffer, 1963-39-84, CH/SI

098 Magazine cover, *Harper's Bazaar*, January 1940; 33 × 25 cm (13 × 9¾ in.); Private Collection

099 Print, *Colas November, Continues to Lead*, 1933; Published by Colas Group; Lithograph and letterpress; 9.5 × 22.5 cm (3¾ × 8⅞ in.); Merrill C. Berman Collection

100 Print, *Colas December, Leads a Great Industry*, 1933; Published by Colas Group; Lithograph and letterpress; 9.5 × 22.5 cm (3¾ × 8⅞ in.); Merrill C. Berman Collection

101 Print, *Colas January, Worldwide Organisation*, 1934; Published by Colas Group; Lithograph and letterpress; 9.5 × 22.5 cm (3¾ × 8⅞ in.); Merrill C. Berman Collection

102 Print, *Colas March, Is Consistently Reliable*, 1933; Published by Colas Group; Lithograph and letterpress; 9.5 × 22.5 cm (3¾ × 8⅞ in.); Merrill C. Berman Collection

103 Print, *Colas October, Is Consistently Reliable*, 1933; Published by Colas Group; Lithograph and letterpress;

9.5 × 22.5 cm (3¾ × 8⅞ in.); Merrill C. Berman Collection

104 Print, *Colas February, Terolas*, 1933; Published by Colas Group; Lithograph and letterpress; 9.5 × 22.5 cm (3¾ × 8⅞ in.); Merrill C. Berman Collection

105 Print, *Colas August, Terolas Alphastic*, 1933; Published by Colas Group; Lithograph and letterpress; 9.5 × 22.5 cm (3¾ × 8⅞ in.); Merrill C. Berman Collection

106 Poster, *Bicycle and Motorcycle Show*, 1935; Published by London Passenger Transport Board (London, England); Lithograph; 25.5 × 30.5 cm (10¹⁄₁₆ × 12 in.); 1983/4/9715, LTM

107 Book cover, *Quack Quack* by Leonard Woolf, 1935 (reprint ed. London: Hogarth Press, 1937); 19 × 12.8 cm (7⅜ × 5 in.); Private Collection

108 Drawing, Design for *Modern Lighting Technics*, 1935; Brush and gouache; 100 × 63.2 cm (39⅜ × 24⅞ in.); Gift of Mrs. E. McKnight Kauffer, 1963-39-155, CH/SI

109 Brochure, *Cambridge Exhibition, Fascism & War*, 1934; Organized by the Hull Workers' Film Society (Hull, England); Printed by Risevers (Cambridge, England); 21 × 14.3 cm (8⅜ × 5½ in.); Private Collection

110 Drawing, Study for *Cambridge Exhibition, Fascism & War*, 1934; Designed for Sylvia Pankhurst (British, 1882–1960); Graphite, brush and gouache, newsprint collage; 31.3 × 26.8 cm (12⁵⁄₁₆ × 10⁹⁄₁₆ in.); Gift of Mrs. E. McKnight Kauffer, 1963-39-962, CH/SI

111 Drawing, London's new entertainment center, 1936; Mixed media, collage, paint; 30.5 × 54.5 cm (12 × 21⁷⁄₁₆ in.); Purchase from Sidney Garrad, E.3288-1980, V&A

112 Book cover, *Art Now* by Herbert Read (London: Faber & Faber Ltd., 1933); 20.6 × 14.6 cm (8⅛ × 5¾ in.); Simon Rendall Collection

113 Drawing, London's new entertainment center, 1936; Mixed media, collage, paint; 30.5 × 54.5 cm (12 × 21⁷⁄₁₆ in.); Purchase from Sidney Garrad, E.3289-1980, V&A

114 Drawing, Study of a mechanical figure, ca. 1935; Designed for Gas Light and Coke Company (London, England); Brush and gouache, graphite; 16.2 × 15.2 cm (6⅜ × 6 in.); Gift of Mrs. E. McKnight Kauffer, 1963-39-913, CH/SI

115 Drawing, Design for Lumlum, 1935; Designed for Lumium Limited (London, England); Gouache; 26.1 × 21.4 cm (10¼ × 8⁷⁄₁₆ in.); Given by Mark Haworth-Booth, E.2356-1990, V&A

116 Poster, *Treat Yourself to Better Play*, 1935; Published by London Passenger Transport Board (London, England); Printed by Vincent Brooks, Day & Son (London, England); Lithograph; 101.4 × 63.2 cm (39¹⁵⁄₁₆ × 24⅞ in.); Gift of Mrs. E. McKnight Kauffer, 1963-39-73, CH/SI

117 Drawing, Design for *L.C.C. Evening Classes, Quickest by Underground*, ca. 1935; Designed for London Passenger Transport Board (London, England); Brush and gouache, collaged photograph; 31.5 × 20.2 cm (12⅜ × 7¹⁵⁄₁₆ in.); Gift of Mrs. E. McKnight Kauffer, 1963-39-505, CH/SI

118 Drawing, Design for *Train Yourself to Better Play*, 1935; Designed for London Passenger Transport Board (London, England); Brush and gouache, photomontage; 31.5 × 20.4 cm (12⅜ × 8¹⁄₁₆ in.); Gift of Mrs. E. McKnight Kauffer, 1963-39-509, CH/SI

119 Drawing, Study for *Quickest Way by Air Mail*, 1935; Designed for British General Post Office (London, England); Graphite, brush and silver oil and blue gouache; 6.5 × 16.4 cm (2⁹⁄₁₆ × 6⁷⁄₁₆ in.); Gift of Mrs. E. McKnight Kauffer, 1963-39-898, CH/SI

120 Drawing, Study for *Quickest Way by Air Mail*, 1935; Designed for British General Post Office (London, England); Graphite, pen and black ink, brush and black ink and white gouache; 11.5 × 25.9 cm (4½ × 10³⁄₁₆ in.);

Gift of Mrs. E. McKnight Kauffer, 1963-39-900, CH / SI

121 Drawing, Study for *Quickest Way by Air Mail*, 1935; Designed for British General Post Office (London, England); Graphite, brush and blue and black gouache; 13.5 × 22.2 cm (5⁵⁄₁₆ × 8¾ in.); Gift of Mrs. E. McKnight Kauffer, 1963-39-899, CH / SI

122 Poster, *Quickest Way by Air Mail*, 1935; Published by British General Post Office (London, England); Lithograph; 75.7 × 50.5 cm (29¹³⁄₁₆ × 19⅞ in.); Gift of Mrs. E. McKnight Kauffer, 1963-39-71, CH / SI

123 Drawing, Study for an advertisement, *The Wizard Comes Out of the Wall*, 1935; Designed for Gas Light and Coke Company (London, England); Graphite and collage; 34.5 × 24 cm (13⁹⁄₁₆ × 9⁷⁄₁₆ in.); Gift of Mrs. E. McKnight Kauffer, 1963-39-649, CH / SI

124 Drawing, Study for *Mechnical Man*, 1934; Designed for Shell-Mex and B.P. Ltd. (London, England); Body color and collage; 28.5 × 18.3 cm (11¼ × 7³⁄₁₆ in.); E.3770-2004, V&A

125 Drawing, Study for a book cover, *5 On Revolutionary Art*, 1935; Designed for Wishart Limited (London, England); Graphite, brush and red, black, and blue gouache; 18.9 × 13 cm (7⁷⁄₁₆ × 5⅛ in.); Gift of Mrs. E. McKnight Kauffer, 1963-39-691-a, CH / SI

126 Book cover, *5 On Revolutionary Art* by Betty Rea, ed. (London: Wishart Limited, 1935); 19 × 13 (7½ × 5 in.); Private Collection

127 Print, Design for *A-D Magazine*, 1942; Lithograph; 20.2 × 28.6 cm (7⁵⁄₁₆ × 11¼ in.); EMcKK / SI

128 Book cover, *Point Counter Point* by Aldous Huxley, 1928 (reprint ed. New York: Modern Library, 1942); 18.2 × 12.3 cm (7³⁄₁₆ × 4¹³⁄₁₆ in.); Barbara Jakobson Collection

129 Book cover, *Winesburg, Ohio* by Sherwood Anderson, 1919 (reprint ed. New York: Modern Library, 1936); 16.9 × 11 cm (6⅝ × 4⁵⁄₁₆ in.); Barbara Jakobson Collection

130 Drawing, Costume design: surrealist figure with red eye, early 1940s; Brush and gouache; 24.6 × 20.4 cm (9¹¹⁄₁₆ × 8⅛ in.); Gift of Mrs. E. McKnight Kauffer, 1963-39-861, CH / SI

131 Drawing, Design for an advertisement, Behind Room Beauty, 1948; Brush and gouache; 25.3 × 18.9 cm (9¹⁵⁄₁₆ × 7⁷⁄₁₆ in.); Gift of Mrs. E. McKnight Kauffer, 1963-39-1218, CH / SI

132 Poster, *28th Annual National Exhibition of Advertising and Editorial Art,* 1949; Published by The Museum of Modern Art (New York, New York, USA); Lithograph; 111.8 × 73.7 cm (44 × 29 in.); Gift of George R. Kravis II, 2018-22-117, CH / SI

133 Magazine cover, *Ringling Bros and Barnum & Bailey, Circus Magazine & Program*, 1949; Lithograph; 27.6 × 21 cm (10⅞ × 8¼ in.); Barbara Jakobson Collection

134 Drawing, Stage design: backdrop for *Checkmate*, ca. 1947; Designed for the Royal Opera House (London, England); Produced and choreographed by Ninette de Valois (Irish, 1898–2001); Music composed by Arthur Bliss (British, 1891–1975); Brush and gouache; 35.4 × 54.6 cm (13¹⁵⁄₁₆ × 21½ in.); Gift of Mrs. E. McKnight Kauffer, 1963-39-272, CH / SI

135 Drawing, Costume design: Black Knight, for *Checkmate*, ca. 1947; Designed for the Royal Opera House (London, England); Produced and choreographed by Ninette de Valois (Irish, 1898–2001); Music composed by Arthur Bliss (British, 1891–1975); Brush and gouache, graphite; 40.7 × 30.5 cm (16 × 12 in.); Gift of Mrs. E. McKnight Kauffer, 1963-39-279, CH / SI

136 Drawing, Costume design: Red Castle, for *Checkmate*, ca. 1947; Designed for the Royal Opera House (London, England); Produced and choreographed by Ninette de Valois (Irish, 1898–2001); Music composed by Arthur Bliss (British, 1891–1975); Brush and gouache,

graphite; 39.5 × 28.7 cm (15⁹⁄₁₆ × 11⁵⁄₁₆ in.); Gift of Mrs. E. McKnight Kauffer, 1963-39-280, CH / SI

137 Drawing, Costume design: Red Queen, for *Checkmate*, ca. 1947; Designed for the Royal Opera House (London, England); Produced and choreographed by Ninette de Valois (Irish, 1898–2001); Music composed by Arthur Bliss (British, 1891–1975); Brush and gouache, graphite; 39.5 × 30.5 cm (15⁹⁄₁₆ × 12 in.); Gift of Mrs. E. McKnight Kauffer, 1963-39-277, CH / SI

138 Drawing, Costume design: Red Knight, for *Checkmate*, ca. 1947; Designed for the Royal Opera House (London, England); Produced and choreographed by Ninette de Valois (Irish, 1898–2001); Music composed by Arthur Bliss (British, 1891–1975); Brush and gouache, graphite; 40.7 × 30.5 cm (16 × 12 in.); Gift of Mrs. E. McKnight Kauffer, 1963-39-278, CH / SI

139 Poster, *Yugoslav People Led by Tito*, 1944; Published by The United Committee of South-Slavic Americans (Chicago, Illinois, USA); Lithograph; 63.5 × 48.3 cm (25 × 19 in.); Gift of Mrs. E. McKnight Kauffer, 1963-39-114, CH / SI

140 Poster, *A Subway Poster Pulls*, 1947; Published by New York Subway Advertising Company (New York, New York, USA); Screenprint; 116.8 × 76.2 cm (46 × 30 in.); Gift of Mrs. E. McKnight Kauffer, 1963-39-119, CH / SI

141 Magazine cover, *Fortune*, November 1945; Lithograph; 33.3 × 26.8 cm (13⅛ × 10⁹⁄₁₆ in.); EMcKK / SI

142 Drawing, Design for *Fortune* cover, 1948; Designed for *Fortune* (New York, New York, USA); Brush and gouache, white crayon, graphite; 40.2 × 33.7 cm (15¹³⁄₁₆ × 13 ¼ in.); Gift of Mrs. E. McKnight Kauffer, 1963-39-1216, CH / SI

143 Drawing, Design for *The United Nations*, 1945; Published by United Nations (New York, New York, USA); Gouache; 42.5 × 35.6 cm (16¾ × 14 in.); Merrill C. Berman Collection

144 Drawing, Design for *The United Nations*, 1946; Designed for United Nations (New York, New York, USA); Brush and gouache; 42.8 × 30.3 cm (16⅞ × 11¹⁵⁄₁₆ in.); Gift of Mrs. E. McKnight Kauffer, 1963-39-159, CH / SI

145 Book cover, *When Last I Died* by Gladys Mitchell, 1941 (reprint ed. New York: Alfred A. Knopf, 1942); 19.5 × 13.3 cm (7¹¹⁄₁₆ × 5¼ in.); 1963-39-1297, CH / SI

146 Magazine advertisement, *Have You Seen the Modern Library in the New Binding?*, ca. 1940; Published by Modern Library (New York, New York, USA); Lithograph; 33.3 × 23 cm (13⅛ × 9¹⁄₁₆ in.); EMcKK / SI

147 Drawing, Illustration for *The Complete Poems and Stories of Edgar Allan Poe*, 1946; Designed for Alfred A. Knopf (New York, New York, USA); Brush and gouache; 40.6 × 30.4 cm (16 × 11¹⁵⁄₁₆ in.); Gift of Mrs. E. McKnight Kauffer, 1963-39-473, CH / SI

148 Drawing, Study for *The Complete Poems and Stories of Edgar Allan Poe*, 1946; Designed for Alfred A. Knopf (New York, New York, USA); Brush and gouache; 35 × 25.7 cm (13¾ × 10⅛ in.); Gift of Mrs. E. McKnight Kauffer, 1963-39-454, CH / SI

149 Book cover, *Exile* by St.-John Perse (New York: Pantheon Books, 1949); 23.3 × 16 cm (9³⁄₁₆ × 6⁵⁄₁₆ in.); Grace Schulman Collection

150 Card, 1948, 1947; Screenprint; 12.5 × 17.5 cm (4⁵⁄₁₆ × 6⅞ in.); EMcKK / SI

151 Poster, *American Airlines to Paris*, 1950; Published by American Airlines (Fort Worth, Texas, USA); Lithograph; 107.1 × 79 cm (42³⁄₁₆ × 31⅛ in.); Gift of Mrs. E. McKnight Kauffer, 1963-39-141, CH / SI

152 Poster, *American Airlines to New York*, 1948; Published by American Airlines (Fort Worth, Texas, USA); Lithograph; 101.4 × 76 cm (39¹⁵⁄₁₆ × 29¹⁵⁄₁₆ in.); Gift of Mrs. E. McKnight Kauffer, 1963-39-139, CH / SI

153 Poster, *American Airlines to Chicago*, 1950; Published by American Airlines (Fort Worth, Texas, USA); Lithograph; 107 × 80.8 cm (42⅛ × 31¹³⁄₁₆ in.); Gift of Mrs. E. McKnight Kauffer, 1963-39-135, CH / SI

154 Poster, *American Airlines to Europe*, 1948; Published by American Airlines (Fort Worth, Texas, USA); Lithograph; 102 × 76.5 cm (40³⁄₁₆ × 30⅛ in.); Gift of Mrs. E. McKnight Kauffer, 1963-39-138, CH / SI

"About the House." On and Off the Avenue. *The New Yorker*, November 5, 1949, 98–102.

"Abstract Images: Display Arranged by Steichen Includes Variety of Experimental Work." *New York Times*, May 6, 1951.

"Address Book." *Interiors*, September 1959, 182.

Advertisement. *Interiors*, March 1950, 177.

Advertisement. *Interiors*, November 1952, 37.

Anderson, Sir Colin. "E. McKnight Kauffer," in *Advertising Review* 1, no. 3 (Winter 1954–55): 36.

Archer, W. G. "E. McKnight Kauffer and T. S. Eliot." *Cambridge Review*, May 1, 1931.

Arnot, Stephen. "Art Experiments in Advertising: What the Modern Movement Means." *The Organiser*, June 1921, 224–25.

"Art: Forthcoming Exhibitions. An American Poster Artist." *New York Times*, October 16, 1921.

Baird, Thomas. "Films and the Public Services in Great Britain." *Public Opinion Quarterly* 2, no. 1 (January 1938): 96–99.

Barnes, Martin, ed. *Curtis Moffat: Silver Society. Experimental Photography and Design, 1923–1935.* Göttingen, Germany: Steidl, and London: V&A Publishing, 2016.

Barr, Alfred H., Jr. "Introduction." In *Cubism and Abstract Art.* New York: The Museum of Modern Art, 1936. Exhibition catalog.

Barton, J. E. *The Changing World: A Broadcast Symposium: (6) Modern Art.* London: BBC, 1932.

———. *Room and Book.* London: Curwen Press, 1932. Exhibition pamphlet.

Beaumont, Cyril W. "Ballet: Settings and Costumes in Recent Productions." *The Studio Magazine of Beauty* (April 1939): 146–56.

Beers, Laura. "Education or Manipulation? Labour, Democracy, and the Popular Press in Interwar Britain." *Journal of British Studies* 48, no. 1 (January 2009): 129–52.

Bernard, Emily. *Carl Van Vechten and the Harlem Renaissance: A Portrait in Black and White.* New Haven and London: Yale University Press, 2012.

———, ed. *Remember Me to Harlem: The Letters of Langston Hughes and Carl Van Vechten, 1925–1964.* New York: Alfred A. Knopf, 2001.

Bliss, Arthur. "Death on Squares." *Great Thoughts*, January 1938, 18–22.

Blunt, Anthony. "Art: Applied Arts." *Spectator*, April 5, 1935, 567.

Book Jacket Designers Guild, ed. *First Annual Exhibition: Book Jacket Designers Guild.* New York: A-D Gallery, 1948.

Boydell, Christine. *The Architect of Floors: Modernism, Art and Marion Dorn Designs.* Coggeshall, Essex, UK: Mary Schoeser in association with the Architectural Library, Royal Institute of British Architects, 1996.

———. "Batik in America and Britain 1920–1930: The Early Career of Marion Dorn." *Text: For the Study of Textile Art Design & History* 24 (Winter 1996): 4–8.

Bradshaw, Percy V. *Art in Advertising.* London: Press Art School, n.d. [1925].

Braun, Adolphe Armand. "E. McKnight Kauffer." Artists Who Help the Advertiser (No. 7). *Commercial Art* 2, no. 14 (December 1923): 324–26.

British Broadcasting Corporation. *Design in Modern Life.* London: BBC, 1933.

Buckley, Cheryl. *Designing Modern Britain.* London: Reaktion Books, 2007.

Burrell, Augustine. "That Fantastic Old Great Man." *The Nation and the Athenaeum*, February 13, 1926, 679.

"A 'Burton' Postponed." *Daily Chronicle* (UK), April 14, 1925.

Byron, Robert. "Broadcasting House." *Architectural Review* 72, no. 429 (August 1932): 47–49.

Carter, Ernestine. *With Tongue in Chic.* London: Michael Joseph, 1974.

Churchill, Sir Winston, Lord Berners, Lord Balniel, and Mary Hutchinson, draft of letter to subscribers of the Old Vic and Sadler's Wells Theatres, n.d. [1932–33]. Lot #34, "Winston Churchill Old Vic Theater Archive," Rare Autographs, Manuscripts and Aviation Auction, One of a Kind Collectibles Auctions, Coral Gables, October 27, 2016.

Coleman, Leon. *Carl Van Vechten and the Harlem Renaissance.* New York and London: Garland Publishing, 1998.

"Colour Gone Mad." *Star*, April 1917. Quoted in Denys J. Wilcox, *The London Group 1913–1939: The Artists and Their Works*, 215. Quantoxhead, UK: The Court Gallery, 1995.

Commercial Art 19, no. 113 (November 1935): 200.

Constantine, Stephen. *Buy and Build.* London: Her Majesty's Stationery Office, 1986.

Corrigan, Faith. "English Honor Designer for Influence in Field." *New York Times*, February 7, 1957.

Crawford, M. D. C. "Design Contest Brings Out Artistic Textile Patterns." *Dry Goods Guide* 46, no. 5 (November 1920): 8.

———. "Fifth Annual Industrial Art Exhibit Opens at Metropolitan Museum Tomorrow." *Women's Wear*, December 14, 1920.

———. "Names of Winners Are Announced in Women's Wear Design Contest." *Women's Wear*, November 15, 1920.

Crawford, William S. "The Poster Campaign of the Empire Marketing Board." *Commercial Art* 6 (January–June 1929): 128–32.

Cremoncini, Roberta, Alexandra Harris et al. *The Poster King: E. McKnight Kauffer.* London: Estorick Collection, 2011. Exhibition catalog.

"Cubist Posters." *Yorkshire Post*, April 23, 1921.

Daines, Mike. "The 'Lost' Labels of E. McKnight Kauffer." *Baseline* no. 20 (1995): 29–36.

"Decorating Ideas: White-Room Revival; Siamese Colours." *Vogue*, April 15, 1951, 82.

Defoe, Daniel. *The Life and Strange Surprizing Adventures of Robinson Crusoe of York, Mariner.* Edited by Kathleen Campbell. London: Frederick Etchells & Hugh Macdonald, 1929.

"Design and Color Quorum on Decorative Fabrics." *American Fabrics* no. 5 (Winter 1948): 122–25.

"Designers Haunt Public Libraries." *Montreal Gazette*, June 8, 1948.

Dorn, Marion. "Islamic Art." *Interior Design*, September 1962, 132–34.

———. Patents for Designs 123,385; 123,386; 123,387 filed October 3, 1940, and issued November 5, 1940. Patent for Design 123,545 filed October 3, 1940, and issued November 12, 1940. *Official Gazette of the United States Patent Office*, 1940, 240, 520.

———. "Textures to Live With: Design Inspired by Natural Forms Touched with Abstraction for Modern Interiors." *Craft Horizons*, September–October 1952, 26–30.

Dreyfus, John. *A History of the Nonesuch Press.* London: Nonesuch Press, 1981.

"Edward Kauffer, Poster Designer: Book Illustrator Who Worked in England for Many Years Dead in Hospital Here." *New York Times*, October 23, 1954.

Elder, Eleanor. *Travelling Players: The Story of the Arts League of Service.* London: Frederick Muller, 1939.

Elgohary, Farouk Hafiz. "Wells Coates and His Position in the Beginning of the Modern Movement in England." PhD diss., University of London, 1966.

Elliot, Walter. "The Work of the Empire Marketing Board." *Journal of the Royal Society of Arts* 79, no. 4101 (June 26, 1931): 736–48.

"E. McKnight Kauffer Has Come Back to His Native Land." *American Artist*, April 1941, 12.

"Empire Fruit." *Times* (London), June 11, 1926, 11. The Times Digital Archive.

Empire Marketing Board, May 1927–May 1928. London: His Majesty's Stationery Office, June 1928.

"English Furnishings." *New Statesman and Nation*, April 9, 1932, 453.

"European Poster Exhibit." *Wellesley News,* May 16, 1929, 5.

Exhibition of Design and Workmanship in Printing. Whitechapel Art Gallery, October 13–November 24, 1915. Exhibition catalog.

Foucrlicht, Ethel M. "Edward McKnight Kauffer's Poster Experience in England and the United States." *The Poster* 13, no. 1 (January 1922): 33–35.

Flower, Desmond. "The Book Illustrations of E. McKnight Kauffer." *Penrose Annual* 50 (1956): 35–40.

"Four Outstanding American Designers." *House & Garden*, May 1942, 43.

Fraser, Ivor. "The Present-Day Poster: An Interesting Debate." *Commercial Art* 2, no. 14, (December 1923): 322–23.

"From Our Critic: Details of Exhibitions." *Times* (London), November 3, 1926. The Times Digital Archive.

Fry, Roger. "The Author and the Artist." *The Burlington Magazine for Connoisseurs* 49, no. 280 (July 1926): 9–12.

Garland, Madge. "Some Impressions by Famous Poster Artists of the Women of Their Day." *Britannia and Eve* 3, no. 8 (August 1931): 52–53.

Gordon, Elizabeth Willson. "On or About December 1928 the Hogarth Press Changed: E. McKnight Kauffer, Art, Markets and the Hogarth Press 1928–39." In *Leonard and Virginia Woolf: The Hogarth Press and the Networks of Modernism*, edited by Helen Southworth, 179–205. Edinburgh: Edinburgh University Press, 2010.

Gordon-Stables, L. "London." *The Studio* 90, no. 388 (July 15, 1925): 42.

Gosse, Sir Edmund. Review of Nonesuch reprint edition of *The Anatomy of Melancholy*, by Robert Burton. *Sunday Times*, January 14, 1925, The World of Books.

"The GPO at Work." *Times* (London), October 19, 1937. The Times Digital Archive.

Green, Oliver. *Frank Pick's London: Art, Design and the Modern City.* London: V&A Publishing, 2013.

Grigson, G. "The Evolution of E. McKnight Kauffer, a Master Designer." *Commercial Art* 18 (1935): 202–6.

Gropius, Walter. *New Architecture and the Bauhaus.* London: Faber & Faber, 1935.

Halliday, Nigel Vaux. *More than a Bookshop: Zwemmer's and Art in the 20th Century.* London: Philip Wilson Publishers, 1991.

Harrison, Charles. *English Art and Modernism, 1900–1939.* London: Allen Lane, 1981. Reprint with a new introduction, published for the Paul Mellon Centre for Studies in British Art, New Haven: Yale University Press, 1994.

Havinden, Ashley. "Introduction." In *E. McKnight Kauffer: Memorial Exhibition of the Work of E. McKnight Kauffer.* London: Lund, Humphries & Co., 1955. Exhibition catalog.

Haworth-Booth, Mark. *E. McKnight Kauffer: A Designer and His Public.* London: Gordon Fraser, 1979.

———. *E. McKnight Kauffer: A Designer and His Public.* Rev. ed. London: V&A Publishing, 2005.

Hind, C. Lewis. "The London Group and Its Aims." *Christian Science Monitor*, May 19, 1919, 14.
——. "Rebel Artists of London and Their Debt to Cézanne." *Christian Science Monitor*, June 30, 1916, 6.
"Hoardings as Picture Galleries." *The Organiser*, 1921, 167.
Hodgkin, Eliot. "The Lettering: The Onlooker Hits Back." *Commercial Art* 18, no. 106 (April 1935): 145–49.
Hoffman, Marilyn. "New York Textile Designer Emphasizes Flair for Originality in Carpet." *Christian Science Monitor*, December 26, 1951.
——. "Rugs Revive the Past: Mediterranean Décor–No. 1." *Christian Science Monitor*, October 24, 1962.
Hollister, Paul. *American Alphabets*. New York: Harper & Brothers Publishers, 1930.
"House Beautiful's Forecast for the Styles of the Fifties." *House Beautiful*, November 1951, 195.
"Housewarming at the Underground: A Cathedral of Modernity." *Observer*, January 12, 1929, 21.
Howard, Hamilton. "Advertising with a Mission." *Courier-Journal* (Louisville, KY), August 13, 1944.
Hughes, Langston. *Shakespeare in Harlem*. New York: Alfred A. Knopf, 1942.
Hurry, Colin. "An American Painter: E. McKnight Kauffer." *Pearson's Magazine* 45, no. 8 (June 1920): 938–40.
Huxley, Aldous. "Foreword." In *Posters by E. McKnight Kauffer*. New York: The Museum of Modern Art, 1937. Exhibition catalog.
Hwang, Haewon. *London's Underground Spaces: Representing the Victorian City, 1840–1915*. Edinburgh: Edinburgh University Press, 2013.

Iyengar, Sujata. "Introduction to Shakespeare and African American Poetics: An Essay Cluster Published in Association with the *Langston Hughes Review*." *Borrowers and Lenders: The Journal of Shakespeare and Appropriation* 7, no. 2 (Fall 2012/Winter 2013): 1–4.

"A Jolly Little Picture." *Evening News* (UK), April 24, 1917.
Jones, Sydney R. *Posters & Publicity: Special Autumn Number*. London: The Studio, 1926.

Karo, George. "Etruscan Art." *Graphis* 11, no. 60 (April 1, 1955): 330–42, 365.
"Kauffer." The Talk of the Town. *The New Yorker* 20, no. 10 (April 22, 1944): 19.
Kauffer, E. McKnight. "Advertising Art: The Designer and the Public." *Journal of the Royal Society of Arts* 87, no. 4488 (November 25, 1938): 51–70.
——. "Advertising Art Now." *A-D* 8, no. 2 (December–January 1941–42): [1–16].
——, ed. *The Art of the Poster: Its Origin, Evolution & Purpose*. London: Cecil Palmer, 1924.
——, ed. "Brief Biography." In *Posters by E. McKnight Kauffer*. New York: The Museum of Modern Art, 1937. Exhibition Catalog.
——. "The Essentials of Poster Design." *Arts League of Service Bulletin 1923–1924* (1924): 11.
——. "Introduction." In Paul Rand, *Thoughts on Design*, edited by Paul Rand, vii–ix. New York: Wittenborn, 1947.
——. "The Poster." *Arts & Decoration* 16, no. 1 (November 1921): 42, 44.
——. "The Poster and Symbolism." *Penrose Annual* 26 (1924): 41–45.
——. "The Poster-Tang Tattoo." *Illustration: A Magazine Devoted to the Craft of Mechanical Reproduction, thereby Dealing with Art and Workmanship in Printing, and Science in Advertising and Commerce* 5, no. 8 (1921): 7–17.
——. "The Symbol Becomes the Poster." *Advertiser's Weekly*, April 20, 1923, iii.
——, and P. K. Thomajan, ed. "Posters by E. McKnight Kauffer." *Design and Paper* no. 29. New York: Marquardt & Company Fine Papers, n.d. [ca. 1948].
Kellner, Bruce. *Carl Van Vechten and the Irreverent Decades*. Norman: University of Oklahoma Press, 1968.
Knighton, Mary A. "Strange Fruit and Patriotic Flowers: E. McKnight Kauffer's Illustrated South." *Southern Culture* 25, no. 4 (Winter 2019): 54–81.
——. "William Faulkner's Illustrious Circles: Double-Dealing Caricatures in Style and Taste." In *Faulkner and Print Culture*, edited by Jay Watson, Jaime Harker, and James G. Thomas, Jr., 28–50. Jackson: University Press of Mississippi, 2017.
Kuh, Katharine. "Introduction." In *The Advance Guard of Advertising Artists*, designed by György Kepes. Chicago: Katharine Kuh Gallery, 1941. Exhibition catalog.

Lewis, Wyndham. *Blasting & Bombardiering*. London: Eyre & Spottiswoode, 1937. Reprint, Berkeley and Los Angeles: University of California Press, 1967.
——. *Vorticist Exhibition*. London: Doré Galleries, 1915. Exhibition catalog.
——. *Wyndham Lewis the Artist: From "Blast" to Burlington House*. 1939. Reprint, New York: Haskell House Publishers, 1971.
"'Louis D'Or' Rugs Shown by Fields." *New York Herald Tribune*, December 26, 1957.
Lynd, Robert. "Robert Burton: His Immortal Museum." *Yorkshire Observer*, February 25, 1926.

MacKenzie, John M. *Propaganda and Empire: The Manipulation of British Public Opinion, 1880–1960*. Manchester, UK, and New York: Manchester University Press, 1984.
Marriott, Charles. "The New Movement in Art." *Land & Water*, October 18, 1917, 19–20.
"A Masterly Poster by McKnight Kauffer." *Commercial Art* 1, no. 5 (February–March 1923): 104.
"Meetings of Societies: Croydon Camera Club." *British Journal of Photography* 64, no. 2965 (March 2, 1917): 112–13.
Melman, Billie. *Women and the Popular Imagination in the Twenties: Flappers and Nymphs*. London: Macmillan, 1988.
"Merchandise Cues." *Interiors*, September 1959, 170.
Meynell, Francis. *My Lives*. London: The Bodley Head, 1971.
——. *The Nonesuch Century: An Appraisal, a Personal Note and a Bibliography of the First Hundred Books Issued by the Press, 1923–1934*. London: Nonesuch Press, 1936.
"Miss Marion V. Dorn, Carpet Designer, 65." *New York Times*, January 29, 1964.
Moore, Marianne. "Introduction." In *Drawings for the Ballet and the Original Illustrations for Edgar Allan Poe by E. McKnight Kauffer*. New York: American British Art Gallery, 1949. Exhibition catalog.
Morrison, Harriet. "New Area Rugs Introduced." *New York Herald Tribune*, February 16, 1962.
——. "Newest Version of an Adaptable Sofa." *New York Times*, November 27, 1950.
——. "Today's Living: Modern Pieces Made to Match." *New York Herald Tribune*, November 28, 1950.
Mortimer, Raymond. "Modern Period Character Mania." In "Decoration Supplement," *Architectural Review* 83 (January 1938): 45–52.
Mueller, William R. "Robert Burton's Frontispiece." *PMLA* 64, no. 5 (December 1949): 1074–88.
"A Museum of Typography—Eight Nations Represented in Comprehensive Display." *Emporia Daily Gazette* (Kansas), June 4, 1935, 5.

Nash, Paul. *Room and Book*. London: Soncino Press, 1932.
Nava, Mica. "Modernity Tamed? Women Shoppers and the Rationalization of Consumption in the Interwar Period." In *All the World and Her Husband: Women in Twentieth-Century Consumer Culture*, edited by Margaret R. Andrews and Mary M. Talbot, 26–64. London and New York: Cassell, 2000.
"New Designs for Wilton Rugs by E. McK. Kauffer and Marion V. Dorn." *The Studio*, January 1929, 37.
"New GPO Post." *Daily Mail*, September 2, 1933. Daily Mail Historical Archive.
Newmeyer, Sarah. Press preview invitation for two circulating exhibitions at The Museum of Modern Art, June 10, 1941.
Nichols, Charles H., ed. *Arna Bontemps–Langston Hughes Letters: 1925–1967*. New York: Dodd Mead, 1980.
Nicholson, Virginia. *Singled Out: How Two Million British Women Survived without Men after the First World War*. Oxford and New York: Oxford University Press, 2008.
"93 Prizes Awarded to Women's Wear Designers." *New-York Tribune*, November 21, 1920.
"Norwich Girl Is in England; Folks Worry." *Binghamton Press*, August 5, 1914, 8.

Olshen, Jessica. *Edward Fields: Carpet Makers*, n.d., vols. 1, 4. Edward Fields company literature available in its showroom, New York, 2019.
"Only in the U.S.A." *House & Garden*, July 1949, 31.
"Opulent New Edward Fields Rugs by Marion Dorn Bow to the Sun King." *Interiors*, February 1958, 120.
Our London Correspondent. "Mr. Pick on Posters." *Manchester Guardian*, February 25, 1939.
"Our Philosophy, Policy and Programme." *Commercial Art* 1, no. 1 (October 1922): 1.
Our Plates. *Commercial Art* 1, no. 1 (October 1922): 21.
Our Plates. *Commercial Art* 1, no. 6 (April 1923): 121.
Our Special Correspondent. "Art in Advertisements: Exhibition of Brilliant Example." *Observer*, July 5, 1925.

"Palette & Chisel." *Colour*, December 1915, xii.
Parker, Robert Allerton. "Edward McKnight Kauffer: A Commercial Artist with Ideals." *Arts & Decoration* 14, no. 1 (November 1920): 48–51.
Pepis, Betty. "New Rugs Inspired by Ancient Motifs." *New York Times*, November 20, 1951.
Peppiatt, Michael. *Francis Bacon: Anatomy of an Enigma*. London: Constable & Robinson, 2008.
Pevsner, Nikolaus. "Patient Progress: The Life Work of Frank Pick." *Architectural Review* 92, no. 548 (August 1942): 31–40.
——, and Ian Richmond. *The Buildings of England: London*. Harmondsworth, UK: Penguin, 1957.
"Pictures in the Modern House: The Newest Phase of Interior Decoration." *Studio International*, July 1932, 48–49.
"Pilgrim Fathers, in Plymouth's Pageant, Not Dour Greybeards but Fine, Sensible Young 'Liberals.'" *St. Louis Post-Dispatch*, July 10, 1921.
"The Present-Day Poster." *Commercial Art* 2, no. 14 (December 1923): 327.
Pringle, Ann. "Classical Drawings Reproduced on Series of Pin-Up Wallpapers." *New York Herald Tribune*, August 18, 1949.
"Products of the Empire." *Times* (London), January 6, 1927. The Times Digital Archive.
"Programme and Policy of The Arts League of Service." *Bulletin of the Arts League of Service*, 1920, 5–6.
"Projecting the Empire." *Times* (London), May 20, 1932. The Times Digital Archive.

Rampersad, Arnold. *The Life of Langston Hughes*. Vol. 2, *1941–1967: I Dream a World*. New York and Oxford: Oxford University Press, 1988.
Rappaport, Erika D. "'A New Era of Shopping': The

Promotion of Women's Pleasure in London's West End, 1909–1914." In *The Gender and Consumer Culture Reader*, edited by Jennifer Scanlon, 30–48. New York: New York University Press, 2000.

Read, Herbert Edward. *Unit 1: The Modern Movement in English Architecture, Painting and Sculpture*. London: Cassell, 1934.

Rennie, Paul. *Design: GPO Posters*. Woodbridge, UK: Antique Collectors' Club Ltd., 2011.

Rogers, W. S. "The Modern Poster: Its Essentials and Significance." *Journal of the Royal Society of Arts* 62, no. 3192 (January 23, 1914): 186–95.

Rose, W. K., ed. *Wyndham Lewis's Letters*. London: New Directions, 1963.

Saler, Michael. *The Avant-Garde in Interwar England: Medieval Modernism and the London Underground*. Oxford: Oxford University Press, 1999.

Sandilands, G. S. "E. McKnight Kauffer." *Commercial Art* 3, no. 13 (July 1927): 1–6.

Schleger, Hans, Sir Francis Meynell, Jack Beddington, Christian Barman, E. C. Gregory, Ashley Havinden, and Sir Colin Anderson. "E. McKnight Kauffer: A Memorial Symposium." *Advertising Review* 1, no. 3 (Winter 1954–55).

Schulman, Grace. "The Designer's Notebook: E. McKnight Kauffer, 1890–1954." In *The Paintings of Our Lives*, 44–45. New York: Houghton Mifflin, 2001.

——. "Gift from a Lost World." *Yale Review* 85, no. 4 (October 1997): 121–35.

Scott, Anthony. *Public Relations and the Making of Modern Britain*. Manchester, UK, and New York: Manchester University Press, 2012.

Shackleton, Edith. "Pirandello's *Henry IV* in English," 1925. Production file for *Henry IV*, Everyman Theatre, 1925, Victoria and Albert Museum, London.

Shell-Mex and B.P. Ltd. *Exhibition of Pictures in Advertising by Shell-Mex & B.P. Ltd.* (London: Shell-Mex & B.P. Ltd., 1938).

Skipwith, Peyton. "Edward McKnight Kauffer: The Underground Poster King." In *Art for All: British Posters for Transport*, edited by Teri J. Edelstein, 127–43. New Haven: Yale Center for British Art in association with Yale University Press, 2010.

——, and Brian Webb. *Design: E. McKnight Kauffer*. Woodbridge, UK: Antique Collectors' Club, 2007.

Sparrow, Walter Shaw. *Advertising and British Art*. London: John Lane The Bodley Head, 1924.

Stanard, Matthew G. "Interwar Pro-Empire Propaganda and European Colonial Culture: Toward a Comparative Research Agenda." *Journal of Contemporary History* 44, no. 1 (January 2009): 27–48.

"St. James's Theatre, 'Othello' by William Shakespeare." *Times* (London), April 6, 1932, 12. The Times Digital Archive.

Stone, Dan. *Breeding Superman: Nietzsche, Race and Eugenics in Edwardian and Interwar Britain*. Liverpool: Liverpool University Press, 2002.

Suga, Yasuko. "State Patronage of Design?: The Elitism/Commercialism Battle in the General Post Office's Graphic Production." *Journal of Design History* 13, no. 1 (2000): 23–37.

Symons, A. J. A. "On Curwen Press Books." *Curwen Press Newsletter* no. 8 (1934): 4–5.

Tatlock, R. R. "The Art Poster and the Art Book." *The Burlington Magazine* 46, no. 267 (June 1925): 304–7.

Taylor, Horace. "The Poster Revival no. 1 — E. McKnight Kauffer." *The Studio* 79 (1920): 140–47.

"Textile Design Competition." *Silk*, December 1920, 80.

The Theatres. *Times* (London), December 6, 1928, 14. The Times Digital Archive.

The Theatres. *Times* (London), February 18, 1932, 10. The Times Digital Archive.

"Thick-Rug Man Shows Flat Ones." *New York Times*, December 6, 1957.

Timmers, Margaret, ed. *The Power of the Poster*. London: V&A Publications, 1998.

Todd, Dorothy, and Raymond Mortimer. *The New Interior Decoration: An Introduction to Its Principles, and International Survey of Its Methods*. London: B. T. Batsford Ltd., 1929.

"Too Good for the Films." *Liverpool Post*, December 16, 1926.

Twemlow, Graham. "E. McKnight Kauffer: Poster Artist. An Investigation into Poster Design and Production during the Inter-war Period Using E. McKnight Kauffer's Oeuvre as an Example." PhD diss., University of Reading, 2007.

——. "E. McKnight Kauffer: The Stencilled Book Illustrations." *Parenthesis, the Newsletter of the Fine Press Book Association* 16 (February 2009): 32–34.

——. "Kauffer's Technique/A Note on Technique." In Ellen Lupton, *How Posters Work*, 38–39. New York: Cooper Hewitt, Smithsonian Design Museum, 2015.

"Two Illustrated Books." *Times* (London), February 5, 1931.

Van Vechten, Carl. *The Splendid Drunken Twenties: Selections from the Daybooks, 1922–1930*. Edited by Bruce Kellner. Urbana and Chicago: University of Illinois Press, 2003.

"Wellesley College Art Museum." *Wellesley News,* May 2, 1929, 7.

Welsh, David. *Underground Writing: The London Tube from George Gissing to Virginia Woolf*. Liverpool: Liverpool University Press, 2010.

Wheeler, Monroe. "The Art Museum and the Art Book Trade." *Museum News* 24, no. 2 (1946): 8.

——. "Posters." In *Art in Progress: A Survey Prepared for the Fifteenth Anniversary of The Museum of Modern Art, New York*, 202–9. New York: The Museum of Modern Art, 1944.

——. *20th Century Portraits*. New York: The Museum of Modern Art, 1942. Exhibition catalog.

"White House Accepts Gift." *Hartford Courant*, July 6, 1960, 13.

Wilcox, Denys J. *The London Group 1913–1939: The Artists and Their Works*. Quantoxhead, UK: The Court Gallery, 1995.

Women's Wear, March 25, 1921, 33.

Woolf, Virginia. *The Waves*. London: Hogarth Press, 1931. Reprint, Oxford: Oxford University Press, 2015.

Worth, Robert F. "Nigger Heaven and the Harlem Renaissance." *African American Review* 29, no. 3 (Autumn 1995): 461–73.

Zachary, Frank. "E. McKnight Kauffer: Poster Designer." *Portfolio* 1, no. 1 (1950).

SELECTED ARCHIVAL COLLECTIONS

Acquisition file no. SC 166–86.2010. Architecture and Design Department, The Museum of Modern Art, NY.

Alfred A. Knopf, Inc., Records. Harry Ransom Center, University of Texas at Austin.

Arnold Bennett Collection. Harry Ransom Center, University of Texas at Austin.

Bennett, Arnold. Collection of typed and autograph letters signed: London, to E. McKnight Kauffer. Department of Literary and Historical Manuscripts, Pierpont Morgan Library & Museum, New York.

The Brummer Gallery Records. The Metropolitan Museum of Art, New York.

Carl Van Vechten Papers Relating to African American Arts and Letters. James Weldon Johnson Collection in the Yale Collection of American Literature, Beinecke Rare Book and Manuscript Library, Yale University, New Haven.

E. McKnight Kauffer Archive. Cooper Hewitt, Smithsonian Design Museum, New York.

E. McKnight Kauffer, Commercial Designer and Illustrator, Collection, Archive of Art and Design, V&A Collections, London.

Exhibition File 59.2. The Museum of Modern Art Archives, New York.

Exhibition File *Modern European Posters and Commercial Typography*. Wellesley College Archives, Wellesley, Massachusetts.

Frank Pick Collection. London Transport Museum Archive, London.

Fry, Roger Eliot. Autograph letters and postcards signed (20): London, etc., to E. McKnight Kauffer, 1917 Sept. 18–1932 Nov. 24. Department of Literary and Historical Manuscripts, Pierpont Morgan Library & Museum, New York.

Glenway Wescott Papers. Beinecke Rare Book and Manuscript Library, Yale University, New Haven.

Huxley, Aldous. Autograph and typed letters signed (7): Sanary (Var), etc., to E. McKnight Kauffer, 1931 Aug. 6–1947 Jan. 19. Department of Literary and Historical Manuscripts, Pierpont Morgan Library & Museum, New York.

The John Johnson Collection of Printed Ephemera, Bodleian Library, University of Oxford.

Leslie Schreyer: Posters, Book Jackets, and Ephemera, Archive of Art and Design, V&A Collections, London.

Mary Hutchinson Papers. Harry Ransom Center, University of Texas at Austin.

Maxwell Ashby Armfield Papers. Tate Archive, London.

Meynell Collection. Cambridge University Library, Cambridge.

Meynell, Francis. Autograph and typed letters signed (68): London, to E. McKnight Kauffer, 1923 Oct. 6–1933 Nov. 6 and undated. Department of Literary and Historical Manuscripts, Pierpont Morgan Library & Museum, New York.

Monroe Wheeler Papers. Beinecke Rare Book and Manuscript Library, Yale University, New Haven.

Nash, Paul. Autograph letters signed (4): Sussex and Dorset, to E. McKnight Kauffer, 1930 Dec. 3–1935 Jan. 24. Department of Literary and Historical Manuscripts, Pierpont Morgan Library & Museum, New York.

Oliver Hill Collection. RIBA Archives, London.

Papers of Kenneth Clark. Tate Archive, London.

Postal Museum Archives. Royal Mail Archive, Calthorpe House, London.

Records of Arthur Tooth & Sons, London. Tate Archive, London.

Simon Rendall Collection, London.

Stephen Tallents Papers. Institute of Commonwealth Studies, University of London.

Transport for London Corporate Archives.

Note: Page numbers in *italic* refer to figures or plates. Those followed by "n" refer to footnotes.

A

Abbott Laboratories, 26n18
 What's New, 129, *130*
Académie Moderne, Paris, 30n9, 138
Acton, Harold, *Cornelian, 23*
Adam, Robert, 83
A-D Gallery, 135, 141
A-D Magazine, 238
Air Raid Precautions, 140
Aldridge, Ira, 72n14
Alfred A. Knopf, Inc. *See* Knopf (publisher)
Allied Artists Association, 34
American Airlines, 23, 134–35, 141
 American Airlines to California, 136
 American Airlines to Chicago, 258
 American Airlines to Europe, 259
 American Airlines to New York, 258
 American Airlines to Paris, 256–57
 Fashions in Flight, 24, 134
American Artist, 129, 132
American Red Cross, 26, 131, 141
 Give, 131
American Silk Mills, 134, 141
 magazine illustration, *135*
Anderson, Sherwood, *Winesburg, Ohio,* 239
Anderson, Sir Colin, 20, 140
Architectural Review, 87
Armfield, Maxwell Ashby, 31n18, 34
Armory Show (1913), 30, 138
Arnot, Stephen, 40n45
Arp, Jean, *82,* 83
Art Directors Club of New York, 135, 141
Arthur Tooth & Sons gallery, 81, 87, 89n33, 139
Art Institute of Chicago, 30n9, 138
Arts & Decoration, 139
Arts and Decoration Gallery, 139
Arts League of Service (ALS), 24, 40, 69–71, 71n5, 138, 139
 Catherine Parr, or Alexander's Horse (Baring), *70*
 Lazarus, 70
 Modern Tendencies in Art, 156
 The Proposal (Chekhov), *70*
Arts League of Service Bulletin, 69, 71, 139, 143
Association of Writers for Intellectual Liberty, 26
 In Defense of Freedom, 26

B

Bacon, Frank, 138
Bahr, Hermann, *Expressionism, 198*
Balniel, Lord, 72
Baring, Maurice, *Catherine Parr, or Alexander's Horse, 70,* 71
Baron (née Sterling Henry Nahum), *Checkmate, 77*
Barr, Alfred H., Jr., 109–10, 110n5, 112, 115, 140
Barton, J. E., 88
Baylis, Lilian, 72, 73n17, 76
Beaumont, Cyril, 76
Beddington, Jack, 23, 83, 96, 139
Bell, Clive, 96
Bennett, Arnold, 20, 20n3, 23, 24, 81, 83, 84, 85, 115
 Elsie and the Child, 54, 56, 139, *187*
 Venus Rising from the Sea, 54
Bernard, Emily, 106n29
Berners, Lord, 72
Berry, Ana, 69
Birkenhead, Earl of. *See* Smith, Frederick Edwin
Birmingham Repertory Theatre, 36

Bliss, Arthur, 24, *73,* 76
 Checkmate score, *77,* 140
Bontemps, Arna, 105
Book Jacket Designers Guild, 132, 141
Boumphrey, Geoffrey, 88
Bradshaw, Percy Venner, 47
British Broadcasting Corporation (BBC)
 BBC Handbook, 86, 199
 BBC Talks, 89
 Broadcasting House, *86,* 87–88
British Journal of Photography, 34–36
British Museum, 139, 179
British Union of Fascists, *The Greater Britain* (Mosley), 24, *26*
Broch, Hermann, *The Sleepwalkers, 126,* 132
Brodovitch, Alexey, 131, 141
Brooklyn Museum, 110n5
Bruguière, Francis, 23, 140
B. T. Batsford Ltd.
 Batsford's Pictorial Guides, 218–19
 The New Interior Decoration (Mortimer, Todd), *82,* 83–84, *85*
The Burlington Magazine, 54
Burton, Robert, *The Anatomy of Melancholy, 50,* 51–54, *52,* 113, 139

C

Cambridge Anti-War Council, 26, *226–27*
Campbell, Elmer Simms, 105
Carlisle House, 89n33, 140
Carson, Alice, 115n27
Cassandre, A. M., 48, 112, 128
Cassell & Co.
 Elsie and the Child (Bennett), 54, 56, 139, *187*
 Venus Rising from the Sea (Bennett), 54
Cecil Palmer, *The Meditations of a Profane Man* ("H"), *194*
Cervantes, Miguel de, *Don Quixote,* 53n16, 54, *55–57,* 56–57, 113n24, 140
Cézanne, Paul, 33, 33n25
Charnaux, 62, *62,* 140
Chatto & Windus
 Cornelian (Acton), *23*
 Eminent Victorians (Strachey), 23
 Look! We Have Come Through! (Lawrence), 138, *151*
 Queen Victoria, 159
Chekhov, Anton, *The Proposal, 70,* 71
Chelsea Art Stores, 31n18, 138
Chéret, Jules, 61, *61*
Chermayeff, Serge, 24, 83, 84, 89
Christian Science Monitor, 33
Chrysler, 139, *204*
Churchill, Winston, 26n19, 72
Clark, C. W., 79
Clark, Sir Kenneth, 20, 23, 23n14, *80,* 81, 96
Coates, Wells, 24, 81, 88, 89, 140
Coburn, Alvin Langdon, 34, 138
Colas Group, *223*
Colour
 Kauffer paintings, *33,* 138
 Poster Gallery, 34, 36, *38,* 138
 Thoughts and Opinions, 40
Commercial Art, 20, 21, 44, 92
 Tropics pentaptych, *93*
Constable & Co., *Woman: A Vindication* (Ludovici), 65, 66
Container Corporation of America, *Montana,* 135, *137,* 141
Council for Art and Industry, 140
Courier-Journal, Louisville, Kentucky, 128
Cournos, John, *Babel, 174*
Courter, Elodie, 112, 115
Covarrubias, Miguel, 100n6
Cracknell, Alfred, Clark's sitting room, *80*
Craig, Edward Gordon, 69n2
Crawford, M. D. C., 118
Crawford, Sir William, 92
Crawford Advertising. *See* W. S. Crawford
Cresset Press, 140

cubism, 34, 53–54, 110
Curtis Moffat Ltd., 24, *82,* 83, 84, 84n17
Curwen, Harold, 47, 54
Curwen Press, 23, 54–56, 87, 139
 Don Quixote (Cervantes), *55–57*
 Elsie and the Child (Bennett), *187*
 Journey of the Magi (Eliot), *189*
 Robinson Crusoe (Defoe), *190*
 Room and Book exhibition brochure, *85*
 Song of Simeon (Eliot), *188*

D

The Daily Herald, Soaring to Success!, 39, 139, *150, 151*
Daily Mail, 95
The Daily Mirror, International Fashion Fair, 159
Davis, Maud B., *E. McKnight Kauffer,* 18
Dayton, F. J. Harvey, 57
Defoe, Daniel, *Robinson Crusoe,* 54, 83, 113n24, 139, *190*
Delaunay, Sonia, 84
Dell & Wainwright
 Arnold Bennett study room, *85*
 Crawford Advertising Agency, *82*
 Study at 41 Gloucester Square, *82*
Derry & Toms, 36, *138*
 Economy and Smartness in Men's Wear, 36, 37
 Summer Sale at Derry & Toms, 149
 Winter Sale at Derry & Toms, 39, 148
Design and Industries Association (DIA), 46, 47
de Valois, Ninette, 24, *73*
 Checkmate, 68, *74–75,* 76–77, 76n19, *77,* 140, 141, *242–45*
Dorland Hall, 88
Dorn, Marion, 20, 27, 117–25, *119, 120, 122*
 in *The Anatomy of Melancholy* (Burton), *52,* 53
 carpet designs, 121, *121,* 123–24, 124n36
 exhibitions (*See* Exhibitions (Dorn))
 floral designs, 118–21, *120*
 interior design, 79–89, *80,* 84n17, 89n33
 on Kauffer, 137
 Kauffer and, 20, 20n6, 26, 110, 118, 135, 139, 140, 141
 letters to Mary Hutchinson, 107n33, 118n12
 return to US, 117–18, 117n1, 118n14, 124
 stage design, 71–72, 71n7
 textile designs, *116,* 118–21, *120,* 123n31, *125*
 wallpaper designs, 121, *122,* 123
Dorn and Fischer Inc., 118n4
Doubleday, 23
 Murder by Latitude (King), *194*
 Murder by the Clock (King), *198*
Douglas, Aaron, 100n6
Dowd, J. H., "The New Gallant," 64, *64*
Driberg, Tom, 107, 107n33
Dwiggins, W. A., 134

E

Eastman and Son, 19n1, 62
 Gloves Cleaned, 63
 The London Dyers and Cleaners (1923), *173*
 The London Dyers and Cleaners (1927), *175*
 Spring Cleaning, 63
Eckersley, Tom, *By Bus to the Pictures,* 47
Edward Fields, Inc., 123
 Walking on Air (Dorn), *121*
Ehrlich, Grace. *See* Kauffer, Grace McKnight
Elder, Eleanor, 69, 71
Elder, Paul, 138
Eliot, T. S., 20, 51, 139
 Journey of the Magi, 189
 Marina, 140, *191*

Song of Simeon, 188
Elliot, Walter, 92
Ellison, Ralph, *Invisible Man,* 100, *101,* 141
Empire Marketing Board, 91–95, 92n2, 92n4, 94n12, 95n18, 97, 139
 Bananas, 92, 94, 110, 110n6
 Cocoa Pods, 92, 94
 Tropics pentaptych, 92–95, *93,* 95n16
Empire Tea Market-Expansion Board, *Tea Drives Away the Droops, 222*
Eno's Fruit Salt
 design drawing, *200–201*
 "First Thing Every Morning," 21, 170
 Keep Well study, *211*
 The Studio magazine, *184*
Ernest Benn Ltd., *VIM, Typography of Newspaper Advertisements* (Meynell), *166*
Etchells, Frederick, 24, 29, 31, 83, 138
Etchells & Macdonald, *Robinson Crusoe* (Defoe), 54, 83, 113n24, 139
Everyman Theatre, 71–72, 71n9, 139
 costume designs for *Henry IV, 192*
Exhibitions (Dorn)
 Arthur Tooth & Sons gallery (1929, 1932), 81, 89n33, 139
 Dorland Hall (1933), 88
 Metropolitan Museum of Art (1920), 118
 New York Public Library (1948), 121
 Royal Academy (1935), 89n33
 Zwemmer Gallery (1932, 1933), 84, 89n33, 140
Exhibitions (Kauffer)
 A-D Gallery (1941, 1948), 135, 141
 Arthur Tooth & Sons gallery (1929), 81, 139
 Arts and Decoration Gallery (1921), 139
 Arts League of Service (1925), 139
 Art Students' League of Chicago (1912), 138
 Ashmolean Museum (1925), 139
 Birmingham Repertory Theatre (1917), 36
 Book Jacket Designers Guild (1948), 132
 Brooklyn Museum (1925), 110n5
 Carlisle House (1932), 89n33, 140
 Chelsea Art Stores (1915), 31n18, 138
 Goupil Gallery (1916), 33, 138
 Hampshire House (1916), 33, 138
 Katharine Kuh Gallery (1941), 112, 135, 141
 Lund, Humphries Galleries (1933, 1935), 140
 Mansard Gallery (1917), 36
 Mansard Gallery (1919), 40, 138
 Mansard Gallery (1920), 40–41
 The Museum of Modern Art (1935), 112, 140
 The Museum of Modern Art (1936), 110, 140
 The Museum of Modern Art (1937), 62, 89, 109, 110–12, 115, 128, 140
 The Museum of Modern Art (1941), 112, 113, 113n24, 141
 The Museum of Modern Art (1942), 115, 115n27
 New Burlington Galleries (1928, 1931), 139, 140
 Royal Academy (1935), 89n33
 Shell-Mex House (1938), 23, 140
 Twenty-One Gallery (1919), 138
 Victoria and Albert Museum (1931, 1949), 140, 141
 Victoria and Albert Museum (1955), 48n26, 137
 Wellesley College Art Museum (1929), 110
 Zwemmer Gallery (1932, 1933), 84, 89n33, 140

F

Faber & Faber Ltd., *Art Now* (Read), *228*
Faber & Gwyer, 139

Journey of the Magi (Eliot), *189*
The Modern Movement in Art (Wilenski), *167*
Song of Simeon (Eliot), *188*
Fantl, Ernestine, 112, 140
Fascism, 24–26
In Defense of Freedom, 26
Fascism & War, 226–27
Faulkner, William, 20, 20n5
Intruder in the Dust, 107n35
Festival of Music for the People, 141
Film Society (London), 23n13, 139
Filmer, A. E., *Henry IV* costumes, *192*
Fischer, Louis, 118, 118n4, 123–24
Fleming, Ronald, 83
Fletcher, Ifan Kyrle, The Play's the Thing, *174*
Fortnum & Mason, 20, 83
booklet cover, *212–13*
invitation to spring exhibition, *78*
Fortune magazine, *248–49*
France, Alfred, *The Way for All, 64, 64*
Frank, Bruno, *12,000, 182*
Frank Henderson, *Expressionism* (Bahr), *198*
Fraser, Ivor, 64
Fry, Maxwell, 81
Fry, Roger, 31, 36, 40, 54, 57, 64, 100, 138
Fuller, Loïe, 61

G
Gainsborough Pictures, 21–23
Garland, Madge, 24, 60
Garnett, David, 53
Garrad, Sidney, *25,* 140
Gas Light and Coke Company
mechanical figure study, *230*
The Wizard Comes Out of the Wall, 236
Gate Theatre Studio, 72, 139
12,000 (Frank), *182*
All God's Chillun (O'Neill), *182*
Gautier, Théophile, *Mademoiselle de Maupin,* 141
General Post Office, 91, 95–97, 95n21, 96n25, 140
advertisement study, *90*
Contact with the World, 96
Outposts of Britain, 96, 96n24, *97*
Quickest Way by Air Mail, 234–35
Gilbey distiller, 89
Gosse, Sir Edmund, 54
Grahame, Kenneth, 138
Grand Opera House, Evansville, 20, 69, 138
The Graphic, 72
Graphis, Tomb of the Triclinium, *125*
Great Western Railway, 140
Great Western to Cornwall, 214
Great Western to Devon's Moors, 215
Gregory, E. C. (Peter), 23, 83, 140
Grierson, John, 96, 96n27
Gropius, Walter, 81n2
Grosz, George, 134
Group X, 40–41, 40n48, 139
exhibition announcement, *41*
Self-Portrait, 28
Village, 41

H
"H," *The Meditations of a Profane Man, 194*
Halliday, Edward, 88
Hammett, Dashiell, *The Maltese Falcon,* 140
Hampshire House, 33, 138
Harmsworth, Alfred, Lord Northcliffe, 62
Harper & Brothers, *Brave New World* (Huxley), *132, 133*
Harper's Bazaar, 131, 141, *222*
Harrick, Frederick Charles, 60n2
Haslewood Books Ltd., *Robinson Crusoe* (Defoe), *190*
Hassall, John, 43, 44
Havinden, Ashley, 48, 139

Haworth-Booth, Mark, 106
Hill, Oliver, 88
Hind, C. Lewis, 33, 40
Hitchcock, Alfred, *The Lodger, 139, 178*
H. M. Stationery Office, *Tropics* pentaptych, *93–94*
Hodder & Stoughton, *The World in 2030 A.D.* (Smith), 24, 66, *67,* 140
Hogarth Press, 23, 51
Quack Quack (Woolf), 26, *225*
Hohlwein, Ludwig, 31, 36
Mittelmeer-Fahrten: Norddeutscher Lloyd Bremen, 36n37, *37*
Holden, Charles, 89
Hollister, Paul, 134
Horst, Horst P., Marion Dorn photo, *120*
House Beautiful, 121
House & Garden, 118n14, 123, 124
Marion Dorn, *119*
Howard, Hamilton, 128
H. R. Mallinson & Company, 118
Hudson, W. H., *Green Mansions, 134, 134*
Hughes, Langston, *Shakespeare in Harlem,* 99, *105–6, 105–7,* 105n26, 106n29, 134, 141
Hull Workers' Film Society, *Cambridge Exhibition, Fascism & War, 226–27*
Hurry, Colin, 30, 30n4, 40, 66
Hutchinson, Jeremy Nicolas, 107, 107n33
Hutchinson, Mary, 20, 72, 107n33
Huxley, Aldous, 20, 57, 62, 112n16
Brave New World, 132, 133
Point Counter Point, 239
Posters by E. McKnight Kauffer, 112, *113,* 140

I
The Illustrated Sporting and Dramatic News, Othello (Shakespeare), *73*
Incorporated Stage Society, 71, 139
Interior Design, 124
Interiors, 123
magazine cover, *125*
Plaque Toltec advertisement, *120*
International Brigade Dependants & Wounded Aid Committee, 140
Iyengar, Sujata, 106

J
J. C. Eno, 139
John B. Stetson Company, 129
Keep It under Your Stetson, 130
Joyce, James, *Ulysses, 132, 133*
Jud Williams, Inc.
Yellow Driftwood (Dorn), *120, 121*

K
Kähler, Erich, *Man the Measure,* 141
Kantor, MacKinlay, *Wicked Water, 132, 133*
Katharine Kuh Gallery, 112, 135, 141
Katzenbach & Warren
Cameo (Dorn), *122*
Etruscan (Dorn), 123, *125*
Master Drawings (Dorn), *122,* 123
Kauffer, Ann (daughter). See Rendall, Ann
Kauffer, Anna Johnson (mother), 138, 141
Kauffer, E. McKnight, *18,* 20, *27, 28, 73*
art education, 30, 30n9, 30n12, 138
The Art of the Poster, 21, *21,* 51, 110, 139
book illustrations, 23, *50,* 51–57, *52,* 53n16, *65,* 66, *67,* 83, *98,* 99–107, *101–2, 104–6,* 131–34, *132, 133,* 140, 141, *197*
career shift, 29–31
Dorn and, 20, 20n6, 26, 110, 118, 135, 139, 140, 141
exhibitions (See Exhibitions (Kauffer))
film industry, 21–23, 23n13, 139
interior design, 79–89, *80,* 83n14, 84n17, 89n33, *197*
lectures, 30n7, 34–35, 46, 47, 61, 67, 107, 131, 135, 141

lettering styles, 39, 40, 128
mental breakdown, 135, 141
in New York, 127–37
obituary, 127, 141
overview of, 19–26
paintings, 30, *31, 32,* 33, *33,* 34, *35, 36, 37,* 139
photomontage, 128
pochoir stencil process, 54–56
poster art (See specific clients)
as "poster king," 29, 29n2
return to US, 109, 115, 117, 117n1, 129
stage design, 20, *68,* 69–77, *70, 73–75, 76,* 76n19, 140, *193, 240*
writings, 46, 46n13, 71, 139
Kauffer, Grace McKnight, 26, 30, 33n25, 38, 129, 138
Kauffer, John (father), 138
Kellner, Bruce, 104n19
Kelmscott Press, 51–53
Kidder Smith, G. E., 115
King, Rufus
Murder by Latitude, 194
Murder by the Clock, 198
Knopf (publisher), 23, 140, 141
The Complete Poems and Stories of Edgar Allan Poe, 134, 137, 141, *252–53*
I Saw England (Robertson), *132, 132*
Nigger Heaven (Van Vechten), 24, 79n1, *98,* 100–103, 100n6, *102, 104,* 104n19, 107, 140
Shakespeare in Harlem (Hughes), *105–6, 105–7,* 105n26, 106n29, 134, 141
When Last I Died (Mitchell), *251*
Knopf, Alfred A., 79n1, 99–100, 103–4
Knopf, Blanche, 20, 20n5, 100, 105
Kodak Girl, 60, 60n2
Kuh, Katharine, 112–13, 135

L
Laird, Harold, 135
Lang, Fritz, *Metropolis, 22,* 139
Lawrence, D. H., *Look! We Have Come Through!, 138, 151*
Leach, Bernard, 84
Le Blon, Christof, 53, 53n12
Le Corbusier, 83, 87
Léger, Fernand, 84
Lewis, Wyndham, 29n2, 31, 40, 40n48, 64, 139
Life magazine, 129
Lombers, Eric, *By Bus to the Pictures, 47*
London Group, 30–31, 33, 36–39, 40, 72, 138, 139
exhibition poster (1917), *38*
exhibition poster (1918), *157*
exhibition poster (1919), *158*
invitation card (1917), *37*
London Passenger Transport Board (LPTB), 47–48, 110, 110n5
Bicycle and Motorcycle Show, 224
How Bravely Autumn Paints upon the Sky, 48, 48n21
L.C.C. Evening Classes, 232
The Tower of London, 48, 49
Train Yourself to Better Play, 233
Treat Yourself to Better Play, 48, 232
Ludovici, Anthony, *Woman: A Vindication,* 65, 66
Lumium Limited, *231*
Lund, Humphries Galleries, 140
Lurçat, Jean, 84
Lynd, Robert, 53

M
Man Ray, 20, *20,* 23, 62, 140
Charnaux, 62
Keeps London Going, 47
Marion Dorn Ltd., 118, 118n12
Mark Hopkins Institute of Art, 30n9, 138

MARS (Modern Architecture Research Group), 81, 89n33
Exhibition of New Architecture, 81
Marx, Enid, 87
Massie, Chris, *Farewell Pretty Ladies,* 141
Matter, Herbert, Marion Dorn photo, *122*
Maugham, Syrie, 83, 89n33
McGrath, Raymond, 87
McIntyre, Raymond, 31n18
McKnight, Grace Ehrlich. See Kauffer, Grace McKnight
McKnight, Joseph, 138
Melville, Herman, *Benito Cereno,* 54, 107n35, 139
Mendel, Vera
in *The Anatomy of Melancholy* (Burton), *52,* 53
The Week-End Book, 139, 164
Mendelsohn, Erich, 81n2
Merck & Co. See Sharp & Dohme
Metropolitan Museum of Art, 117
Meynell, Francis, 23, 24, 39, 51–53, 51n5, 56–57, 88, 138–39
in *The Anatomy of Melancholy* (Burton), *52,* 53
VIM, Typography of Newspaper Advertisements, 166
The Week-End Book, 139, 164
Meynell, Gerard, 139
Meynell, Vera. See Mendel, Vera
Millais, John Everett, *Bubbles,* 46
Milton, Ernest, 72, 72n14, 140
Mitchell, Gladys, *When Last I Died, 251*
Modern Library, 131–32
Have You Seen the Modern Library, 251
Mademoiselle de Maupin (Gautier), 141
The Maltese Falcon (Hammett), 140
Native Son (Wright), 100, *101*
Point Counter Point (Huxley), *239*
Ulysses (Joyce), *132, 133*
Winesburg, Ohio (Anderson), *239*
Modern Merchandising Bureau, 134, 141
Moffat, Curtis. See Curtis Moffat Ltd.
Moholy-Nagy, László, 81n2
Montagu, Ivor, 139
Moore, Henry, 87
Moore, Marianne, 20, 127, 135, 137
Fables of La Fontaine, 141
Morley-Fletcher, Inc., 123n31
Morris, Cedric, 83
Morris, William, 51–53
Mortimer, Raymond, 81
The New Interior Decoration, 82, 83–84, 85
Mosley, Oswald, *The Greater Britain,* 24, *26*
Mowatt, Anna Cora, *Fashion; or, Life in New York,* 72
The Museum of Modern Art, New York, 109–15
Abstraction in Photography (1951), 121
Americans 1942 (1942), *113*
Brazil Builds (1943), *114,* 115, 115n26
Cubism and Abstract Art (1936), 110, 140
European Commercial Printing of Today (1935), 112, 140
Film Library, 113
Good Design exhibitions, 117n2
A History of the Modern Poster (1941), 112, 113, 113n24, 141
Kauffer lectures, 61, 67, 107, 131, 141
Museum of Modern Art Publications, 114
New Rugs by American Artists (1942), 115, 115n27
Organic Design in Home Furnishings (1941), *108*
Posters by E. McKnight Kauffer (1937), 62, 89, 109, 110–12, *113,* 115, 1 28, 140
20th Century Portraits (1942), 115, 115n27

28th Annual Exhibition of Advertising and Editorial Art (1949), *241*

Musto, Fred, BBC Broadcasting House, *86*
Myers, L. H., *The Clio, 186*

N
Nahum, Sterling Henry (Baron), *Checkmate,* 77
Nash, Paul, 57, 81, 83, 84, 87, 110
New Architecture and the Bauhaus (Gropius), 81n2
New Burlington Galleries, 139, 140
New Theatre, 140
The New Yorker, 127–28
New York Public Library, 121
New York Subway Advertising Company, *A Subway Poster Pulls, 247*
New York Times, 46, 117, 127, 134, 141
New York Times Magazine, 135
Nicholson, Ben, 87
Nonesuch Press, 23, 51n5
 The Anatomy of Melancholy (Burton), *50,* 51–54, *52,* 113, 139
 Benito Cereno (Melville), 54, 107n35, 139
 Don Quixote (Cervantes), 53n16, 54, *55–57,* 56–57, 113n24, 140
 The Week-End Book (Mendel, Meynell, ed.), 139, *164*
Novello and Company, Ltd., *Checkmate* score, *77*

O
Observer, 84
Ognyov, Nikolai, *The Diary of a Communist Schoolboy,* 198
O'Neill, Eugene, *All God's Chillun, 182*

P
Pan American World Airways, 135, 141
Pantheon Books
 Exile (St.-John Perse), *254*
 Man the Measure (Kähler), 141
 The Sleepwalkers (Broch), *126,* 132
Parker, Robert Allerton, 139
Penrose Annual, 139
Percy Lund, Humphries & Co., 23, *25,* 140
Perelman, S. J., 20, 132
Petrie, Maria Zimmern, 30, 39, 138
Pevsner, Sir Nikolaus, 43–44, 83n12
Picasso, Pablo, 53, 100
Pick, Frank, 23, 31, 33, 40, 41, 43–44, 46–48, 47n16, 88, 92, 138
Pirandello, Luigi, *Henry IV,* 71–72, 71n9, 139, *192*
Poe, Edgar Allan, 134, 137, 141, *252–53*
The Poetry Bookshop, *The Chapbook,* 165
Pomeroy Day Cream, 62, *63,* 88, 139, *172*
Poor, Henry Varnum, 118
Portfolio, 109, 128, 131, 137, 141
Power, J. W., 83
Putnam, *The Clio* (Myers), *186*

R
Rampersad, Arnold, 105
Rand, Paul, 61, 129, 135, 141
Random House, 23, 132, 134
 Farewell Pretty Ladies (Massie), 141
 Green Mansions (Hudson), 134, *134*
 Invisible Man (Ellison), 100, *101,* 141
 Wicked Water (Kantor), 132, *133*
Ravilious, Eric, 84
Rea, Betty, *5 On Revolutionary Art,* 140, *237*
Read, Herbert, *Art Now, 228*
Rebel Art Centre, 30n3, 31
Rees, John M. (stepfather), 138
Reeves, Ruth, 123n31
Rendall, Ann (daughter), 26, 26n19, 30n4, 33n25, 129, 139
Representation of the People Act (1918), 91n1

Ringling Bros and Barnum & Bailey, 141, *241*
Robertson, Ben, *I Saw England, 132, 132*
Robeson, Paul, 72n14
Rogers, W. S., 59
Rosenthal, George S., 131
Rosse, Hermann, 118
Royal Academy, 89n33
Royal Ballet, 76
Royal Birmingham Society of Arts, 138
Royal Opera House
 Checkmate, 68, *73,* 242–45
Royal Society of Arts, 140
Russell, Gordon, 88

S
Sandilands, G. S., 44–46
Schleger, Hans (Zero), 20, 59, 140
Schulke, Harry, 121
Schulman, Grace, 17, 135, 137
Seminar, 129
Shakespeare, William
 Othello, 72, 72n14, *73,* 140
 The Tempest, 193
Shackleton, Edith, 72
Sharp & Dohme (Merck & Co.), *Seminar,* 129, *129*
Shaw, George Bernard, 24
 Shelf Appeal, 21
Shell-Mex and B.P. Ltd., 23, 89, 139, 140
 Actors Prefer Shell, 206
 Aeroshell Lubricating Oil, 208–9
 BP Ethyl, 22
 Magicians Prefer Shell, 207
 Mechanical Man study, *236*
 Stonehenge, 217
Silkar Studios, Inc.
 Leaves of Grass (Dorn), 116
 Plaque Toltec (Dorn), 123, *125*
Simon, Oliver, 54
Simon and Schuster, *Poems* (Thompson), *210*
Sloane's furniture, 123n31
Smith, Bernard, 46, 62
Smith, Frederick Edwin, first Earl of Birkenhead, *The World in 2030 A.D.,* 24, 66, *67,* 140
Society of Industrial Artists, 81, 140
Spanish Medical Aid Committee, 140
Stanard, Matthew G., 92n10
Steichen, Edward, 121
Stein, Gertrude, 100
Steinthal & Co., 36, 113, 138
 El Progreso, 152
 Murciélago, 153
 Rompe Espina, 153
Stieglitz, Alfred, *Equivalents,* 121, *121*
St. James's Theatre, 140
St.-John Perse, *Exile, 254*
Strachey, Lytton
 Eminent Victorians, 23
 Queen Victoria, 159
The Studio, 184–85
Studio International, 82, 83
Sunday Times, 54
Symons, A. J. A., 54

T
Tallents, Sir Stephen, 91, 92, 95, 95n23
T. B. Lawrence, 139
Thompson, Dunstan, *Poems, 210*
The Times (London), 72, 96
Tito, Josip Broz, 129, *246*
Todd, Dorothy, *The New Interior Decoration, 82,* 83–84, *85*
Tooth, Dudley, 83, 83n14, 140
Toulouse-Lautrec, Henri de, 61
Transport for London, *Power,* 180–81
Tschichold, Jan, 140
Twenty-One Gallery, 138

U
Underground Electric Railways Company of London (UERL), 23, 31–33, 40, 43–49, 43n1, 64–65, 64n22. *See also* London Passenger Transport Board (LPTB) and Transport for London
 The Bright Hours, 203
 British Industries Fair, 204
 Epping Forest by Motor Bus, 154
 The Flea at the Museum of Natural History, 44, 45
 Godstone, 33, *145*
 Hadley Wood by Tram, 176
 Hatfield by Motor Bus, 155
 London History at the London Museum, 42, 168–69
 London Museum of Practical Geology, 164
 Museum of Natural History, 44, *177*
 Near Walthamcross by Tram, 176
 The North Downs, 32, 33
 Oxhey Woods, 31, 33, *147*
 Piccadilly Extension, 205
 A Pillar'd Shade, 216
 The Quiet Hours, 64, *202*
 Regatta Time, 44, 45
 The "Rocket" of Mr. Stephenson, 44, *173*
 Route 160 Reigate, 33, *45*
 Socrates at the British Museum, 179
 Summertime, 44, *171*
 Surrey Heaths, 33
 Theatres, Quickest Way Underground, 179
 Twickenham by Tram, 44, *46*
 In Watford, 31, 33, *146*
 The Way for All, 64, *64*
 Whitsuntide Pleasures by Underground, 44, *46*
 Whitsuntide in the Country, 44
 Winter Sales, 41, 44, 66, *162–63*
 From Winters Gloom to Summers Joy, 110, *111*
United Committee of South-Slavic Americans, 129, *246*
United Nations, *250*
Unit One, 81

V
Van Gogh, Vincent, 30, 30n14, 31, 31n15, 33
Van Vechten, Carl, 53n16, 99–100, 103, 104, 105, 106
 Nigger Heaven, 24, 79n1, *98,* 100–103, 100n6, *102, 104,* 104n19, 107, 140
Verdi, Giuseppe, 72
Vickery, John, 96n24
Victor Gollancz Ltd., 23, 139
 Babel (Cournos), *174*
 The Diary of a Communist Schoolboy (Ognyov), *198*
 The Open Conspiracy (Wells), *198*
Victoria and Albert Museum, 48n26, 137, 140, 141
Vic-Wells Ballet, 76–77, 141
Vigil Silk, 39, 62
 label, *63*
 The Pure Silk, 38, 160
 Vigil for Lovely Frocks, 161
Viking Press, *Fables of La Fontaine* (Moore), 141
Villiers Engineering Company, 139, *195*
Vogue, 123
vorticism, 31, 34, 40
Vuillard, Édouard, 33

W
Wadsworth, Edward, 31, 34, 87
 Enclosure, 38
Waldman, Bernard, 23, 134–35, 137, 141
Waldman, Grace. *See* Schulman, Grace
Waldman, Marcella, 23

Wales, Prince of, 92n7
Walker, Alec G., 39
Webster, Susan Beatrice, 138
Wellesley College Art Museum, 110, 112n18
Wellesley News, 110
Wells, H. G.
 The Open Conspiracy, 198
 Things to Come, 140
Wescott, Glenway, 115, 135
Westminster Press, 23, 139
 "First Thing Every Morning", Eno's "Fruit Salt", 21, 170
 Pomeroy Day Cream, 172
 The Westminster Press, 170
Wheeler, Monroe, 113–15, 135
White House (Washington, DC), 124n36
Wilenski, R. H., *The Modern Movement in Art, 167*
Wilton Royal Carpet Company, 81, 84n17, 139, *196*
Wishart Limited, *5 On Revolutionary Art* (Rea, ed.), 140, *237*
Woman's Labour League, *The Labour Woman,* 58, 66, *67*
Women's Wear, 118
Woolf, Leonard, 20, 51
 Quack Quack, 26, 225
Woolf, Virginia, 20, 51, 64, 64n24
Wright, Richard, *Native Son,* 100, *101*
W. S. Crawford, *82,* 83, 83n12, 139

Y
Yale Review, 137
Yorke, F. R. S., 81
Yorkshire Observer, 53
Yorkshire Post, 29

Z
Zachary, Frank, 109, 128, 129, 131, 135, 137, 141
Zero (Hans Schleger), 20, 59, 140
Zimmern, W. H., 36, 138
Zwemmer Gallery, 84–86, 89n33, 140
 Room and Book exhibition brochure, *85*

CONTRIBUTORS

Taryn Clary served as a curatorial intern in the Department of Product Design and Decorative Arts at Cooper Hewitt (2018–19). She holds a BA in art history and French from Amherst College (2016) and an MA in decorative arts, design history, and material culture from Bard Graduate Center, New York (2019), where she concentrated on nineteenth- and twentieth-century American art and design. Her MA Exhibition Qualifying Paper received the 2019 Mr. and Mrs. Raymond J. Horowitz Foundation for the Arts Award.

Caitlin Condell is the associate curator and head of the Department of Drawings, Prints, and Graphic Design at Cooper Hewitt, where she oversees a collection of nearly 147,000 works on paper dating from the fourteenth century to the present. She has organized and contributed to numerous exhibitions and publications, including *Underground Modernist: E. McKnight Kauffer* (2021), *After Icebergs* (2019–20), *Nature—Cooper Hewitt Design Triennial* (2019–20), *Fragile Beasts* (2016–17), *Making Design* (2014–15), and *How Posters Work* (2015), at Cooper Hewitt, and *Making Room: The Space between Two and Three Dimensions* (2012–13), at the Massachusetts Museum of Contemporary Art (MASS MoCA).

Teri J. Edelstein is principal of Teri J. Edelstein Associates, Museum Strategies. She holds a PhD in art history from the University of Pennsylvania. Her publications include the books *Art for All: British Posters for Transport* (Yale University Press, 2010), *Perspectives on Berthe Morisot* (Hudson Hills, 1992), and, with her husband, Neil Harris, *En Guerre: French Illustrators and World War I* (The University of Chicago Library, 2014). She has published articles in *The Burlington Magazine* and *Victorian Studies* and has contributed to edited volumes including *Art Deco Chicago: Designing Modern America*. A former deputy director of the Art Institute of Chicago, she curated *Everyone's Art Gallery: Posters of the London Underground* there in 2019.

Steven Heller is cochair of the MFA Design program at the School of Visual Arts, New York, and former art director of the *New York Times Book Review*. He writes a column for *Design Observer* and The Daily Heller for *Printmag.com*. He has authored, coauthored, and edited more than 190 books on graphic design and illustration. Heller is the recipient of the Smithsonian's National Design Award for Design Mind (2011), the AIGA Medal for Lifetime Achievement (1999), the Art Directors Club Hall of Fame (1996), and the Ladislav Sutnar Award (2014). His most recent book is *Teaching Graphic Design History* (Allworth, 2019).

Juliet Kinchin was curator for twelve years at The Museum of Modern Art, New York, where she was involved in numerous exhibitions and publications on aspects of twentieth-century design. She holds MA degrees from Cambridge University and the Courtauld Institute of Art of the University of London, as well as a DLitt from the University of Glasgow, where she was the founding director of the graduate program in decorative arts and design history. She previously worked at Glasgow Museums and at London's Victoria and Albert Museum, and held faculty positions at the Glasgow School of Art and Bard Graduate Center.

Caroline O'Connell is a curatorial assistant at Cooper Hewitt, where she works on historic and contemporary exhibitions. Her work explores intersections between design and material culture with an emphasis on process and collecting. O'Connell has helped organize publications and exhibitions that include *Underground Modernist: E. McKnight Kauffer* (2021), *Nature—Cooper Hewitt Design Triennial* (2019–20), and *Wyss Institute Selects* (2019), at Cooper Hewitt, and *Introspective* (2016) at Bard Graduate Center.

Aidan O'Connor is a design curator and consultant based in Minneapolis. She has worked in curatorial departments at The Museum of Modern Art, Cooper Hewitt, and The Metropolitan Museum of Art, all in New York, and Harvard's Peabody Museum of Archaeology and Ethnology, and has guest-curated exhibitions for the High Museum of Art, Atlanta, and Vandalorum, Sweden. Additional experiences include teaching design history at the School of Visual Arts and at Pratt Institute, New York, directing strategic initiatives for AIGA, and managing the National Design Awards. Along with her broad expertise in modern and contemporary design, her special interests include design for children, the Cold War, Nordic cultures, gender, pop culture, sustainability, advertising, and STEAM education.

Emily M. Orr is the assistant curator of modern and contemporary American design at Cooper Hewitt. She holds a PhD in the history of design from the Royal College of Art/Victoria and Albert Museum. Her exhibitions at Cooper Hewitt include *Underground Modernist: E. McKnight Kauffer* (2021), *Botanical Expressions* (2019–20), and *The Jazz Age: American Style in the 1920s* (2017). Orr has written articles and chapters on a range of design history topics and is the author of *Designing the Department Store: Display and Retail at the Turn of the Twentieth Century* (Bloomsbury, 2019).

Kristina Parsons is a researcher, lecturer, and historian of visual and material culture. She is a curatorial assistant at the Jewish Museum in New York and previously served as a curatorial assistant and research cataloger at Cooper Hewitt in support of the exhibition *Underground Modernist: E. McKnight Kauffer* from 2018 to 2020. She completed her MA in design history and curatorial studies at Parsons School of Design, New York, where she now teaches in the School of Constructed Environments. She has contributed variously to museum exhibitions, curatorial projects, and publications including *Design and Violence* (2015) and *Items: Is Fashion Modern?* (2017), both at The Museum of Modern Art.

Julie Pastor is a curatorial assistant at Cooper Hewitt, where she develops and organizes exhibitions and books on modern and contemporary design. Her exhibitions and publications include *Willi Smith: Street Couture* (2020), *The Road Ahead: Reimagining Mobility* (2018), *The Senses: Design Beyond Vision* (2018), and *By the People: Designing a Better America* (2016). Pastor has also researched and cataloged many works in Cooper Hewitt's Drawings, Prints, and Graphic Design collection.

Kimberly Randall is the collections manager in the Textiles Department at Cooper Hewitt. The department's collection comprises approximately 27,000 textiles, costumes, accessories, trimmings, and sample books representing twenty-four centuries of textile production in Europe, the Americas, Asia, and Africa. Randall has contributed to museum exhibitions and publications at Cooper Hewitt including *Tools: Extending Our Reach* (2014) and *Embroidered and Embellished* (2019), a show focusing on French eighteenth-century embroidered waistcoats.

James Smalls is a professor of visual arts and an affiliate professor of Africana studies and gender, women's, and sexuality studies at the University of Maryland, Baltimore County. His research and publications focus on the intersections of race, gender, and queer sexuality in nineteenth-century European art and in the modern and contemporary art and visual culture of the black diaspora. He also teaches design history. He is the author of *The Homoerotic Photography of Carl Van Vechten* (Temple University Press, 2006) and is presently at work on a book titled *Féral Benga: African Muse of Modernism*.

ACKNOWLEDGMENTS

The planning and execution of this book, *E. McKnight Kauffer: The Artist in Advertising*, and the accompanying exhibition, *Underground Modernist: E. McKnight Kauffer*, have been years in the making. These joint projects have depended on the contributions of many people.

We are deeply indebted to the gracious support and assistance of Simon Rendall, Kauffer's grandson. Simon's enduring commitment to Kauffer's legacy has facilitated the research of many curators and scholars over the years. We are grateful to be among those whom he has entrusted with furthering the knowledge and understanding of his grandfather's work and life. Simon, his wife, Sarah, and their sons, Frederick and Edward, have welcomed us into their home on countless occasions. They have shared stories, connections, and personal insights as well as a wealth of archival material. This project would not have been possible without their encouragement, generosity, and friendship.

It has been our privilege to become acquainted with the extraordinary poet Grace Schulman. Grace donated significant archival holdings documenting Kauffer's work to Cooper Hewitt, Smithsonian Design Museum, and she has been a crucial advocate of both the publication and the exhibition. Her moving recollections of Kauffer have anchored our research and filled in gaps in our knowledge. As we have navigated the highs and lows that come with any undertaking as significant as this one, Grace has lifted our spirits and championed both our work and our lives. We are honored to call her a friend.

Were it not for the extraordinary efforts of two newly minted Kauffer scholars, this book would not be in your hands today. Kristina Parsons was scrupulous in her work as the research cataloger of Cooper Hewitt's Kauffer collection and archive. As the curatorial assistant in charge of the publication, she offered indispensable insights and investigative research, which can be found throughout this publication and in the exhibition. Caroline O'Connell, as the curatorial assistant in charge of the exhibition, demonstrated organizational talents and impeccable practicality to juggle the myriad tasks of mounting such a complex show while lending vital assistance to the publication.

Even several generations after his death, Kauffer continues to inspire generosity among those familiar with his work. It is in this spirit of kindness that a remarkable number of individuals have shared their time and knowledge with us. These include a group of scholars who have researched and published extensively on Kauffer, including Mark Haworth-Booth, Peyton Skipwith, Graham Twemlow, and Brian Webb. It was Twemlow's visit to the Kauffer archive at Cooper Hewitt in 2012 that inspired the work that ultimately led to this project. Additional insight and support have been provided by Jeremy Aynsley, Nicky Balfour Penney, Merrill C. Berman, David Bownes, Christine Boydell, Neville Brody, Sophie Churcher, Sarah Farkas, Paul Galloway, Oliver Green, Mary Knighton, Katharine Meynell, Alan Powers, Jack Quinn, Uthra Rajgopal, Paul and Karen Rennie, Mark Resnick, Gordon Samuel, Jolie Simpson, Andrea Tanner, Nicolette Tomkinson, Brian and Gail Webb, and Emma West.

We are also deeply grateful to the following institutions and individuals for their generous support and assistance with this exhibition and publication project: Birmingham Royal Ballet; British Council Collection; the Cleveland Museum of Art; John Bright Collection; London Transport Museum; Manchester Art Gallery; Mary Evans Picture Library; The Metropolitan Museum of Art; The Museum of Modern Art; Museum of New Zealand; The National Archives; National Art Library; National Portrait Gallery, Smithsonian Institution; New York Public Library; Peter Harrington Rare Books; RISD Museum; Royal Institute of British Architects; Royal Opera House; Smithsonian Libraries; Stanford University Special Collections; Tate; The UK Government Art Collection; Victoria and Albert Museum, and The Whitworth. Special gratitude is due to Merrill C. Berman, William Crouse, Barbara Jakobson, Simon Rendall, Paul and Karen Rennie, Mark Resnick, Leslie J. Schreyer, Grace Schulman, and Brian and Gail Webb, who have supported our endeavors by opening up their significant collections of Kauffer's work to us.

In tracing Kauffer's legacy in both London and New York, we have drawn from the strengths of an international group of museum and private collections, archives, and libraries. Our travels on both sides of the Atlantic Ocean have enlightened us, and we have gained invaluable insights from many colleagues. AHRC-Smithsonian Rutherford Fellowships awarded by the Arts and Humanities Research Council (AHRC) of the United Kingdom enabled three-month residencies at the Victoria and Albert Museum (V&A) and travel in the UK. V&A staff provided tremendous support and access to their unparalleled Kauffer and Dorn collections. Our appreciation extends to Tristram Hunt, director, and in particular to Joanna Norman, head of research, who was a gracious host. Claudia Heidebluth provided steadfast administrative assistance. Tao-Tao Chang, formerly of the V&A and now head of infrastructure at the AHRC, expertly guided us through the fellowship process, as did Kaja Marczewska, research grants manager. Thanks also go to former Research Department members Richard Baxter, Alice Bailey, and Cecilia Rosser. We are extremely grateful to all of the members of the Prints, Drawings, and Photographs Department: Zorian Clayton, assistant curator, deserves special notice for patiently helping us to navigate the collection and providing unfailing support of many kinds; Gill Saunders, head of Prints, and Margaret Timmers, curator emerita, championed our research; Catherine Flood, curator, made critical introductions, and Ella Ravilious provided gracious oversight of our hours spent in the Prints and Drawings Study Room. Christopher Wilk, keeper of Furniture, Textiles and Fashion, was a thoughtful advocate of our research. In the National Art Library, Ruth Hibbard and Deborah Sutherland enthusiastically introduced us to the Jobbing and Printing Collection and assisted with access and loans. The V&A resources of the RIBA Study Room, Archive of Art & Design, and the Theatre & Performance Archives were also essential to our research.

This project demanded a measure of detective work, and the staffs of many other institutions assisted our researchers: Archives of the Philadelphia Museum of Art; Archives Center, National Museum of American History, Smithsonian Institution; Bancroft Library, University of California, Berkeley; Beinecke Rare Book and Manuscript Library, Yale University; British Film Institute; British Library; British Museum; Cambridge University Library; Elmer Holmes Bobst Library, New York University; Harry Ransom

Center, University of Texas at Austin; Imperial War Museum, London; Institute of Commonwealth Studies; Islington Local History Center; King's College, Cambridge; London Transport Museum; Manchester Art Gallery; The Metropolitan Museum of Art; The Museum of Modern Art and MoMA Archives; National Portrait Gallery, London; Pierpont Morgan Library & Museum; Rare Book & Manuscript Library, Columbia University; Royal Institute of British Architects; Royal Opera House; Smithsonian American Art Museum; Smithsonian Libraries; Tate and Tate Archive; The Whitworth; The Wolfsonian-FIU; The Wolfsonian Library; and Yale Center for British Art.

The collaboration and contributions of many individuals over the years have enabled the completion of this work. Our sincere thanks to Julie Pastor, who was instrumental in the early phase of project development. Taryn Clary and Anna Talley conducted primary archival research that provided the backbone for the project from the outset. Doreen Ho, curatorial capstone fellow from the MA History of Design and Curatorial Studies program, offered jointly by Parsons School of Design and Cooper Hewitt, has been a steadfast collaborator on many aspects of the project, from checklist formation to bibliographic entries. Collections assistant Mir Finkelman provided countless hours of assistance in digitizing and studying Cooper Hewitt's holdings. Many interns, fellows, and former staff members in the Drawings, Prints and Graphic Design Department conducted superb research and contributed to the success of this project, including Chelsea Arenas, Sophia Boosalis, Andrew Gardner, Lily Gildor, Nikky Gonzalez, Virginia McBride, Rebekah Pollock, Rachel Pool, Vianna Newman, Jeremy Witten, and Karin Zonis. A critical Smithsonian Collections Information Systems (CIS-IRM) grant funded the cataloging of Cooper Hewitt's Kauffer collection as well as the processing, rehousing, and creation of a finding aid for the E. McKnight Kauffer Archive, completed by LInda Edgerly and Suzana Chilaka of The Winthrop Group, and the digitization of this material, carried out by Toya Dubin and her expert team at Hudson Archival. In London, Hugh Gilbert skillfully oversaw photography of private collections. In New York, Matthew Flynn beautifully captured Cooper Hewitt's Kauffer collection, while Janice Hussain masterfully managed the digital assets. Essential financial assistance for the publication was provided by the late Drue Heinz, a stalwart patron of the Drawings, Prints and Graphic Design Department. Additional support was provided by the AHRC and Furthermore grants in publishing, a program of the J. M. Kaplan Fund.

At Cooper Hewitt, an extraordinary staff navigated big and small challenges to bring this project to fruition. We would like to express our gratitude to John Davis, interim director, for his endorsement of this vast research project and celebration of the museum's foremost collection of Kauffer's work. Curators, conservators, exhibitions managers, registrars, preparators, art handlers, librarians, digital media producers, educators, graphic designers, and communications and marketing specialists have all been critical to the success of this publication and exhibition. Current and former colleagues who provided exceptional support include Shamus Adams, Carl Baggaley, Sarah Barack, Peter Baryshnikov, Caroline Baumann, Cat Birch, Laurie Bohlk, Elizabeth Broman, Susan Brown, Daryl Cannon, Kristi Cavataro, Marites Chan, Marcy Chevali, Perry Choe, Sarah D. Coffin, Jennifer Cohlman-Bracchi, Gail S. Davidson, Christina De León, Jennifer Dennis, Tara Dougherty, Milly Egawa, Kira Eng-Wilmont, Mary Fernanda Alves da Silva, Debby Fitzgerald, Laura Fravel, Chris Gautier, Vasso Giannopoulos, Rachel Ginsberg, Paul Goss, Dana Green, Alexa Griffith, Jody Hanson, Del Hardin Hoyle, Marilu Datoli Hartnett, Kim Hawkins, Gregory Herringshaw, Nolan Hill, Rachel Hunnicutt, Rick Jones, Nathaniel Joslin, Kathleen Kane, Sarah Lichtman, Andrea Lipps, Nilda Lopez, Ellen Lupton, Margery and Edgar Masinter, Elizabeth Matos, Warwick McLeod, Chris Moody, Emma Mooney, Phoebe Moore, Antonia Moser, Milo Mottola, Ruki Neuhold-Ravikumar, Nykia Omphroy, Angela Perrone, Paula Pineda, Adam Quinn, Kimberly Randall, Kim Robledo-Diga, Wendy Rogers, Carolyn Royston, Julia Siemon, Larry Silver, Rona Simon, Ruth Starr, Ann Sunwoo, Michael Sypulski, Ashley Tickle, Cindy Trope, Stephen Van Dyk, Mathew Weaver, James B. Wilson, Yao-Fen You, and Paula Zamora. Cara McCarty, former curatorial director, and Matilda McQuaid, acting curatorial director, championed this project from the beginning. Yvonne Gómez Durand, Molly Engelman, and Stephen Nunes expertly guided the exhibition through its development. Ali Stewart of Universal Design oversaw the stunning exhibition design with Nelli Wahlsten, and Lucienne Roberts, John McGill, and David Shaw of Lucienne Roberts+ created the compelling exhibition graphics.

On behalf of all the contributing authors, we extend our sincere thanks to Pamela Horn, Cooper Hewitt's director of cross-platform publishing, and Matthew Kennedy, cross-platform publishing associate, for making this outstanding book a reality. It was our true pleasure to work with Lucinda Hitchcock, who is responsible for the book's enchanting and thoughtful design. David Frankel provided a sympathetic edit and generously worked against the clock to meet deadlines. We wholeheartedly salute our fellow authors on this impressive accomplishment. *E. McKnight Kauffer: The Artist in Advertising* is the product of your collective knowledge and eager collaboration.

Emily extends heartfelt thanks to family, friends, and colleagues in the US and the UK for their continual encouragement and advice over the course of this project. For the love and support that has sustained her through every step of this publication and exhibition, Caitlin is grateful to her partner Matthew Grill and to her family Sarah Whitham, Henry Condell, Morgan Condell Morton, Jake Morton, and James Carl Morton.

Finally, we wish to thank each other. Through laughter and tears, breakthroughs and setbacks, we have supported each other in our work on this project, and in the many ways that life has often intervened. We are grateful, above all, for our friendship.

Caitlin Condell and Emily M. Orr

275

A Note from the Designer

Kauffer is an artist who was an ad man, an ad man who was an artist, a Montana man from London, a British gent from the United States. He made radical Dada-esque typography for his intellectual friends and polite illustrative posters for public consumption. He was a misfit and a wanderer (of styles and tropes and motifs), always looking for a place to land, for a manner, a technique. His eloquence allowed him to articulate his role, but his body of work showed a jester, a tester, a dilettante, and a master, all rolled up in one.

Kauffer doesn't fit any simple definition. A modernist with tendencies toward the illustrative, an illustrator with tendencies toward Dada. An American more comfortable in the United Kingdom. Considering Kauffer's personal qualities and the varied nature of his work, I wanted to design a reading experience that nodded to these contradictions. Fully justified text in clean, rectilinear blocks, but slightly out of alignment. Posters that go over the gutter, forcing you to engage your body in turning the book to see the full vertical aspect. Occasional edges that spill off the page or into the gutter. Clusters and constellations of images grouped to be at once legible but also showing the broad array of types of work and influences bumping into each other.

I hope I was able to create some structure, pacing, rhythm, and grace in my use of space—both positive and negative space. My eye looks to the form and the counter-form, and I designed each spread as its own composition and as part of the overall gestalt that the book establishes.

A book is a slow but nevertheless time-based medium. It contains interior space and involves timing, sequence, and rhythm. There was flow and movement in Kauffer's career and this design attempts to offer flow and movement as well. Introducing footnotes as marginalia not only brings the relevant information to the main pages (rather than relegating it to backmatter), but also adds a secondary voice to the page. This voice of scholarship helps to position this book uniquely: as both a visual compendium *and* a document of considerable research. —Lucinda Hitchcock

Jacket/Poster: *Well Done! 11 World Records, Villiers*, ca. 1928; Designed by E. McKnight Kauffer at W. S. Crawford Ltd. (London, England); Published by The Villiers Engineering Company (Wolverhampton, England); Lithograph; 76.1 × 50.7 cm (29 15/16 × 19 15/16 in.); Gift of Mrs. E. McKnight Kauffer, 1963-39-75, Cooper Hewitt, Smithsonian Design Museum; Photo by Matt Flynn © Smithsonian Institution

This book is published in conjunction with the exhibition *Underground Modernist: E. McKnight Kauffer*, Cooper Hewitt, Smithsonian Design Museum, New York

 This publication is made possible in part by Furthermore: a program of the J. M. Kaplan Fund.

ISBN: 978-0-8478-6774-5
Library of Congress Control Number: 2020933262

First copublished in the United States of America in 2020 by

RIZZOLI Electa
Rizzoli Electa
A division of Rizzoli International Publications, Inc.
300 Park Avenue South, New York, NY 10010
RIZZOLIUSA.COM

COOPER HEWITT
Cooper Hewitt,
Smithsonian Design Museum
2 East 91st Street, New York, NY 10128
COOPERHEWITT.ORG

For Cooper Hewitt
Pamela Horn, Director of Cross-Platform Publishing and Strategic Partnerships
Matthew Kennedy, Publishing Associate and Image Rights

For Rizzoli Electa
Charles Miers, Publisher
Margaret Rennolds Chace, Associate Publisher
Lynn Scrabis, Managing Editor
Alyn Evans , Production Manager
Loren Olson, Editor

Design: Lucinda Hitchcock
This book is typeset in Circular, from Lineto, and Simplon and Sang Bleu, by Swiss Typefaces.

Facebook.com/RizzoliNewYork
Twitter: @Rizzoli_Books
Instagram.com/RizzoliBooks
Pinterest.com/RizzoliBooks
Youtube.com/user/RizzoliNY
Issuu.com/Rizzoli
Facebook.com/CooperHewitt
Twitter: @CooperHewitt
Instagram.com/CooperHewitt
Youtube.com/user/CooperHewitt

2020 2021 2022 2023 / 10 9 8 7 6 5 4 3 2 1
Printed in China